different saməs

**New Perspectives in
Contemporary Iranian Art**

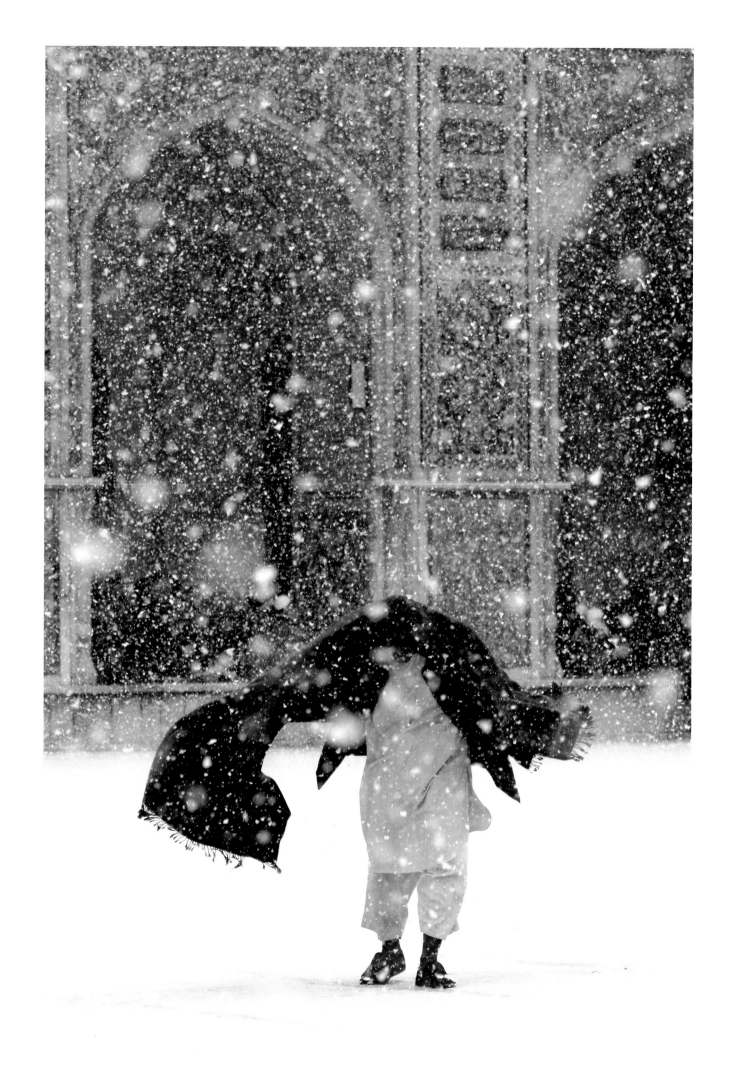

different saməs

New Perspectives in Contemporary Iranian Art

Editor
Hossein Amirsadeghi

Essays
Hamid Keshmirshekan
Mark Irving
Anthony Downey

Thames & Hudson

For Ali Asghar Amirsadeghi
Father, salt of the earth

TransGlobe Publishing Limited
35 Old Queen Street
London SW1H 9JD
United Kingdom

info@tgpublishingltd.com

First published by
Thames & Hudson in association with
TransGlobe Publishing Limited
© 2009 TransGlobe Publishing

Text and captions copyright:
© 2009 Hossein Amirsadeghi

Distributed worldwide
(except in the United States, Canada and the
United Arab Emirates):
Thames & Hudson Ltd.
181A High Holborn
London, WC1V 7QX
United Kingdom

www.thamesandhudson.com

ISBN: 978-0-500-97697-5

A CIP catalogue for this book is available from
the British Library

Designed by Struktur Design Limited
Printed in Singapore

previous page
Hassan Sarbakhshian
From the 'Daily Life' series
Photograph
© Hassan Sarbakhshian
Courtesy of Hassan Sarbakhshian and
Silk Road Gallery, Tehran

Foreword

Hossein Amirsadeghi

In creating this book I've had to think long and hard on the subject of art and its relationship to culture and society. Does art have an impact on society? Or is art society's indirect stirring for cultural change? What are these issues of 'self' and 'the other' that Iranian artists like to bring up when talking about their oeuvre and the meaning behind the meaning? How much truth is there in developing theories of the 'hybridization' and 'globalization' of art discussed in this book?

To tell the truth, I have not been able to come up with any views that can rival the existing social, evolutionary, cultural and anthropological theories. Ready explanations for the sudden outpouring of art from Iranians, living inside and outside the country may differ in detail, but all take into account the value of diversity. And, of course, the importance of money, the 'lubricant' that allows art to thrive (and too often allows bad art to survive). These presumptions – for they are merely that and no more, the subject being too short-lived to have acquired a theoretical base – speak of the confrontation of tradition with modernity.

The very fact of the existence of this new Iranian art movement in its manifest forms is itself the best guide to an understanding of its roots and branches. While the profiles in this book try to peek into the artists' individual aesthetics, psychologies and sociologies, at the end of the day true art transgresses borders and boundaries, allowing new and refreshing insights into the social make-up of any national group. Imagination is universal, creativity its reflection. But bad art – and there's plenty of it about on the contemporary Iranian scene – is a poisoned pill guaranteed to defeat any movement, miring the oeuvre in pretension, social obsession and eventual emasculation through weak imitation.

Having said all this, this book does attempt – for the first time – some theoretical explanations. It begins with three essays that discuss the development of Iranian art over the past hundred years. Hamid Keshmirshekan's essay gives one of the most comprehensive overviews yet of the developments, socio-political underpinnings and trends during this period, while Mark Irving's intriguing essay uses

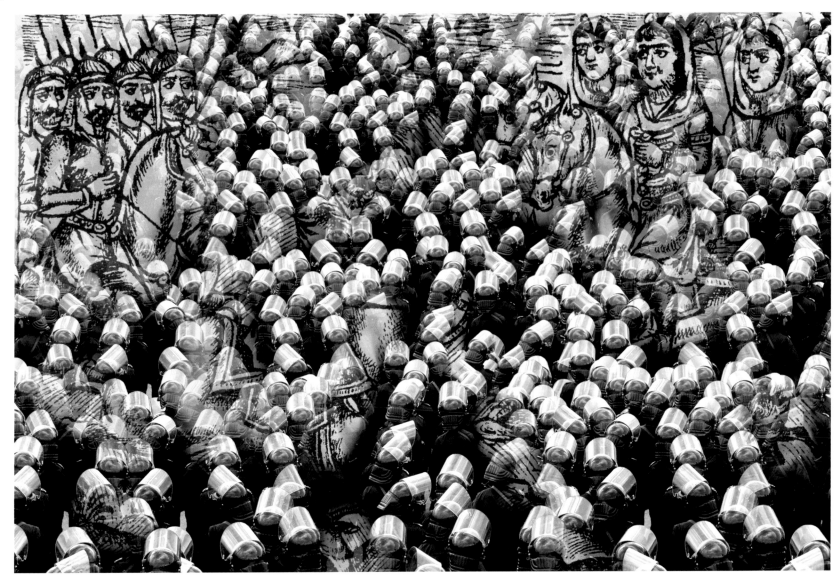

Western critical theory to trace similarities between recent trends in Iranian and Western art. Anthony Downey adds a Western scholar's perspective to the whole phenomenon, while addressing some of the issues underlying the surge of interest in the art of this part of the world. Iranian art has always held a fascination for me not only for its intrinsic aesthetic values, but because its power resonates with my sense of self – my identity and sense of Persian-ness – having now lived more of my life away from my homeland, than within it.

During this thirty-year absence from Iran, I have tried in small ways to water my Iranian roots by creating publications and events that measure the greatness of our culture, and honour the spirit and essence of Eranshahr. Books like *The Arts of Persia* (1989) and *Peerless Images: Persian Painting and its Sources* (2002) have been, I hope, important contributions to the study and understanding of Iranian art, from the beginning of recorded history to the end of the Qajar dynasty. *Different Sames: New Perspectives in Contemporary Iranian Art* is an attempt to complete this art historical sweep, to bring it up to the present day.

In the foreword to *Peerless Images*, I wrote of the continuity in Persian culture and the relationship between art and social origins. I said:

> The earliest historical mention of Persians appears in the annals of the Assyrian King Shalamanseser II in 836 BC. Throughout this long period in history, a sense of Persian cultural identity in political, social, religious, and artistic terms has resulted as much from adaptability as resistance. Herodotus, the Greek historian writing in the 5th century BC, remarked on the propensity of Persians to imitate peoples of other lands. This continuity in change is perhaps the most remarkable of its people's achievements.

'Persian painting,' I concluded, 'visually defines this historical characteristic.... This art form has played a central role in Iranian culture.... [It is] an art form as dazzling as it is mystifying and intriguing.' Those words, used in relation to historical painting, can just as easily be applied to modernist and contemporary Iranian art. This, in my opinion, is testimony to that 'continuity in change' explored in *Peerless Images*. Exploring these different themes had informed my purpose in searching for the storytelling medium of Persian painting then, and has now been transformed into the visual feast that is *Different Sames*. Differences and similarities are readily discernible between Iranian contemporary art and global artistic trends.

Different Sames tries to tell its own story through the various fine art media employed by the Iranian artists whose works are shown and discussed in this book. The first section deals with history and theory, the art historical and critical essays commingling with the works of most of the leading Iranian modernists. These early pioneers' contributions to the Iranian art movement are no less important for being represented only in passing. I made a decision early on to place the emphasis on the contemporary movement, mixed with a smattering of headline Iranian modernists with regional and international recognition. I wanted a visual expression of the storytelling aspect of Iranian painting, and for the artists' own works to be self-revealing as to cause and effect. I wanted to seek out the roots of the art in relation to the socio-political circumstances affecting our culture's transformation since the advent of the Islamic Republic of Iran. I wanted visual and theoretical answers to questions such as: How have artistic tendencies changed under a relentless regime of religious-political indoctrination? Has the post-Revolution generation (who now make up 70 per cent of the population) been culturally beaten down? Has there really been 'continuity in change' in Iranian art? And what are young contemporary Iranian artists trying to say through their work?

Some answers to these questions are revealed in the book's second part, where we have selected works from both established and newer artists within Iran and from across the large and creatively vibrant Iranian Diaspora. When good, the works allow the reader fresh perspectives on 'differentials' and 'sameness' in relation to the previous generations of Iranian art, and some current trends in the Western art world. Much of the art showcased here has a subtext that deals with the jarring (and often hypocritical) paradoxes of day-to-day Iranian society, from the iconoclastic interpretations of some of the female artists in their criticism of the role of women in contemporary Iranian society, to the overreaching out-of-the-box artwork of others wanting to express their anger and frustration with the status quo. This book, in fact, has tipped in favour of female Iranian artists – not by some sort of positive discrimination, however, but simply through artistic merit.

In selecting artists for this book I have benefited from the advice and counsel of a large group of art people: experts and cognoscenti, curators and artists, critics and collectors. Given the paucity of expertise on the subject of contemporary Iranian art, I have had to educate myself, while at the same time keeping a distance from certain choppy, ego-saturated Persian waters. The final line-up is thus, to a certain extent, a reflection of personal taste. I am not a collector of modern or contemporary Iranian art, nor do I intend to become one. Rather, my goal has been to make a beautiful book to help better understand and appreciate Iranian cultural and artistic trends. While trying to showcase the best in contemporary Iranian art, I've wanted in particular to foreground the achievements of the younger generation of artists, whether living and working under extremely difficult circumstances inside Iran, or in the United States, United Kingdom, France, Germany or other countries. At times brash and petulant, their work nevertheless has a thrilling vibrancy.

When I first set out to make this book, the overarching vision was to create a visual platform for talent and art historical interpretation. I have steered clear of art jargon, the elitist argot that

Sadegh Tirafkan
Multitude #7, 2008
Digital photo collage, print on RC paper
Edition of 6
75 x 112 cm
© Sadegh Tirafkan
Courtesy of Sadegh Tirafkan

Hossein Amirsadeghi

permeates contemporary art writing. Though Iranian contemporary art is still new to the international scene, such groundbreaking exhibitions as 'Unveiled: New Art from the Middle East', held at the Saatchi Gallery, London, in 2009, demonstrate that there is real and rising interest. Contentiously, some elements within the Iranian contemporary movement are already trapped by their agents' own agendas, while others are prone to striking pseudo postures. It is my hope that this book will encourage the growth of expertise, professionalism and integrity in the Iranian contemporary art world.

Some have argued that contemporary Iranian art is all about money and social cachet, that it is already just an extension of the globalized, bloated contemporary art world. But this would be to play down the hard work and dedication of those interlocutors – the curators, gallery owners, art patrons and collectors – who have been active in the last fifty years. For this reason, I have included a number of profiles within the alphabetical frame of the book's second section to reflect their contributions. Once again, the list is not comprehensive but representative of vanguard elements.

Different Sames is a most timely contribution to the study of Iran's culture and heritage, given both the importance of the country historically and the present troubled geopolitical climate. The confluence of factors such as the thirtieth anniversary of the Islamic Revolution, the election of a new United States administration set on reviewing relations with the present Iranian regime, and the hype surrounding Iranian artists internationally, as exemplified by major auction house sales, is purely coincidental.

'Art, propaganda tool of faith and ideology, has suffered equally at the hands of such destructive traits,' I argued back in 2002. I thought then, and continue to think today, that Iran's rich and extravagant cultural legacy is born as much from social resignation as from individual determination. Iran's citizens, I have said, have too often been eager to surrender their free will to despotism. 'Fashioned from fatalism and nurtured in fundamentalism, religion has often acted as a historical break on cultural and social renewal, encouraging society's blame of others for all their ills.' This crop of new Iranian artists will hopefully counter points in my argument, but we have a long way to go in order to break the crippling, ring-fenced perimeters that religion and social mores impose upon our society.

The present generation of Iranian artists is not afraid to experiment, often testing the limits of social, cultural, political and religious acceptability. This can clearly be seen from the selected works, some of whose temerity puts other cutting-edge contemporary Middle Eastern scenes to shame. This book is a point of departure, an account of these modern Iranians' intriguing stories.

It is to them, the new Persian Manis of today, that I dedicate this book.

Hossein Amirsadeghi, London, February 2009

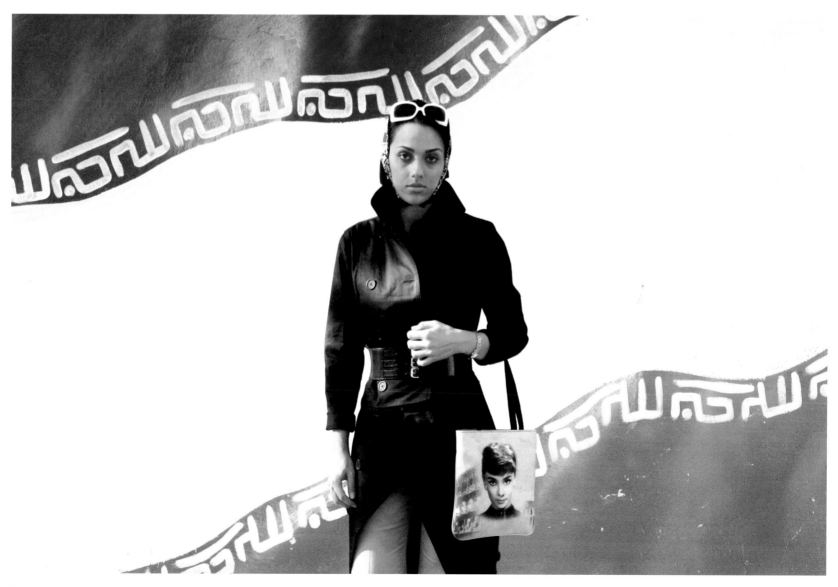

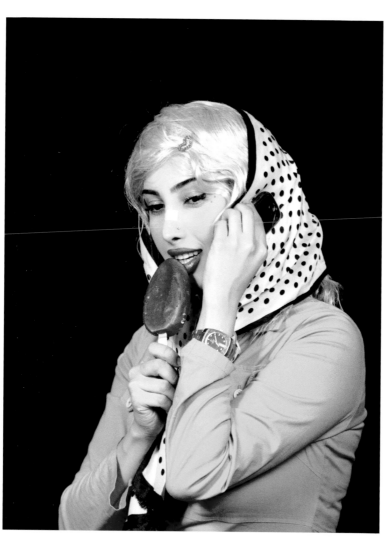

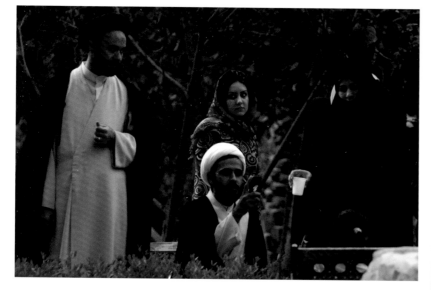

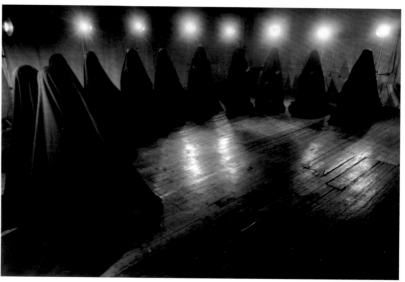

Hamid Keshmirshekan

Modern and Contemporary Iranian Art: Developments and Challenges

Early Developments: Kamal al-Mulk and the Madrasa-i Sanayi'-i Mustazrafa

The artistic relationship between Iran and Western Europe dates back at least as far as the Safavid period (1502–1736), but it was the Qajar period (1785–1925), and specifically the late 19th and early 20th centuries, that saw the first widespread adoption of Western artistic techniques and worldview. This influence, as will be seen, stemmed from direct contact with Western traditions through scholarships to study in Europe and the creation in Iran of art schools staffed by Western-trained teachers. In fact, the period saw such a growth of interest in Western European art that it even came to challenge the existing style of Qajar painting, which itself was an amalgamation of Iranian pictorial tradition and that of European post-Renaissance art. The critical moment in this adoption was the foundation of the first Iranian academy of fine art, the Madrasa-i Sanayi'-i Mustazrafa, by the Dar al-Funun[1] graduate Mohammad Ghaffari, better known as Kamal al-Mulk (1847/8–1940). This shift in art education and artistic production would have a huge impact on 20th-century Iranian art.

The 19th century saw the cultural and industrial revolutions of northwestern Europe spread to the rest of the world. As Stephen Vernoit has described, Muslim societies everywhere were suddenly faced with an international political and commercial system that worked to the advantage of Europeans.[2] This, combined with an unprecedented series of social changes, ushered in a new political order that affected the rulers of both colonized and independent Muslim countries. In addition, imported goods and works of art from industrialized Europe began to supplant traditional products, thus challenging the economic basis of Muslim life.[3] Bit by bit, Muslim societies saw the decline of indigenous forms of visual arts and architecture and their replacement by European styles. New patterns of taste were accompanied by a growing interest in Western forms of literature, music and art.[4]

Kamal al-Mulk graduated from the Dar al-Funun having studied painting and history, and in 1882 was granted the title of *Naqqash-bashi* (great court painter) by Nasser al-Din Shah (ruled 1848–96). Later, during the reign of Muzaffar al-Din Shah (1896–1907), he was able to continue his art studies in Florence, Rome, Paris and Vienna on a three-year government-sponsored educational mission, beginning in 1897. Like his uncle, Sani' al-Mulk (Abu'l Hassan, 1814–66), Kamal al-Mulk spent many hours studying the works of the European Renaissance and Baroque masters, though he ignored contemporary Impressionist works. In his memoirs he repeatedly stressed his admiration for the paintings of Rembrandt, Raphael and Titian.[5]

As Kamal al-Mulk's reputation and abilities grew, he acquired new duties as a court painter. He depicted important events, palace buildings, gardens and painted portraits of the Shah and his family, working in a highly detailed style that placed a premium on realism.[6] Indeed, since his trip to Europe was in the capacity of a royal artist, it was perhaps not surprising that he should spend so much time studying Old Masters rather than the new ones, since one of the aims of the trip was to extend his technical knowledge. His preference was for European official art of that period, the academic style favoured by the Salon. This academic influence is especially noticeable after his return to Iran in 1900–1901, and even his later works, in which he presented social subjects with more indigenous themes, tend to be painted in a naturalistic style. However, a look at his works before his journey to Europe shows that he already had some knowledge of post-Renaissance European techniques,[7] and he had already made copies after masterpieces by Rembrandt, Titian and Rubens. Much of this knowledge was self-taught, but some may have come from the Dar al-Funun. Landscapes around Tehran, lively scenes of his journey to Iraq, and the dignitaries of the time were the dominant themes after the trip to Europe.

The most significant outcome of Kamal al-Mulk's journey to Europe, however, was the establishment of Iran's first academy of fine art, the Madrasa-i Sanayi'-i Mustazrafa, in 1911. The indirect catalyst for this foundation, Ruin Pakbaz argues, was the Iranian Constitutional Revolution of 1906,[8] which marked the first signs of a new development in Iranian arts and literature, and created social and cultural changes that in turn provided an important background for the new arts.[9] With the consent of the post-revolutionary government and following his own artistic vision, Kamal al-Mulk tried to implement a Western artistic educational system in his Madrasa. The school, under the jurisdiction of the Ministry of Higher Education (*Ma'arif*), was intended to be devoted exclusively to the instruction and promotion of fine art, especially the 'science of painting'.[10] Indeed, the academy's mission statement explicitly referred to painting as a 'science' and set out the school's primary function as being a 'disseminator of this science'.[11] Among the subjects taught were oil and watercolour painting, sculpture, carpet weaving, drawing and, later, lithography. The records from the Madrasa show that the school blended traditional apprenticeship systems with a European academy-style approach.[12]

Nevertheless, Kamal al-Mulk's main aim in establishing the Madrasa-i Sanayi'-i Mustazrafa was to train art students in Western academic methods, and this often came at the expense of traditional

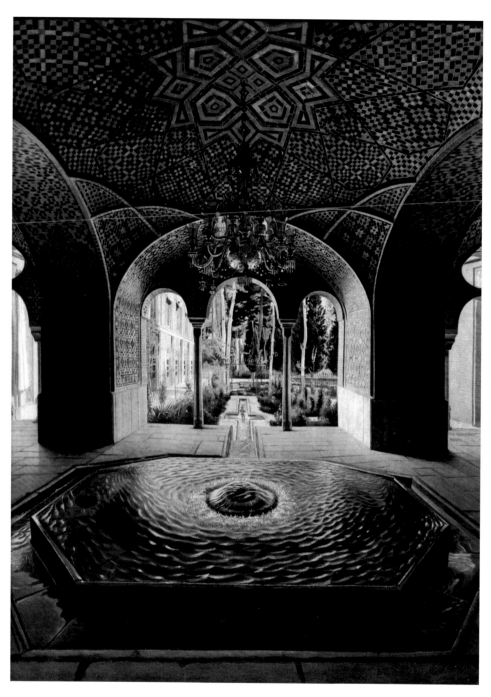

Hamid Keshmirshekan

Kamal al-Mulk
Howz-Khana-i Sahibqaraniyya
(Golestan Palace), 1882
Oil on canvas
52.5 x 65 cm
Golestan Palace Museum, Tehran
Courtesy of the Museum

media such as manuscript illumination and lacquer-work. As mentioned earlier, Iranian artists had already been blending traditional Iranian and European art for centuries, but Kamal al-Mulk and his followers were able to extend the European influence considerably – indeed, his naturalistic style, the so-called 'School of Kamal al-Mulk', dominated the visual arts in Iran during the first few decades of the 20th century, and set the tone for Iranian art for some time after.

Kamal al-Mulk himself directed the Madrasa for sixteen years until his retirement in 1927, training many followers who like him aspired to imitate the 'beauties of nature'.[13] Although the Madrasa never developed into a fully fledged academy, it confirmed the supremacy of Western or European art in Iran, and also launched the careers of many great artists who continued to follow his teachings.[14] The best known and most influential of these include: Ali Mohammad Heydarian (1896–1990), who played a key role in the establishment of the Faculty of Fine Arts, Tehran University; Ismail Ashtiani (1892–1971), who in about 1928 founded the Kamal al-Mulk Fine Arts High School (Hunaristan-i Kamal al-Mulk); Hassan Ali Vaziri (1889–1956), who taught at the Madrasa and the Faculty of Fine Arts; Hossein Sheykh (1911–91), who was a teacher and director of the Kamal al-Mulk Fine Arts High School; Ali Akbar Yasami (1903–80), who lived, worked and taught in Tabriz; and Abul Hassan Seddiqi (1897–1995), a leading Iranian sculptor who taught at the Madrasa and the Faculty of Fine Arts.

The Renewal of Persian Miniature Painting

Kamal al-Mulk's Western-influenced approach may have dominated the Iranian artistic world in the early 20th century, but it did not go completely unchallenged. A group of traditionalist artists, usually referred to as miniaturists, were at the same time attempting to revive Timurid and late Safavid artistic traditions, in particular those of the so-called Tabriz and Isfahan Schools of the 16th and 17th centuries. Beginning in the late Qajar and early Pahlavi periods, these miniaturists taught several pupils who then went on to promote the style both in Tehran and in Isfahan. Thanks to the efforts of artists such as Hossein Taherzadeh Behzad (1887–1925) and Mirza Hadi-Khan Tajvidi (1892–1940, who had also attended Kamal al-Mulk's Madrasa), the establishment of the School of Traditional Arts (Madrasa Sanayi'-i Qadima) in 1929 was followed by a period of renewed activity that led to the formation of the so-called 'Tehran School' of miniature painting. Aboutaleb Moghimi (1912–70) and Mohammad Ali Zavieh (1912–90) belonged to the second generation of this school. Similar developments could be found in Isfahan, where Issa Bahadori directed the High School of Traditional Arts; other important figures in that city included Mirza Agha Emami (1882–1946) and Hossein Haj Mossavarolmolki (1889–1967). Hossein Behzad (1894–1968) and Sorougin (1896–1996), although they did not participate in either of these regional schools, were key figures in this period, and their highly personal styles of miniature painting had considerable influence on Iranian visual arts.

This renewal of traditional Persian painting was encouraged under the rule of Reza Shah Pahlavi (ruled 1925–41), not least through the creation of the School of Traditional Arts. Although the state primarily supported modernization, traditional arts such as miniature painting and calligraphy were encouraged for their distinguishing Iranian characteristics and their relation to Iranian cultural heritage. One of the main reasons for the establishment of the School of Traditional Arts was to train artists who could help decorate the newly built Marmar Palace in traditional style. In fact, several other centres and museums were formed, including various workshops and the Iranian National Museum of Arts – the latter preserving many works by prominent artists of the Tehran School.

The second and third generations of artists have followed the same pattern, while becoming more interested in social, mystical and poetical themes, and keener to incorporate contemporary subject matter. These include such artists as Mahmoud Farshchian (b. 1929), Houshang Jazizadeh (b. 1933), Mohammad Bagher Aghamiri (b. 1950), Ardeshir Mojarrad Takestani (b. 1949) and Majid Mehregan (b. 1945).

Ali Mohammad Heydarian
Landscape, 1977
Oil on canvas
55 x 85 cm
Private collection
Courtesy of the collector

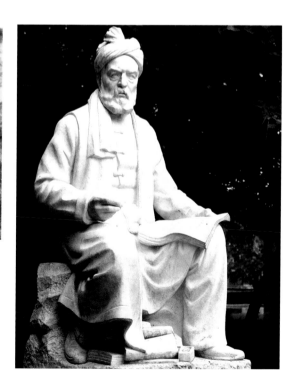

Abul Hassan Seddiqi
Statue of Ferdowsi, 1969
White carrara marble
Tus, Mashhad

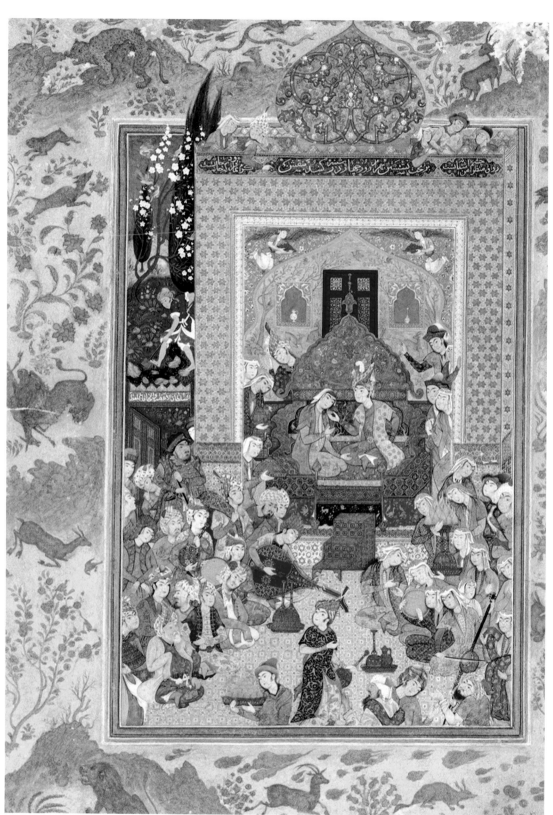

Mirza Hadi-Khan Tajvidi
Purple Dome, 1930
Gouache and watercolour on paper
22 x 31 cm
National Arts Museum, Tehran
Courtesy of the Museum

Hamid Keshmirshekan

The Modern Art Movement in Iran during the 1940s and 1950s

The development of modernism in art in Iran can be seen as mirroring the rapid modernization processes occurring in other areas of Iranian life and socio-political culture. Instrumental in this shift was the Faculty of Fine Arts in Tehran University, the first university art academy in Iran, which encouraged the adoption of modern Western art and in the process became the cradle of modern art in the country for the next few decades. Tehran University, founded in 1934, was designed as a centre for scientific and cultural modernism, and as such was a key part of Reza Shah's modernization strategy. Naturally, the state's education policies and university curricula were at the heart of this official strategy.[15]

The first Director of the faculty was French architect and archaeologist André Godard. He was responsible for setting the curriculum and employing the teaching staff, which included several former students of Kamal al-Mulk, such as Ali Mohammad Heydarian, Hassan Ali Vaziri, Abul Hassan Seddiqi and Mohsen Moghaddam. The staff also included Mohsen Foroughi, Fathollah Obbadi, Yevginu Aftandilian and Marthe Célestine Éve (better known as Madame Ashub),[16] all graduates of the École des Beaux-Arts in Paris.[17] These appointments suggest that it was not Godard's aim to place emphasis on contemporary European avant-garde movements. As Javad Hamidi (1918–2002), the first graduate of the faculty, remarked, 'at that time, the academy did not allow the student much leeway for modernism.'[18] Nevertheless, records show that the European instructors did expose the students to late 19th-century French modern art. Certainly new tendencies appeared in the works of students such as Hossein Kazemi (1924–96), Ahmad Esfandiari (b. 1922), Abdollah Ameri (b. 1922), Mehdi Vishkai (b. 1920) and Mahmoud Javadipour (b. 1920). This new generation began to reject Kamal al-Mulk's template and looked for new sources of inspiration, challenging the official, Salon-influenced art of that period. Their work shows the influences of late 19th-century French art (especially Impressionism and Post-Impressionism) and Russian Realism.[19] The most adventurous students were even influenced by artists such as Cézanne and Van Gogh.[20]

The year 1945 saw the first graduations from the faculty. Several of the graduates left Iran in the years immediately following the Second World War, to continue their studies in European institutes, mainly in France (especially at the École des Beaux-Arts in Paris) and Italy. Jalil Ziyapour (1920–99), Javad Hamidi, Mahmoud Javadipour, Hossein Kazemi and Manouchehr Yektaei (b. 1922) were among these pioneers. After their return to Iran, having been exposed to contemporary European art, they started to propagate what they had seen and learnt. These artists were joined by others, such as Houshang Pezeshk-Niya (1915–72), who had graduated from the Istanbul Faculty of Fine Arts and who were equally keen to promote avant-garde styles. Together, these artists were the pioneers of modern Iranian art during the 1940s and 1950s, envoys of modernism from Impressionism and Expressionism to Cubism and abstract art.

Even before these travels, however, Iran had been exposed to Western culture and art through the Allied Forces' brief occupation in 1941. As Ehsan Yarshater points out, during the 1940s, 'Iran was suddenly exposed to a cross-current of variegated ideas and ideologies. New directions were sought with avidity, and new concepts were embraced with relish.'[21] The growing intellectual atmosphere in Iran had strengthened the desire of young Iranian artists to experience new Western artistic approaches. Moreover, in the post-war years, a huge number of well-known Western novels, poems and philosophical works were being translated into Persian and analytical discussions on these materials increased among the Iranian intelligentsia. There were public debates around the necessity and the virtues of modern art – a debate echoed in the world of poetry, where 'new' was pitted against 'classical'.[22] When Jalil Ziyapour, one of the most passionate advocates of modern art, returned home from his time in France, he arrived to find a growing verbal battle between supporters of modern Persian poetry and those of classical poetry. Ziyapour didn't hesitate to side with the modernists.

Jalil Ziyapour
Ghuchani Woman, 1953
Oil on canvas
94 x 212 cm
Tehran Museum of
Contemporary Art
Courtesy of the Museum

The 1940s also saw the first exhibitions of modern art in Tehran. Until the mid-1950s, due to the indifference of governmental institutions,[23] these were often sponsored by and held in cultural institutes such as the Iran-Soviet Cultural Society and the Iran-France Institute. Thus, the first exhibition by the new generation of artists was held in the Iran-France Institute in 1945; these artists were going to spend the rest of the decade fighting to gain public acceptance of their art.[24] The first major exhibition of Iranian art was organized by the Iran-Soviet Cultural Society in 1946. Later, however, these exhibitions were held in new private galleries, which also became places of discussion and debate between artists.

The year 1953 saw the advent of a new attitude towards modernism, one in which the government gradually offered more support. Two major exhibitions held that year brought modern art from the avant-garde fringes into official artistic circles. The first was held at the Mehregan Club (home of the National Teachers' Association), and showed the work of graduates of the Faculty of Fine Arts alongside works by more established and prominent artists. The other exhibition was held in the palace of Prince Gholam-Reza Pahlavi (Mohammad Reza Shah's brother), and was thus officially sponsored. The inclusion of modernist works in this show seemed to mark the end of the cultural authorities' indifference towards modern art.[25] Soon after, in the mid-1950s, Iranian modernists began to receive official support from the Department of Fine Arts (Idara-i Kull-i Hunar-hay-i Zibay-i Kishvar), which later became the Ministry of Culture and Art.[26] In the late 1950s, government policy regarding modern art changed and the department employed a number of modernist artists, which further stimulated the growth of modern art.[27]

The modernist artists had meanwhile established footholds such as the *Khorus Jangi* ('Fighting Cock') association[28] (which promoted European-style modernism) and the Apadana[29] and Saba[30] galleries. With the 1958 Tehran Biennial, which was the first comprehensive exhibition of modernist Iranian artists, modernism was formally approved by the official art custodians of the country.

The pioneers, however, were still faced with opposition on two fronts: from Kamal al-Mulk's followers and from the miniaturists, both of whom, to the modernists at least, seemed to be conservative reactionaries. In addition, the modernists still had to win over the public. Perhaps it was this need to familiarize the public with modern art that led the pioneers to try to promote it through their societies, magazines and exhibitions.

The sensibilities of modernism also had to be balanced against a growing preoccupation with identity. Nationalist sentiment motivated the young artists to refer to their roots and to seek an understanding of the national culture. Many of the young modernists sought to distinguish their work from that of similar artists in other countries, and to find a kind of art work that would identify them as Iranian. A similar search for identity can also be found in contemporary Iranian modernist literature.

So, in an attempt to 'Iranicize' their works, these artists tended to embrace subjects or themes that would be immediately recognized as Iranian. Some used colours that were said to be typical of the Iranian landscape, while others drew on traditional pictorial sources such as standard figures from manuscript painting. Subjects such as tribal or village life, rural people and nomadic tribes, Iranian rituals and women dressed in the *chador* can all be found, executed in different modernistic styles. This tendency would continue and even increase in the following years and decades.

Houshang Pezeshk-Niya
Bandari Women, 1959
Gouache on cardboard
50 x 70 cm
Collection of Niloufar Pezeshk-Niya
Courtesy of the collector

Hossein Kazemi
Ethereal Girl and the Hunch-Back Man, 1954
Oil on canvas
46 x 65 cm
Collection of Javad Karbasi-Zadeh
Courtesy of the collector

Manouchehr Yektaei
Persian Still Life, 1975
Oil on cardboard
100 x 150 cm
Tehran Museum of Contemporary Art
Courtesy of the Museum

The Development of Modernism from Mid-century to the 1970s

The second phase of modern Iranian art coincides with the process of 'adaptation' discussed above, and covers the period from the mid-1950s to the 1970s. In fact, the desire to 'Iranicize' modern art appeared alongside a more general growth of nationalist and nativist sentiment among intellectuals and the political elite. During the 1940s and 1950s, the terms 'national art' and 'national school of art' were frequently used both by artists and by cultural administrators to define this kind of art. This is the period in which the question of identity came to the fore, leading to the combination of elements from the pre-Islamic and Islamic Shi'ite heritage of the country with the Western language of art.

Between the mid-1950s and the late 1970s art was vigorously sponsored both by the state and by foreign and private institutes, though the governmental cultural departments came to dominate artistic activity. The structure of art and artistic organization in Iran was essentially pyramidal, with the government trying to establish, through the patronage of individual artists and movements, a 'formal art' that would form the basis for a national school of art. This trend can be easily discerned in the selection of artists' works, the awarding of prizes and the manifestos written for exhibitions such as the Tehran Biennials, which were supported by the government.

Thus, these decades are marked by two forces: first, a conscious attempt to fit into the currents of the Euro-American artistic scene, which was considered as one the state's cultural goals during Mohammad Reza Shah's reign (1941–79). And second, the emphasis placed on 'national' and 'Iranian' identity by cultural officials and individual artists. It has been argued that this kind of policy by the government provided a suitable ground for the formation and development of a 'decorative' art (in both painting and sculpture) with a formal resemblance to the pictorial tradition of Iran.[31]

One example of an official programme launched and supported by the Department of Fine Arts was the Tehran Biennial. Through such events, which attempted to emulate famous European biennials such as those held in Venice and Paris, the organizers hoped to foster a kind of modern art that would comply with the state's cultural ideals.

The first Tehran Biennial was held in April 1958 in the Abyaz Palace, and represented an important step in the popularization of modern Iranian art. The main goals of the Biennial's founders, who were a combination of modernist artists and government cultural officials, were to 'bring in opportunities for the critical evaluation of works of Iranian artists, to familiarize the public with the new artistic styles, to create a closer understanding and rapport between them and the artists, and to select, through a panel that included knowledgeable national and internationally reputed foreign experts, several works of Iranian artists to represent the country at a number of foreign art festivals, notably the Venice Biennale.'[32]

It is interesting to compare modern Iranian art and modern Iranian poetry during the late 1950s and 1960s. Both were essentially urban art forms, limited to the middle classes. But unlike modern poetry, the visual arts benefited from the wide-ranging support of the state. Publications, festivals and commissions all flourished during the economic boom of the 1960s, while the five Tehran Biennials, prizes and scholarships for study abroad, closer links to international associations, employment of foreign instructors, overhaul of the old educational curriculum, and the establishment of the Faculty of Decorative Arts (Hunarkada-i hunar-hay-i taz'ini) all played important roles in the development of Iranian art. Queen Farah herself widely supported avant-garde art through the establishment of the Office of Queen Farah and the Farah Pahlavi Foundation in the early 1970s.[33] A growing number of art galleries and agencies defined and catered for new markets, while associations with cultural institutions from the United States, Italy and Germany, and the Sirous Gallery in Paris (where modern Iranian art and design were exhibited), all played a role in the formation of an active art scene. This scene was also helped by art clubs in Tehran and other cities, and galleries in Tehran such as Aftab, Mehrshad, Saba, Mes, Litu, Borghese, Zarvan, Zand, Saman, Seyhoun and Talar-i Qandriz. This activity facilitated the (relatively) rapid establishment of reputations, structure and interest that continued to develop until the 1979 Islamic Revolution. All the time, the issue of identity in art continued to be discussed at artistic and intellectual gatherings.[34]

This second generation of pioneer modernists, which flourished during the 1950s, had mostly been trained in Iran and Europe. They included artists such as Marcos Grigorian (1925–2007), Sohrab Sepehri (1928–80), Bahman Mohasses (b. 1931), Abolghasem Saidi (b. 1925) and Mohsen Vaziri Moghaddam (b. 1924).

A graduate of the Tehran Faculty of Fine Art and the Accademia di Belle Arti in Rome, Marcos Grigorian initially worked in an Expressionist vein but shifted to abstract earthworks. He encouraged

Marcos Grigorian
Rebirth, 1970
Mixed media
70 x 70 cm
Collection of Mohammad Ehsaei
Courtesy of the collector

experimentation with new materials, and his works played heavily with texture effects. Grigorian returned to Iran in 1954 and pioneered one of Tehran's first art galleries, the Galerie Esthétique; he was also instrumental in the organization of the new biennial exhibition that would become known as the Tehran Biennial,[35] and served as chairman of the 1958 Biennial. He was also instrumental in introducing Iranian artists to the international art scene.

Sohrab Sepehri, who was also a leading avant-garde poet, was interested in the simple life and its portrayal. Although the highpoint of his artistic career came in the 1960s and 1970s, he had worked with progressive artists in such circles as the *Khorus Jangi* association in the 1950s. His works from this period show an interest in Far Eastern art, especially Japanese Zen painting. He tried to introduce new techniques, such as the 'Sumi ink' method and the *Sessho* attitude towards nature. This tendency increased over the next two decades, as he became more and more distinguished. The whole atmospheric colour of his paintings was extracted from nature. Sepehri's most typical paintings of this period are the semi-abstract works in muted tones, reminiscent of the colours of the desert around his native Kashan. As in his poetry, Sepehri introduced simple, remote and serene surroundings into his atmospheric compositions and directed the viewer's mind to a world of lyricism and contemplation.

Bahman Mohasses studied in Italy and Abolghasem Saidi studied in France, and both decided to stay in those countries. Unlike Mohasses, who had a distinctive and sharp social expressive style, Saidi favoured traditional motifs and poetic traits in his works.

Mohsen Vaziri Moghaddam, an emotive modernist, studied at the Tehran Faculty of Fine Arts and then the Accademia di Belle Arti in Rome, and used elements from traditional design and architecture in his early works. Using two-dimensional geometric shapes with bright colours in his later works, he also created various experimental works in a variety of media.

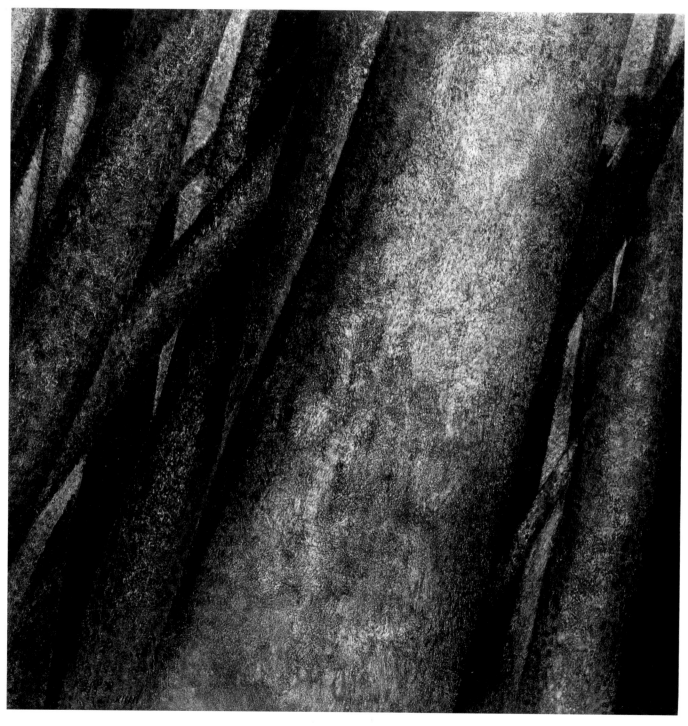

Sohrab Sepehri
Trees Trunks, mid-1970s
Oil on canvas
200 x 200 cm
Tehran Museum of
Contemporary Art
Courtesy of the Museum

Another pioneer modernist who started his artistic activities in the mid-1950s with the establishment of one of Iran's first private galleries, the Modern Art (Humar-i jadid) Gallery, was Zhazeh Tabatabaei (1928–2008). A painter, sculptor, dancer, actor and poet, Tabatabaei began his career in the late 1950s by studying traditional Iranian images, including the formal characteristics of Persian painting, Qajar patterns and *Qahveh-khaneh* (coffee house) painting; he then combined these various sources with an expressionistic style. Later, in the early 1960s, his interest in Shi'ite religious folk art, fables and sayings grew and he became one of the main members of the *Saqqa-khaneh* neo-traditionalist group.

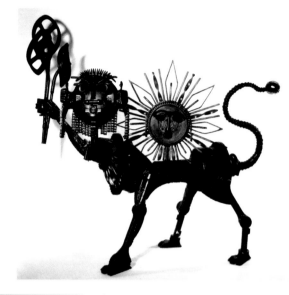

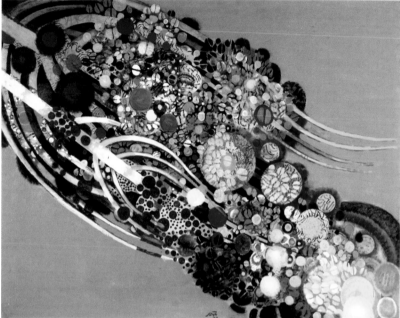

above
Zhazeh Tabatabaei
Lioness and the Sun Lady, 1960s
Metal
40 x 140 x 160 cm

left
Abulghasem Saidi
Abstraction of Flowers, 1973
Oil on canvas
164 x 212 cm
Tehran Museum of Contemporary Art
Courtesy of the Museum

left
Bahman Mohasses
Young Boy and Bird, 1966
Oil on canvas
70 x 200 cm

right
Mohsen Vaziri Moghaddam
Movement III, 1963
Coloured sand on canvas
180 x 200 cm
Tehran Museum of Contemporary Art
Courtesy of the Museum

The *Saqqa-khaneh* Movement

The *Saqqa-khaneh* movement was perhaps the most popular tendency in modern Iranian art in the 1960s.[36] The main purpose of this group of artists was to build on the previous generation's explorations of artistic and national identity. The term *Saqqa-khaneh* was coined by the art critic, journalist and lecturer in English at the Tehran College of Decorative Arts, Karim Emami, and was first applied to the paintings of Charles Hossein Zenderoudi exhibited in the Third Tehran Biennial, 1962.

The term was initially used to describe the works of artists (both painters and sculptors) who had borrowed elements from votive Shi'ite art but had presented them in modern form. Over time, it came to be applied to any modern Iranian art that incorporated traditional decorative elements or forms. The traditional use of the term in Shi'ite folk culture is linked to 'Zamzam'[37] and, going back several centuries, with the martyrdom of Imam Hossein at Karbala in AD 680. In the words of Yarshater,

> [The *Saqqa-khaneh*] votive foundations installed for public drinking are humble, charitable structures which [could still until recently] be seen in the older quarters of Persian towns and cities. Each consists of a small, unassuming niche provided with a water tank, a copper or brass bowl, and some other paraphernalia. It is generally dedicated to the spirit of the Shi'ite martyrs who were massacred by their Umayyad opponents while suffering thirst in [the] scorching desert near Karbala. The primary function of *Saqqa-khaneh* is to offer cool water to all passers-by, but it caters also to some of the spiritual needs of the populace.... [Traditionally,] it contains the portrait of an Imam, which imparts an air of sanctity to it. There are metal trays to which candleholders are affixed for those who want to dedicate a candle to the memory of a saint or a deceased relative. Small locks or pieces of rag are fastened to a chain attached to some part of the saint whose portrait watches over the *Saqqa-khaneh*. A few objects of vague religious significance may also enhance the pious mood of the *Saqqa-khaneh*: a hand cut out of sheets of brass or tin, a string of beads, a mirror, black or green draperies with prayers or verses of the Qur'an embroidered on them, and small pictures or prints of the events of Karbala.[38]

The *Saqqa-khaneh* artists looked to cults, rituals and the ephemera of folk culture for inspiration. These traditional sources, however, were then fused with contemporary styles to create a distinctly regional artistic experience relevant to the modern world. Kamran Diba correctly notes that 'what made this movement revolutionary was the modernistic [approach to] tradition and sense of freedom from the bonds of past cultural clichés.'[39] If the very notion of the avant-garde can be seen as a function of the discourse of originality, the actual practice of vanguard art tends to reveal that 'originality' is a working assumption that itself emerges from a ground of repetition and clichés. In this, *Saqqa-khaneh* was certainly the most influential avant-garde movement in the formation of the neo-traditionalist[40] art in Iran at the time.

The other side of the coin, however, was that the *Saqqa-khaneh* movement paid particular attention to the modern Western language of art. Whereas the *Saqqa-khaneh* artists had all already used the modern language in various forms, the pioneers attempted to incorporate religious-folk art while recognizing the harmonic correspondence with modern Western art (especially abstract art). The *Saqqa-khaneh* artists believed that they could accomplish a modern–traditional synthesis that would exemplify the Iranian character. It was, in fact, the seminal nature of their work that opened the intense creative debate around the issue of identity. As Yarshater remarks:

> This occurred as a restatement of those sources or a re-working of them into new visual statements, or the conjuring-up of a vision of the past lost to modernized Persian life such as a Qajar dancer, a woman in veil, an old-time musician, or an arrangement of...religious symbols in a non-religious context.[41]

Most members of the movement had some sort of relationship, either as students or as teachers, with the Tehran Faculty of Decorative Arts (Hunarkada-i Hunar-hay-i Taz'ini). This had been established in 1961 with the purpose of training experts in the applied arts. Several important modernist painters, sculptors and designers were trained there under the direction of foreign and Iranian instructors. Decorative painting, graphic design, sculpture, interior architecture and other applied arts were all taught in the faculty, and students were encouraged to seek local sources of inspiration, symbols and idioms, and to familiarize themselves with Iran's decorative heritage through various courses.

The *Saqqa-khaneh* artists drew on the Iranian pictorial tradition, experimenting, analysing and combining its forms, colours and textures.[42] This type of folk art with its relative variety and diffusion was rooted among the public. These artists used a vast range of sources: craft motifs, talismanic and magical seals, pictures

and shirts, ancient pottery motifs, elements of Qajar art, Persian calligraphy and painting, Achaemenian and Sassanian inscriptions and epigraphy, and Assyrian bas-reliefs. The combination of Iranian poetry and Eastern gnosticism would be picked up by subsequent artists. Besides the interest in the formal aspects of these traditional sources, the artists also turned to mythical and literary subject matter and folk proverbs.

The *Saqqa-khaneh* movement can be classified into two periods, early (1962–*c.* 1964) and late (1964 onwards). In the early period, as mentioned, the artists were mainly inspired by votive folk materials, whereas the late period shows influences from a wider range of Iranian pictorial traditions. The artists most closely linked to the movement include Charles Hossein Zenderoudi (b. 1937), Parviz Tanavoli (b. 1937), Faramarz Pilaram (1938–83), Mansur Qandriz (1935–65), Nasser Oveisi (b. 1934), Sadeq Tabrizi (b. 1939), Zhazeh Tabatabai (b. 1928–2007) and Massoud Arabshahi (b. 1935).[43]

Parviz Tanavoli, a sculptor, painter and lithographer, and collector and scholar of Persian art, was a pioneer of modern sculpture in Iran. His private gallery, Atelier Kaboud (active 1960–62), had a huge impact on the development of modern Iranian art and in particular the formation of the neo-traditional tendency. His gallery was the first to exhibit the works of several contemporary artists such as Charles Hossein Zenderoudi. Without doubt his gallery, and his extensive friendships with other artists, formed the basis for the *Saqqa-khaneh* movement.[44]

Tanavoli is a genuine craftsman, in the mould of the traditional goldsmiths and silversmiths of Iran, rather than a modern artist or sculptor in the Euro-American tradition. His work refers back to metalwork and formal traditions of applied art, and suggests an affiliation with native popular craft (especially Irano-Islamic crafts). Nevertheless, he was a passionate believer in modernism. Reworking tropes from classical Persian literature, Islamic folk-art and calligraphy, he produced works that provocatively fuse style and meaning.

Tanavoli's fellow artist Zenderoudi trained first at the Tehran Faculty of Decorative Arts, and then in Paris. He is one of the most emblematic artists of the *Saqqa-khaneh* movement, his work characterized by a fusion of avant-garde spirit with an instinctive

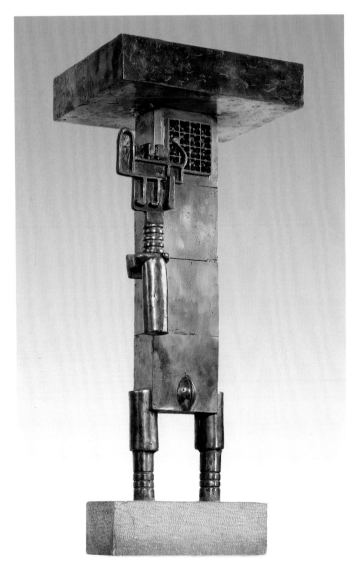

above
Charles Hossein Zenderoudi
AB+35-0, circa 1962
Natural pigment on paper mounted on board
98 x 145 cm
Tehran Museum of Contemporary Art
Courtesy of the Museum

left
Parviz Tanavoli
Poet and the Lion Bone, 1969
Bronze
30 x 48 x 97 cm
Tehran Museum of Contemporary Art
Courtesy of the Museum

innovation. He began by using votive Shi'ite iconography and then shifted to using alphabetical letters as the major element in his canvases in various ways. The freshness and originality of his early works, inspired by these talismanic forms, really stood out. Zenderoudi's interest in calligraphy continued to grow (and continues to the present day) and he began to experiment with Persian and Arabic calligraphic elements. His rhythmical compositions of repeating interwoven words and numbers resemble written prayers, although he often used the words in an ironic way, similar to the contemporary Parisian Lettrist artists.

The artistic development of Faramarz Pilaram, another graduate of the Tehran Faculty of Decorative Arts, at one point bore similarities to that of Zenderoudi – that is, in incorporating words, letters and geometrical forms inspired by Shi'ite iconography. His early *Saqqa-khaneh* works are characterized by the use of old seals, which appear as a part of geometrical compositions. An accomplished calligrapher, Pilaram later experimented with various abstract styles in which calligraphy, especially the *Nasta'liq* script, played a central role.

While Zenderoudi and Pilaram concentrated on calligraphy, others used symbols and abstract designs from traditional sources. A graduate of the Tehran Faculty of Decorative Arts, Mansur Qandriz used stylized Persian motifs from textiles, tribal forms and ancient metalwork, coloured with a limited palette. He was an artist who, 'had struggled in the various stages of his artistic development, with obsessive care and hesitancy, to elaborate and define a truly Iranian style.'[45] In the early 1960s, using traditional textiles and designs, he developed a distinctive semi-abstract style characterized by geometric patterns and stylized images of human, birds, fish, the sun, swords, and so forth. Sadly he died before he was able to take his ideas further.

Inspired chiefly by large-scale Qajar paintings, hand-painted cloths, Persian ceramics and calligraphy, Nasser Oveisi created complex designs that dwelt on a few simple themes: human figures, horses and painted pottery. His works show joyful women with joined eyebrows and large oblong eyes, sometimes alone, sometimes in groups, and men – polo players, riders with falcons on their arm, lovers – reminiscent of certain standard types of Persian classical painting.

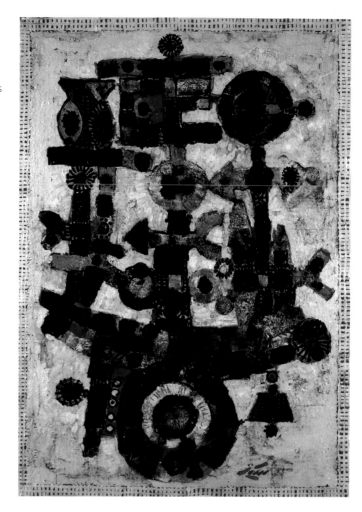

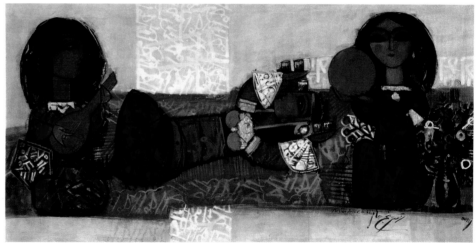

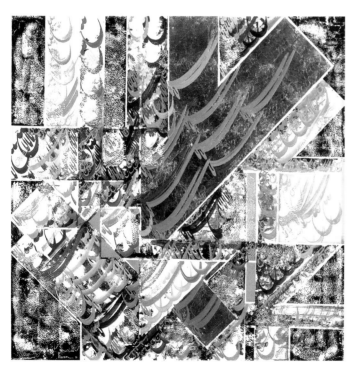

top
Mansur Qandriz
Untitled, 1963
Oil on canvas
80 x 115 cm
Tehran Museum of Contemporary Art
Courtesy of the Museum

left
Faramarz Pilaram
Composition, 1976
Acrylic and gold leaf on canvas
105 x 105 cm
Tehran Museum of Contemporary Art
Courtesy of the Museum

above
Nasser Oveisi
Five Goblet-Dance, 1960s
Oil on canvas
90 x 200 cm
Tehran Museum of Contemporary Art
Courtesy of the Museum

The paintings of Sadeq Tabrizi were at first inspired by symbolic folk objects such as blue beads, old keys and locks, manuscript pages, old signature seals, penmanship practice sheets, metal bowls, coloured glass or bits of semiprecious stone.[46] Tabrizi also drew upon Persian painting, Qajar portraits and forms of religious and folk paintings found in coffee houses. His works frequently show the rhythmical repetition of motifs and of identifiable traditional objects that signify tales of the past. Since the early 1960s, Tabrizi has also used elements of *Nasta'liq*-like calligraphy as a main element in some of his canvases. His rhythmical and lyrical compositions using calligraphic elements were exhibited during the 1970s and 1990s.

Another graduate of the Tehran Faculty of Decorative Arts, Massoud Arabshahi, went back even further to draw inspiration from the art of pre-Islamic Persia. He searched for inspiration among the motifs of Babylonian, Assyrian and Achaemenian rock carving and scripts and Zoroastrian texts. He was an artist who, although affiliated with the *Saqqa-khaneh* group, did not use religious folk sources. However, he did share the other members' attitude and spirit, and his early works (and even the later ones) show many common *Saqqa-khaneh* aesthetic characteristics. His works also often incorporate the forms and colours of Iranian-Islamic architecture.

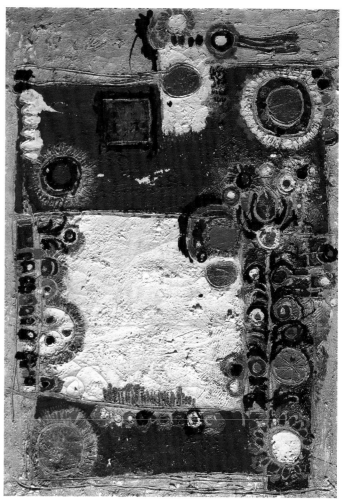

above
Massoud Arabshahi
Untitled, 1967
Acrylic and mixed media on canvas
65 x 134 cm
Tehran Museum of Contemporary Art
Courtesy of the Museum

left
Sadeq Tabrizi
Untitled, 1960s
Gouache on paper

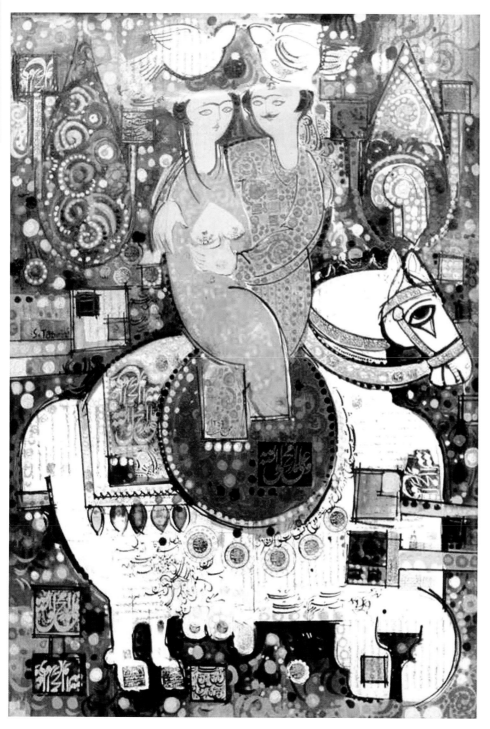

Other Developments in the 1970s

The *Saqqa-khaneh* movement led to the emergence of other groups in Iran, all of which dealt with the issue of identity and combined a modernistic approach with traditional materials. For example, Monir Farmanfarmaian (b. 1924), using traditional motifs from vernacular architecture, architectural designs and Islamic geometry, adapted the ancient techniques of reverse-glass painting and mirror mosaics in her works. Other movements included so-called 'Easternism', 'gnosticism' and *Naqqashi-khatt*.

The most significant of these new movements was *Naqqashi-khatt* (calligraphic painting). This trend was influenced by pioneers of the *Saqqa-khaneh* group such as Zenderoudi and Pilaram, who had put calligraphy at the heart of their work. They influenced other artists including Mohammad Ehsai (b. 1939), Reza Mafi (1943–82) and Nasrollah Afjei (b. 1933). However, whereas for the *Saqqa-khaneh* artists and their followers calligraphy was just one part of their explorations of Iran's pictorial tradition, in *Naqqashi-khatt* the focus was almost solely on calligraphy, and the artists placed greater emphasis on tradition.

The *Saqqa-khaneh* artists' approach was based on the use of calligraphy as the main element in a dynamic abstraction freed by their individual imaginations. The pictorial construction of their canvases showed no sign of the particular characteristics of traditional calligraphy, which places emphasis on the text – whether religious or literary – to be read. Their interest, instead, was in the basic shapes of the letters of such calligraphic styles as *Nasta'liq*, *Shikasteh*, *Thuluth*, *Kufic*, and *Muhaqqaq*, and their combination as structural elements in the overall composition. However, there is no observance of the conventional rules and standard norms of calligraphy. The *Naqashi-khatt* group, on the other hand, was mostly made up of professional calligraphers who had been inspired by the *Saqqa-khaneh* movement and its innovative employment of traditional elements. Their images adhered to traditional standards of calligraphic form, its anatomical principles and also its legibility. Having literary, religious or narrative concepts, their works mostly represent readable and meaningful words or verses from the Qur'an or poetry.

Although Mansoureh Hosseini (b. 1936) was neither a member of the *Saqqa-khaneh* movement nor of *Naqqashi-khatt*, her use of calligraphic forms had begun in the mid-1950s, making her one of the first to work in this area. A graduate of the Tehran Faculty of Fine Arts and the Accademia di Belle Arti in Rome, Hosseini developed her work from a subjective rendering of emotional experience into a mixture of expressionistic style with calligraphic forms. She was inspired by different types of Arabic and Persian calligraphy including *Kufic*, *Nasta'liq* and *Shikasteh*, although her massive coloured, unreadable abstract paintings cannot be related to any specific style of calligraphy.

A professional calligrapher, Mohammad Ehsai began with a different outlook to that of the *Saqqa-khaneh* artists, structuring his canvases around traditional calligraphic forms. An artist of religious conviction, Ehsai has continued to be an important member of the *Naqqashi-khatt* tendency since the late 1960s. In some of his works executed after 1968, there is little intensity of colour and the artist tries to create three-dimensional forms by using chiaroscuro. Although the content of an inscription is very important for Ehsai, legibility is less important; rather, he lets his sentiments, led by religious beliefs, to participate freely in the creation of a spiritual atmosphere.

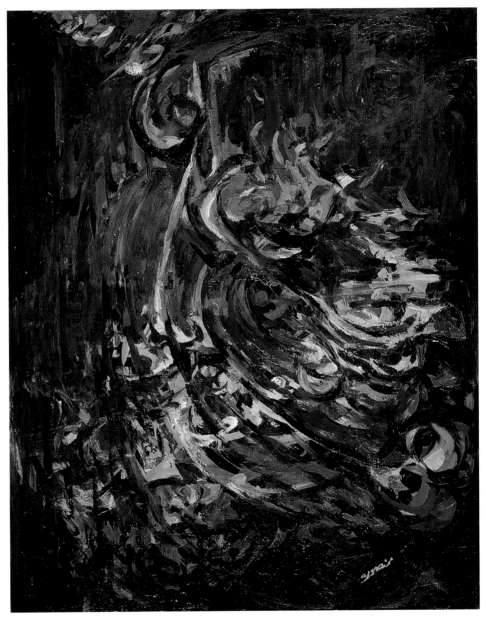

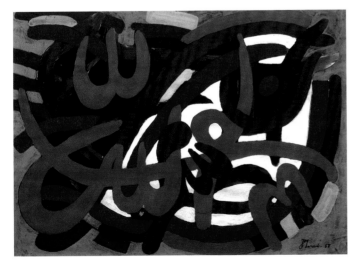

left
Charles Hossein Zenderoudi
Untitled, 1968
Acrylic on panel
62 x 83 cm
Fine Art Museum, Sa'd-Abad Palace
Courtesy of the Museum

above
Mansoureh Hosseini
In the Memory of an Epic, circa 1973
Oil on canvas
80.5 x 190.5 cm
Collection of the Centre of Plastic Arts
Courtesy of the Centre

Something of Ehsai's ideology can be found in the work of his friend and leading member of the *Naqqashi-khatt* trend, Reza Mafi. Mafi had just finished the Society of Iranian Calligraphers' course in 1968–9 when he began his major *Naqqashi-khatt* works. He started with semi-coloured *Siyah-mashqs* (practice sheets) in the early 1970s, but soon shifted to a more experimental use of calligraphic forms. Towards the end of his short life he used elegant brown and beige curves with great freedom of expression. He brought a fresh attitude towards the aesthetics of traditional handwriting, believing that traditional scripts are extremely rich and hugely expressive. He also created a series of monochrome works inspired by Sohrab Sepehri's poems in the later years of his life. Ruin Pakbaz remarks that Mafi's last work, now in the collection of Akbar Seif Nasseri, was made on his deathbed and illustrates well the extent of his minimalist style.[47]

Nasrollah Afjei is another professional calligrapher who completed the Society of Iranian Calligraphers' course, in 1963–4, before following the *Naqqashi-khatt* trend. In his case, however, he has always shied away from pure abstraction, since this would contravene calligraphic conventions – he has never sacrificed traditional calligraphic standards for other artistic purposes.

Jalil Rasouli (b. 1947) started his professional career as a neo-calligrapher in the mid-1970s, but continued in the post-revolutionary period of the 1980s and 1990s. His early *Naqqashi-khatts*, from the late 1970s and early 1980s, present figurative shapes alongside the *Thuluth* script. This kind of usage was associated with some forms of the *Tawqi'* scripts written in the 19th century, in which different figures were formed out of meaningful words.

The 1970s saw Iranian contemporary art reach a new peak of activity. The establishment of grand cultural and artistic venues, national and international festivals and exhibitions, and the development of the art market,[48] spurred on mainly by the government but also by the private sector, all injected new life into the scene. Two new cultural venues would prove to be particularly important: the Tehran Museum of Contemporary Art and the Niavaran Cultural Cente. Both were established under the umbrella of the Farah Pahlavi Foundation and planned by the eminent architect Kamran Diba (b. 1937), who was himself an artist and collector. Directed by Diba, the Tehran Museum of Contemporary Art

above
Mohammad Ehsai
Untitled, 1974
Oil on canvas
120.3 x 120.3 cm
Tehran Museum of
Contemporary Art
Courtesy of the Museum

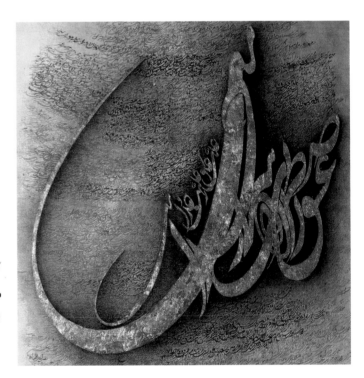

left
Reza Mafi
Untitled, 1975
Oil on canvas
Tehran Museum of Contemporary Art
Courtesy of the Museum

above
Nasrollah Afjei
Love, 1992
Oil on canvas
122 x 122 cm
Tehran Museum of Contemporary Art
Courtesy of the Museum

was inaugurated in 1977 and quickly initiated a new phase of modern and contemporary Iranian art. Its important and large collection contained key Western works of art from the late 19th century up to the 1970s, as well as major contemporary Iranian art. The Niavaran Cultural Centre opened the following year.

Though dominated by modern and contemporary approaches, Iranian art in the 1970s was pluralistic, and the decade saw a growth in the number of artists and groups. Among the most active figures were Iran Darroudi (b. 1936), Hossein Mahjoubi (b. 1930), Parviz Kalantari (b. 1931), Behjat Sadr (b. 1924), Aydin Aghdashloo (b. 1940), Nicky Nodjoumi (b. 1941), Nahid Haghighat (b. 1943) and Alireza Espahbod (1952–2007), as well as Parvaneh Etemadi (b. 1947), Hanibal Alkhas (b. 1930), Fereydoun Ave (b. 1945), Ali Azargin, Jafar Rouhbakhsh (1940–96), Bahman Jalali (b. 1944), Mahin Nourmah (b. 1948), Mehdi Hosseini (b. 1943) and Habibollah Ayatollahi (b. 1934). Founded in 1975, perhaps the most active and influential group of artists was the Independent Group of Painters and Sculptors (Guruh-i azad-i naqqashan va mujassama-sazan). This included many of the groundbreaking artists of the time: Marcos Grigorian, Massoud Arabshahi, Gholamhossein Nami (b. 1936), Mohammad Ebrahim Jafari (b. 1940), Abdolreza Daryabegi (b. 1930), Sirak Melekonian (b. 1931), Morteza Momayyez (1935–2005) and Faramarz Pilaram. This group was especially active in organizing exhibitions, but came to an abrupt end with the 1979 Islamic Revolution.

Hamid Keshmirshekan

above
Parviz Kalantari
Untitled, 1975
Pisé (clay and straw) and paint on canvas
100 x 140 cm
Tehran Museum of Contemporary Art
Courtesy of the Museum

top
Alireza Espahbod
Freedom, 1991
Oil on canvas
120 x 120 cm
Private collection
Courtesy of the collector

right
Gholamhossein Nami
Untitled, 1977
Mixed media on canvas
135 x 160 cm
Courtesy of artist

Revolutionary and Post-Revolutionary Art

The 1979 Revolution that led to the creation of the Islamic Republic produced profound yet contradictory changes in the social and cultural spheres of Iranian life. Art was greatly affected, with modernism now giving way to an art based on revolutionary aspiration and ideological Islamic traditions. The official cultural and artistic policies of the Pahlavi regime were brought to an abrupt halt, and the twin Pahlavi doctrines of modernism and nationalism were frozen. Modernism, moreover, was condemned for being 'elitist' and unable to communicate with the public. Ram argues that 'revolutions are also – perhaps principally – struggles over memory',[49] while Matsuda remarks that a revolution requires 'war on the memories of the old order.... Humanity would be possible only when such memories were destroyed, the old forms and vestiges crumbling as their props were pulled down.'[50] In Ram's words, the Islamic Revolution's 'commitment to break with the past [in the form of the monarchical system] provided a foundation upon which to build a new society.'[51] As noted by Pakbaz, under the new regime, 'with the denial of the existence and function of the official art pursued under Mohammad Reza Shah, many artistic administrators and a number of artists left the scene. A young, [unexperienced] force came to the fore and, in a hasty and radical reaction, rejected all that had been done in the [previous regime].'[52]

Revolutionary art aimed at creating narratives around revolutionary slogans. Storytelling and the articulation of an ideological or political message, as well as social commitment, were the most important features of these works. This, combined with their simple, understandable form and execution, led to their popularity with and acceptance among the masses. This kind of art was approved, encouraged and supported, especially in the first decade after the Revolution, by the cultural section of the new revolutionary government, which fully controlled all artistic activity.

The various kinds of revolutionary art, especially posters, stamps and murals, featured Shi'ite iconography and quite often calligraphy, though now mixed with a propagandistic quality influenced by other 20th-century revolutionary artistic prototypes (especially those from the Soviet Union, Mexico and Cuba). Socialist Realism, the preferred style of revolutionary artists, became a common language and appeared widely immediately after the Revolution. Making use of symbolic Shi'ite elements, these artists gave a realistic expression to such concepts as 'Revolution' and 'martyrdom'.

This situation continued, and was even exaggerated, during the Iran–Iraq War of 1980–88, which caused considerable upheaval in Iran. The decade of revolution and war was, however, a prosperous time for Iranian graphic arts, witnessing a growth in mass-produced graphic images in the form of posters that dealt with epic, religious

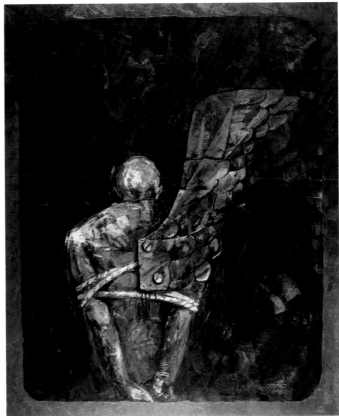

above
Hossein Khosrojerdi
Flight
Acrylic on canvas
130 x 160 cm
Artistic Centre of Islamic Propaganda
Organisation
Courtesy of the Organisation

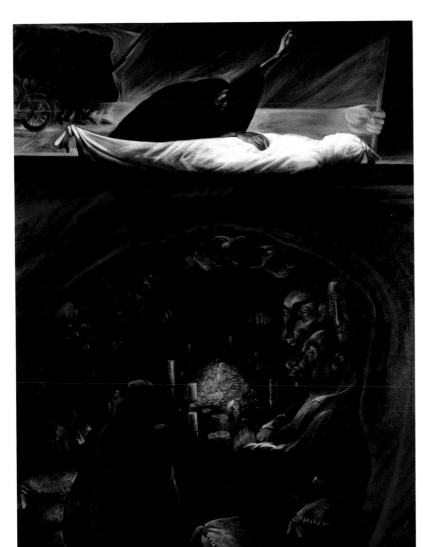

left
Kazem Chalipa
Coin-Eating Rats, 1986
Oil on canvas
200 x 250 cm
Artistic Centre of Islamic Propaganda
Organisation
Courtesy of the Organisation

and political themes. This production was met by interest from a large public. Furthermore, 'popular beliefs and rituals were converted into stamps, banknotes, and chewing gum wrappers, and directed towards mass mobilization for the Revolution and war.'[53] This period also brought with it a new popular art form – propaganda murals. These murals celebrated the personalities of the Ayatollah Khomeini and other religious leaders, and commemorated the deeds of Islamic 'martyrs', in particular the heroes of the Iran–Iraq War.

Much of this revolutionary art was produced by a group of young, ideologically minded artists who shared common socio-political, revolutionary and certain religious interests. These artists had had their first major show in the Ershad Assembly (Husseyniyya-i Irshad) in Tehran in 1978, just before the Revolution. This marked the beginning of the Centre of Islamic Thought and Art (Huza Andisha va Hunar-i Islami), which later came under the Islamic Propaganda Organization (Sazman-i Tablighat-i Islami). In time, poets, filmmakers, writers and musicians joined the group and established the Artistic Centre of the Islamic Propaganda Organization (Howza Hunari-i Sazman-i Tablighat-i Islami) in 1981. Some have commented on how the works produced by these artists were initially rather experimental and were only later appropriated and used as an ideological weapon by officials, but most of these artists were happy to be considered members of the so-called group of 'Revolutionary artists'. The most important figures of this group (mainly students at the Tehran Faculty of Fine Art or the Tehran Faculty of Decorative Art) include Kazem Chalipa (b. 1957), Hossein Khosrojerdi (b. 1957), Habibollah Sadeghi (b. 1957), Nasser Palangi (b. 1957), Iraj Eskandari (b. 1956) and later Mostafa Goudarzi (b. 1960), Ali Vazirian (b. 1960), Abdolmajid Hosseini Rad (b. 1959), Abolfazl Aali (1955–87), Abdolhamid Ghadirian (b. 1960) and Morteza Asadi (b. 1958).

It soon became obvious that these artists were being supported by cultural officials. Before the formation of this group, however, other independent attempts had been made to create revolutionary works (though focusing less on Islamic and more on Third World concerns), including various paintings and posters during 1977–9. Of these artists, the Shishegaran brothers stand out for their popular posters on the theme of revolution, produced without any financial support or sponsor.

During this period, art centres were established in various ministries and militia units, including the Farabi Foundation in cinema, National Radio and Television, the Martyr and Veterans Affair Foundation (Bunyad-i Shahid va Janbazan) and the War Propaganda Army Staff (Sitad-i Tablighat-i Jang). All of these supported the revolutionary arts. The major official body of cultural and artistic affairs in post-Revolution Iran, however, was the Ministry of Culture and Islamic Guidance, which had been established through the merger of two pre-Revolution Ministries: of Culture and Art, and of Information and Tourism. This new body, founded in 1980, was initially called the Ministry of Islamic Guidance, and then in 1987 was renamed the Ministry of Culture and Islamic Guidance. The support of these establishments for so-called 'committed' or revolutionary art ensured that it became an ideological art based on official interests.

During this time young revolutionary artists filled exhibition halls, civic institutions and public spaces such as the Tehran Museum of Contemporary Art (the most important venue for art) with large propaganda paintings, posters and murals commemorating the Islamic Revolution and other revolutionary struggles. Furthermore, with the Cultural Revolution in 1980, which led to the temporary closure of all universities (they were reopened in 1983), art institutions came under the control of ideological revolutionary thought, with teachers typically being members of the Artistic Centre of the Islamic Propaganda Organization.

Despite this complex and difficult situation, however, several well-established artists, as well as many young artists, chose to stay in Iran. The activity of pre-Revolutionary artists, however, was not recognized or supported by official channels until the early 1990s.

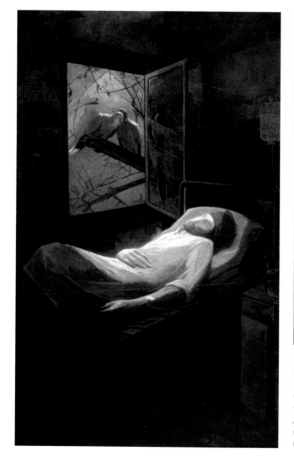

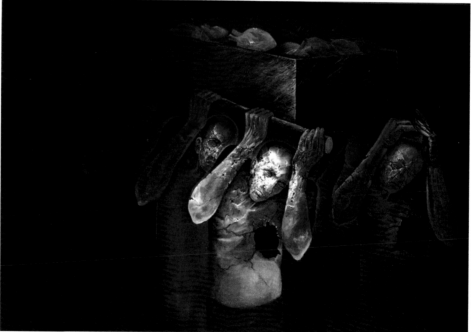

left
Iraj Eskandari
Visiting the Sick, 1986
Oil on canvas
100 x 150 cm
Artistic Centre of Islamic Propaganda Organisation
Courtesy of the Organisation

above
Habibollah Sadeghi
The Funeral of Hearts, 1983
Oil on canvas
112 x 170 cm
Artistic Centre of Islamic Propaganda Organisation
Courtesy of the Organisation

Calligraphic Tendencies and Traditionalist Trends

The post-Revolution years saw art custodians enthusiastically promoting traditional cultural values and looking to forge an Irano-Islamic art quite distinct from Western art[54] – without, however, advocating any specific theoretical or practical principles or models. This put Iranian art into an ambiguous position from the late 1970s to the early 1990s. Perhaps the most significant shift over this period was the increase in attention paid to the traditional Islamic arts. Traditional art forms such as miniature painting, calligraphy, coffee-house painting, classical poetry and even relatively traditional music, flourished. The Iranian Society of Calligraphers[55] expanded their activities and membership both in Tehran and in all of the other provinces of the country. Those *Naqqashi-khatt* artists who were also eminent calligraphers were gradually able to present their works, in large part because they already contained religious or literary narrative and were directly related to the Islamic tradition championed by the new officials. Some of the key artists in this group were Rafat Negarandeh (b. 1947), Gholam Ali Ajalli (b. 1939) and Fereydoun Mambeygi. They, in turn, were followed by a new generation of younger artists whose works paralleled those of the pioneers. Traditional miniaturists were also considered practitioners of so-called 'Irano-Islamic' art and so received encouragement, both officially and privately. The most prominent artists of this group in the post-revolutionary period included Majid Mehregan (b. 1945), Mohammad Bagher Aghamiri (b. 1950) and Ardeshir Mojarad Takestani (b. 1949). In the following years they were even granted the privilege of having their own national biennial.

Cultural Identity and Post-Revolutionary Modernism: National Art Biennials

In the years immediately after the Islamic Revolution, exhibitions were often held to mark particular anniversaries (especially of the Revolution itself) in public spaces such as the Tehran Museum of Contemporary Art. Heavily influenced by the politicized and propagandized atmosphere of those years, these shows included paintings and graphic works by 'committed' artists, as well as a range of traditional arts such as calligraphy, *Naqqashi-khatt* (now conveying a clear religious or political message), coffee-house paintings and contemporary miniature paintings. Few of these exhibitions, however, were either systematic or comprehensive.[56]

The end of the Iran–Iraq War in 1988 ushered in a period of artistic renewal in Iran, and by the end of the 1980s, various private galleries that had been closed were reopening, while other new ones were springing up. These galleries exhibited non-political and non-ideological art. Contemporary Iranian art really regenerated during the early 1990s, as new trends, attitudes and methods came to the fore. The same period also saw the organization of national exhibitions in which various kinds of modernistic approaches were presented. It is not surprising, however, that many works created in the 1990s show the uncertainty characteristic of a transitional era. The Ministry of Culture and Islamic Guidance began to organize regular biennials (and triennials) covering painting, photography, sculpture, ceramics, illustration and caricature.

Alongside these exhibitions, the Tehran Museum of Contemporary Art held lectures and conferences, which, in the early 1990s at least, considered issues of cultural and artistic identity and how their identity could be preserved against the 'mighty storm of Western culture'. At the same time, there was a growing ambition to participate in the international art scene. A look at exhibition catalogues and conference proceedings from that time shows a growing awareness of contemporary international art movements, without specifically championing that kind of art. The formal stance of Iran's officials still clearly promoted resistance to 'other cultural norms' of 'cultural globalization' or so-called 'Westernization'. This attitude explains why in official cultural and artistic events the preference remained for cultural authenticity, historical specificities, artistic identity and traditional values, particularly of Islam or of so-called Irano-Islamic Shi'ite traditions. The aim was to find a balance between positioning the country in relation to the global culture while at the same time confronting Western aggression.[57]

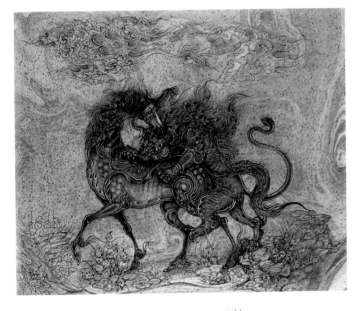

above
Majid Mehregan
The Battle of Horse and Dragon, 1987
Gouache and watercolour on paper
48 x 48 cm
Tehran Museum of Contemporary Art
Courtesy of the Museum

right
Zohreh Tabrizi
Kilim Weaving, 1993
Gouache and acyclic on canvas
77 x 140 cm
Courtesy of artist

In this period, a host of old questions resurfaced, although they were now posed in a different way. The Revolution, like many other revolutions, had caused a schism between the old and the new generations. Perhaps for this reason it is not surprising to see, in the post-Revolution official exhibitions, many of the approaches of the previous generation being repeated. Thus we find a revival of romanticized traditional scenes in a realistic style; the recurring use of symbolic motifs and manipulation of coloured elements such as tile designs marked by tints of gold and lapis lazuli, green and blue; the frequent use of seals; the repeated drawing of arabesque designs, calligraphic forms, illumination and miniature painting with oil on canvas and in posters; and portraits of Qajar women with joined eyebrows, adapting them to modern styles. At their best these new works were comparable with those of the previous vanguard artists. The struggle of the generation of artists before the Revolution, especially in the 1960s, when modern Iranian art was at its height, and its concern over the issue of cultural identity, had resulted in art that combined tradition[58] with modernism, including the *Saqqa-khaneh* movement. Now, in the 1990s, something similar was happening.

Among intellectuals there was concern about the issue of identity both in art and culture, but also concern about the place of Iranian society in a fast-changing world. Shayegan, in his book *Cultural Schizophrenia*, writes about 'the mental distortions afflicting those civilizations that have remained on the sidelines of history and played no part in the festival of changes,'[59] underlining how this situation can nevertheless be enriching if one accepts the challenge consciously, lucidly and without resentment. Intellectuals maintained that artists could creatively combine the contemporary language of art with traditional materials, but that contemporary culture, life and interests had to play the main role in art. This idea was very similar to what was being discussed in the pre-Revolution period of the 1960s and 1970s.

Gradually the Socialist Realism and traditionalism of the years immediately after the Revolution gave way to a more democratic approach to art and culture. Among the most active and prolific artists of this period, working in painting, sculpture and photography, were Nosratollah Moslemian (b. 1951), Bahram Dabiri (b. 1950), Homayoun Salimi (b. 1948), Jafar Rouhbakhsh (1940–96), Shahla Habibi (b. 1945), Iraj Karimkhan Zand (1952–2006), Farideh Lashaei (b. 1944), Ali Akbar Sadeghi (b. 1937), Farah Ossuli (b. 1953), Samila Amir Ebrahimi (b. 1950), Mohammad Ali Traghijah (b. 1943), Ya'qub Ammamehpich (b. 1946), Ahmad Amin Nazar (b. 1957), Bahman Jalali (b. 1944), Mahmoud Kalari (b. 1951), the prominent photojournalist Kaveh Golestan (1950–2003), Koorosh Shishegaran (b. 1945) and Saeid Shahlapour (b. 1944).

Masoumeh Samadi
This Life is a Plantation for Afterlife (Qur'anic verse), 1995
Gouache on paper
50 x 70 cm
Courtesy of the artist

Hamid Keshmirshekan

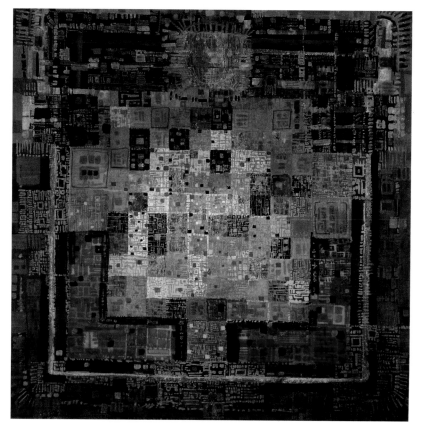

above
Nosratollah Moslemian
Untitled, 1998
Acrylic on canvas
90 x 90 cm
Courtesy of the artist

right
Jafar Rouhbakhsh
Untitled, 1994
Oil on canvas
100 x 100 cm
Tehran Museum of Contemporary Art
Courtesy of the Museum

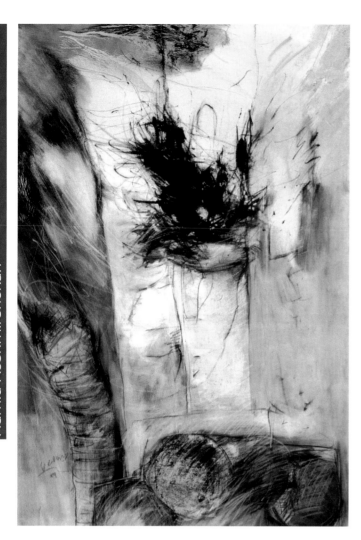

left
Farideh Lashaei
Untitled, 2000
Oil on canvas
80 x 120 cm
Courtesy of the artist

below
Bahman Jalali
Untitled, 2007
Photographic print
70 x 70 cm
Courtesy of the artist

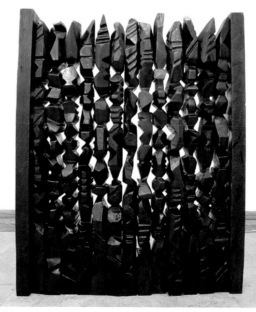

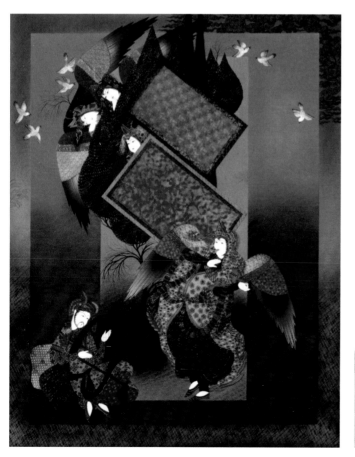

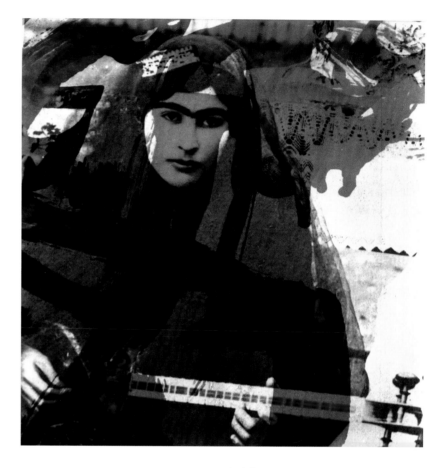

far left
Farah Ossuli
From the 'Hafiz' series, 2002–2005
Gouache on cardboard
76 x 76 cm
Courtesy of the artist

left
Saeid Shahlapour
Untitled, 2006
Wood
30 x 160 x 197 cm
Tehran Museum of Contemporary Art
Courtesy of the Museum

Diasporic Art and the Question of 'Self' and 'Other'

Apart from the shifts occurring within Iran, the post-Revolution period also witnessed the formation of art communities across the Iranian Diaspora. The feeling of duality and continuous negotiation between the past and present plays a large role in the work of Iranian artists living outside Iran. Some of these artists have since become well-established members of the international avant-garde. The work of these artists concerns variously the questions of context, identity, critical interpretation of 'self' and 'other', and cultural memory. As Donald Winnicott writes, loss of identity can cause anguish, since we identify ourselves with our possessions and surroundings. In this light, moving from one's homeland is not just a change of location, but also implies the loss of relationships and a sense of being outside the people or group with whom one is identified.[60] Instead, the individual now classifies themselves in contrast to other people and groups. The host countries have completely different cultural norms and geography from the country of origin. It is not surprising, therefore, that one of the common approaches of diasporic art is socio-political commentary seen through the lens of personal narrative.

The first generation of self-exiled artists included figures such as Siah Armajani, Abbas Attar and Ghassem Hadjizadeh. A prominent public artist and architect now living in the United States, Siah Armajani (b. 1939) creates sculptural installations for public spaces, experimenting with the concept of community development. Abbas Attar (b. 1944) is a well-known photojournalist and artist, whose series of black-and-white photographs, *Iran Diary*, illustrates thirty years of Iranian history, from 1971 to 2002. His more recent images, made following his visit to Iran after seventeen years of self-imposed exile (from 1980 to 1997), illustrate contemporary life there, in particular the youth culture. Ghassem Hadjizadeh (b. 1947), who left Iran and has been in Paris since 1993, is famous for his use of old photographs, which have become the main source of his imagery and suggest a nostalgic return to the past.

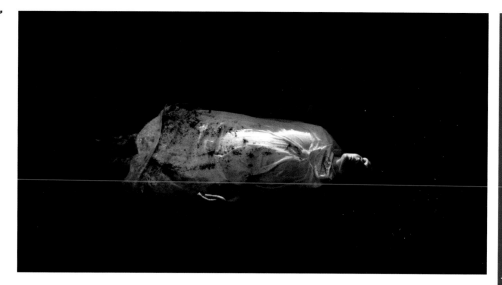

Hamid Keshmirshekan

Another Paris-based artist, Ghazel (b. 1966), has produced a series of video diaries. Her series 'Me' (1997–2003), made up of self-portraits of her performing various unusual actions while encumbered by a *chador*, shows her feeling of alienation from Iranian society in the post-Revolution period.

Shirazeh Houshiary (b. 1955) has established herself in London and is known as one of the leading artists of her generation. In 1994 she was nominated for the prestigious Turner Prize. Her work, which includes paintings, prints and installations, makes frequent reference to Islamic geometry and formal traditions, and draws inspiration from Iranian literary sources, in particular the poetry of the 13th-century Sufi mystic Rumi.

Perhaps even better known in the West is Shirin Neshat (b. 1957), who has lived and worked in New York since 1974. Neshat has attracted much attention because her chief theme is gender relationships and the situation of women in Islamic countries. Challenging the perception of Iran's social, cultural and religious code, her series of photographs 'Women of Allah' (1993–7) depicted militant Muslim women and examined the idea of martyrdom. More recently, Neshat has produced a series of split-screen video installations, filmed mainly in Morocco, which are commentaries on the male/female dynamic in Islamic societies.

The photographer and film director Mitra Tabrizian (b. 1959) looks at contemporary issues and debates, with her specific interests ranging from post-feminism and post-colonial theories and the

Shirin Neshat
Still from the video *Mahdokht*, 2004

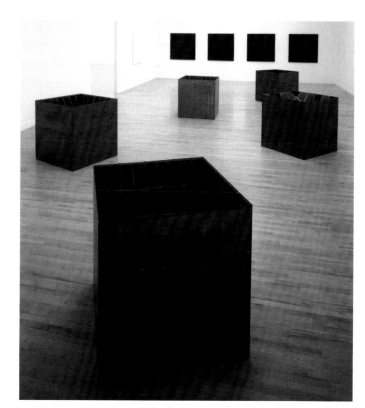

Shirazeh Houshiary
The Enclosure of Sanctity, 1992–3
Sculpture installation

effects of late capitalism (in particular in Britain) to the shifting realities of life in post-Revolution Iran. Her photographic series 'Border' (2005–2006) shows real immigrants lost in thought, as though they had brought their borders with them, remaining divided between their present situation and their longing for their old home, or their desire to feel at home in the new environment.

One of the largest communities of diasporic artists can be found in the United States. Usually referred to as 'Iranian-American' artists, they were either politically exiled or self-exiled. Yari Ostovari addresses historical and mythological themes in his intellectual, postmodern works. While showing an obvious interest in poetry and literature, his works also demonstrate a concern with the issues of 'self' and spirituality. In Hengameh Fouladvand's words, 'In the "Simulation" series seeing an image is no longer the only valid basis for believing. For Ostovari, the purpose becomes to cultivate new identities. Violins become something else and multiple instruments become the norm to picture the "other".'[61]

For another Iranian-American artist, Taraneh Hemami (b. 1960), the Iranian Diaspora can be viewed, heard and potentially understood through the body of the individual. Her narrative works penetrate the silence surrounding the Iranian Diaspora experience. Incorporating motifs and design elements derived from traditional Iranian architecture, she documents cultural memory through a dialogue of past and present experiences of members of Diaspora communities.

Shahram Entekhabi (b. 1963), who lives and works in Berlin, addresses issues relating to his memories of the Iran–Iraq War. In his work *Key*, for example, Entekhabi uses this everyday object to symbolize his personal experience: his escape from death and the life that he chose in exile as an architect and video artist. On the other hand, the installation artist and poet Farkhondeh Shahroudi (b. 1962), who also lives in Berlin, has for many years elaborated on the concept of the garden as Paradise. Her notion of Paradise is the re-creation of beauty and symbolizes her homeland from exile.

Other artists have created more critical political narratives. Parastou Forouhar (b. 1962) and Marjane Satrapi (b. 1969) use graphic imagery and writings to address complicated and controversial subjects, while sharing their personal experiences of the politics of identity in a shocking way.

There are, of course, many other Iranian diasporic artists living and working across Europe and North America. Some names include Avish Khebrehzadeh (b. 1969), Malihe Afnan, Bijan Saffari, Miryan Schahabian and Haleh Niazmand (b. 1962).

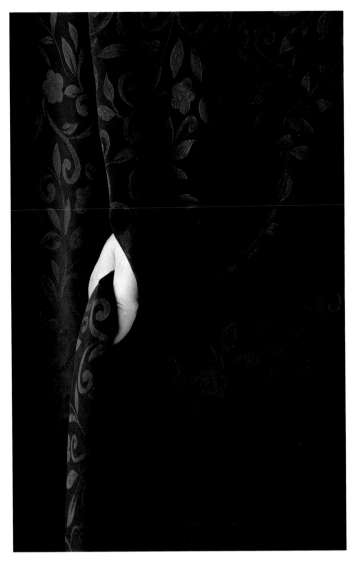

above
Parastou Forouhar
Friday, 2003
Colour photography mounted
on aluminium
73.5 x 149 cm

below
Mitra Tabrizian
Tehran, 2006
Colour photography mounted
on aluminium
50 x 152 cm

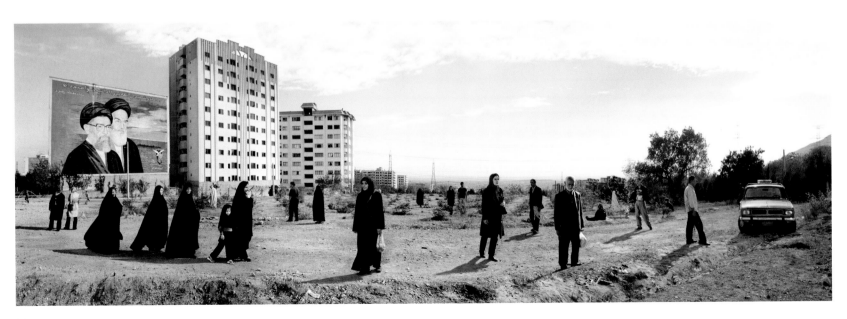

The Emergence of New Artists, New Art and New Media: The Question of Contemporaneity

The third phase of post-Revolution art in Iran began with the election in 1997 of the moderate president Mohammad Khatami (the former Minister of Culture and Islamic Guidance, 1983–92). It was a turning point in contemporary Iranian art and culture. After the election, the artistic and cultural environment changed dramatically. Exhibitions and art activities multiplied rapidly in big cities, especially in the capital Tehran. Visual arts assumed a significance not seen since the Islamic Revolution. In particular, the Tehran Museum of Contemporary Art, the main focus of contemporary Iranian art, began to include non-political art in group exhibitions. The museum,[62] and in particular the Centre of Plastic Arts of Iran (*Markaz-i Hunar-hay-i Tajassumi-i Kishvar*), played a key role in promoting various forms of contemporary Iranian art. This centre, which came under the control of the Deputy of the Ministry of Culture and Islamic Guidance for Artistic Affairs, had been established in 1983, and was directed by the head of the Tehran Museum of Contemporary Art. The directorship of Ali Reza Sami Azar, between 1998 and 2005, saw a relaxation of control on visual arts activities, including those in major public and commercial galleries. The Centre of Plastic Arts also began to support commercial galleries in Tehran and other cities through funding and collaborations, while private galleries were freed of the requirement that they gain the centre's approval for each show they wanted to mount.[63] This marked a decisive reduction in government control of artistic affairs. The museum and the centre also supported visual arts through the establishment of organized programmes, including giving their biennials more comprehensive aims (while also directly involving the newly established artists' societies) and holding thematic exhibitions both of contemporary Iranian art and of international contemporary art (for example, on 20th-century British sculpture in 2004 and contemporary Japanese art in 2005). National and international gatherings and academic discussions on different aspects of contemporary art and culture were also organized. The number of art publications and public places exhibiting visual arts grew considerably.

Ahmad Nadalian
River Still Has Fish, 1999-
Plour Village
Courtesy of the artist

In fact, the Museum of Contemporary Art had begun these programmes as early as 1990–91, by organizing different national (and sometimes international) biennials, but they were now more systematic and determined. This period of liberalization also saw the exhibition of works by both prominent pre-Revolution Iranian artists and contemporary Western artists represented in the Museum's rich collection. Eminent Iranian artists such as Charles Hossein Zenderoudi, who had left Iran and cut their links with the art scene there after the Revolution, were now invited to participate in solo or group exhibitions. Particularly important in this context was the 'Pioneers of Iranian Modern Art' series of exhibitions. Curated by Ruin Pakbaz, these exhibitions included works by pre-Revolution Iranian modernist artists such as Zenderoudi, Massoud Arabshahi, Parviz Tanavoli, Mansureh Hosseini, Behjat Sadr and Mohsen Vaziri Moghaddam. There were even completely unprecedented exhibitions of the works of Diaspora artists such as Shirin Neshat and Shirazeh Houshiary.

The Museum of Contemporary Art also increased its international activities by establishing links with other art institutions and museums, lending works from the Western collection (many of which had been unseen for years) and organizing a number of exhibitions of Iranian artists in Europe, America and Asia.

above
Miryan Schahabian
From East to West, 2008
Digital print, photography and copper sheet
Courtesy of the artist

right
Khosro Khosravi
Untitled, 2006
Acrylic on canvas
Courtesy of the artist

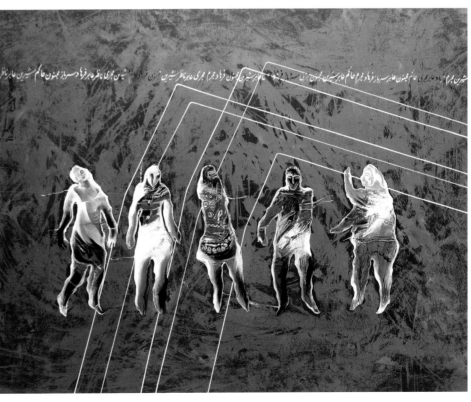

Hamid Keshmirshekan

top
Rozita Sharafjahan
Red Mirage, 2008
Video, sound installation
Courtesy of the artist

above
Mehran Mohajer
*The Memories of an Indolent,
Fatigued, Flaneur*, 2008
Negative colour print
77 x 77 cm
Courtesy of the artist

left
Behnam Kamrani
Leyli Inside the Shop-glasses, 2009
Digital image
Courtesy of the artist

The year 2001 saw the establishment of the more conservative Iranian Academy of Arts. According to the Academy's charter, its activities should focus mainly on 'Islamic' art – both traditional and contemporary[64] – as well as 'Iranian' and 'Eastern' art. 'International' – perhaps meaning Western – contemporary art was considered less important.[65] Established as a centre for artistic policy-making, the Academy did not have a mandate to get involved in artistic activities, though it nevertheless continues to organize various exhibitions from across the Islamic world including calligraphy, posters and painting, mainly in the Academy's newly established galley, the Saba Cultural and Artistic Centre. Alongside its biennials of contemporary art from the Islamic world, the Academy has also held various conferences on subjects such as the philosophy of art, traditional art, and art and globalization.

The third phase of post-Revolution Iranian art also saw the development of new means of visual expression, such as video, installation and art photography, and the emergence of a new generation of artists (many of them women) whose concern is less with the affirmation of the identity of a community than with their own biography within a society undergoing radical change. This period was defined by, on the one hand, artists' eagerness to experiment with new idioms and, on the other, a new willingness from official channels to promote and support these experiments. This coincidence of interests created fertile ground for the development of the 'New Art' in Iran. Artists now had the opportunity to get funding for their projects, which required more and more money, space and other equipment. As a result many artists who had previously worked in such media as painting, sculpture, cinema or theatre switched to the new fine art media. These artists range from emerging young talents to older, better-established artists, filmmakers or performers such as Abbas Kiarostami (b. 1940), Daryoush Mehrjoui (b. 1939), Seifollah Samadian (b. 1953) and Atila Pesyani (b. 1957). Some of the artists who came to prominence in this phase are Behruz Darash (b. 1942), Ahmad Nadalian (b. 1963), Hossein Khosrojerdi (b. 1957), Jamshid Haghighatshenas (b. 1962), Ali Zakeri (b. 1959), Masoumeh Mozaffari (b. 1958), Khosro Khosravi (b. 1965), Rozita Sharafjahan (b. 1962), Behnam Kamrani (b. 1968), Mehran Mohajer (b. 1964), Barbad Golshiri (b. 1982), Shahab Fotouhi

(b. 1980), Neda Razavipour (b. 1969), Pooya Aryanpour (b. 1971), Farhad Moshiri (b. 1965), Farshid Azarang (b. 1972), Mahmoud Bakhshi (b. 1977), Bita Fayyazi (b. 1962), Simin Keramati (b. 1970), Shadi Ghadirian (b. 1974), Khosrow Hassanzadeh (b. 1963), Rokni Haerizadeh (b. 1978), Afshin Pirhashemi (b. 1974), Amir Mobed (b. 1974), Sadegh Tirafkan (b. 1965), Ghazaleh Hedayat (b. 1979), Shahriar Tavakoli (b. 1969), Hamed Sahihi (b. 1980), Behrang Samadzadegan (b. 1979), Peyman Houshmandzadeh (b. 1969), Ahmad Morshedloo (b. 1973), Koorosh Adim (b. 1971), Mehdi Moghimnejad, Samira Eskandarfar (b. 1980), Amirali Ghasemi (b. 1980) and Morteza Darrehbaghi (b. 1969).

The presence of Iranian artists in international arts events and exhibitions such as the Venice Biennale[66] in this period was the direct result of this opening up of cultural boundaries. Exhibitions of Western and Asian art in Iran during recent years have resulted in the creation of an atmosphere in which Iranian artists are determined to stand alongside their counterparts around the world and fully take part in the contemporary international art scene. Moreover, increased access to electronic media, journals and books has

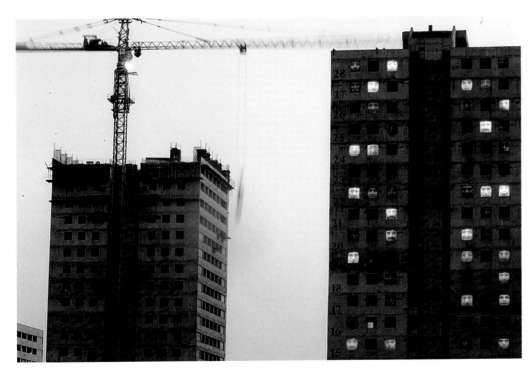

above
Barbad Golshiri
The Incredulity of Saint Barbad, 2004
Video, sound and light installation, Tehran,
Courtesy of the artist

left
Shahab Fotouhi and **Neda Razavipour**
Census, 2003
Ati-Saz Buildings, Tehran
Courtesy of the artists

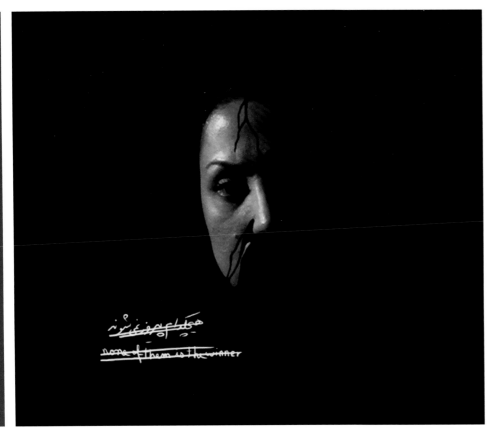

above
Simin Keramati
Self-portrait, 2008
Still from the video
Courtesy of the artist

right
Amir Mobed
Waiting Sweetheart (Mistress)
Wood, metal and hair
30 x 50 x 110 cm
Courtesy of the artist

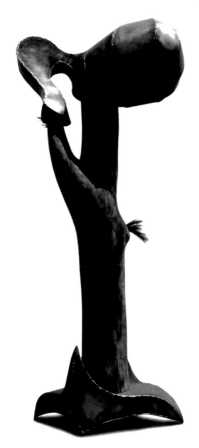

meant that Iranian artists are becoming familiar with other cultural values. Recent years have also brought success to certain Iranian artists, who have received recognition and awards in international exhibitions such as the Asian Art Biennial in Bangladesh, the Beijing International Art Biennial in China and the Sharjah Art Biennial. One of the reasons for this success, as in Iranian cinema, has been the emphasis on presentation of social and political issues such as gender relations.

The international cultural market welcomes contemporary forms of Iranian expression, even if they find limited distribution inside Iran. In recent years the market for all sorts of non-European-American art has developed, with more exhibitions of such art in Western and non-Western cultural venues. The wealthy Persian Gulf states have started to play an increasing role as a market for artists from other countries in the region, including those from Iran, through new museums, events and exhibition spaces – for example, Art Dubai or Christie's auction house[67] in Dubai. It is difficult to say if it is by choice or coincidence, but the majority of today's artists produce for the international or 'global' market. This has led to a concern in certain areas that artists will end up producing work solely for international art festivals and exhibitions. Many artists, however, have chosen not to follow such formulated criteria and instead make their art reflect their own lived experience.

While the Iranian state remains marked by religious ideology and revolutionary fervour, the younger generation (which accounts for almost seventy per cent of the population) appears to be neither committed to the Revolution nor very ideological in any conventional sense. However, they do seem to be inventing a new politics for the 21st century. Many of this generation reject a fixed, unified identity and instead propose a hybrid, unfixed and negotiable identity. Artists of this generation address critically the actual problems and issues in society, and shy away from the depiction of local characteristics.[68] Their references to tradition and cultural values tend to be critical, satirical or ironic when they demonstrate fashionable ways of life, especially youth and popular culture. Artists of this generation also

enjoy ironic, kitschy interpretations of hybrids between traditional Iranian forms and those of the consumerist and globalized popular culture widespread in Iran. This often humorous language has also become a common method to criticize 'exoticism' and a metaphorical reaction against 'official' values.

If Khatami's presidency had brought a cultural and intellectual explosion, giving voice to new ideas in art as well as in social and political issues, the election in 2005 of Mahmood Ahmadinejad as President of the Islamic Republic marked another dramatic shift. After 2005, the official attitude towards art echoed the first phase after the Islamic Revolution. This can be seen in exhibitions such as that from 2006 that looked at 'resistance' (held in the Tehran Museum of Contemporary Art), and in the establishment of the Palestine Museum and the Museum of Art of the Revolution. The Deputy of the Ministry of Culture and Islamic Guidance for Artistic Affairs maintains that, 'In the ninth government [i.e., that of Ahmadinejad] artistic matters and concepts have been illuminated by religion. With this, art will be distributed among the public from isolation.'[69] Officials have promoted traditional, Islamic and revolutionary values, while at the same time encouraging extreme xenophobia towards the West. The response from artists has been unenthusiastic, and in fact a large number of young artists have overreacted culturally against this philosophy by concentrating on contemporary Western art. For many artists today, the debates of the 1960s and 1970s about authentic identity are no longer relevant, and they are keen not to repeat the work of previous generations. It seems that the younger generation is tired of the slogans of their precedents, and since there is a limited chance for showing their work in official venues such as the Tehran Museum of Contemporary Art, they have focused their attention outside the country. Within Iran itself, the newly established artists' societies are in a state of limbo, no longer able to rely on official support in organizing biennials and exhibitions. This is undoubtedly a critical juncture, and the visual arts in Iran clearly face enormous challenges – as does the wider Iranian society. Given the complex nature of this society, it is difficult to say what might happen next.

top
Ghazaleh Hedayat
The Sound of My Hair, 2005
Hair, nail and a sound of a hammer
Courtesy of the artist

above
Peyman Houshmandzadeh
Untitled
Triptych photography
40 x 60 cm
Courtesy of the artist

left
Samira Eskandarfar
Untitled, 2008–2009
Acrylic on canvas
150 x 200 cm
Courtesy of the artist

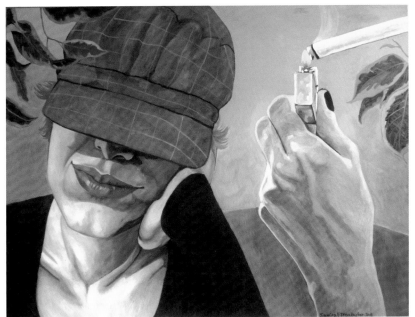

Vatan (homeland): A Rumination on Territoriality

Mark Irving

It took a visit to Tehran in 2004 for me to appreciate what seeing and belonging could mean. This in itself was a surprise, given the years I had spent visiting museums, galleries and artists' studios across the world and what I had presumed was the not over-promising potential of modern Iran as a place of conceptual learning. As is so often the case, the medium for this revelation was art, with sexual allure close by in the shadows. When the taxi pulled up outside the modest apartment in north Tehran, there was little sign that a shrine to high art lay inside. There, hanging above a sofa, was a homage to Titian's *Venus of Urbino*, an oppressively dark, oily echo of the original, her face looming out of an unpleasant blackness like a sullen moon, her bare feet set far to the right like strange asteroids. And in the middle, nothing. Just a simple geometry of lines linking head to feet. The artist – he will remain nameless – gestured towards the room behind, where a sister painting was to be found, the Venus this time partially formed but not nude. Polite utterances of wonder passed between artist and visitor. Then, in the bedroom, the finale: the Venus triumphantly nude, gracing the wall above the meticulous marital bed, a holy of holies in which art and passion were blissfully mixed.

This ritual of unveiling was doubly instructive. First, it spoke of how, given his fear of discovery and censure by the state, he had stoked an intensity of feeling within the compressed space of both his limited talent and the apartment/studio in which he feverishly worked. (Paradoxically, this intensity owed its existence to the particular climate in which visual culture operates in Iran.) Second, it spoke of the differences between looking and seeing, showing and revealing, a qualitative gap of understanding. I re-entered the taxi with a sense of sadness about his isolation, his painterly archaeology and its poverty of means and the sheer alien-ness of his cultural territoriality within the context of both Tehran and contemporary art practice in general. I had, I reflected, witnessed a scene from 19th-century fiction, a narrative of oppression and creative heroism, in which the protagonist's sheer certainty of conviction provides the measure of his sense of moral worth. That the subject of his adoration and his accomplice in his abbreviated act of resistance was Venus, goddess of Beauty, made it all the more solipsistic. All that was missing was the upward and downward plunge of a dozen violin bows.

The encounter didn't typify Iran – there are 'stuck' artists

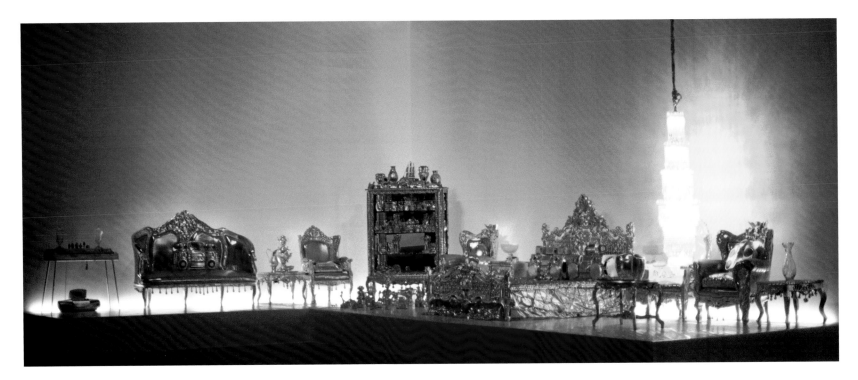

everywhere – but it provoked the question: what does 'contemporary' or 'new' – let alone 'radical' – mean? What impact can a context such as Iran have on these terms and their application? Context inevitably opens up other questions, about territories, *territoriality*, *de-territorialization* and *re-territorialization* – issues the French philosopher and writer Gilles Deleuze (1925–95) explored in his book *Kafka: Towards a minor literature (theory and history of literature)* (1986). Deleuze has become an increasingly important writer within creative, philosophical and political circles – none other than the philosopher Michel Foucault said, perhaps in respectful jest, that the 20th century should be considered 'Deleuzian' – and the growing application by others of his ideas to different fields of practice has only served to enhance his reputation. In asking 'what is a minor literature?', Deleuze employs an analysis of Kafka's use of language to examine what, among other questions, might constitute a revolutionary condition. In so doing, Deleuze offers us a set of theoretical tools with which we can unpick what it might mean to be an Iranian contemporary artist and the different meanings that could be assigned to the term 'homeland' (*vatan*).

For Deleuze, 'a minor literature doesn't comes from a minor language; it is rather that which a minority constructs within a major language'. His use of the term 'minor' is not derogative, as in the sense of 'lesser' – he does not adopt a position of canonical superiority where one language, one literature or mode of expression is valued as 'higher' than another, even if he acknowledges the internal assumptions and tensions about purity and corruption, centrality and marginality that lie within language. While his example is provided by Kafka with German literature and language as the contextual field, 'Kafka' can easily be replaced with a number of different subjects and their subsets: contemporary art practice and its recognizable languages; Islam; Persian-ness; memory, identity and identification. By replacing one field of enquiry with a network of other fields in this way, we can not only test the capacity of Deleuze's ideas to retain their residual strength outside his given illustration but also bring new readings to these other fields. For example, the ardent disciple of Titian in north Tehran could be said to be operating within the major language of canonical 'Old Master' painting and theory (or indeed, of aesthetics) but living within what might be regarded, as least from a Western perspective, as the 'minor' outpost of contemporary creative practice of Iran. 'Territoriality' here is therefore operating at a geopolitical and conceptual level. Fans of contemporary Iranian cinema and photography would doubtless take issue with the notion of these being 'minor' cultural forms, but then issues of territorial emphasis and evaluation are highly subjective and depend on the subject's relation to the 'language' or expressive output in question.

In debating 'minor' and 'major', Deleuze claims that the 'first characteristic of minor literature in any case is that in it language is affected with a high coefficient of de-territorialization'. It is, therefore, distanced from its maternal roots, placed through a variety of circumstances in a context in which it has a poor claim to sovereignty over its context. The 'second characteristic of minor literatures,' according to Deleuze, 'is that everything in them is political.' In 'major' literatures, on the other hand:

> the individual concern (familial, marital, and so on) joins with other no less individual concerns, the social milieu serving as a mere environment or a background...all become as one in a large space.

In other words, 'major' here enables the personal to come to the fore and find its society. It is, in effect, a condition of relative comfort and molecular protection shaped by the consanguinity of values, habits and objectives held by those expressing this major language. In the context of Iran, merely being an artist there necessitates a heightened political sensibility, an awareness of being (almost) unconnected to the mainstream of contemporary art practice, of being outside the 'room' (Deleuze's 'large space', which we might translate as the art fair, the exhibition, the critical seminar, the press review, an art prize, a cultural consensus, a canon: being included).

Minor literature is totally different:

> its cramped space forces each individual intrigue to connect immediately to politics. The individual concern thus becomes all [the] more necessary, indispensable, magnified, because a whole other story is vibrating within it.

Mark Irving

Farhad Moshiri
Living Room Ultra Mega in House of World Cultures, Berlin
© Farhad Moshiri
Courtesy of Farhad Moshiri

Mapped onto the context of daily life in Tehran, this characterization might well be recognized by many writers, artists, theorists and others resident there. From finding enough materials to work with to getting around the city, from receiving letters and catalogues from abroad (or not) to showing and disseminating their work – in fact, the whole process of quotidian life – it is impossible for people not to hit against 'the system' given the splintered spaces and channels in which they have to operate. The ingenuity of survival in Iran requires a constant negotiation with these difficulties, and in so doing it produces a common recognition – a collective sense – among these survivors of what it takes to survive.

Deleuze continues:

> The third characteristic of minor literature is that in it everything takes on a collective value. Indeed, precisely because talent isn't abundant in a minor literature, there are no possibilities for an individuated enunciation that would belong to this or that 'master' and that could be separated from a collective enunciation.

But far from casting these players within the minor (that is, not central to the international contemporary art world axis of London-Berlin-New York-Los Angeles-Beijing-Moscow) context of Tehran as 'suppressed talents' (another version of the romantic tragic hero), the Iranian-Lebanese curator and writer Rose Issa asserts that Iran's condition may in fact present *no* obstacle to creative production and innovation. 'They [artists, writers, filmmakers, photographers] make do with nothing', she says. 'The problems people meet are in fact stimulating. You have to resolve them. People invent ways around things and this is how they find the 'possible'. Do you think it would have been credible for a 17-year-old girl like Samira Makmalbaf, director of *The Apple* (1998) to make a film at this age in the West? There is a culture in Iran of just doing it, even with leading artists such as Abbas Kiarostami. He didn't have a camera and trolley for a moving shot in traffic, so he stuck a camera in a box on the front of his bicycle and sped off.' This view is supported by Ziba de Weck Ardalan, the Iranian-Swiss curator and director of the Parasol unit art foundation and gallery, London: 'the Revolution was in fact liberating in terms of freeing up artistic creativity. Before it, Iran was so dominated by the West, we didn't do much by ourselves. The Revolution made people think about their condition. They were forced to react to a new situation, to make work despite it. This is an essentially Persian response.' The use of the term 'Persian' is interesting as it connotes a characteristic embedded deep within Iranians that is cultural, rather than political, instinctive rather than taught, shared rather than individuated.

'Cramped space', then, has its virtues for those creative practitioners drawn to strategies of subversion; given the context of contemporary Iran, this constriction is primarily *politically* configured. I remember entering the apartment of artist Farhad Moshiri in Tehran to find myself temporarily blinded by a suite of gilded Louis XV-style drawing room furniture. Spectacularly vulgar, the assemblage – forming *Living Room Ultra Mega* (2003) – took on the pretensions of the upper-middle-class urban Iranian

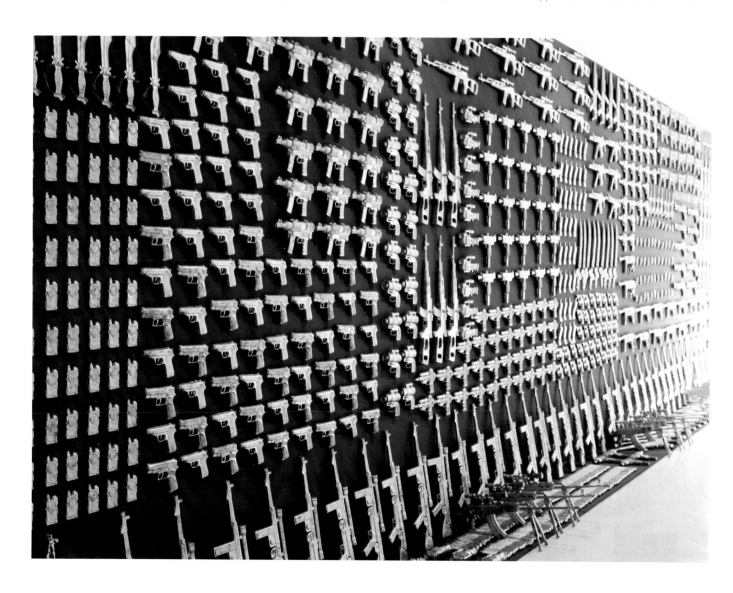

household, with its longing backward glance to pre-Revolutionary Iran and a luxurious life of powdered afternoon cakes. With this piece and others like it, Moshiri made over what was already a de-territorialized object – the French-style sofa, removed from its cultural and geographical context but carrying with it the eradicable scent of overblown privilege – into an *artistic medium*. He then re-territorialized it as contemporary art. We talked about architecture, Tehran and art, remarking how the *bazaari*-class who dominate government had, interestingly, refrained from adorning their new apartment blocks – strange Postmodernist confections of black market chic with Russo-Asiatic riffs – with the kind of propaganda murals their Revolutionary forebears had once commissioned. He showed me boxes of machine guns, pistols and rifles – all gilded replicas – that he planned to send to New York from Iran (this later became *Rogue Gun Installation* at the Kashya Hildebrand Gallery, New York, a few months later).

This kind of artist-as-terrorist subversion (not 'Arms to Iran', but reverse traffic) belongs to a venerable and cheerfully ongoing tradition, honed in the West but not defined by its perimeters alone. Moshiri's strategy thus links him to a 'major' language where his work reads easily once its particular antagonists (Persian-ness; a certain class posturing; international politics) are identified. The photographs of Amirali Ghasemi (*Party*, 2005) show Tehrani party-goers in full swing but with their faces cut out. As such they offer an oxymoronic pull-push of intimate anonymity, with the documentary 'truth' of the photograph denied and its crude self-censorship commenting nonchalantly about the sheer absurdity of it all. A subversion of the role of women within traditional Islamic settings – housebound and home-centred – is traced in Shadi Ghadirian's series 'Like Every Day' (2002). In it, the usual privacy of the home is replaced by a domestic iconostasis, an act that firmly places her and her work within an established and international 'major' feminist literature, while its reductive use of kitchen implements as both replacement body parts and symbols of confinement owes a debt to Picasso's bicycle handlebar-and-seat bull's head and to Surrealism in general.

These make-do-and-mend solutions can become part of a practitioner's expressive language – indeed, Deleuze remarks how 'Kafka emphatically declares that a minor literature is much more able to *work over its material*' (my italics). The poverty of material means, then, is not what confines creative work in Tehran to the delegation of 'minor' – Issa claims that 'there are plenty of galleries there in which artists can show work; it's just that there aren't many good ones'. Rather, it is a poverty of public *receptivity*, a failure, arising from mutual suspicion and sheer incomprehension, of the official

cultural infrastructure to recognize and endorse these pockets of innovative practice, converting them into a critically sanctioned 'major' language. It is, in short, an absence of an immediate market of sufficient critical mass (in terms of available cash, diversity of institutional support, educational awareness of collectors and so on). The work of some of these practitioners is, however, absorbed into critical forums internationally, with art markets, galleries and collectors, film festivals and film studies courses deliberating and sanctioning their work, thus blending it into their 'major' literatures or disciplines.

But even in the heart of the Western art market, Iranian modern and contemporary art is only just emerging as an individual category, with auction houses cautiously including it among sales of Arab contemporary art. The Iranian-ness of Iranian art (what designates it as 'minor' or specific) arguably comes from the way artists and filmmakers use the motifs, visual vocabulary and other signs understood to belong to an Iranian context and experience. Kiarostami's disarmingly effortless visual poetry (sometimes comic, always rich in its reductive simplicity), Moshiri's bad-boy camping-up (playful theft, a well-trodden example of *épater la bourgeoisie*), Ghasemi's purposeful self-censorship (deliberately inelegant), Ghadirian's voluntary burying of the self (an act of critique) are made all the more possible by Iran being what it is, not what it is not. 'This generation have to work with their own lives as their subject. Documenting their life is the best option for them as they have nothing else to do', says Issa. Kafka's declaration that 'a minor literature is much more able to work over its material' again comes to mind.

The firm governance in Iran imposed on showing and looking – especially in Tehran, a city noticeable for its curious marriage of public art and architecture – produces a smog of official rhetoric about the visual that hovers over everything. Much of it emanates from the well-known propaganda murals and posters decorating major public buildings and streets in the capital's centre. Rhetoric depends on a controlled policing and manipulation of language – be it written, oral or visual – and prefers a highly selective vocabulary of ideas persuasively delivered. For Western visitors, central Tehran proclaims a Manichean worldview, where good and evil are depicted as mutually quarantined binary opposites. Across the public squares, faith, sacrifice and devotion face off against secularism, tyranny and death – a polarization that, when these murals were first produced in the years following the Islamic Revolution of 1979, seemed unique to Iran but which subsequently informed the iconography of outrage developed across radicalized sectors of the Islamic world in general.

Many of the formal qualities of these murals – the vivid,

Mark Irving

Farhad Moshiri
Rogue, 2005
1100 toy guns in gold leaf
© Farhad Moshiri
Courtesy of Farhad Moshiri

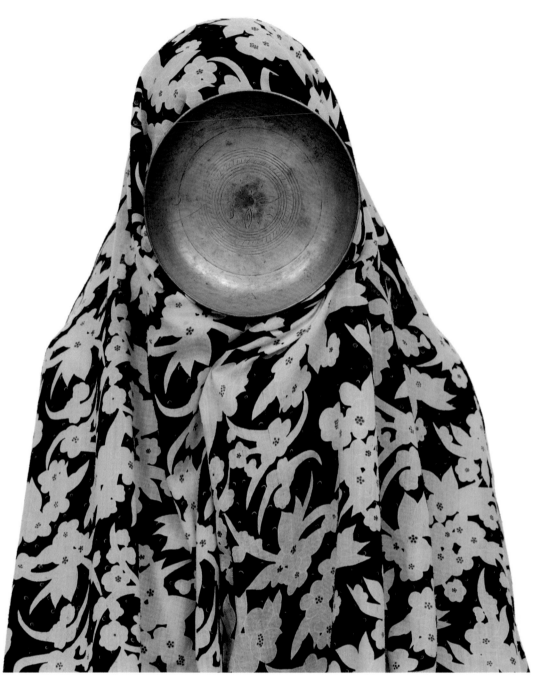

Shadi Ghadirian
Like Every Day, 2008
C-Type photograph
© Shadi Ghadirian
Courtesy of Shadi Ghadirian

often jarring colour juxtapositions, the distortions in scale between representations of the central human actors and their pictorial setting, the tendency for idealized stylization – owe a debt to the revolutionary propaganda art found in early 20th-century Mexico, the Soviet Union and China. But these Iranian examples of the genre are distinctive in their insistence on the blurring of political and religious space. Leading historical characters from the Shi'ite brand of Islam that predominates in Iran are often seen to share pictorial space with contemporary figures, be they political leaders or 'martyred' ordinary folk elevated to near-sainthood. In some murals, Ali, the son-in-law of the Prophet Muhammad and the founder of Shi'ism, is shown without his face for reasons of religious propriety. This results in some strikingly odd images: we see streams of water emanating from where his face would have been (for Iranians, running water has an intense poetry) or just circular blanks supporting the traditional green headwear as he bends over the body of a fallen martyr in the manner adopted by the Virgin Mary in Christian representations of the *Pietà*. In these latter images, his compassionate stance is strangely neutered by the absence of a face. The effect of this absence of presence, as it were, encourages the spectator to create a mental picture of Ali with which to complete the image, thus stimulating a transition from 'looking' to 'being'. This invitation to enact the visual is as much to do with the conflation of religious and political objectives that typifies a theocracy, but it also reflects older traditions of collective performance in Iran, such as the *rawzah khani* or ritual of mourning for the death of the third imam, al-Husayn ibn Ali, in AD 680.

It's no accident that these murals, with their use of mystical soft focus, neutralized environments in which heavenly clouds tend to float above endless oceans of undisturbed water, and kitsch colouring, echo the lame romantic clichés usually employed in the opening credits of television soaps. Iranian television is full of such images, usually preceding the frequent worthy discourses on religious philosophy delivered by bearded, suited men seated by huge vases of vividly artificial flowers. The link is significant, since it underlines the universally anaesthetic influence of the Islamic government upon the visual arts and the media in Iran. Under these conditions, the visual realm is held hostage: public morals are transformed into public murals and the act of looking is itself made political. The effect upon public artistic discourse is devastating, smothered by a seamless political continuity, one favoured by totalitarian regimes everywhere. It's all about the projection of presence and in this, murals beat almost everything, even television. You don't have to switch on a mural to see it and there are no advertising breaks. Even billboards get pasted over eventually.

Those murals addressing the regime's hatred for its main enemy, the United States of America, are generally less clunking. Here, contempt and outrage prove to be far more creatively inspiring than unblinking devotion or respect (a paradox that had also benighted the 17th-century English poet and revolutionary mage John Milton in his depiction of good and evil in his epic poem *Paradise Lost*). Many of these murals are located near the former US embassy, now a government-held building edged with sentinel towers and barbed wire. The seizure of the embassy in November 1979 and the subsequent long-drawn-out hostage crisis provided a geographical focal point for anti-American sentiment. If these murals could speak, they would be deafening. In clustering around the former embassy with such intensity – serving, perhaps, as giant thought bubbles capturing the angered sentiments of (now much depleted) crowds of anti-American protestors – it is as if they have sought to exorcize the memory of the former American presence in Iran.

There's a keen irony in the fact that many of these images – almost all of which play upon the American flag as their theme – demonstrate the kind of graphic imagination one associates with Pop Art, a visual style pioneered by American artists. In one, the Statue of Liberty, fronting the flag, wears a death's head mask; in another, the stars and stripes are replaced with skulls and raining bombs respectively; in yet another, the outline of a stars-and-stripes pistol is etched, with spaghetti-western flourish, against a stunningly beautiful (and unmistakably Persian) pattern mimicking turquoise and purple wall tiles. There is something profoundly moving in the way that the instinct to prettify survives the directive to hate. In these murals, the enemy is presented as everything that the Islamic Revolution claims it is not: skulls and weapons versus streams and opalescent dawns, death versus life, even though so many of the slogans included in the murals praise the virtues of violent death. A visit to the Martyrs' Museum, situated with intended potency just opposite the old US embassy, allows you to hear their stories and see their relics neatly displayed in individual glass cases: an instance of Kafka-esque life imitating art imitating life.

The artists who created these murals in the years immediately after the Revolution must have felt their moment had come. Young artists received permission from municipalities, the Martyrs Foundation and other revolutionary institutions to exhibit their talents in the service of the Revolution. In provincial towns, the murals were primitive but in Tehran, under the supervision of experienced artists, the paintings took on a much more professional appearance. One of the most prominent artists, whose students drew hundreds of revolutionary paintings on Tehran's buildings, was Hanibal al-Khas,

a leftist Assyrian intellectual and an expert on murals. When I asked a group of young artists in Tehran what they made of these murals, they shrugged their shoulders in amused contempt: 'nobody really cares about them', said one, to general agreement. 'Sometimes people direct fireworks at them on purpose during public festivities. But if they are damaged, they get repaired by the government.' For this generation, public art is contaminated by a crisis of faith – not only, perhaps, in the clerical leadership but also in the belief that art can have a public voice.

Something of this loss of faith in art (and perhaps also in faith itself) is evident in the way that posters have replaced murals on the streets of Tehran as the communications medium favoured by the political class. Employing photographic collage featuring clerical leaders shown in a limited range of varied compositions, these recent images dispense with painterliness and the now-defunct pretence of cultural authority once claimed by the murals. Fine art has given way to advertising. This shift in media is perhaps inevitable, given the rise of a new class of visual competition within the public realm: the large-scale commercial and predominantly digitally produced advertisement. The US embassy remains closed, but capitalism's presence rears its head ever more strongly. For artists living in Iran, the street-as-arena has become a dead zone, dead in both relevance and inspiration, dead in terms of the potential for subversion. Young

Iranian artists, like young artists everywhere, aren't interested in classic revolutionary ideology (so pre-Postmodern). I don't know whether Calvin Klein's near-nude underwear models will ever grace Tehran's cityscape, or if radical chic will replace just plain radical. Some messages are just too hard to hear.

But for those Iranian artists living outside Iran, these streets can have a curious allure. They still draw back London-based artist Mitra Tabrizian, who had left Iran in 1977. Her photographic project 'Tehran' (2006) is a reminder of the latent potency of 'homeland' as a creative resource while revealing the destabilizing gap between its romantic promise and the actuality on the ground. 'I still feel like an outsider [in Iran] as well as in the UK. Iran has become this imaginary notion of home that features strongly in my work.' The project involved her working a three-day shoot on the outskirts of the city (the liminal or the threshold between states or territories is a central concern for Tabrizian) as she composed her panoramic photograph. The work presents a curiously static scene – people appear to be going about their daily activities but each individual is held in a form of private self-contemplation, their direction uncertain, their purpose blurred. The rather vacuous character of her choice of location was significant: 'This was a newly built post-Revolutionary landscape, but it looked like a no man's land. Conceptually, I was interested in the notion of "waiting" that Samuel Beckett developed

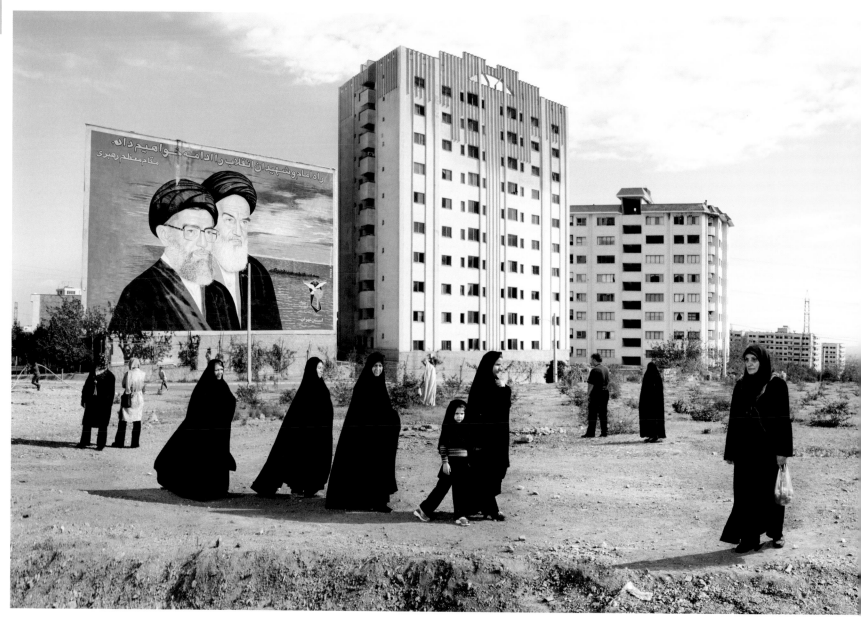

in *Waiting for Godot*. In Iran, everybody seems to be waiting for something to happen but it never does.'

The work is as much an investigation of the gap between political rhetoric and delivery as a creative test of what happens when you mix photographic genres, allowing one to contaminate the other. The work was shot in three sections at the same time of day and was assembled on computer – 'I wanted the impact of the billboard poster but of a high quality which couldn't be achieved using a normal panoramic camera,' says Tabrizian. The image is therefore neither strictly a documentary image, an artistic collage nor an entire fiction, and its poetry (often the default position of resistance in Iran) is subtly conveyed. 'It differs from the usual representations of Iran – the social documentary/journalistic approach. Or the constructed images, often on a "big" subject, favoured by some photographers working in Iran. Or "abstract" photography with a poetic slant. Or the tendency to "exoticize" (in photography, or video),' writes Tabrizian in the catalogue for 'This is That Place', an exhibition of her work shown at Tate Britain, London, in 2008. Allying this image instead to contemporary Iranian cinema, where non-actors are also frequently used and where the mundane is turned into an allegory of wider significance, the work sits at a point between art, documentary and indeed film. 'I'm interested to blur the distinction between art and documentary,' she says. Decoupling from documentary but

emphasizing 'site', involving photographic assemblage but refusing to indulge in the fine art 'charm' of collage, hinting at the 'other world' of a filmic subjectivity but declining the blandishments of the poetic gesture, Tabrizian composes something new: a *re-territorialization* of what it means to come home and to be 'homeless' in terms of a deliberate interdisciplinarity.

Issa's comment that 'none of these exiled Iranian artists make their name until they return to Iran' rings true of that slightly afflicted but paradoxically fortunate generation who left the country before or slightly after the 1979 Revolution. Y. Z. Kami, now resident in New York, returning to Iran in 1989, experienced what he calls 'a sudden realization, for the first time, of being an exile'. Being an exile has, he says, certain freedoms – 'you can explore whatever you want' – but it was a photograph he found in a house there of himself as a boy that initiated what he openly admits was an 'obsession' with his past and with memory itself. Between 1990 and 1991, this obsession was explored in around forty sketches, drawings and paintings, in which the photograph appeared and reappeared – photography asserting its territoriality within the near-pathological, the fixative, the self-as-subject. (Some were included in 'Endless Prayers', his one-man show at Parasol unit in November 2008 to February 2009). Captured by the image where the image had once, in common parlance, 'captured him', he was, he says, 'an exile in time'. Nowhere is this more

Mitra Tabrizian
Tehran, 2006
Colour photography mounted on aluminium
50 x 152 cm
© Mitra Tabrizian
Courtesy of Mitra Tabrizian

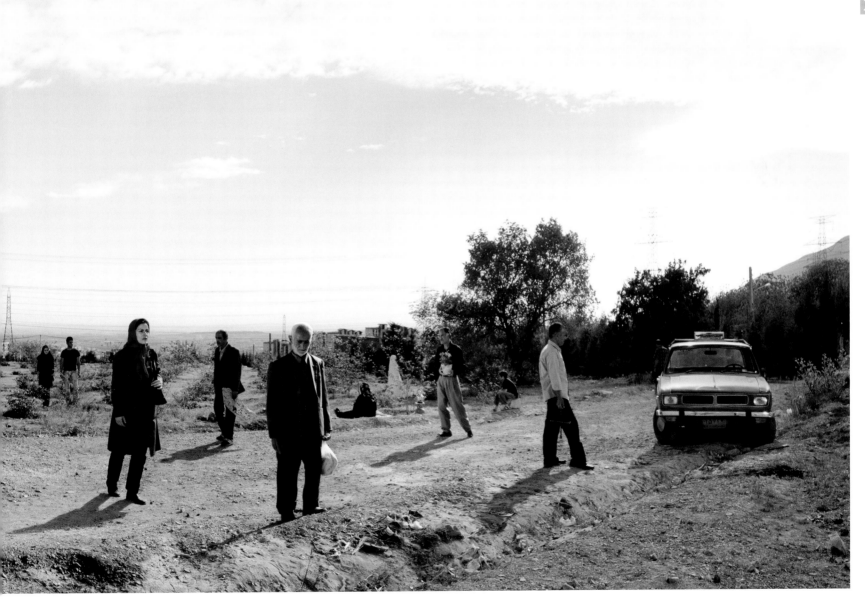

visible than in *Self-Portrait as a Child* (1989) where the photograph is reproduced in paint (meticulous, yet announcing its painterly idiom) and spliced into another background scene (broadly painted, the 'other') showing women dressed in late 19th-century attire having tea. The scene has a near acoustic resonance, a persuasive *mise-en-scène* that provokes a meditation on the passing of time while retrieving a certainty of self and its place. 'Art has no country, but the artist does,' Kami states.

Death (the 'major space' we all share), and the place of art as a statement of defiance (thus, an affirmation of life) despite this inevitability, is explored throughout Kami's work. His portraits simply do not rest: their quivering surfaces, the denial of finite perimeters delineating his sitters, the often closed or averted eyes, all build towards a strategic refusal to be confined to the mundane practice of making likenesses (after all, can't photography do that better?). Instead, the near-photographic realism of his paintings (Kami uses snapshots of his sitters as a formative step to drafting his paintings – 'I'm very clear about their quality not being good,' he says) is deliberately disturbed, like a stone thrown into a glassy pond. In his all-male series *Untitled (18 Portraits)* (1995–6), involving portraits of friends, colleagues and encounters, Kami references the celebrated late Roman funerary portraits found at Fayum, Egypt. These references are evident in the size, composition, dusty pigmentation and compassionate understanding on the part of the painter towards the subject about the sheer miracle of being individually alive. 'No subject interests me more than the human face. I don't just see faces, I meet them', he says. The soul, the *ka*, the spirit: painting as seeing, as reconstituting, making visible. 'I felt that there was a breath – one breath – going through all of them,' he says, when asked what had dictated his choice of sitters. In using the Fayum portraits as his reference point, Kami has *de-territorialized* them as portraits of the dead – therefore, from Death – and extracted them from being museum artefacts. He has *re-territorialized* or repurposed

them as portraits of the living and as influential agents within contemporary art practice.

Dryness blows across all of Kami's work. 'In the summer of 1996, I travelled across Iran by car for two months. The architecture and landscape were amazing. The dryness of the deserts and mountains was compelling, ascetic and spiritual at the same time. I felt it had the quality a Sufi ascetic would understand and need,' he explains. Deserts are traditionally where people are tested: perhaps creative endeavour needs a similar deprivation, a forced loneliness and ingenuity in order to survive, to meet itself, a condition where the *intensive* is developed, marking – to use Deleuze's phrase – 'a movement of language towards its extremes'. This is the hub of Deleuze's argument: that, for Kafka (and all those testing what a revolutionary condition might be), there was/is but one aim: 'to be a sort of stranger within his own language'.

For Deleuze, 'language stops being representative in order to now move toward its extremities or its limits'. The work of Shirazeh Houshiary, with its fidgeting concentration upon the difficulty of articulating *presence*, explores territory that Deleuze would surely have recognized. Her exhibition at the Lisson Gallery, London, in the summer of 2008 read like an account of a journey into space. Not the space of quantum physics – although scientists in that field would do well to consider the implications of her work – but rather the uncertain territory between darkness and light, being and undoing, here and there. *Black Light* (2008), *Untitled* (2008) and *Brittle Moment* (2007), among others, articulate a sensibility influenced by Minimalism and Conceptual Art (two 'major' languages within art practice) but do so using a number of strategically limited devices such as a restricted colour palette (blues, greys, white, silvers, blacks, some rose, little else) and a deft, miniature gestural dialect that employs words from Farsi. To all but the initiated, these blurred microscopic words appear as sonic readings, seemingly originating from outer darkness or projected onto it. The work, then, is expressly

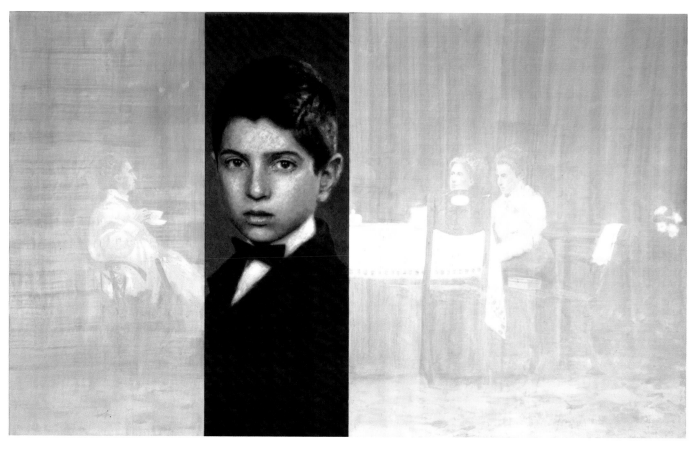

Y. Z. Kami
Self-Portrait as a Child, 1990
Oil on canvas
205.7 x 335.3 cm
Photo © Zindman/Fremont,
Courtesy of Y. Z. Kami and
Gagosian Gallery

spatiotemporal in its desire to operate beyond the limits of the picture surface, and aligns itself with the not-unrelated quests of Lucio Fontana and Ad Reinhardt to test the limits of painting. Houshiary's interest in surface goes beyond a debate about the endgame of painting; instead, for her, the surface is an intimate point of contact, of experience: 'gazing into surface is very powerful,' she says, referencing Nietzsche's dictum that 'nothing is deeper than the skin'. Her fixation on surface, its assurance as a territory of continuing viability, considers what looking might mean and how the viewer's presence might be represented in the work itself. Paintings such as *Presence* (2006–2007) and animations such as *Veil* (2005) nibble away at the distinction between artist-as-author, viewer-as-receiver.

In writing about the characteristic behaviours of those who attempt to produce a 'revolutionary condition', Deleuze distinguishes between those 'operating by exhilaration and over-determination' who bring about all sorts of worldwide *re-territorializations* – this might best describe Kami – and those who 'proceed by dryness and sobriety, a willed poverty, pushing *de-territorialization* to such an extreme that nothing remains but intensities' – this might best describe Houshiary (my italics). Houshiary declares she is 'not an Iranian of today' and that she feels completely 'alienated in Iran'. This acknowledged displacement of self – something she finds inspiring in the poetry of Rainer Maria Rilke, for whom 'homelessness' was a creative state of being – is crucial to her work: '"Home" for me is like to be in the threshold of the door. One could move outside or inside from this vantage point,' she says. Kafka would surely have understood. That said, the Iranian-ness of Houshiary's work – the references are there, very carefully controlled – has been almost totally rinsed of territorial specificity, but something persists. A memory of the dome at the shrine at Mashad, the poetry of Rumi (the poet most often mentioned to me by the artists and curators I spoke to), the Sufi willingness to surrender the self to the beyond. In seeking to control or direct this referential language, Houshiary has arrived at something close to a mythic language, 'on the horizon of cultures, caught up in a spiritual or religious re-territorialization'.

What use then Deleuze? To wrest his chosen contextual field – Kafka, language, the revolutionary condition – and repopulate it with questions about Iranian art, has been a calculated theft, a high-risk strategy. Sometimes crime pays. We'll see who finds me out. *Kafka: Towards a minor literature (theory and history of literature)* is generous in not declaring its certainties without acknowledging their limitations: 'all these factors can have ambiguous edges, changing borders, that differ for this or that material'. Indeed, he writes of a 'blur of languages, and not at all a system of languages'. But in setting out what 'revolutionary' might mean – 'there is nothing that is major or revolutionary except the minor' – he reminds us of the importance of the margins. Iran – crazy, frustrating, beautiful Iran – undid many of my preconceptions and will doubtless continue to do so. Deleuze tested them further, reminding me what language and its literatures can mean. Writing this essay has been a form of coming home.

Shirazeh Houshiary
Still from *Veil*, 2005
© Shirazeh Houshiary
Courtesy of Shirazeh Houshiary

Diasporic Communities and Global Networks: The Contemporaneity of Iranian Art Today

Anthony Downey

The distinction between the so-called 'Occident' and 'Orient' has often been staged around issues of representation and the inevitably thorny subject of culture. Who gets to represent whom and in what manner has been, from at least the 17th century onwards, a source of often rancorous debate and critical contention. In 1978, Edward Said traced the accumulative effect that these historical representations had had on the West's perception and subsequent understanding of the Middle East. Said's argument was relatively radical: the production of systems of knowledge that secured the West's 'imaginative command' over the Middle East, he proposed, went hand in hand with Western economic interests in those territories. Although a highly contentious argument at the time, today the essence of his thesis is widely accepted: Western systems of representation, collectively assembled and disseminated under the aegis of 'Orientalism', set up a binary relationship between West and East whereby the definition of the latter as irredeemably 'other' and exotic rendered it the passive object of knowledge-gathering and thereafter a source of wealth-extraction.

Western images of the Orient produced throughout the 18th and 19th centuries had a number of connotations, not least the notion of a localized population who lived in a 'timeless' hinterland that thrived on religious atavism, cultural intolerance, political extremism and tribal militarism, if not overt barbarism. The Orient, unlike the Occident, could not escape the past and therefore could not progress into modernity. Artistic production from the region was therefore seen in terms of craftsmanship and, in aesthetic terms, predominantly looking towards historical ideals as opposed to the present. Such views, far from abating with time, have proved remarkably durable and are inextricably linked to a strategy that sought to homogenize whole regions rather than examine the particularity and uniqueness of cultural production from individual areas. What was required (and is still required today) was an approach that examines the historical contexts and contemporary ambivalences of cultural output in particular countries rather than forms of neo-Orientalist reductiveness and conceptual abbreviation. All of which brings us to the relatively unique case of modern-day Iran.

If we put to one side the blinkered view of the Middle East as a mono-cultural and monolithic force, the suggestion that contemporary Iranian cultural production is predominantly inward-

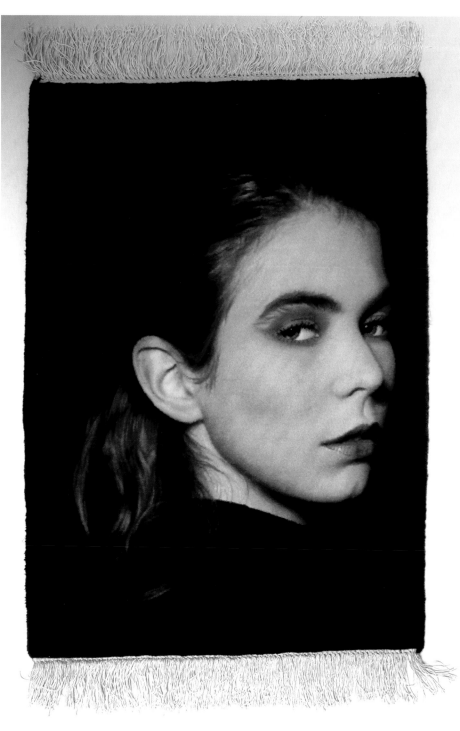

Shirana Shahbazi
Farsh-01-2004
from the 'Farsh/Teppiche' series, 2004
Handknotted rug, wool on silk
70 x 50 cm (approx.)
Edition of 3
Courtesy of Cardi Black Box, Milan/London

looking or bound by tradition is simply unsustainable – especially when we consider the emergence of modernism in the region in the 1940s, the level of cross-cultural contact that historically existed between Iran and the West, the diasporic make-up of its international community, and the globalized level of engagement that is the hallmark of contemporary Iranian visual arts. In the context of the visual arts, and in order to more fully understand their contemporaneity, we need to consider not only the heterogeneous cultural practices that exist in Iranian visual culture today, but also the institutional contexts within which Iranian art is being produced, curated, exhibited, collected and ultimately exchanged. To fully understand what is happening in contemporary Iranian art we must factor in the effects of globalization and the way in which contemporary art production follows routes and patterns that until recently were relatively unfamiliar.

The advent of the modern art movement in Iran has been traditionally associated with the forced abdication of Reza Shah and his replacement by his son Mohammad Reza Pahlavi. However, this view needs to be qualified: in the first instance, Pahlavi's removal was largely a Western-led initiative that was in response to his role in inaugurating a form of economic and social modernism in Iran – a modernity that the West had no real interest, literally and figuratively, in either supporting or developing. In cultural terms, the statement also suggests that Iran was culturally closed to Western influences until the 1940s. Yet Iran's Academy of Fine Arts had been founded in 1911 by Kamal al-Mulk (also known as Muhammad Ghaffari), who had studied in Europe and who had introduced many Western ideas to Iranian arts. Furthermore, the internationalist aspect of Iranian modern art in the 1960s and contemporary Iranian art today had already been seen in 1867, 1873, 1878 and 1900, when art from the region was displayed at world fairs in Paris and Vienna. Admittedly, al-Mulk's rather academic style of painting did fall out of favour following his death and further still with the ascendancy, under the direction of André Godard, of the College of Fine Arts. But the point remains that cross-cultural propagation was already a key feature of the arts in the early part of the 20th century. This commitment to the visual arts, moreover, was furthered by artists such as Marcos Grigorian (1925–2007), who in turn taught Hossein Zenderoudi (b. 1937). Seeking to conjoin an aesthetic that looked to popular culture and the cultural

resonances of Iran's past, Zenderoudi and artists such as Parviz Tanavoli (b. 1937) developed a uniquely Iranian form of art that sought to reconcile both traditionalist and modernist aesthetics.

Artists working in Iran today have a similar relationship to both the globalized contexts of international culture and the relatively localized concerns of their country. We can see this duality in the work of Farhad Moshiri (b. 1963), who was born in Shiraz, studied at the California Institute of Arts and now lives and works in Tehran. In works such as *Only Love (Faghat Eshgh)*, 2007, we are presented with a relatively traditional-looking representation of a jar that recalls both 13th-century Iranian pottery and the Sassanid pottery found at Susa. Through an intricate process of painting and folding his canvasses, Moshiri's finished works take on the patina and craquelure of the pots he is representing. Although this could be seen to be an exercise in verisimilitude, there is a subtle point being made here about how cultural legacies are used to promote global views on certain regions and their traditions. Often decorated with Farsi calligraphy, which is traditionally associated with verses from the Qur'an or Persian poetry, it nevertheless becomes clear that Moshiri's brand of calligraphy does not necessarily allude to either the Qur'an or to poetry but to everyday Iranian words – popular street slang, the brand names of mass-produced commercial products and drinks, lyrics from contemporary Iranian pop music. The traditional pedagogical forms of the past and the enunciative practices of the present are combined here in a hybrid process that further questions any easy distinction between the two – and, consequently, any simplistic categorization of contemporary visual culture in Iran.

If we examine the work of Shirana Shahbazi this not only becomes clearer but we also register the influence of the Iranian Diaspora that stemmed from the 1979 Islamic Revolution. Born in Tehran in 1974, the artist studied photography in Dortmund and Zurich before settling permanently in the latter city. In *Farsh-01-2004*, 2004, Shahbazi worked from photographs taken in cities as diverse as Harare and Shanghai; these images were subsequently reproduced on a large scale by Iranian billboard painters for the 2003 Venice Bienniale. The enormous images take on a Madonna-like reference. The photographs are also the basis for carpets produced by master weavers, a process that refers not only to the carpet tradition in Islam and Iran but also to formal aspects of prayer mats. What we

have here is the macro and micro, the international and national, the globalized and the local, and Shahbazi's practice, like that of so many of her peers, could indeed be defined within a national context but, importantly, one that takes an internationalist – that is, hybrid and appropriationist – approach to art as a practice.

This brief discussion of two artists, one in Iran, the other in Zurich, could preface a broader debate that would take in a variety of Iranian artists including, but not limited to, Monir Farmanfarmaian, Siah Armajani, Shirin Neshat, Shirazeh Houshiary, Khosrow Hassanzadeh, Y. Z. Kami and Shirin Aliabadi, all of whom explore global issues through local practices and also translate the local onto the global. Diasporas not only have an impact on the host communities but also inform the culture of the parent country. Add to this the manner in which globalization reconfigures the idea of the local and indigenous, and we begin to see Iranian visual culture as a fluid and permeable force. The fact of the Diaspora, the transmigration of people, has effectively hyphenated any sense of a unilinear or even univocal national, cultural and social identity. And herein lies one important aspect of the contemporaneity of Iranian art. Nonetheless, to fully understand the phenomenon that is contemporary Iranian art we need also to view it in its broader institutional context. Zenderoudi's work, for example, was exhibited in the Venice Bienniale as far back as 1962 and in the now-defunct Paris Bienniale in 1961, while Tanavoli's work is collected by major museums from MoMA in New York to the British Museum in London. This interest in Iranian art, stemming from the formation and subsequent support of the visual arts by institutions such as the College (or Faculty) of Fine Arts, opened at Tehran University in 1938, and the establishment in 1949 of Iran's first commercial gallery, Apadana, has to be seen alongside other institutional landmarks, not least the Tehran Biennials of 1958 and 1960 and, in 1977, the inauguration of the Tehran Museum of Contemporary Art. It may be a source of surprise to some that the latter institution is home to one of the world's most important collections of Western art, including works by Francis Bacon, Marcel Duchamp, Willem de Kooning, Donald Judd, Mark Rothko, Jasper Johns and Andy Warhol. In 1999, the museum held a show of Pop Art that included Warhol and Rauschenberg, and more recently it has held shows of contemporary Iranian photography (2002), Abstract Expressionism

(2003), contemporary British sculpture (2004) and a survey of Gerhard Richter's work (2004).

On an international level, the largest grouping of Iranian art outside of Iran is the Abby Weed Grey Collection which was established by the eponymous collector in New York in 1974 to house her extensive collection. Apart from holding important works by artists such as Tanavoli, Zenderoudi and Faramarz Pilaram, the collection has provided a forum for cultural dialogue. In 2002 the Grey Art Gallery staged 'Between Word and Image: Modern Iranian Visual Culture', a comprehensive show that included work by Siah Armajani, Marcos Grigorian and the Iranian photographer Abbas. In terms of Iranian involvement in international shows, it should be noted that a number of international curators have been both responsive to and responsible for some critically important shows in the last decade or so. 'Iranian Contemporary Art', one of the first shows of Iranian art in Britain, opened at the Barbican Centre in London in 2001, curated by Rose Issa and Ruin Pakbaz. In the same year, the first loan exhibition of Iranian art since the 1979 Revolution, 'A Breeze from the Gardens of Persia: New Art from Iran', opened at the Meridian International Center in Washington. More recently, Iranian artists have taken part in Documentas IX, X and XI, and there have been many exhibitions of Iranian contemporary art, including 'Far Near Distance: Contemporary Positions of Iranian Artists' (2004, Haus der Kulturen der Welt, Berlin, curated by Rose Issa); 'Iran.com: Iranian Art Today' (2006, Museum for New Art, Freiberg, curated by Isabel Herda and Nicoletta Torcelli); 'Word into Art' (2006, British Museum, curated by Venetia Porter); and 'Naqsh' (2008, Museum of Islamic Art, Berlin), which looked at gender and role models in Iran. Included in these exhibitions were artists as diverse as Parastou Forouhar, Shadi Ghadirian, Ghazel, Khosrow Hassanzadeh, the filmmaker Marjane Satrapi and the photographer Mitra Tabrizian. Tabrizian is a another example of an international Iranian artist: born in Tehran in 1959, she left in 1977 for a school in Exeter and thereafter the Polytechnic of Central London, where she studied photography. She now lives and works in London, has a gallery in Berlin, and shows around the world (there was a retrospective of her work at Tate Britain in 2008).

The extrinsic influence of globalization is also felt on sales of Iranian art, and nowhere more so than in the auction houses. Sales of art from the Middle East at Sotheby's, London, in 2007 and 2008

Farhad Moshiri
Only Love 'Faghat Eshgh', 2007
Swarovski crystal diamonds and
oil on canvas, mounted on board
170 x 230 x 7 cm
© Farhad Moshiri

featured Iranian art prominently, with no less than twenty-five Iranian artists in one auction. In Dubai in April 2008, the Christie's sale of Modern and Contemporary Arab and Middle Eastern Art went beyond pre-sale expectations, selling for over twenty million dollars, which was approximately 33 per cent higher than their previous record in October 2007. It was in the former sale that the world record for an Iranian artist was set, with Parviz Tanavoli's *The Wall (Oh Persepolis)* selling for $2,841,000. Of the top sixteen highest-selling works from the Middle East, the top four places are held by Iranian artists (Tanavoli, Zenderoudi, Mohammad Ehsai and Moshiri, the latter being the first artist from the Middle East to sell at auction for over one million dollars), while no less than eight Iranian artists appeared overall (the others being Faramarz Pilaram, Hossein Kazemi, Massoud Arabshahi and Shirin Neshat). It is also significant to note that the collectors of these works are relatively international and that these sales have given a considerable fillip to the development of commercial galleries specializing in Iranian art in London, New York, the Middle East and elsewhere. The list of such galleries is extensive and includes The Third Line (Dubai), the Elahe Gallery (Tehran), the Green Art Gallery (Dubai), Agial Art Gallery (Beirut), Silk Road Gallery (Tehran), Seyhoun Gallery (Tehran) and Sfeir-Semler (Beirut). Needless to say, the list of

art galleries outside of the Middle East that regularly display Iranian art is extensive, including Lisson Gallery (London), Kashya Hildebrand (New York), Galerie la B.A.N.K. (Paris), Daneyal Mahmood Gallery (New York) and Gladstone Gallery (New York).

Far from representing an indigenous cultural output that narrowly looks to the past (although the past does play a part), Iranian contemporary art is a nationally and internationally based collection of art practices that, in some instances, draws upon the legacy of modernism in Iran, and yet does so through the lens of a globalized cultural context and through its diasporic constituency. Iranian contemporary art offers a significant degree of complexity when it comes to considering contested notions such as modernity (internationalism) and tradition (regionalism), the global and the local and, perhaps most notably, the aesthetic and conceptual divisions to be found in the so-called Western and Eastern canons. This is not so much to reverse Western critical views and re-engage the hierarchies that were put in place by Orientalist discourse as it is to point out that the long-term diasporic, internationalist and outward-looking forms of art in Iran have long been engaged in that most pressing of cultural concerns: the fragmentation of the present and the ensuing diversification of cultural production.

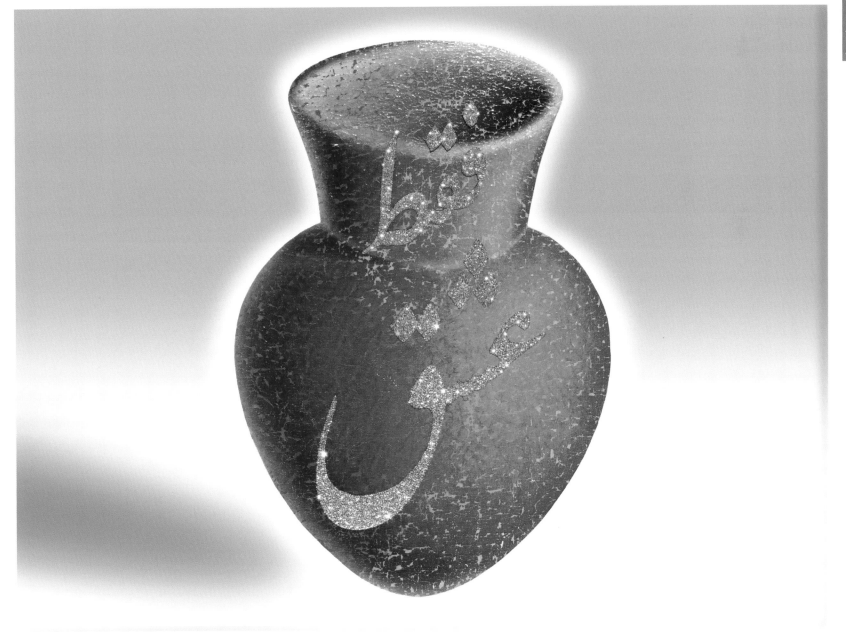

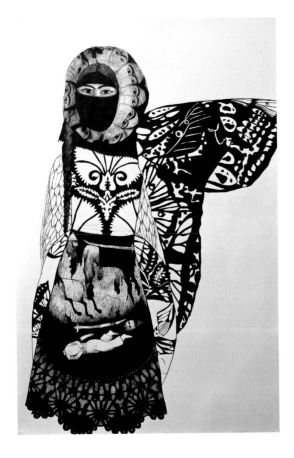

Samira Abbassy was born in Ahwaz, Iran, in 1965. Her Arab-Iranian family moved to the United Kingdom in 1967, where she studied painting at Canterbury College of Art. After enjoying a successful career in London throughout the late 1980s and 1990s, showing in Cork Street and at the Royal Academy of Arts, in 1998 she moved to New York, where she is now permanently based.

Abbassy works mostly in paint, using a distinctive, almost naive style. Vivid colours and mythical creatures create a dreamlike and mystical feel. There is also often a strongly autobiographical element to her work, and Abbassy describes how she became a 'fictional historian' in her art. 'I reinterpreted stories about a homeland that I only saw as a child. I created an "imaginary homeland" and reinvented the cultural ground beneath my feet. It is as though I had become the ambassador of my own "never-never land" from which I was exiled....'

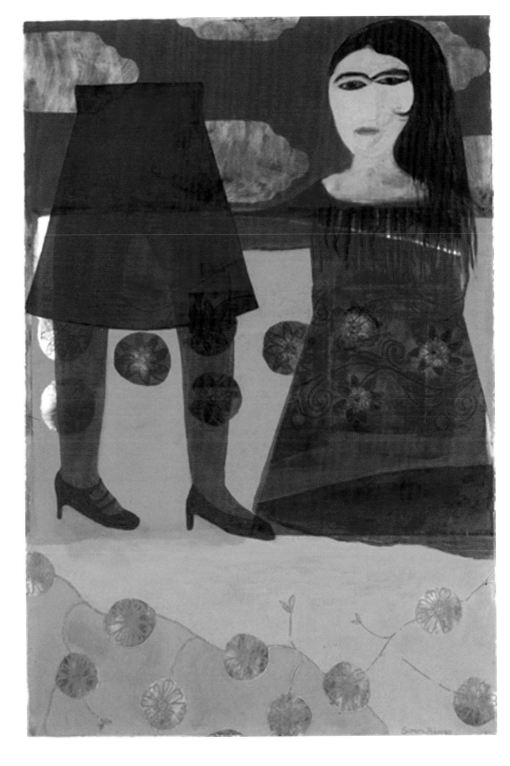

above
Moth to a Flame, 2008
Charcoal on paper
112 x 76 cm
© Samira Abbassy
Courtesy of Samira Abbassy

right
Personal Bisection, 2005
Oil and collage on paper
112 x 76 cm
© Samira Abbassy
Courtesy of Samira Abbassy

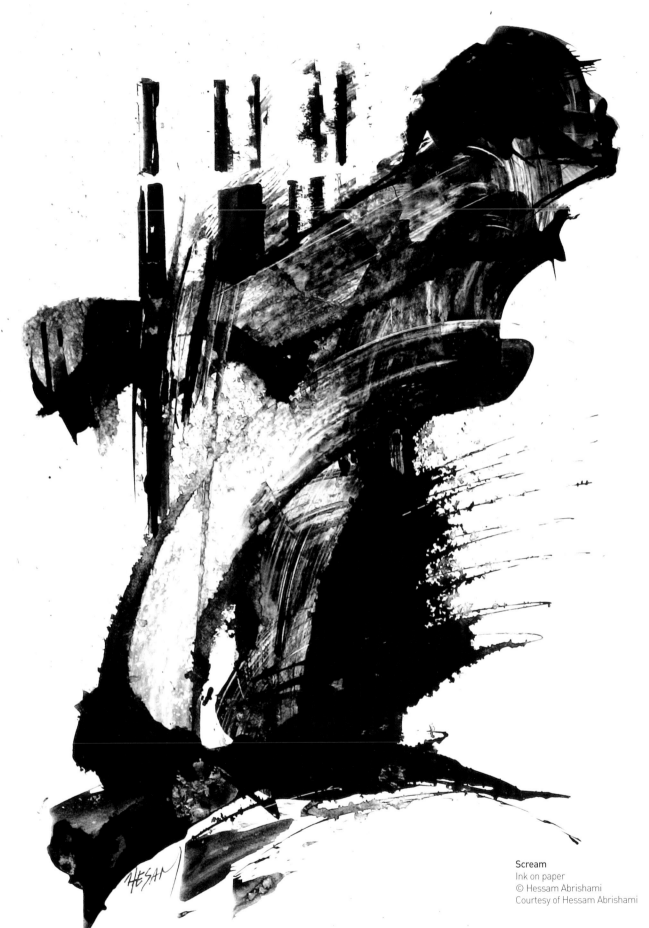

Scream
Ink on paper
© Hessam Abrishami
Courtesy of Hessam Abrishami

Hessam Abrishami was born in the city of Shiraz, Iran, in 1951. He discovered his love of painting and art when he was fifteen, and received his first award just a couple of years later.

Abrishami went on to study in Perugia, Italy (which he considered to be 'the centre of art in Europe'), at the Accademia de Belle Arti 'Pietro Vanucci'; later he moved to Los Angeles, California, where he continues to work. His art has been called by one newspaper: 'A statement in the fluidity of human figures.... [Abrishami] creates a tension between each figure, a kinship of place or condition that provokes the viewer to seek reasons for such relationships.' His influences tend to be European, notably modern masters such as Cézanne and Picasso. While his paintings are bold and colourful, Abrishami describes them as a 'cry of pain' against the 'tyranny and injustice in our world.'

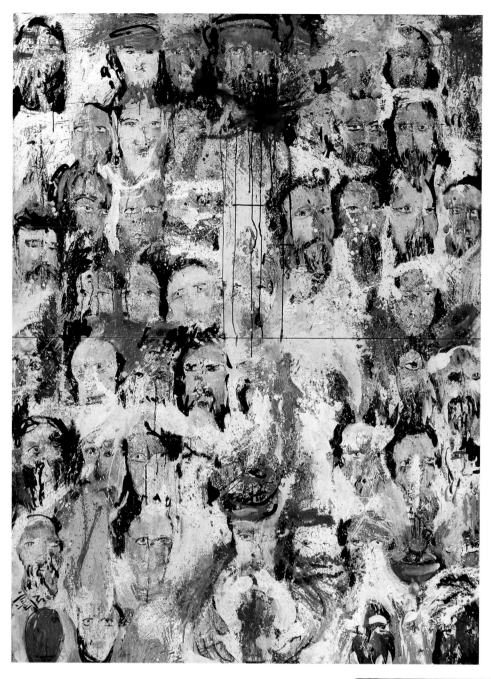

Born in 1976 in Tehran, Alireza Adambakan studied painting at Azad University in the same city, graduating in 1999. Since then he has exhibited his paintings widely inside Iran, where he continues to live and work. He is also an active member of the Iranian Society of Painters.

Adambakan is first and foremost a painter, working typically in oils, although he has also worked in other media such as fresco. His paintings cover a wide range of subjects – sometimes figures, sometimes elements of architecture, more recently landscapes – though the forms are often blurred and partially obscured by the expressionistic brushwork: indeed, some of his works even border on the abstract. What unites them, however, is a love of shimmering colour.

above
The Seventy Two, 2003
Mixed media on canvas
(in two parts)
200 x 150 cm
Private collection, London

right
Untitled, 2008
Oil on cardboard
50 x 65 cm
© Alireza Adambakan
Courtesy of Alireza Adambakan and
Assar Art Gallery, Tehran

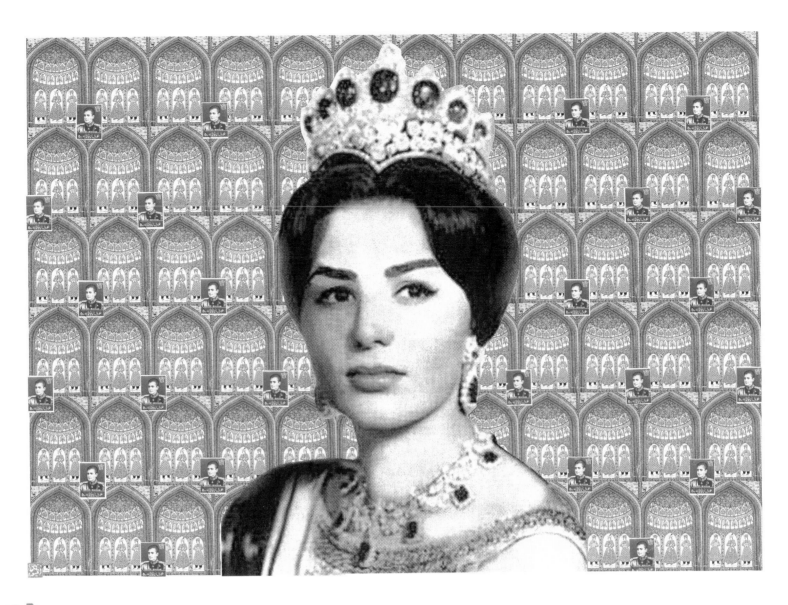

above
From the 'Fairytale Icon' series, 2009
Mixed media
42 x 59 cm
© Afsoon
Courtesy of Afsoon

left
**From the 'Seasons of Love Talismans'
series**, 2008
Linocut on photograph
29 x 42 cm
© Afsoon
Courtesy of Afsoon

Afsoon grew up in Iran, spent her late teens and early twenties in San Francisco, and now lives and works in London. Her work has been shown widely in London, and has been bought by the British Museum.

Most of Afsoon's work is done in linocut, collage and etching. She begins with a sketch, which she then works on for a few days, developing it into the final image to be cut and printed. She sometimes combines printing and photography – and even text – to create intriguing juxtapositions of imagery and introducing new layers of meaning. Afsoon also collects vintage photographs, old advertisements and interesting pieces of fabric, which are mixed and matched in the collages to often humorous effect.

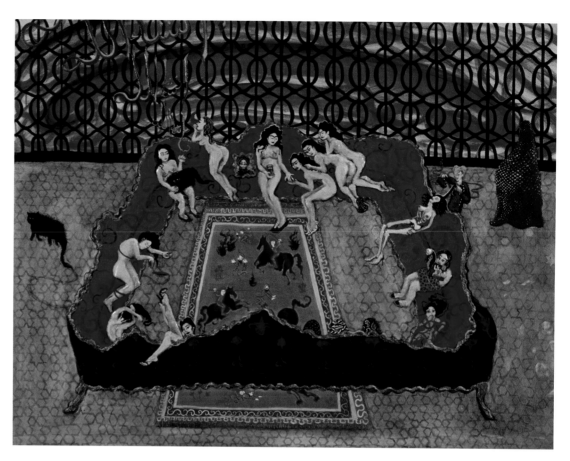

above
Wanted Hand, 2006
Acrylic, glue and glitter on gessoed panel
91.5 x 122 cm
© Negar Ahkami
Courtesy of Negar Ahkami and
LTMH Gallery, New York

left
Islamables Matryoshka Dolls, 2007
Gesso, acrylic and glitter graffitied over
'America Antiterror' Russian dolls
Dimensions variable
© Negar Ahkami
Courtesy of Negar Ahkami and
LTMH Gallery, New York
Photo: Jeff Barnett-Winsby

Negar Ahkami was born and raised in the United States, but grew up feeling oppressed by the dehumanizing media representations of Iran, and of Iranian women in particular. 'They [the West] can't get past these stereotypical images.'

Ahkami's fascination with the plight of Iranian women in their own country, and their exotic and dehumanizing representation in the United States – whether because of the veil or through other entrenched cultural stereotypes – has had a profound effect on her art. 'All my work comes from this place of dealing with the negative media stream.' Ahkami traces the roots of media stereotypes to Orientalist genre painting, and often revisits Orientalist themes in her work: 'I'm subverting this [exoticizing] genre...my women have an inner life to them,' she explains. Thus, while Ahkami uses and plays with stereotypes, she complicates them with her own observations.

Certainly Ahkami's art has an obliquely autobiographical element. Born in 1971, at the age of eight, Ahkami's world was turned upside down by the maelstrom of the Islamic Revolution, even from a distance. The part of her life centred on regular family visits to Iran was severed, and the American embassy hostage crisis caused an identity crisis, as her school friends suddenly saw her as Iranian rather than American. 'The neighbourhood kids would tease me, and Iranians would tease me for my inability to converse in Persian,' she remembers.

The effects on her self-confidence were profound, resulting in Ahkami's suppression of her self-identity in order to survive. 'I really struggled with my roots and...learned to block out the Farsi [Persian] language...and the depressing news.' Ahkami explains that her story is fairly typical among Iranians born in, or growing up in, the United States around that time. 'I was hyper-sensitive to the images of Iran,' she says, 'as well as disappointed at how educated Americans based their assumptions of Iran entirely on negative media images'.

Ahkami took refuge in art and started painting at the age of ten: 'I liked drawing figures from an early stage.' But she soon became bored with observational drawing and started to use her imagination. At eighteen, she spent some time as an intern at the Metropolitan Museum of Art in New York, home to one of the best collections of Persian art in the West.

There, Ahkami became fascinated with Persian miniatures, but also frustrated with their perfection and lack of connection to the depressing news. As she explains: 'I love art that is visceral and raw...my fantasy was for there to be such a thing as Persian Expressionism.' The closest she got to this vision was the work of Ardeshir Mohassess. Her one real connection between herself and her original homeland became the art – 'the one thing I'm most proud of,' as she puts it. 'There is a need to connect and art is the space through which I connect.... I went back to my roots at Columbia [University, where she studied Middle Eastern Languages and Cultures] and sought out my Persian heritage.' That immersion in Persian culture had a tremendous healing effect on her, she says, and has become an important foundation for her unique aesthetic.

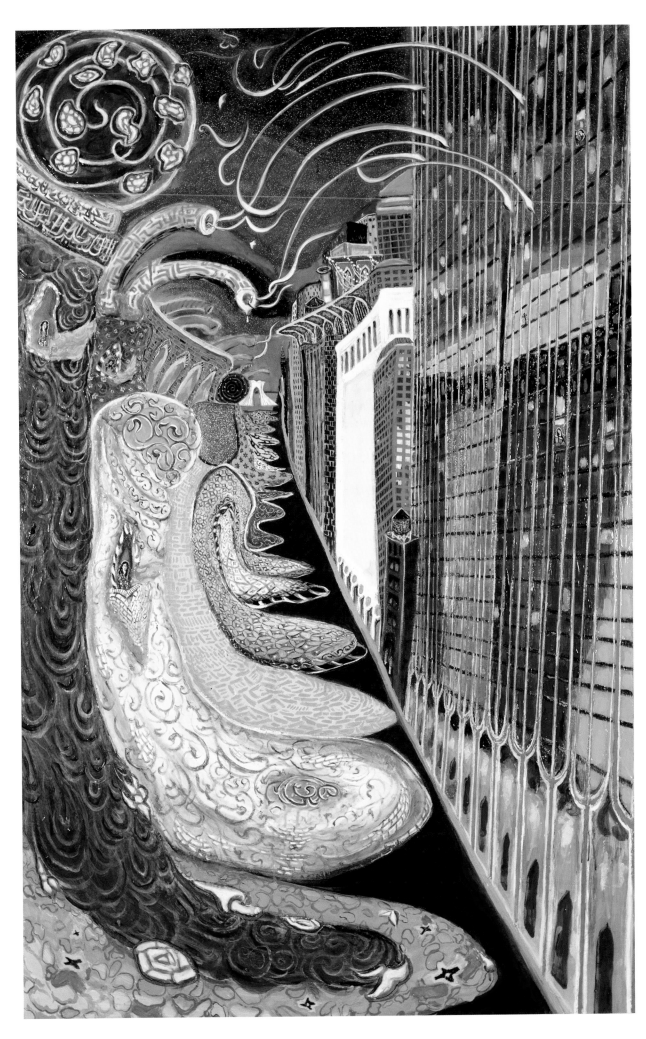

Tale of Two Cities, 2008
Acrylic and glitter on gessoed panel
142 x 91 cm
© Negar Ahkami
Courtesy of Negar Ahkami and
LTMH Gallery, New York

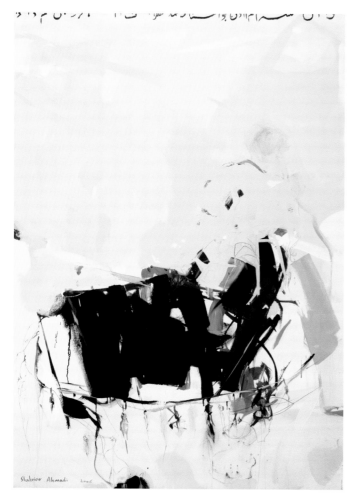

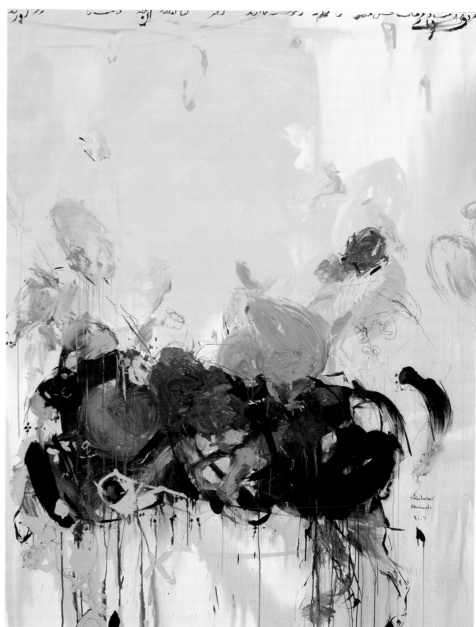

The work of Shahriar Ahmadi, who was born in Kamiaran, Iran, in 1979, sits on the border between calligraphy and abstraction. He has already participated in over fifty group and solo shows in Iran, the United States, the United Kingdom and China.

Coming from a family of artists, Ahmadi began by 'creating portraits with words', using calligraphy. Working mostly in acrylics (applied by hand), though also in ink, his works are spontaneous and lively, and are often compared to those of Cy Twombly. He professes to be greatly influenced by the history and culture of Iran, and often refers to religion, albeit in an oblique way – for example, in the 'What is Maaddeh?' series he revisited the story of Adam and Eve. The recent 'Rumi in my Chalice' series – which references the famous Persian mystical poet – has moved into more abstract, colourful territory. For Ahmadi, painting is first and foremost a form of self-expression – one that is, in his words, 'filled with riddles and mystery.'

above
Untitled, 2006
From the 'Rumi in my Chalice' series
Mixed media on canvas
200 x 140 cm
© Shahriar Ahmadi
Courtesy of Shahriar Ahmadi and Assar Art Gallery, Tehran

right
Untitled, 2007
From the 'Rumi in my Chalice' series
Mixed media on canvas
245 x 190 cm
© Shahriar Ahmadi
Courtesy of Shahriar Ahmadi and Assar Art Gallery, Tehran

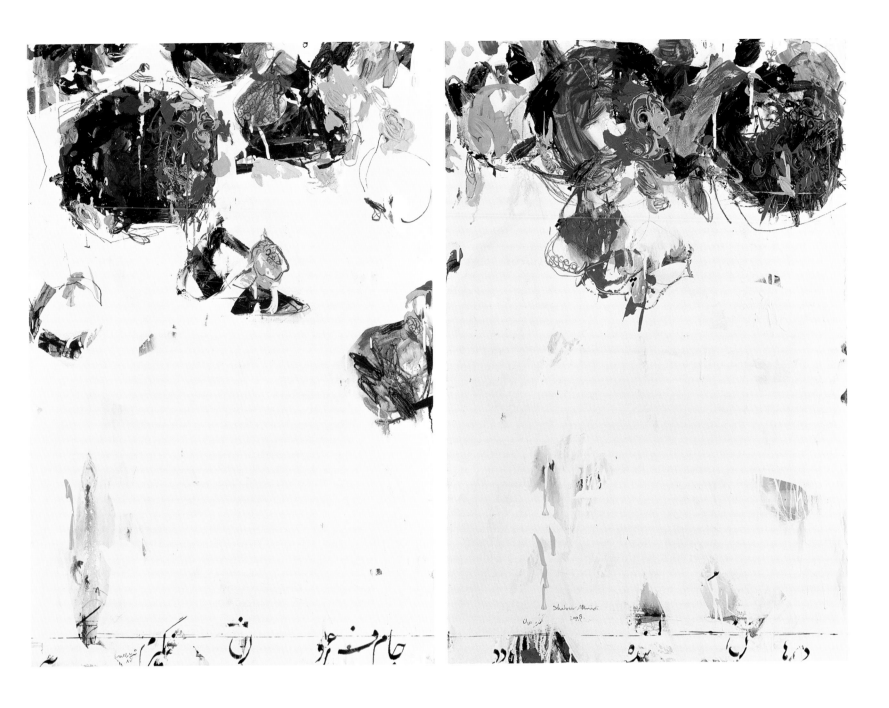

Untitled, 2007
From the 'Rumi Molana' series
Mixed media on canvas
Diptych
140 x 100 cm (each)
Private collection, London

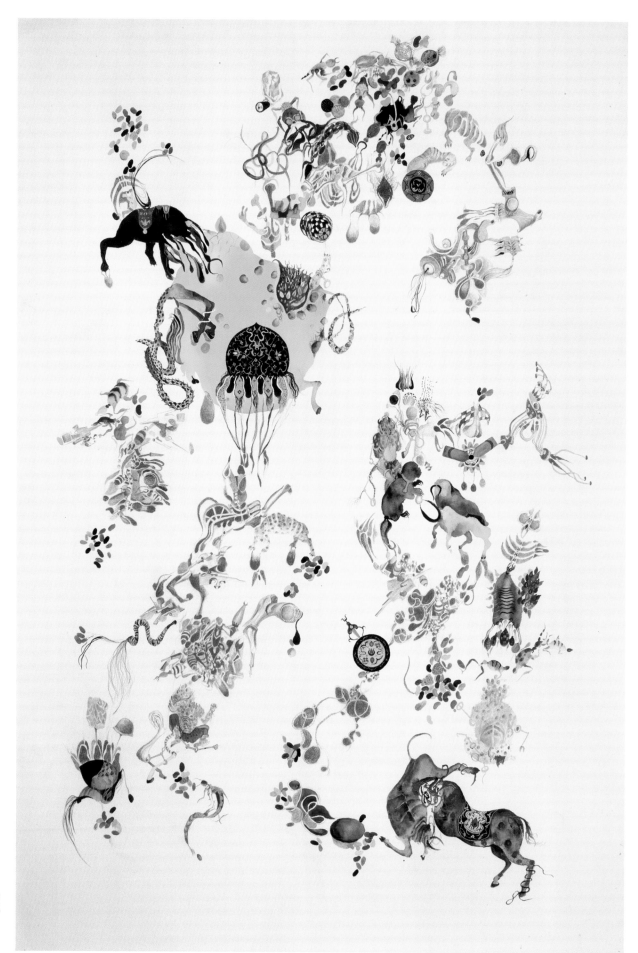

Shiva Ahmadi

Born in 1975 in Tehran, Shiva Ahmadi studied at the Azad University in the same city, graduating in 1998. She then went on to study for a Master of Arts and Master of Fine Arts at Wayne State University in Detroit and the Cranbrook Academy of Art in Bloomfield Hills.

Ahmadi's work reflects the trauma of her childhood, caused by the Islamic Revolution and the devastating Iran–Iraq War. At the outbreak of the recent Iraq war, in 2003, Ahmadi was working on an artist's placement at Skowhegan, Maine, and she was immediately reminded of her earlier experiences.

This political consciousness combined with an interest in Persian miniatures to create a powerful – and beautiful – set of works that obliquely deals with the subject of war. In Ahmadi's own words, her paintings are 'very political...they talk about immigration, they talk about exile, they talk about politics, they talk about women.' Painted in jewel-like watercolours, they are at once a celebration of Persian culture and a reflection on past and present turmoil.

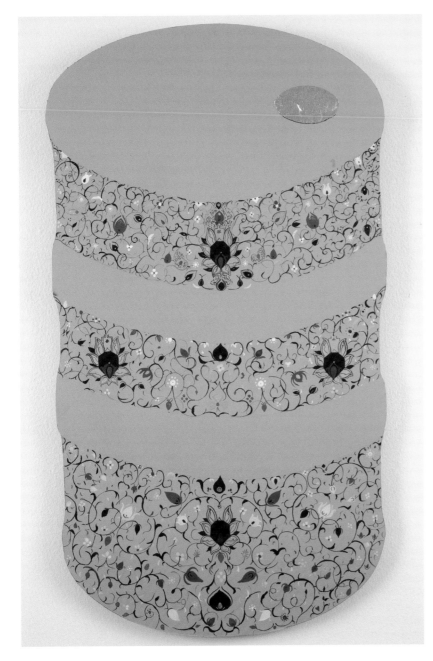

above
Oil Barrel (green), 2008
Watercolour and gouache on paper
mounted on wood
58.5 x 33 cm
© Shiva Ahmadi
Courtesy of Shiva Ahmadi and
LTMH Gallery, New York

opposite
Pigs, 2007
Gouache and watercolour on paper
152 x 101.5 cm
© Shiva Ahmadi
Courtesy of Shiva Ahmadi and
LTMH Gallery, New York

above
Oil Barrel (red), 2008
Watercolour and gouache on paper
mounted on wood
59 x 33 cm
© Shiva Ahmadi
Courtesy of Shiva Ahmadi and
LTMH Gallery, New York

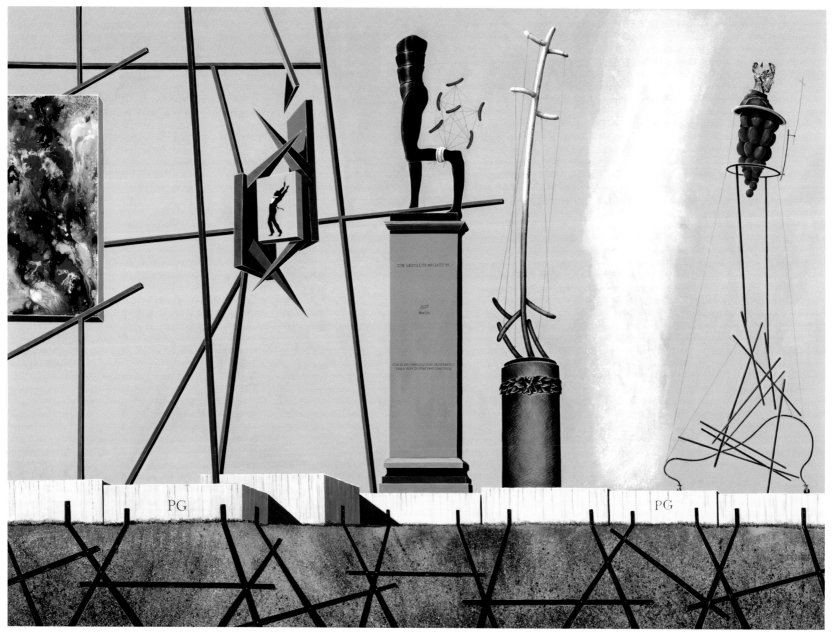

Nader Ahriman was born in Shiraz, Iran, in 1964, but has spent a large portion of his life in Germany, and continues to live and work in Berlin. His paintings border on the surreal, and are faintly reminiscent of the work of Max Ernst, Giorgio de Chirico or even Marcel Duchamp, with imaginary architecture, amorphous forms, and quasi-mechanical elements floating in large, empty spaces.

The central issue in Ahriman's works seems to be the relationship between humans and machines, with body parts being replaced by mechanisms and his figures restricted in their decision-making. Curious wire- or grid-like constructions seem to hold the painting together while also conjuring up a prison. Not surprisingly, there is a significant philosophical underpinning to the work, with Ahriman finding inspiration in everything from Plato to Ezra Pound, Aristotle to Jung – indeed, it has been said that Ahriman's goal is to give concrete form to abstract modes of thought. The recent 'Stromboli' series took as its starting point Nietzsche's Zarathustra – who, perhaps only partially by coincidence, was also Persian.

above
Der Hirte entfernt sich von der Gestalt des Bewußtseins auf dem Plateau G, 2007
Acrylic on canvas
220 x 300 cm
© Nader Ahriman
Courtesy of Nader Ahriman and Klosterfelde, Berlin

opposite
Die absolute Negation – ein New Yorker Galerist im Anzug von Jil Sander, 2007
Acrylic on canvas
240 x 170 cm
© Nader Ahriman
Courtesy of Nader Ahriman and Klosterfelde, Berlin

Nader Ahriman

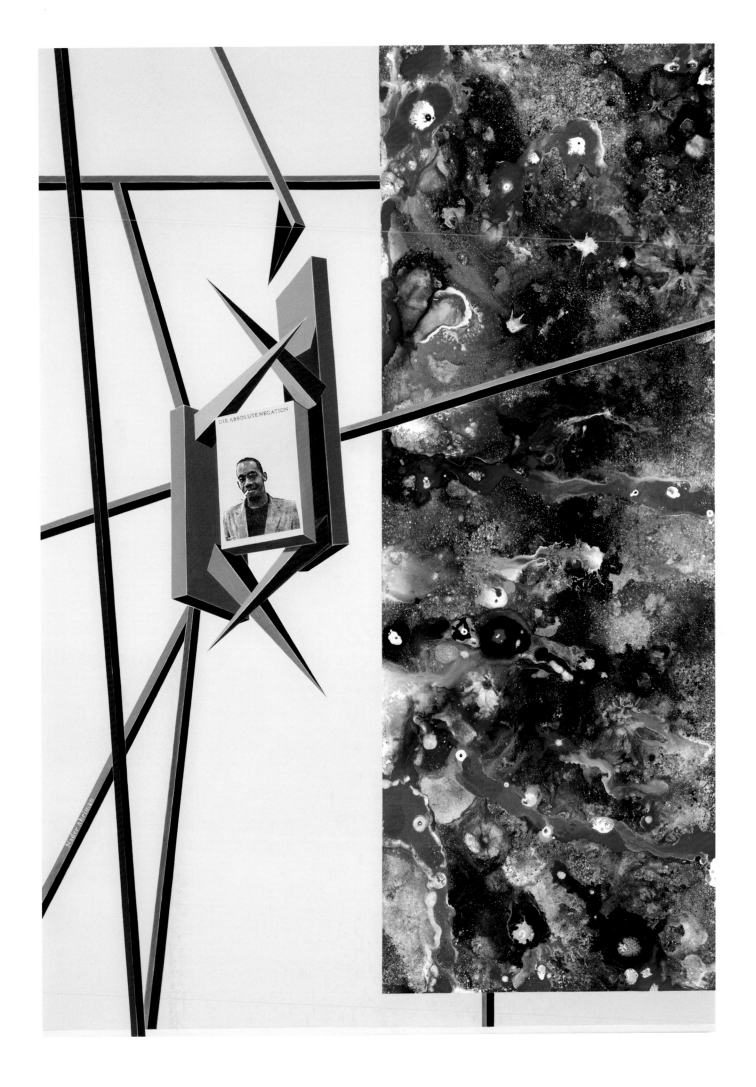

DIE ABSOLUTE NEGATION

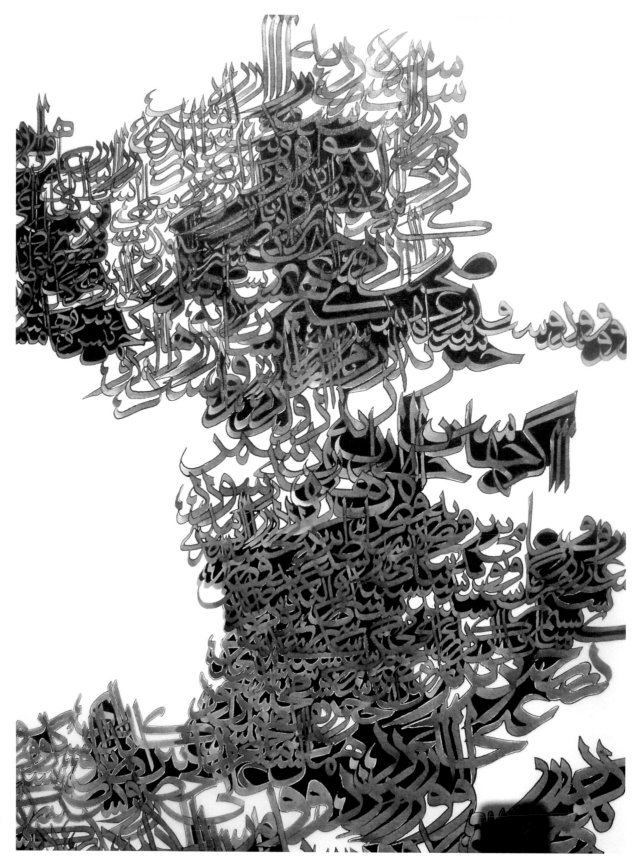

Ali Ajali is considered one of the few living masters of calligraphic painting. Born in Mianeh, Iranian Azerbaijan, in 1939, from early childhood he was an accomplished painter, even before his formal training. Ajali studied at Tehran's Lycée Français and undertook his university education at the College of Decorative Arts, in the same city. Although Ajali was trained as an interior designer, he dedicated himself to painting and in time mastered the art of Iranian calligraphy.

Since the 1970s, at one time or another, Ajali has headed the departments of calligraphy at almost every major institute of higher education in Iran, making him a very influential figure. Perhaps his greatest contribution to the arts of Iran, however, has been his strong belief in, and defence of, artistic integrity.

Vernal, 2007
Acrylic on canvas
180 x 150 cm
© Ali Ajali
Courtesy of Ali Ajali and
Xerxes Fine Arts, London

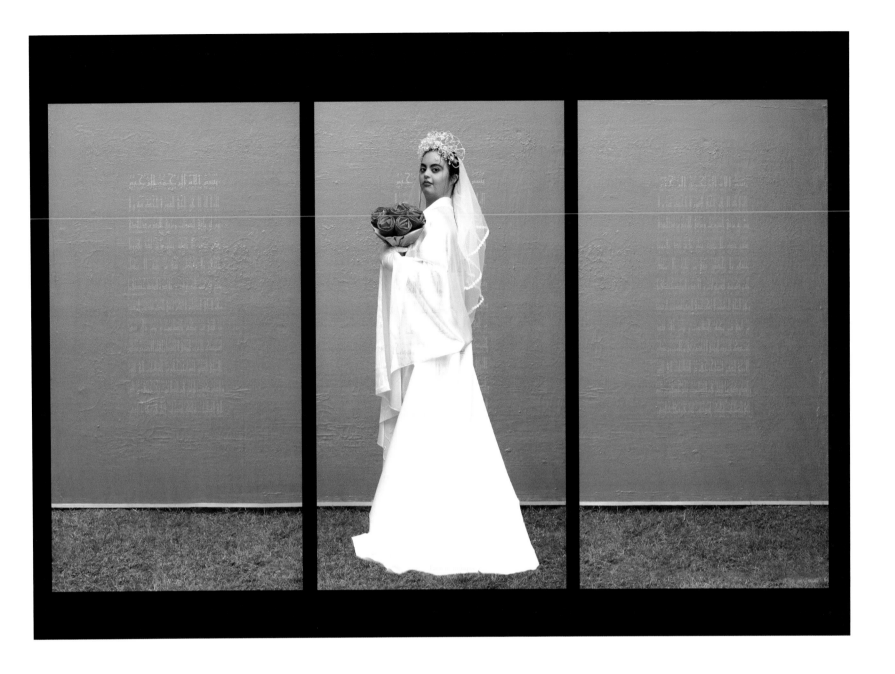

I am Mandana, 2008
Digital print on canvas
170 x 270 cm
Edition of 2 + 1AP
© Mania Akbari
Courtesy of Mania Akbari and
Xerxes Fine Arts, London

Mania Akbari was born in Tehran in 1974. To many she is best known as the director of the film *20 Angosht* (*20 Fingers*), released in 2005 and which won a prize at the Venice Biennale – or even as an actress. Before that she had starred in Abbas Kiarostami's *Ten*, and since then she has produced *10+4*, which documented her battle against cancer.

However, Akbari began her career as a painter, and continues to produce large-scale art works, often in the form of sound and video installations or digital prints on canvas. Some of these bold and striking works play with the artist's own identity and experiences, while others look at the role of women in society in general. One such recent series shows a young Iranian girl called Mandana in varying female roles: sensuous libertine, submissive bride, anonymous chador-clad woman. The decision to make Mandana, who has Down's syndrome, the subject of the portraits suggests Akbari's belief that women have been historically marginalized and misunderstood by men.

For Alaleh Alamir, art has always been more of a necessity than an indulgence: 'I was brought up to speak various languages fluently in a place where expressing one's self wasn't welcome.... So the things I wasn't allowed to say, I looked for other ways to express them.... The reason I started making art early in life, was simply because of a pressing need to be "free".'

Born in Tehran in 1959, Alamir moved to the United States in 1977 to study art. In 1986 she was awarded a Master of Fine Arts from the Parsons School of Design, and subsequently worked on a paper on 'Numerical Systems and Colour Perception' for a doctorate at New York University.

Wary of categorization, Alamir describes herself as a 'visual poet', and over her career she has explored many different media, from paintings (such as the series of sky paintings, *SAAT : Les Heures*, which Alamir has been working on since 1989) to installations that play with coloured displays of light, water and reflections; and from engravings to film and photographs. In addition, she writes and performs poetry, and has collaborated with LaMonte Young, as well as with the radical Fluxus art group. If pressed, however, Alamir admits that her preferred medium is drawing: 'It shows the essentials, it's impossible to lie with it,' she explains.

All of this activity suggests that Alamir is striving to create a form of 'total art'; certainly the interdisciplinary spirit is central to her work, and she has described herself as being part of a 'New Renaissance' that brings together the disparate disciplines of optics and perception, spiritual practice, mathematics, philosophy, poetry and calligraphy. Alamir offers her own take on this blurring of boundaries: 'My cross-cultural background influences and explains most of my artistic concerns, and for as long as I can remember I have been looking for the universal, for the boundless. I always thought the notion of boundaries to be somewhat arbitrary. Crossing them came naturally to me, probably thanks to my nomadic genes... it might also explain my need for a multi-disciplinary activity.'

above left
Hamin Ast
Oil on canvas
© Alaleh Alamir
Courtesy of Alaleh Alamir

above
In The River, 1995
Oil on canvas
125 x 150 cm
© Alaleh Alamir
Courtesy of Alaleh Alamir

opposite
Aqua – Iris y Pergamino, 1999
Installation view
Canvas, medium and pigments
850 x 215 cm
Glass, plexiglass, pigments and water
120 x 90 x 30 cm
© Alaleh Alamir
Courtesy of Alaleh Alamir

Alaleh Alamir

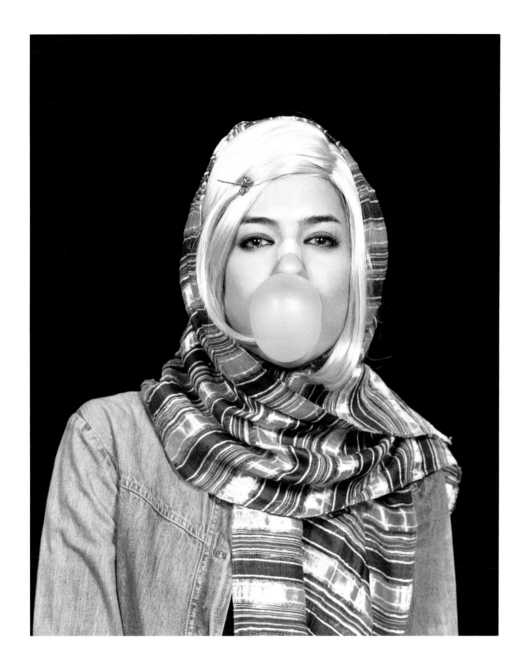

Shirin Aliabadi was born in Tehran in 1973, but then moved to Paris while young and spent most of her childhood there. She studied History of Art and Archaeology at the University of Paris, and although she subsequently concentrated on fine art practice, this critical background has led into her parallel work as a curator, in which capacity she frequently collaborates with Farhad Moshiri. She has exhibited widely internationally, including in London, Geneva, Rome, Dubai and New York.

As an artist, Aliabadi works with photography, video and installation, producing works that more often than not chart changes in everyday life in Iran. The 'Miss Hybrid' series from 2006–2007, for example, identified and documented a current fashion trend among young Iranian women. These women are all trying to look as Western as possible, with blond hair, blue or green contact lenses

and surgical nose tape. Aliabadi has tried to capture the 'aesthetic parameters' that form and define the aspired-to identity of today's young Iranian women – sparked by a deep desire to transform themselves into a perceived 'Western' alternative, mostly via these cosmetic interventions. Such conflicts between 'East' and 'West' have also been explored in recent collaborations with Farhad Moshiri, notably *Operation Supermarket* (2008), in which subverted packaging spells out 'We Are All Americans'.

Other works have studied changes in Iranian family life, the way in which young girls are used on the covers of magazines, or, in the case of the 'Girls in Cars' series (2005), caught made-up Iranian girls on their way to parties. In a sense, Aliabadi is capturing scenes from the battle between religious orthodoxy and pop culture, though without predicting who might win.

above
Miss Hybrid 3, 2006
Inkjet print on plexiglass
150 x 122 cm
© Shirin Aliabadi
Courtesy of Shirin Aliabadi and
The Third Line Gallery, Dubai

right
Girls in Cars series, 2005
Colour photographs on paper
70 x 100 cm
© Shirin Aliabadi
Courtesy of Shirin Aliabadi and
The Third Line Gallery, Dubai

opposite
Miss Hybrid 5, 2008
Lambda print
114 x 150 cm
© Shirin Aliabadi
Courtesy of Shirin Aliabadi and
The Third Line Gallery, Dubai

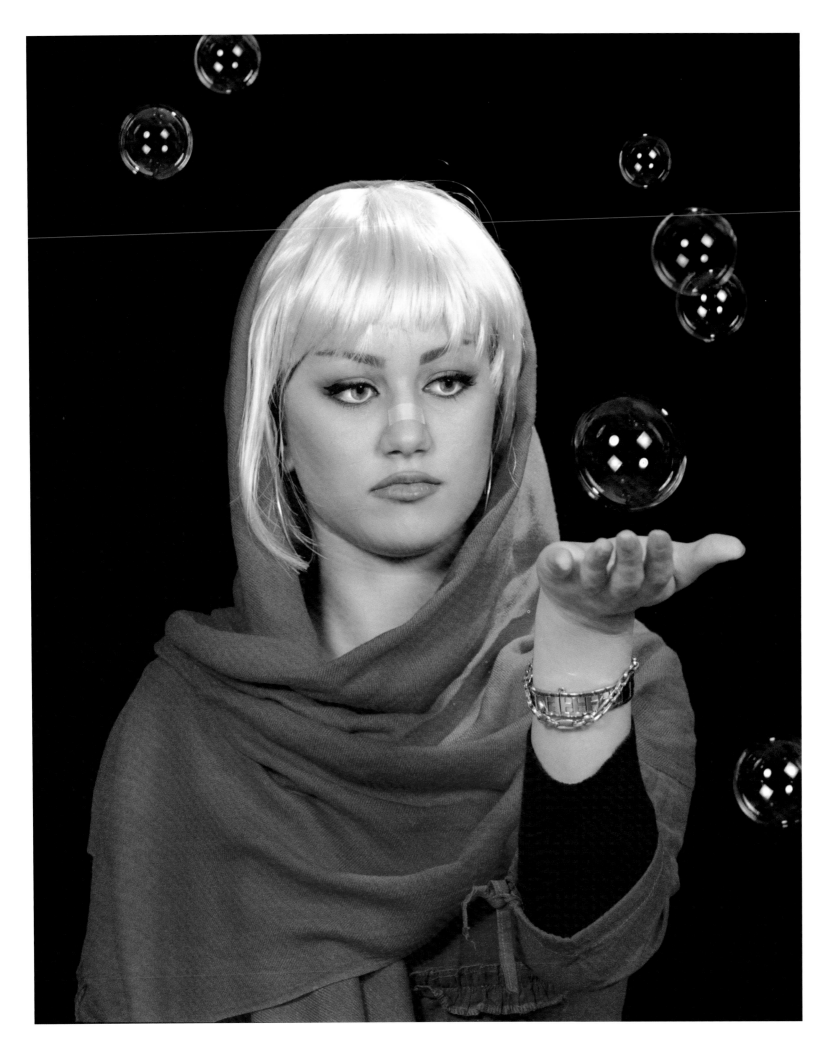

71

Born in Iran in 1967, Samira Alikhanzadeh studied first at the Alzahra University, and then took a Master of Fine Arts at Azad University, Tehran, which she completed in 1998. Today she exhibits regularly in Tehran, and has taken part in group exhibitions internationally.

Alikhanzadeh's earlier paintings depicted windows and frames, reflecting an obsession with light effects; however, one day, stumbling on a box of old photographs, she began to incorporate these new elements. Today her works are populated by children and women from the past, nameless faces dressed in long-gone fashions. Another common tactic in her works is the use of shards of mirror, which are employed to partially incorporate the viewer into the piece, encouraging them to think about their own identity or heritage. The overall impression is one of melancholy, of time passing.

above
Untitled, 2008
Acrylic and mirror on printed board
120 x 120 cm
© Samira Alikhanzadeh
Courtesy of Samira Alikhanzadeh and
the Assar Art Gallery, Tehran

right
Untitled, 2007
Acrylic and print on board
Diptych 180 x 150 cm
Private collection, London

Untitled, 2008
Acrylic and mirror on printed board
100 x 130 cm
© Samira Alikhanzadeh
Courtesy of Samira Alikhanzadeh and
the Assar Art Gallery, Tehran

Samira Alikhanzadeh

above
From the 'NS book' series, 2008
Digital print on paper and gold stamp on fabric
29.7 x 21 cm
© Nazgol Ansarinia
Courtesy of Nazgol Ansarinia

opposite
Patterns, 2008
Ink drawing and digital print on
semi-transparent paper
30 x 40 cm
© Nazgol Ansarinia
Courtesy of Nazgol Ansarinia

When discussing the cutting edge of contemporary Iranian art, one name that frequently comes up is that of Nazgol Ansarinia. Working across a variety of media, from photography to video to drawing, her works often focus on everyday objects and their relationship to the larger social context. Most distinctive of all have been her recent works that play with traditional carpet motifs, where the apparently decorative surface hides layers of meaning.

Ansarinia was born in Tehran in 1979, the same year as the Islamic Revolution. After graduating from the London College of Communication she went to the California College of the Arts (CCA) in San Francisco, where she completed a Master of Fine Arts in 2003. She then returned to Tehran where she has chosen to live and work: 'It is important for me to work in my own environment and in my own country,' she says.

Though relatively young, Ansarinia is already beginning to receive international recognition.

Just recently it was announced that she was one of three recipients of the prestigious Abraaj Capital Art Prize, one of the most valuable in the world. Perhaps aware of the current hype surrounding Iranian art, however, she says: 'I'm not interested in being famous fast...I'd like to take my time to become or rich or recognized.'

A common tension in Iranian artistic practice is that between making art and making a statement. Ansarinia, however, sees things from a different perspective: 'Whatever you write or create is a form of statement. My work is always focused on the environment that I live in, portraying very ordinary, everyday life. And my position within that context...the things that I relate to, that intrigue me. I'm a deconstructionist who reconstructs the torn-apart elements that show something new about something so banal that has gone unnoticed. So repetitive that it becomes a part of routine life.'

'As to art being a statement, I don't know what the definition of art is...is there a fixed definition? Art in every form is a reinterpretation of our surroundings, and our lives...our experiences.'

Working in Tehran and exhibiting and selling in the West opens up an interesting question about what art means to different cultures. Ansarinia is well aware of the schism, stating that 'what is accepted as art in the Western experience would not be considered as art in a different environment' – not automatically, at least. Does this mean, then, that her art, though produced in Iran, is made for export only? 'No, I wouldn't say that. If I were to speak in particular about one of my earlier works, a collection of verbs redrawn from the colourful calligraphic writings on walls in Iran, which is three-dimensional and colourful and not graffiti; this is not a work I'd show in a Western context. It's a kind of work that needs to live in Tehran...to be seen in its own context...in order for it to be understood and appreciated.'

Many artists and critics fear the corrupting influence of the money now pouring into Iranian art from collectors, but Ansarinia takes a fairly balanced view of it. 'The big money in Iranian art is both positive and negative. Positive, in the sense that Iranian artists can have self-respect, and make a decent living. Negative, in the other sense that [artists] become repetitive and self-limiting. Plus, it's become almost a competition between artists in who sells more, and the most expensively.'

'The challenging environment in Iran is actually what may be inspiring the [art] work. If you're looking to make a living or to succeed in art you basically know you're on your own,' Ansarinia suggests. 'The rising interest and the money in Iranian art is therefore a great help.'

Ansarinia says that her work is very much process-based. 'I never know in advance the medium or the result,' she says. 'It all depends on how it develops as I research and create visual materials around it. When I see the finished work, I look at it as [part of a continuum] in the longer time frame...every piece helps me direct my work to the next level.'

Ansarinia has chosen to work in Iran, which many artists would find very challenging. 'I did

a residency in Italy and that was the hardest environment to start a project in. It was a stark contrast coming from Iran. There was a lot of talk about art as a way for social change. In such a calm and nice environment to speak about changing the world seemed too easy to me. People saw me as a pessimist, I think. Even though I have lived and travelled the world, it was hard for me to adapt to that environment. With all the complicated problems and issues in the world, at the time I found that kind of optimism almost naive.... My work is not informed by pessimism, but to speak about art as this extremely powerful tool for social change...is not what I believe in.'

above and right
Patterns, 2008
Digital drawings and ink on paper
43 x 32 cm
© Nazgol Ansarinia
Courtesy of Nazgol Ansarinia

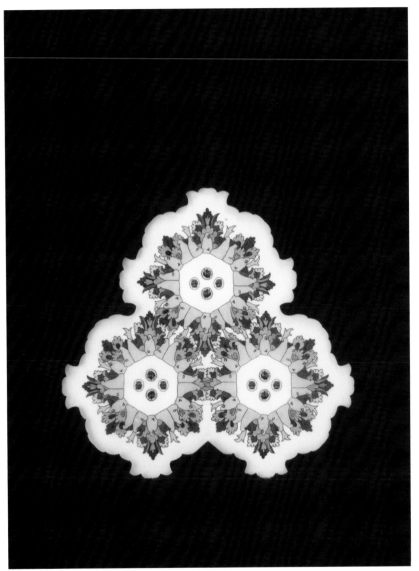

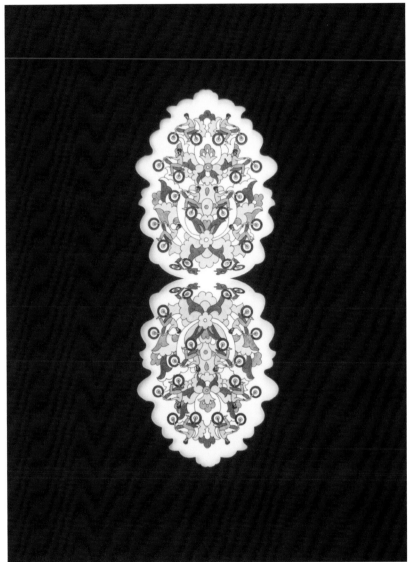

above and left
Patterns, 2008
Ink drawing and digital print on
semi-transparent paper, laser-cut velvet
30 x 40 cm
© Nazgol Ansarinia
Courtesy of Nazgol Ansarinia

The photographer Haleh Anvari was born in Tehran in 1962, and was sent to boarding school in the United Kingdom, before going on to study Politics and Philosophy. She returned to Iran in 1992, and later taught herself how to take photographs.

In recent years Anvari has become well known for her depictions of women in brightly coloured chador, which contradict the typical Western image of Iranian women clad head to toe in black. She has also conveyed this through a performance piece, *Power of a Cliché*, which she has performed around the world. Anvari herself has respect for the chador, but says: 'In Islam, they say that women should have an eye on decency, but I don't see why, first, decency has to be exclusive to the female of the population and, second, why it has to be black.'

above top row
From the 'Chador-dadar' series, 2006
Photograph, Dubai
© Haleh Anvari
Courtesy of Haleh Anvari

From the 'Chador-dadar' series, 2006
Photograph, India, Amber Fort
© Haleh Anvari
Courtesy of Haleh Anvari

From the 'Chador-dadar' series, 2006
Photograph, London, Big Ben
© Haleh Anvari
Courtesy of Haleh Anvari

From the 'Chadornama' series 2, 2005
Photograph, Iran
© Haleh Anvari
Courtesy of Haleh Anvari

above bottom row
From the 'Chador-dadar' series, 2006
Photograph, Paris, The Louvre
© Haleh Anvari
Courtesy of Haleh Anvari

From the 'Chadornama' series 1, 2005
Photograph, Iran
© Haleh Anvari
Courtesy of Haleh Anvari

Boland ghamat-tarin
koh dar tariki shab gom nakhahad shod, 2008
Acrylic on canvas,
120 x 150 cm
© Shaqayeq Arabi
Courtesy of Shaqayeq Arabi

Shaqayeq Arabi is a painter, sculptor and
installation artist with a career already
stretching back over twenty years. Born in
Tehran, she studied traditional Persian painting
in the early 1990s, and then trained in graphic
design at the Alzahra University in Tehran; she
later moved to Paris, where she studied at the
Sorbonne, earning a Master of Fine Arts in 2003.
Today Arabi has a studio in Dubai.

Arabi's paintings are resolutely abstract,
but nonetheless animated. For her, they are a
form of spontaneous personal expression, an
inward journey, a record of her feelings and
emotions. Colour is critical to the compositions,
which are built up in layers. Arabi also takes
photographs with similar abstract qualities, and
has produced both sculptural installations and
more conventional sculpture using plastics.

Shaqayeq Arabi

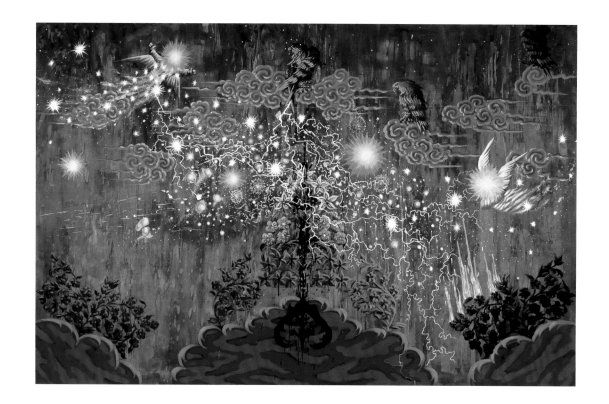

Kamrooz Aram was born in Shiraz, Iran, in 1978, just one year before the Islamic Revolution. His family moved to the United States when he was eight years old, where he trained as an artist, first at the Maryland Institute in Baltimore, and then at Columbia University in New York.

His paintings are often executed in vibrant, psychedelic colours, combining imagery from a variety of sources, both Eastern and Western, ancient and contemporary. Stylized clouds, lifted from Persian miniatures, drift by on night-vision green skies, while perfectly formed flowers derived from Persian carpet patterns grow from a camouflage-patterned earth beneath. While some canvases appear almost abstract, in others the space is occupied by birds or what appear to be angelic beings.

Aram also produces delicate pen drawings that combine portraits with beautiful, swirling organic and geometric forms. These smaller works feature both anonymous and specific popular figures that might fit various cultural,

political and religious persuasions. For example, in one drawing he places a Mullah face to face with a black nationalist, the turban of the first mirrored in the Afro hairstyle of the second. As in his paintings, Aram is comfortable appropriating imagery from a variety of resources.

Theoretically, Aram has been strongly influenced by Edward Said's landmark book, *Orientalism*. At university he found it problematic that 'especially among students, it was common to take advantage of the exotic elements of Eastern cultures as seen through Western eyes, resulting in a sort of self-Orientalization' – and it was this that he set out to work against. Though Aram says that he has never been interested in 'identity politics', neither did he want to produce completely apolitical art. His art may obliquely address the issue of the 'other', but Aram also stresses that it has no 'correct' reading – as he explains: 'People get hung up on symbols and signifiers, and the challenge for me is to provide material for a multitude of readings.'

top left
Mystical Visions Undetected by Night Vision Strengthen the Faith of the Believers and Make their Enemies Scatter Part II, 2007
Oil and stickers on canvas
185.4 x 287 cm
© Kamrooz Aram
Courtesy of Kamrooz Aram and
Perry Rubenstein Gallery, New York
Photographer Jason Mandella

above
From the 'Mystical Visions and Cosmic Vibrations' series, 2009
Ink on paper
76.8 x 92.1 cm
© Kamrooz Aram
Courtesy of Kamrooz Aram and
Perry Rubenstein Gallery, New York
Photographer Jason Mandella

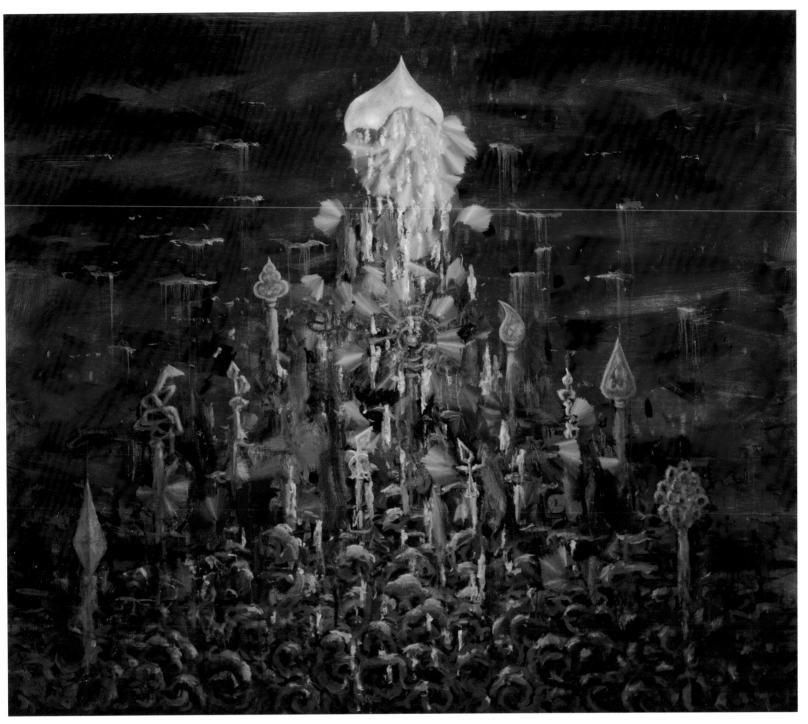

Rally at the Gates, 2008
Oil on canvas
182.9 x 213.4 cm
© Kamrooz Aram
Courtesy of Kamrooz Aram and
Perry Rubenstein Gallery, New York
Photographer Jason Mandella

above
Everything Scatter, 2008
Oil on canvas
182.9 x 213.4 cm
© Kamrooz Aram
Courtesy of Kamrooz Aram and
Perry Rubenstein Gallery, New York
Photographer Jason Mandella

right
Blazing Glory II, 2008
Oil on canvas
213.4 x 213.4 cm
© Kamrooz Aram
Courtesy of Kamrooz Aram and
Perry Rubenstein Gallery, New York
Photographer Jason Mandella

Kamrooz Aram

The Pinnacle of Pride and Inherited Glory, 2008
Oil and collage on canvas
152.4 x 213.4 cm
© Kamrooz Aram
Courtesy of Kamrooz Aram and
Perry Rubenstein Gallery, New York
Photographer Jason Mandella

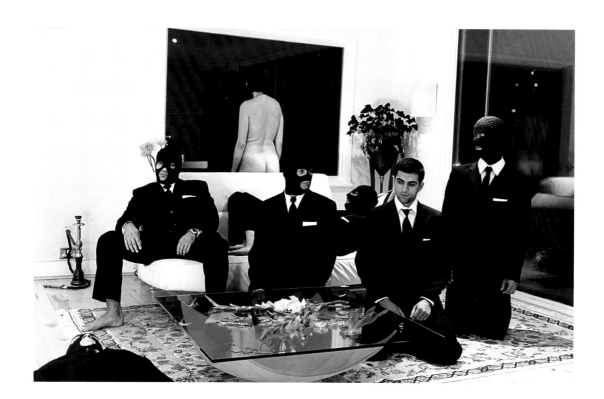

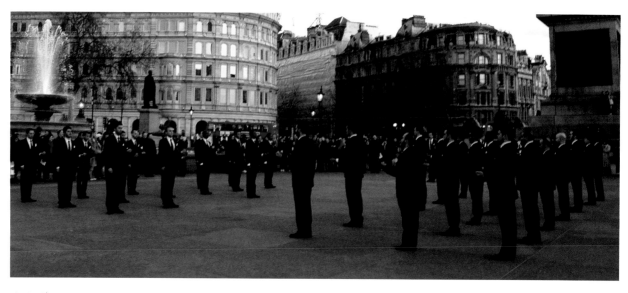

Born in southwestern Iran in 1968, Reza Aramesh moved to the United Kingdom aged sixteen. Though he had originally intended to travel on to New York, he ended up staying in London, where he went on to study Fine Art at the prestigious Goldsmiths College; today he remains based in the city. He has shown internationally, from Israel to Beijing, and has also had work commissioned by the Barbican Art Gallery in London and the 2008 Zoo Art Fair.

Aramesh says of his art that, 'I am interested in poetic and political compositions that can be realized in a diverse range of media, including performance, installations, video, photography and work on paper.' Using this wide range of media, as well as a regular published scrapbook called *Centrefold*, Aramesh explores the themes of identity, politics, religion and morality.

His photography, in particular, is heavily influenced by film and photographic history. One recent photographic series, for example, 'Between the eye and the object falls the shadow' (which was inspired by Goya's 'Disasters of War'), used migrants to recreate well-known scenes from recent conflicts in the context of stately homes in the English countryside. Thus we find re-enactments of a photograph from the first Gulf War of an Egyptian soldier guarding Iraqi prisoners. Other work has similarly used amateur or semi-professional actors to recreate scenes, as well as referencing the work of iconic photographers such as Robert Mapplethorpe.

Aramesh uses his art to explore his identity and his origins. His works are populated with balaclava-wearing 'terrorists' in incongruous situations, or Asian men in pinstripe suits and masks. In fact masks appear very frequently in Aramesh's art. However, while such works clearly refer to Western unease at the 'other', Aramesh has said that they are also a 'critique of the Iranian middle-class aspiration to an idealized notion of Western culture.' This dark joke cuts both ways.

top
Action 09. The Eternal Spring, 2004
C-type print mounted on aluminium
124 x 183 cm
© Reza Aramesh
Courtesy of Reza Aramesh

above
I am a Believer, 2006
C-type print mounted on aluminium
© Reza Aramesh
Courtesy of Reza Aramesh

above
Action 52. An Egyptian soldier guards Iraqi prisoners in the Kuwaiti desert, August 2, 1990, 2008
From the series 'Between the eye and the object falls the shadow'
Silver gelatine print mounted on aluminium
124 x 157 cm
© Reza Aramesh
Courtesy of Reza Aramesh

left
Action 28. You were the dead, theirs was the future... Homage to Robert Mapplethorpe, 2007
C-type print mounted on aluminium
124 x 153 cm
© Reza Aramesh
Courtesy of Reza Aramesh

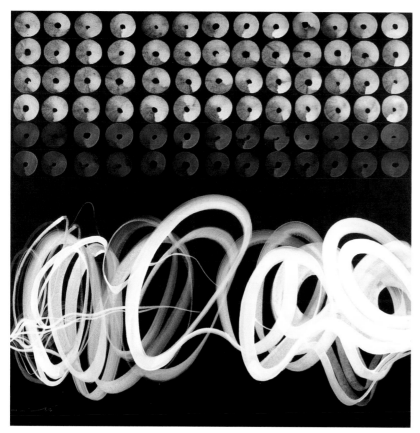

Born in Tehran in 1971, Pooya Aryanpour studied at the Azad University, Tehran, graduating with a Masters degree in 1999. He has had solo shows in Sweden and Iran (at the Golestan Gallery), and has participated in group shows internationally.

First and foremost a painter, Aryanpour employs modified forms of Persian letters; by actively transforming their meaning, he creates a type of abstract, conceptual calligraphy, symbolic in nature. Repetitive marks are juxtaposed against long flowing lines, creating compositions that hint at writing; the white forms are set against dark backgrounds of purples, blues and blacks, creating a sense of suspense and drama. Aryanpour himself calls these creations 'accidental events'.

above left
Untitled, 2008
Acrylic on canvas
150 x 150 cm
Private collection, London

above
Untitled, 2007
Acrylic on canvas
150 x 150 cm
Private collection, London

above
Untitled, 2008
Acrylic on canvas
150 x 200 cm
Private collection, London

left
Untitled, 2007
Acrylic on canvas
180 x 250 cm
Private collection, London

Pooya Aryanpour

Sara Arianpour was born in 1980 and grew up in Tehran. Her mother, who was also a painter, inspired in her a love of art from an early age. Arianpour studied graphic design as well as fine arts, and then went on to study painting at Soureh University. Today she is a member of the Iranian Society of Painters, and has exhibited at various galleries in Tehran.

Arianpour's paintings and drawings are dramatic and often disturbing. Slightly reminiscent of Francis Bacon, she shows heads that often appear to be contorted – perhaps in pain, perhaps in anger. The heavily worked surface blurs outlines and the figures merge with the dark, shadowy ground.

Untitled, 2008
Acrylic on canvas
160 x 95 cm
© Sara Arianpour
Courtesy of Sara Arianpour

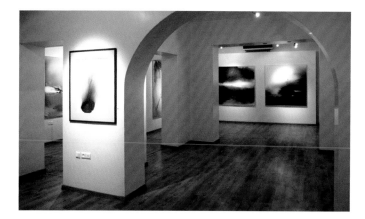

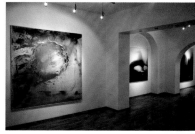

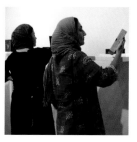

The Assar Art Gallery in Tehran was founded on 27 October, 1999, 75 years to the day after the birth of Hossein Kazemi, one of Iran's most prominent modern art pioneers. The gallery specializes in all areas of contemporary visual arts, from photography to paintings and sculpture, counting among its artists some of the best-known names in the region, such as Sadegh Tirafkan, Ali Reza Adambakan and Mohammad Hossein Emad, among many others. Its innovative shows ensured that it soon became a principal player in the Iranian contemporary art scene.

The gallery was founded by architects Hamid Agah and Anoushiravan Soltan Attar and managed and curated by Omid Tehrani. Of course, setting up a gallery is not an easy business, and several of the founders' family members were dragged in to help. The building

used was provided by Maryam Keyhan. Like many of Tehran's galleries, it is not especially large, with three spaces for shows, but the intimate scale brings visitors close to the art. The first exhibition was a group show, and since then collective shows have been a strong feature of the gallery, each one offering a snapshot of the latest developments in local art.

It is Tehrani who is responsible for selecting interesting artists whose work they can exhibit. Tehrani himself studied for degrees in Painting and Industrial Design, at Tehran University, but decided early in his career that he would be better off servicing the art market than making art. 'I wasn't that good really,' he says.

Tehrani's first encounter with art was as an assistant to a dealer located near his university; he soon found a connection between his studies and his chosen career. 'I gathered artworks from

my teachers – who included such luminaries of Iranian modern art as [Ayedin] Aghdashloo and [Mohammad] Ehsai – and we organized a sell-out show.' The Iran–Iraq War had just ended and people were beginning to take a fresh interest in art as the country recovered.

Tehrani is a cultural realist, understanding the limits of what can be achieved under the difficult conditions imposed by the Iranian authorities. 'Even though the art movement declined during those dark war years,' Tehrani recounts, 'there were still people operating in small groups. There have always been certain key people who have moved the art movement in Iran and others tend to follow them.'

Tehrani may be a practical man, but he is still moved every time he visits an artist's studio and discovers new work or young talent. 'We then translate this new art, these new visions,

into money by putting together shows,' he explains. 'It keeps all of us alive...and keeps me vital.' Tehrani claims he never gives up on a potentially talented artist, however long it takes: 'We work on talent until the artist is "discovered".' After the gallery's second group show the team running the gallery realized that the most important thing in each artist was a 'love of the arts', and since then this has been their driving motivation.

'Art dealers,' Tehrani claims, 'are a little like film directors.' Always behind the scenes, moving pieces around, quietly setting up the frames and bringing together all the different elements that help a successful artist to finally break through.

Born in Tehran in 1979, Madjid Asgari began taking photographs when he was just fourteen, influenced by the films of Andrei Tarkovsky. He then studied for a degree in Graphic Design from the Azad University in Tehran.

Fascinated by process, Asgari often prints his photographs onto aluminium, to give a cold, clinical feel (as well as to reflect the viewer).

Time spent in hospital as a child influenced the first aluminium series, 'Code 99', and in fact many of his photographs since then have aimed to capture the fluorescent light and antiseptic atmosphere of hospitals. The other two important themes running through Asgari's work are death (as can be seen in 'The Empty', 2008), and nostalgia.

Madjid Asgari

Resuscitation, 2007
Digital photography printed on aluminum
(8 panels)
© Madjid Asgari
Courtesy of Madjid Asgari

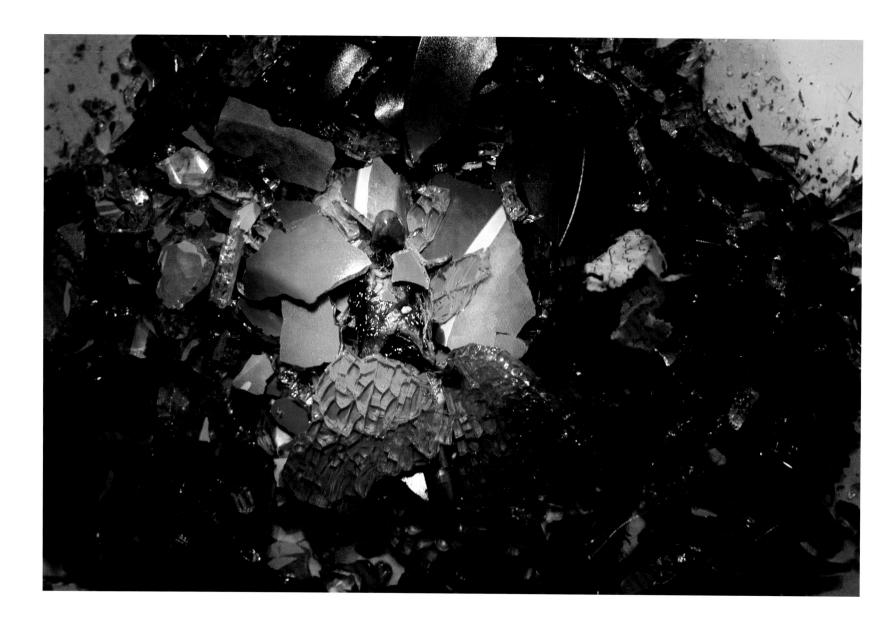

Born in Tehran in 1980, Mehraneh Atashi studied photography at Tehran University. Today she is internationally recognized as one of Iran's best young photographers, and she has exhibited her work very widely, both in Tehran and internationally.

Atashi has a reputation for capturing in photographs the other side of Iranian daily life. Earlier photographs attempted to show the hidden face of modern Iranian life, especially searching out and documenting Tehran's youth culture. An even more groundbreaking series from 2004 documented the interior of a *Zourkhaneh* ('house of strength'), a type of gym for Iranian men that would normally be completely off limits for women. In this series she used mirrors to ensure that she, too, was in each shot – a quietly subversive statement.

This quiet subversion continued the following year in a series of self-portraits in which only her feet appear, along with other items from her life, such as photographs of other people. Since then she has worked on more abstract photography, of paint on windows and graffiti.

Atashi has in the past expressed frustration at the way in which Westerners view Iran and its politics. She herself tries to avoid questions of politics directly, and prefers people simply to look at her work.

Self Portrait, 2006
Digital print
70 x 100 cm
Edition of 7
© Mehraneh Atashi
Courtesy of Mehraneh Atashi
and Khastou Gallery, Los Angeles

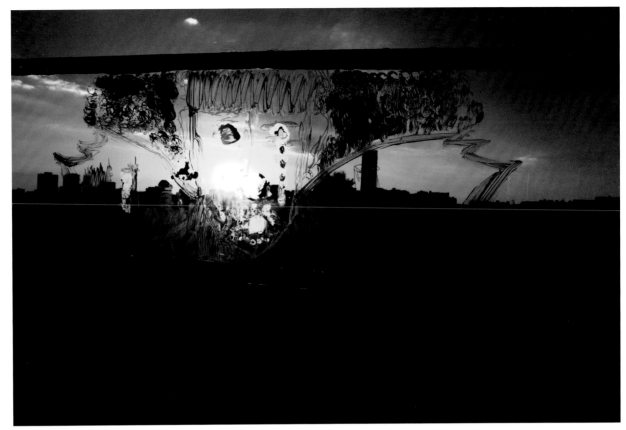

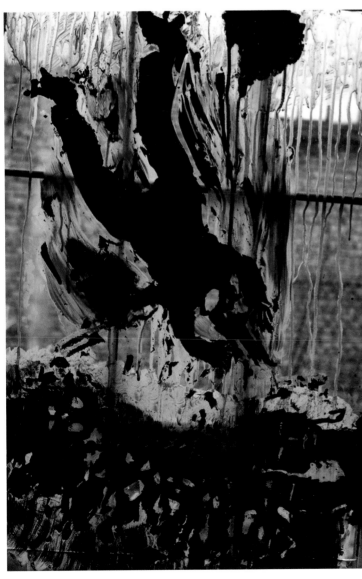

above
21st-century shield, 2008
Digital print on handmade paper
80 x 120 cm
Edition of 5
© Mehraneh Atashi
Courtesy of Mehraneh Atashi
and Khastou Gallery, Los Angeles

left
1386 Solar Hegira, 2008
C-type photographic print
80 x 120 cm
Edition of 7
© Mehraneh Atashi
Courtesy of Mehraneh Atashi
and Khastou Gallery, Los Angeles

Mehraneh Atashi

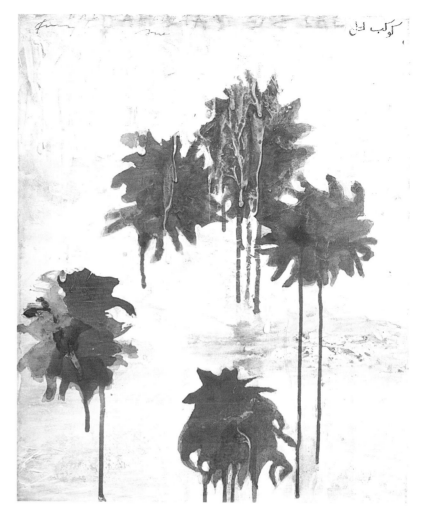

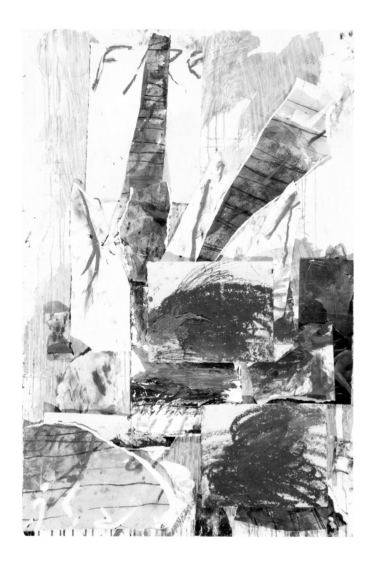

above
Lal Dahlia, 2007
Mixed media on canvas
100 x 50 cm
© Fereydoun Ave
Courtesy of Fereydoun Ave

left
Fire, 2007
Mixed media and collage
on paper
109 x 74 cm
© Fereydoun Ave
Courtesy of Fereydoun Ave

Painter, designer, curator, gallery owner, impresario, collector and installation artist, Fereydoun Ave has been a singularly important voice in the contemporary Iranian art world for almost forty years. An emphatic man, his opinions are expressed forcefully: 'I'm an artist. I'm a gallery owner. That's it, period! The gallery thing developed because I was an artist. I wanted to do it right and there wasn't anyone doing it right in Iran in 1970.'

Ave, who is of Zoroastrian origin [an ancient Persian religion that pre-dates Islam], was born into a relatively wealthy landowning family in Iran. His parents were free-spirited and culture played an important role in their lives. At age eight Ave was sent to boarding school in England for a Western education. Later, he received a scholarship to attend the Royal College of Art in London in 1964, but subsequently went to Arizona State University to study agriculture. Fortunately for him Frank

Lloyd Wright had founded an architecture department at the college and instead of digging up tubers in the Arizona desert, Ave concentrated on the applied arts of the theatre and film.

Tired of the American West, Ave then moved to New York, into the cultural maelstrom of the 1960s, before setting off yet again on a ship travelling around the world. He spent a year at sea, exploring life and art: 'No school teaches you the stuff I saw...you learn more by seeing and tasting and feeling when you travel than any textbook can provide. When you actually experience different cultures and see contrary aesthetics, you existentially learn with your whole being.' Back in New York he enrolled at university, where he was taught film and art by Martin Scorsese and Andy Warhol. Then, in 1970, Ave finally returned to Iran, where he became a set and costume designer. His first job was with the Iran-America Society, housed,

coincidentally, in a building designed by Frank Lloyd Wright.

Ave claims that he always knew he would be an artist: 'When someone says to me "I want to be an artist", I reply that you're either are an artist, or you're not...there are no two ways about it.' But he does concede that the creative arts were a blur for him early in his career. 'Art was music, art was dance...it was films and fashion...it was everything. The boundaries of art were blurring towards the latter part of the last century, and were sometimes difficult to distinguish.'

For Ave, Iran in the late 1960s and 1970s was a place of incredible cultural activity: 'We were doing so much...there was so much to do to catch up for centuries of cultural neglect. I look at Dubai today and remember Tehran's boom days in the 1970s when the Queen [Farah Pahlavi] was trying to make Iran a forum for the arts not just locally, but internationally.' Ave

himself reflects this internationalism: 'Art is international.... Travel the world and you can see the sameness of some of the important art movements.' He is also sure of the importance of the artist in society: 'Artists are society's antennae. They catch cultural vibrations before any politician can. Politics can stifle art, or it can encourage it, and history has shown that whenever the former course is enforced, societies tend to unravel and empires collapse.'

For Ave, courage and confidence come from feeling a sacred sense of self. 'I believe in the power of the individual...I believe in the holiness of each person,' he explains. 'This is the very core and source of creativity. This is what an artist is all about.' He does not believe that religion or nationality should inform art: 'The whole point is to liberate yourself from these labels! The 21st century is about awareness. When you become aware of everything, you become everything and you become the

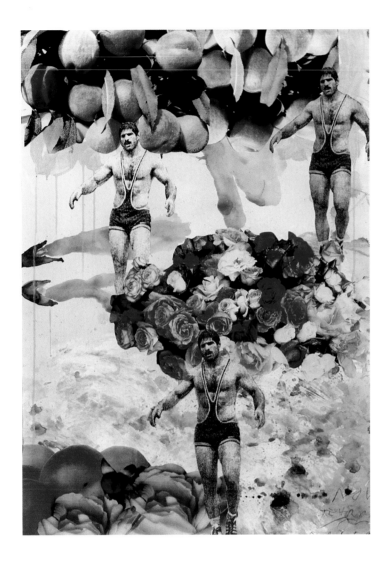

awareness.' Ave says that he did not begin to feel 'Zoroastrian' until after the Islamic Revolution. 'I felt Iranian, just like the Jews or Armenians or any of the other minorities that together made the Persian whole.'

Aside from his discussions of aesthetics and historicisms, Ave has a very practical side to him that helped him grow within the Iranian contemporary art scene. He is also frank about the importance of money: 'Money is the lubricant that brings time and space together and makes things exciting,' he argues. 'Art is like the ingredient that keeps a great soufflé from collapsing.... It's about vision and patronage. Vision with no money can't work, and money without vision is a disaster.'

above
Rostam in Late Summer, 2000
Mixed media and collage
on paper
99 x 73 cm
© Fereydoun Ave
Courtesy of Fereydoun Ave

right
Endangered Species, 2003
Inkjet print on paper
100 x 50 cm
© Fereydoun Ave
Courtesy of Fereydoun Ave

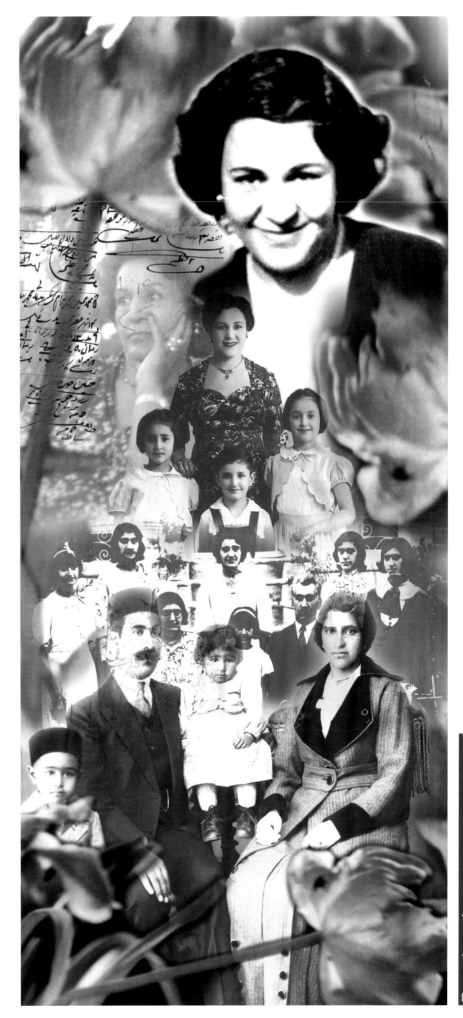

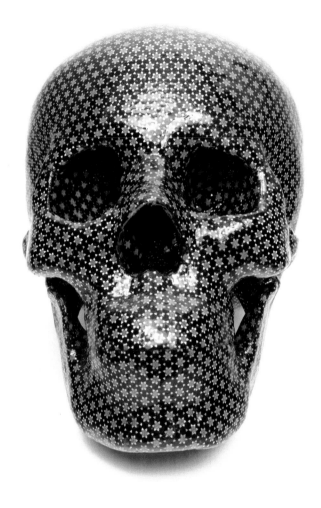

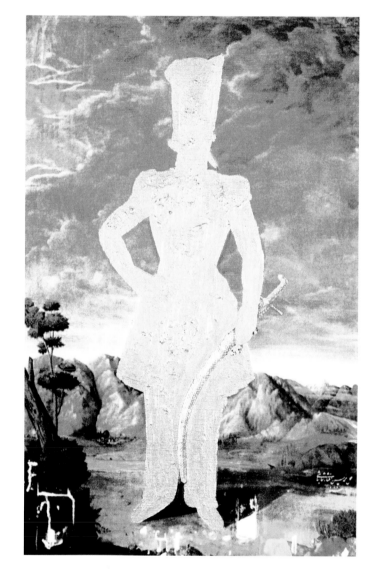

Born in 1974 in New York City to Iranian parents, Andisheh Avini studied at Hunter College in the same city and continues to live and work there. Although not born in Iran, Avini has remained close to his Persian roots, reading Farsi and making frequent trips to the country. Perhaps for this reason his work deals with the twin themes of identity and anonymity.

Anonymity was specifically addressed in some of Avini's earlier works, which included silhouettes and anonymous portraits; these were followed by a series of calligraphic works, that often used unconventional materials such as sheep's blood (standing for sacrifice). Other more recent works include gradual dissections of the human body, peeling away the layers – a direction that culminated in a series of sculpted skulls delicately decorated in traditional Persian patterns.

above
Untitled Skull, 2006
Plastic skull and marquetry (*Khatam*)
15.2 x 22.9 x 12.7 cm
© Andisheh Avini
Courtesy of Andisheh Avini
and I-20 Gallery, New York

right
Untitled, 2006
Bleach, gold leaf and inkjet print on canvas
© Andisheh Avini
Courtesy of Andisheh Avini
and I-20 Gallery, New York

Rozita Sharafjahan has survived cancer, revolution, prohibition from practising her profession, and proscription by the Iranian authorities from producing art. All of this in half a lifetime. Yet she can still lay claim to playing a leading role in having brought artistic change to contemporary Iran. 'We essentially restored the developmental process in the arts that came to a stop with the Islamic Revolution of 1979,' she says.

Founder of Tehran's Tarahan Azad ('Free Design') Gallery, Sharafjahan is not shy of bold statements: 'Yes, we have been pioneers in the contemporary Iranian art movement, as galleries that came before us, and those who have sprung up like spring flowers in the past few years, have concentrated on the buying and selling of art, without much expertise.'

Azad Art Gallery is a loose grouping of intellectuals and artists who first set up shop in 1999 with the objective of bringing together like-minded creatives in a 'thought exchange'. This brought new thinking to the practice of art and created the possibility for local artists to be exposed to more critical appraisal and feedback, counteracting some of the stultifying conformity imposed by the regime. Iran's first truly underground artistic centre, Azad has breached local taboos around art and culture,

and constantly pushed the artistic envelope.

Sharafjahan, whose name means 'noble of this world', was born in Tehran in 1962 and studied sculpture at Tehran University. Her graduation coincided with the Islamic Revolution, which viewed sculpture in a poor light and forced Sharafjahan to switch to the more religiously acceptable painting. Since obtaining her Masters from Tehran University, she has focused her energies on research, all the while searching out and fostering young talent in the arts.

Sharafjahan describes the Azad Gallery as a centre of experience. 'We began to be drawn to new mediums like video and audio art, photography, installation and performance art...all of which were relatively new to the Iranian public. We focused on new art, instead of just trying to promote artists to sell their works.' Sharafjahan readily admits that Azad lacks business sense and marketing expertise, and that its survival is dependent on the artists themselves.

During the reforming years of Mohammad Khatami's presidency, organizations such as Azad received some government support, but all that changed with the election of President Mahmoud Ahmadinejad. Sharafjahan doesn't mince her words: 'We all know what the political

climate in Iran is like, but things are layered in subtle ways and there is a vibrant underground cultural movement spreading in the country.'

Nevertheless, things have recently changed with the authorities clamping down on the freedom of galleries and artists. Sharafjahan attributes this change in attitudes to the international noise created by high-price auctions and sales of Iranian artworks outside the country. But more importantly, there is the question of the struggle for the soul of Iran's post-Revolution generation, who make up two thirds of the exploding population.

Sharafjahan reminds us that until quite recently, Islamic Iran was a very closed-off society with certain reactionary elements in power wanting to ensure conformity in thought and action. 'They haven't had much luck!' Sharafjahan smiles. 'If we compare ourselves to other countries, our artists have moved very rapidly in the last ten to fifteen years and can now be seen in the vanguard of progressive movements across the global art world.... If we have been able to overcome all the obstacles and problems placed before us,' she continues, 'we have been able to create a new movement, a ferment, from inside Iran.'

Azad is busy with its multifarious schemes promoting Iranian art and culture by any means available. 'We put on shows, readings, performances...we publish books and tracts, anything to help introduce people to the arts.' Sharafjahan would like to do more, but parallel government institutions and organizations monopolize the cultural arena for reasons of politics, economics and social control. 'We have to separate art from the galleries and place artworks outdoors where the public has more access to them and they can reach a larger audience.'

Are people like Sharafjahan beating their heads against a brick wall? 'That's been the story of my life,' she replies smiling. 'If I didn't do what I do I would feel empty, redundant. There is no financial dimension to what we do here, and I'm not a businesswoman anyway. In a way, its my small contribution to society.'

Sharafjahan continues: 'It's the protest element in art which has attracted me ever since I was a small girl. I couldn't fit into the normal school system, so I went to art school instead. It's the anger...it's self-expression. For some, it is self-aggrandizement. For me it is my life.'

Shoja Azari is a man of few words, preferring to let his art speak for him. Born in Shiraz, Iran, in 1958, Azari left home in 1977 to attend college in New York. He then returned to Iran in 1979 to the excitement of the Islamic Revolution, only to leave his country for good in 1983 after falling foul of the new orthodoxy.

Originally a filmmaker, Azari's relationship with his long-term partner, Shirin Neshat, has gradually turned him to video art. Since 2006 Azari has been working on some revolutionary concepts of his own, creating a new art form through the projection of looped video onto paintings, thus animating the static artwork.

A good example of this technique is his 'Silence' series (2007–2008). Based on Claude Monet's studies of seasonal effects, these 'video paintings' bring nature's colours to life, with reflections upon shimmering water projected onto the canvas. 'These are exact mirror images painted hyper-realistically,' Azari explains. 'They're a new "moving painting", which Shahram Karimi (Azari's long-time friend and collaborator) paints and I make the video to project onto the work, thus creating this eerie effect.'

The collaborators are presently involved in creating another series of works entitled 'Oil Paintings', a play on words that crosses the geopolitics of petroleum with the artist's medium. These 'moving' paintings and video projections depict scenes from the 1991 Gulf War and Saddam Hussein's firing of Kuwait's oil wells.

'The really interesting aspect of these works is the very close collaboration between Shahram and myself, and between Shirin and me,' Azari explains. 'Painters have always wanted to bring real light into play...to find ways to connect light to pigment. I think we may be on to something here.'

Azari has been interested in art since childhood. 'We used to make "wall newspapers" in eighth grade and paste them up on the school walls, but that was quickly forbidden and at the age of fourteen we had to go underground,' he recalls. 'We developed political consciousness at an early stage, diving into books, art and theatre...exploring cultures. But the roots were all innocent.'

Azari believes that the present 'ferment' (as he calls it) surrounding Iranian art has everything to do with the extraordinary development of higher education in Iran during the past few decades. 'In pre-revolutionary Iran we used to have dozens of graduates every year in fine arts and graphics,' Azari remarks. 'Now there are hundreds streaming into the market every year with very little to do and a lot of opportunity to make cultural waves, or mischief. It's a niche, a little corner for free expression.'

'The "metropolitization" of Iran is also an important factor,' Azari continues. 'Massive urbanization and the eradication of illiteracy to a greater degree than ever before have created forces which have yet to play themselves out.' He believes that Iran has always played a pivotal cultural and political role in the wider region. 'Iran has always been the engine, the fire, in every sense...what you see in art, you will also see in politics.'

Azari attributes the new wave of ferment to both local and international developments, not

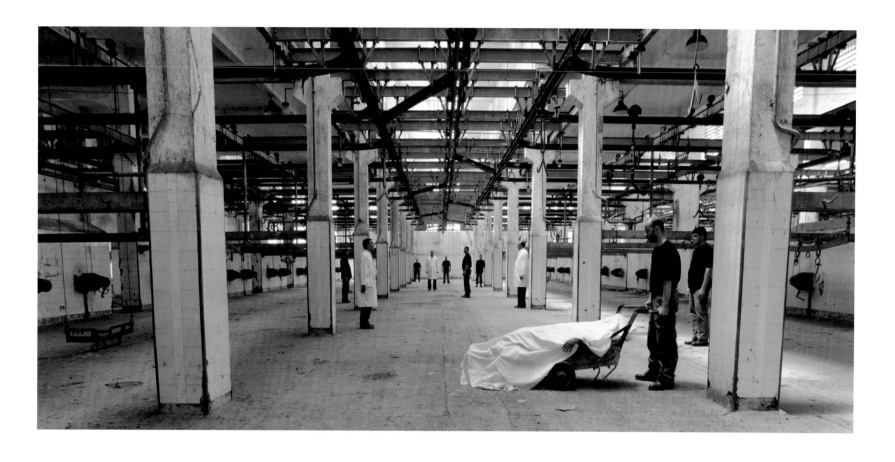

least the exponential rise of global interest in the arts. 'When I was a student the museums were mostly empty. Look at them now!'

Yet despite this, he is somewhat critical of the 'monetization' of art and its effect on the contemporary Iranian art scene. 'The recent prices at auction [for Iranian art] are almost killing the pristine spirit of the art,' Azari complains. 'The art is transformed as there is a mad scramble to try to grab a piece of the pie. It's really sad, almost a circus. The same thing happened to the once-thriving Iranian cinema movement, which is now seriously dead. New filmmakers are just trying to copy the original wave, making films for Western reaction rather than home audiences.'

above
Untitled from the 'Odyssee' series, 2008
Digital C-print
75.5 x 159 cm
Edition of 5
© Shoja Azari
Courtesy of Shoja Azari

left
Stills from the film 'K'
© Shoja Azari
Courtesy of Shoja Azari

opposite
Untitled from the 'Odyssee' series, 2008
Digital C-print
105.5 x 133.5 cm
Edition of 5
© Shoja Azari
Courtesy of Shoja Azari

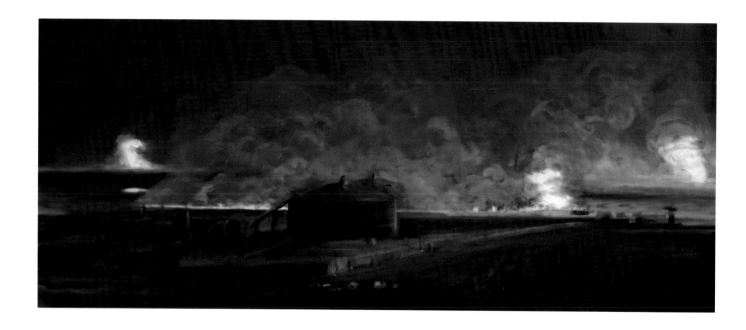

Shoja Azari and Shahram Karimi
From the 'Oil Painting' series, 2008
Acrylic on canvas with video projection,
projector and DVD player
152.5 x 241.5 cm
Edition of 5
© Shoja Azari and Shahram Karimi
Courtesy of Shoja Azari, Shahram Karimi
and LTMH Gallery, New York

Shoja Azari and Shahram Karimi
clockwise from top left
Spring, Summer
Autumn, Winter
From the 'Silence' series, 2007–2008
Acrylic on canvas with video projection,
projector with DVD player
© Shoja Azari and Shahram Karimi
Courtesy of Shoja Azari, Shahram Karimi
and LTMH Gallery, New York

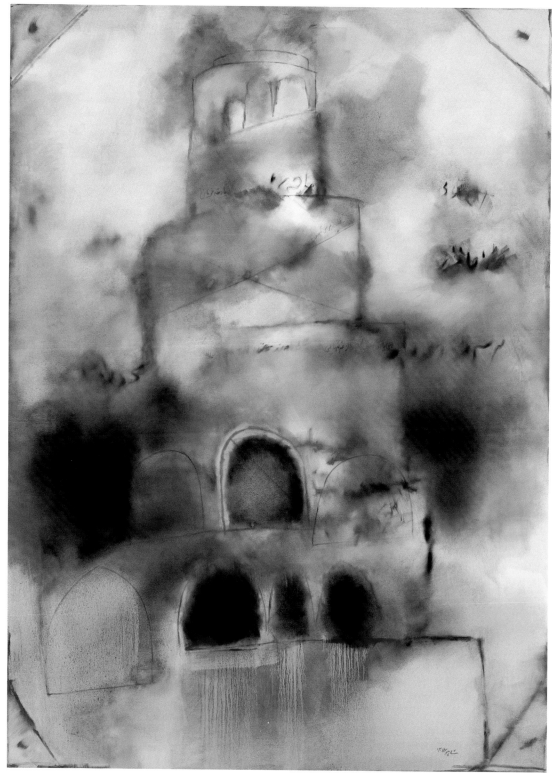

Untitled, 2008
Oil on canvas
190 x 140 cm
Private collection, London

Born in 1979 in Marivan, Iran, Shahoo Babai took his degree in painting in Tehran. Since then he has become a member of the Iranian Society of Painters, and has exhibited widely in Iran, as well as in group shows in the United Kingdom and China.

While Babai's works are sometimes given concrete names, the subject is often difficult to discern: some show towers reminiscent of archaeological and historical remains found in the region, while others show forms that could be windows or doorways. One motif with particular significance is the Tower of Samarra, a 9th-century spiral minaret in Iraq that Babai uses to explore issues of cultural vulnerability and memory.

However, on other occasions the paintings dissolve into almost total abstraction, a mass of blotches that bleed into one another. The common thread running throughout his works is the distinctive palette of earthy or washed-out tones.

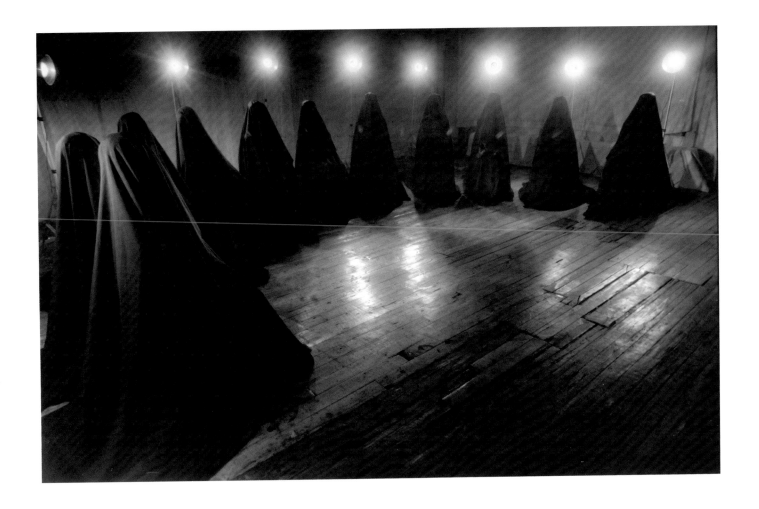

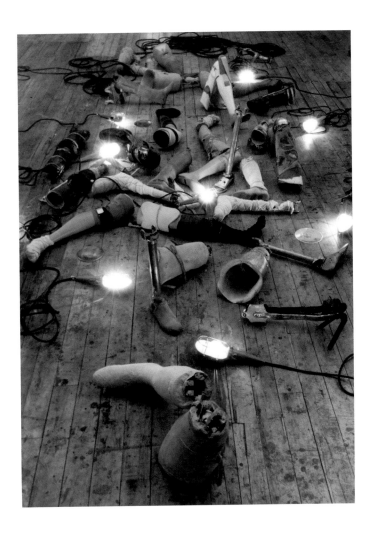

Born in Iran in 1942, though of Armenian origins, Sonia Balassanian studied at the Pennsylvania Academy of the Fine Arts and the Pratt Institute, in New York. She now lives and works in New York and Yerevan, Armenia. Her work covers the areas of video, performance, photo-collage and writing; in her words, it 'explores and links my multi-faceted identity with the physical and perceptual world surrounding me.' Balassanian also explains that her work 'relates intimate images to broader social and cultural issues including gender identity and relations, the aftermath of war, and the role of the individual, especially the individual artist, in today's society.'

Balassanian's preferred medium is video, since it allows for 'the simultaneous development of several ideas'. Recent video works include a split-screen installation made for the Armenian Pavilion at the 2007 Venice Biennale.

Sonia Balassanian

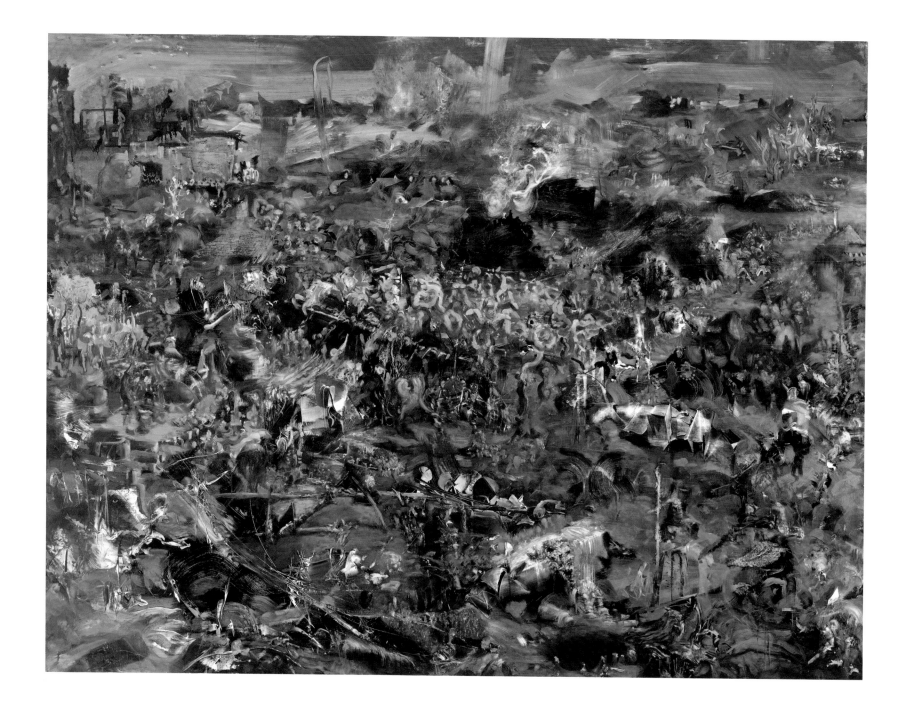

Ali Banisadr was born in Tehran in 1976, but moved to the United States when he was twelve years old; there, in San Francisco, he promptly got into graffiti. In 2005 Banisadr graduated from the New York School of Visual Arts, and in 2007 was awarded a Master of Fine Arts from the New York Academy of Fine Arts. He had his first one-man show the following year, and already his work is being widely collected.

Banisadr's paintings are highly distinctive. At a glance they seem to represent battles, and he has stated that they draw on his experiences as a refugee from the Iran–Iraq War. Unsurprisingly, Banisadr's paintings are frequently compared to those of Hieronymus Bosch, and with good reason: just as in Bosch's masterpieces – for example, *The Garden of Earthly Delights* – the surfaces of Banisadr's paintings crawl with frenzied life, with fires breaking out, bits of fragmented landscape showing through and tiny figures attacking each other in scenes of

pure anarchy. However, on closer inspection, the illusion breaks down, and the viewer is confronted with just brush marks – in fact, the canvas becomes virtually abstract.

The other major influence in Banisadr's paintings is that of Persian miniatures – this is especially noticeable in the palette, which can tend towards the garish. One can also see traces of Persian mythology – for example, we find a retelling of the Marco Polo story of the Hashashins, a military sect whose members were drugged before going into combat. In fact, *The Hashashins* is also somewhat reminiscent of Albrecht Altdorfer's magnificent painting *Battle at Issus*, teeming with tiny soldiers – a sort of modern history painting. Others, such as *In the Name of*, have especially brightly coloured geometric backgrounds, which Banisadr says remind him of the sound of breaking windows during the war.

above
Amen, 2008
Oil on canvas
126.5 x 167.5 cm
© Ali Banisadr
Courtesy of Ali Banisadr and Leslie Tonkonow
Artworks + Projects, New York

opposite
The Hashashins, 2008
Oil on linen
122 x 91.5 cm
© Ali Banisadr
Courtesy of Ali Banisadr and Leslie Tonkonow
Artworks + Projects, New York

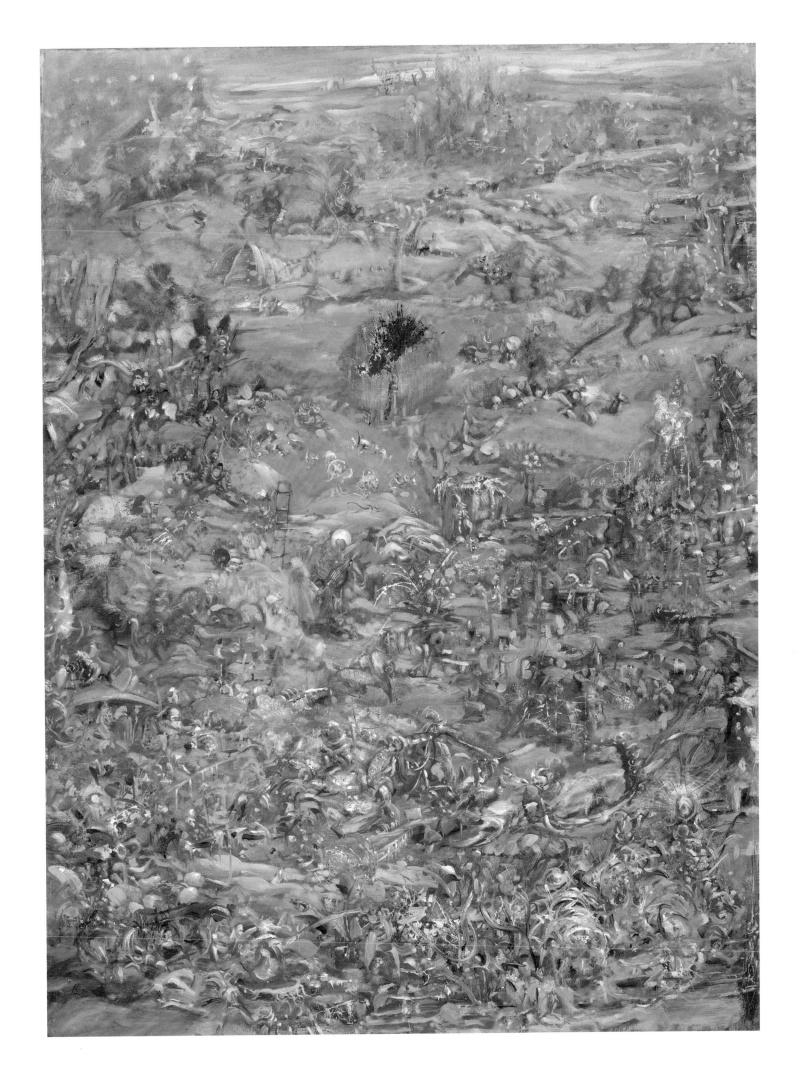

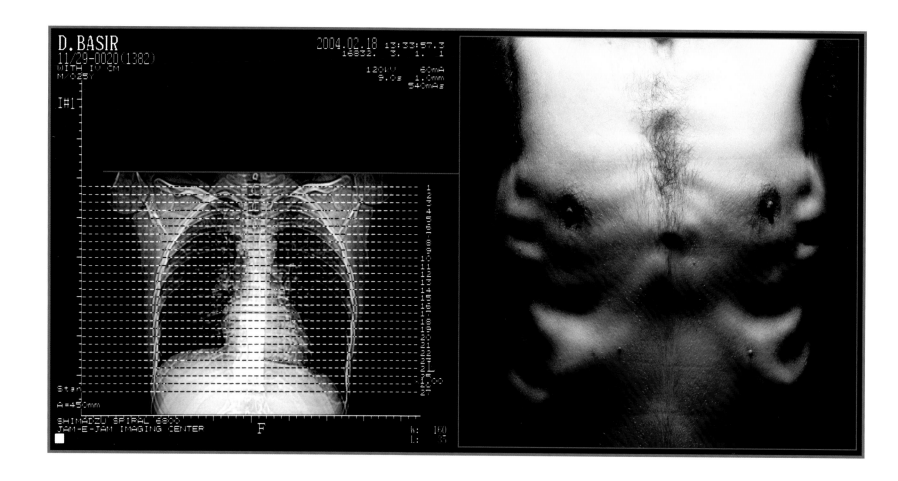

Untitled self-portrait, 2005–2006
X-ray and colour photograph
40 x 80 cm
© Dadbeh Bassir
Courtesy of Dadbeh Bassir

Dadbeh Bassir was born in Tehran in 1978, just six months before the Islamic Revolution. He studied for a degree in Photography in Tehran, from which he graduated in 2004, and he continues to live and work in Iran. Many of his photographs are autobiographical – 'I always see myself as the closest subject,' says Bassir – dealing in particular with a serious illness that he suffered in 2003. Works such as the haunting *After Six Months* (2003) catalogue Bassir's own physical deterioration, and he would later revisit this subject as a sort of exorcism. The result, produced from 2005 to 2006, was the 'Untitled' self-portrait series that incorporates x-rays alongside his own photography.

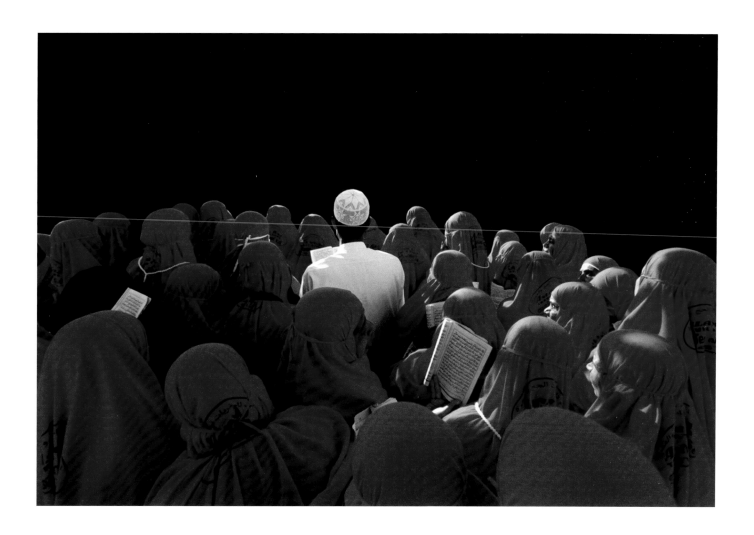

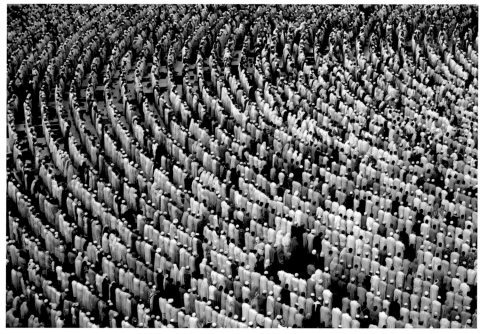

above
The Chant of Faith, 2008
Digital print on canvas
115 x 170 cm
Edition of 5 + 1AP
© Jamshid Bayrami
Courtesy of Jamshid Bayrami
and Xerxes Fine Art, London

left
The Focus, 2008
Digital print on canvas
115 x 170 cm
Edition of 5 + 1AP
© Jamshid Bayrami
Courtesy of Jamshid Bayrami
and Xerxes Fine Art, London

Born in Iran in 1961, Jamshid Bayrami is today recognized as one of the country's best photojournalists. A self-taught photographer who lists his influences as being Diane Arbus and Henri Cartier-Bresson, Bayrami began his career as a war reporter, making a name for himself during the Iran–Iraq War. However, after the student revolts of 1999 he began to move away from reportage, to concentrate on documenting the culture and people of Iran.

Since then, Bayrami has gradually extended his coverage to include other subjects, especially religious practice. Perhaps his greatest series of photographs to date has been that taken of the Hajj – the holy pilgrimage to Mecca – in 2006. In this, he captured every last ritual in remarkable detail.

Destruction, Iran
Photograph
© Fataneh Dadkhah
Courtesy of Fataneh Dadkhah

Destruction, Iran
Photograph
© Fataneh Dadkhah
Courtesy of Fataneh Dadkhah

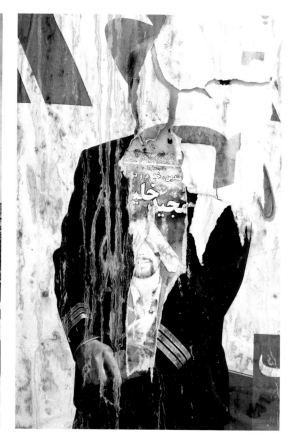

Untitled, Iran
Photograph
© Fataneh Dadkhah
Courtesy of Fataneh Dadkhah

Born in Tehran in 1952, Fataneh Dadkhah
graduated from the College of Mass
Communications and Social Sciences in
the same city. She is widely recognized as
the pioneer of stage photography in Iran,
responsible for documenting the rebirth of
Iranian religious theatre (*Ta'ziyeh*) after the
1979 revolution; in 1983 she published *Theatre
Photography*, perhaps the definitive book on the
subject. In 2001 she moved to the United States,
where she developed a more abstract style of
photography. Dadkhah's work has featured in
many international publications, including the
Washington Post and the French *Elle* magazine,
and has also been exhibited widely both in Iran
and abroad, most notably in 2002 at the Lincoln
Center in New York.

Untitled, London
Photograph
© Fataneh Dadkhah
Courtesy of Fataneh Dadkhah

Untitled, London
Photograph
© Fataneh Dadkhah
Courtesy of Fataneh Dadkhah

Untitled, USA
Photograph
© Fataneh Dadkhah
Courtesy of Fataneh Dadkhah

The Lines, USA
Photograph
© Fataneh Dadkhah
Courtesy of Fataneh Dadkhah

Untitled, USA
Photograph
© Fataneh Dadkhah
Courtesy of Fataneh Dadkhah

Untitled, USA
Photograph
© Fataneh Dadkhah
Courtesy of Fataneh Dadkhah

Water Collection, Iran
Photograph
© Fataneh Dadkhah
Courtesy of Fataneh Dadkhah

Water Collection, Iran
Photograph
© Fataneh Dadkhah
Courtesy of Fataneh Dadkhah

Fataneh Dadkhah

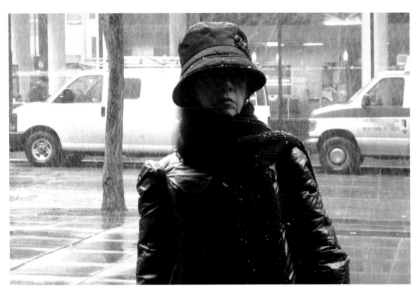

The writer and scholar Fereshteh Daftari is widely seen as the leading authority on contemporary Iranian art. A curator at New York's Museum of Modern Art since 1988, she has played a critical role in advocating non-Western contemporary art through a series of groundbreaking exhibitions.

It was on her invitation, for example, that Sonia Balassanian, Y. Z. Kami and Shirin Neshat became the first contemporary Iranian artists to show in the prestigious 'Projects' series, in 1993, 1997 and 1999, respectively. Later, in 2002, Daftari was invited by the Director of New York University's Grey Art Gallery to curate an exhibition of Iranian modern art that included works by Hossein Zenderoudi and Parviz Tanavoli. The scholarly essay she produced for that exhibition remains a seminal text on the subject. Perhaps her best-known contribution to this field, however, was the exhibition held at MoMA in 2006, 'Without Boundary: Seventeen Ways of Looking'. This exhibition was the first attempt by a major institution in the United States to explore the work of contemporary artists from across the Islamic world living mostly in the West.

'"Without Boundary" took place at a time when there was a great deal of negative representation of the Islamic world in the Western media,' Daftari explains. 'I was hoping this exhibition would act as an antidote to that vision of the world marked by an "us versus them" mentality. While protecting the cultural specificity of each artist, I tried to counter the perception that reduces different voices to a ghettoized, demonized, monolithic entity.'

The show included such diverse Iranian artists as Shirazeh Houshiary, Y. Z. Kami, Shirin Neshat, Marjane Satrapi, Shirana Shahbazi,

and well as a dozen non-Iranian artists. 'The artists in this exhibition didn't belong together,' according to Daftari. 'They did not share the same approach to aesthetics, politics or spirituality. They did not share the same country, culture, history, religion or artistic language and medium. Some were political whereas others had different concerns. The point was to show complexity, heterogeneity and diversity.' She then adds: 'This exhibition was an important example of the relevance of art in questioning reductive thinking, which is the seed of many conflicts today. In this sense, I believe its very existence was profoundly political.'

Daftari's insistence on open boundaries is a position against what she calls a 'cloisonné method of thinking', and not 'a disregard for origins'. Just as important, she explains, was the fact that 'the show, mounted in an institution that firmly believes in "quality" and "originality", managed to dismantle another simplistic idea: the notion of the derivative East versus the creative West.'

In fact Daftari goes even further, to question the whole notion of 'Islamic' art: 'I question it because it is an academically imposed identity/label, defined and designed by Occidental scholars beginning in the 19th century. How can you brand the art of a vast area stretching from Indonesia to Morocco, spanning a period from the 7th century to the 21st century, as Islamic? Just imagine a Middle Eastern scholar referring to art produced anywhere and at any time in the West, and by artists of different religions, as Christian art?'

Furthermore, as Daftari explains, many artists from Islamic countries are actually revising or working against traditional 'Islamic' art. 'When an artist is reacting against,

contradicting, subverting, or breaking away from a certain authority/movement/tradition can you name this artist after that authority? Of course not. A Pop artist is not an Abstract Expressionist. And for sure they would not be lumped together as Christian, especially when several of them were Jewish. Such generalizations are only symptomatic of distance.... In "Without Boundary" the whole argument for the validity of the term "Islamic art", I think, fell apart most blatantly in the section where I juxtaposed carpets by Mike Kelley, Shirana Shahbazi and Mona Hatoum.'

For this reason, Daftari is careful to distinguish between art and religion when using the word 'Islamic'. 'Look at Mona Hatoum, who is a Christian Palestinian artist with a secular voice living and working in Europe. In a variety of ways, she has been contaminating the so-called purity of Minimalist abstractions with political messages. To label her art "Islamic" is to ignore the communities she identifies with, as well as the aesthetic currents she chooses to tamper with.' Conversely, the label would be justified if used for a devout Muslim copying the Qur'an. In Iran, the term has an additional political connotation: fervent supporters of the Islamic regime are considered Islamic. This adjective, therefore, would be appropriate for those artists who advocate or propagandize a specific political ideology. In short, the application of the term Islamic...needs to be determined on a case by case basis.'

On recent developments in the market for Middle Eastern art, Daftari remarks that, 'the market has become the arbiter. It has replaced the filter of critics and curators. The positive, albeit dangerous, aspect of the market explosion is the creation of incentives for younger artists, as well as long overdue financial rewards for others. The down side, however, has been to allow for a culture of dilettantism that says anything goes if it's saleable, especially a certain kind of banal ethnicity – something, mind you, all cultures are prone to.'

Of course, interpretation of art still largely relies on critics and curators, who in turn need to be trained. 'We do have enterprising people with very good intentions and bright young people who have just entered the field. Our educational systems and institutions, however, need to cultivate visual literacy and critical thinking. We also need more professional curators and critics armed with insights instead of self-aggrandizing agendas. Private philanthropists, too, can be of huge help here. We have some of all of the above. We need more.'

One common theme in Iranian art is that of 'identity', which Daftari recognizes as a complex topic: 'I tried dealing with it in my essay "Another Modernism: An Iranian Perspective". In the past three decades, however, the veil became its most visible cipher. During the Iran–Iraq War,

the artists of the Islamic Revolution depicted veiled women and their martyred men as role models. Outside Iran, as early as 1982–3, the pioneer Christian Armenian-Iranian artist Sonia Balassanian photographed herself wearing the Islamic "hijab" and defaced her self-portraits with censored writing. The gesture was an act of empathy towards the abused women left behind.'

'A decade later, the narrative of the veil reached new dimensions with the arresting images and video installations of Shirin Neshat,' Daftari continues. 'The veil has continued to inspire artists as well as instigate a range of reactions towards what one critic has coined "chador art". Identity, however, is not the only subject of concern among Iranian artists, either inside or outside Iran, nor is the veil its only signifier. Houshiary, for instance, opposes pitting the self against the other. She finds identity politics to be divisive. Instead she allows for every proposition to be impregnated with its opposite: light with darkness, presence with absence. Y. Z. Kami, too, steers clear of identity politics. In his paintings he is concerned and reconciled with humanity's precarious condition, with the passage to impermanence. These are philosophical and spiritual questions with no expiration date.'

The other critical topic in Iranian art, related to identity, is the question of roots. Daftari takes a balanced view on the subject: 'Your beginnings are of great importance but so too are your itineraries, your journeys. An identity fixed at birth equals arrested development. I'm not alone in opposing essentialist thinking, boiling everything down to one facet out of many, searching for a single, magic, authentic, Iranian ingredient.' She accepts, however, that cultures, when threatened, react chauvinistically: 'I understand why cultural identity is affirmed as a defence against Western hegemony. Sometimes in art what's at stake is not Western hegemony but rather Western apathy. Self-Orientalizing, however, is not the desirable answer. I think it's ironic that the Middle Eastern public has developed a taste for the tale of an exotic self.'

Challenging boundaries, questioning convenient labels, there is no doubt that Daftari has made a significant contribution to the appreciation of Middle Eastern art from a uniquely privileged position at MoMA. Yet from her point of view, it has been just part of the process: 'For me, [MoMA] has been a second university where, working with some of the curatorial giants of our time, I learnt the craft of curating. I then tried to apply those lessons to the kind of art that fills my life with a sense of social purpose. Within my limits, I've persevered in letting at least a few voices of the non-Western world be heard by a wider audience.... No culture has a monopoly on talent.'

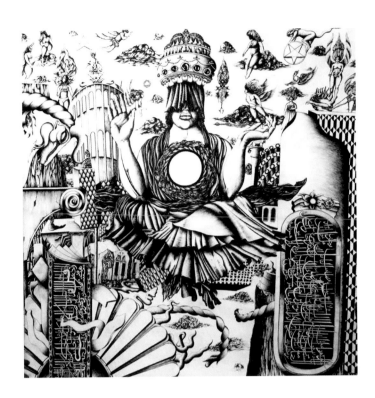

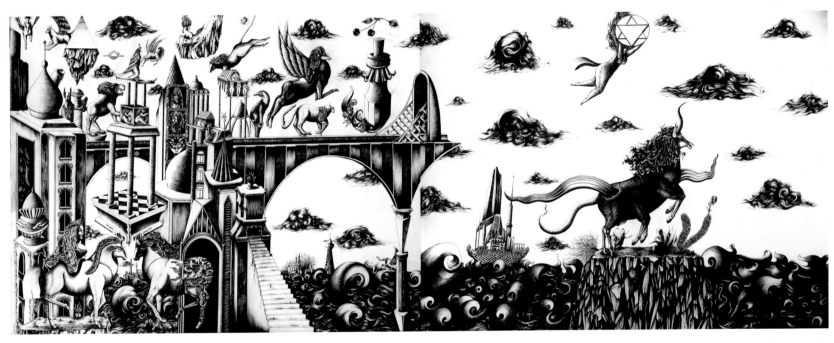

top
Untitled
100 x 240 cm
Roller pen or black ink on cardboard
© Alireza Dayani
Courtesy of Alireza Dayani and
Mah Art Gallery, Tehran

above
Untitled
150 x 150 cm
Roller pen or black ink on cardboard
© Alireza Dayani
Courtesy of Alireza Dayani and
Mah Art Gallery, Tehran

Alireza Dayani was born in Tehran in 1982, and
went on to study Psychology. He has exhibited at
several of Tehran's leading galleries. His highly
distinctive and minutely detailed works are
executed in black ink, often on cardboard. The
scenes tend to be inspired by mythology, with
legendary creatures such as griffins appearing
alongside arcane and mystical symbolism.
The settings, with their peculiar furniture and
architecture, in some respects recall the work
of M. C. Escher, in others that of Salvador Dalí.
The end result, however, is completely unique.

These photographic works by Kamran Diba
are inspired by props used by Bita Fayyazi
in her installation work *Play Ground*.
(courtesy Espace Louis Vuitton, Paris)
© Kamran Diba
Courtesy of Kamran Diba

Kamran Diba is both an artist and an Aga Khan Award-winning architect. He conceived, designed and built the seminal Tehran Museum of Contemporary Art. Inaugurated in 1977, it was the Muslim world's first such cultural edifice.

'Modern art has always been current in Iran,' Diba reflects. 'I remember when I was in high school in 1950s Tehran, local ironmongers used to make what they themselves called "Picasso doors", wrought-iron gates for the capital city's modern-style villas.'

'Architects brought modernism to Iran,' he continues. 'They totally changed the fabric of Iranian society by breaking up the old Persian cultural and religious tradition of the *birooni* and *andarooni*.' This historical and socially important concept can be literally translated as the 'inner' and 'outer' quarters, with one housing the extended female members of the family, and the other the men and boys. 'The modern architectural social concept,' Diba asserts, 'was a form of lifting the veil on communal living in Iran. The buffer between the "inner" home and the street was broken, and the Iranian nuclear family was born.'

'Western art and architecture came to Iran in waves...awareness began to grow and there was a fascination with 20th-century figures such as Picasso. Those same *ahangars* [ironmongers]

structured and painted their doors and gates [according to the rules of] Geometric Cubism!'

Diba taught himself to paint while studying architecture in the United States in the early 1960s, when the modernist Iranian art movement was moving into new interpretations of traditional Persian calligraphy. 'The *Saqqa-khaneh* school, which looked at the inner religious beliefs prevalent in the popular culture of Iran, was short-lived. I was already painting pure abstract calligraphy in the 1960s, even before [Hossein] Zenderoudi,' Diba claims.

During the 1960s and 1970s, Diba propagated *memari mardomi* (socially sensitive architecture). To emphasize his ideas, he commissioned the sculptor Parviz Tanavoli to make realistic human figures in bronze, to interact with visitors to his architectural designs. These were later reproduced and placed in the city's public spaces and parks. His first shows of painting and installation were held at the Seyhoun Gallery in 1967 and 1975, respectively, and in 1976 he began combining performance and painting at Tehran's Gallery Zand. As a first cousin of Farah Diba, then Empress of Iran, Kamran Diba pushed for public art spaces in the capital's expanding metropolitan area.

'You have to remember' – Diba's gestures are emphatic – 'that in the 1960s, artists were

painting in isolation, not communicating with each other. There was no flow of ideas between them and a [lot of practice was built around] straight copying of Western art movements.' He helped set up an art club in Tehran where artists could gather to exchange ideas and to show their works. 'The Tehran Museum of Contemporary Art was the culmination of these activities. We built the museum to give artists historical legitimacy [while allowing] ordinary people to go and see Iranian and international art for the first time.'

'My intention was to make a strong collection of Iranian artists and the Empress [Farah] not only supported the museum, but she also pushed the government to buy Iranian artists. My purpose was to place local artists in a national and international context,' Diba says. He not only designed and built the museum, putting together the staff and hiring international curators to create exhibits, but even trained the guards and janitors to do their jobs professionally.

'Art and culture isn't just about artists... more importantly, it has to do with institutions,' Diba continues passionately. 'The only institution which is concerned with the conservation of recent art history in Iran is the Tehran Museum of Contemporary Art.' The museum today not

only boasts the best collection of modern and contemporary Iranian art, but also houses one of the most comprehensive collections of Western modernist and contemporary works outside of the Western world, with an estimated value of well over a billion dollars.

'Alas,' Diba laments, 'in spite of many good Iranian artists, we lack authentic voices in the contemporary Iranian art movement today. With no properly functioning institutions, curators, authoritative critics...the Tehran Museum of Contemporary Art itself has been left adrift, its first show of the [Western] collection held twenty-five years after the Revolution by Sami Azar Ali Reza [the museum's director, who was replaced in 2005]. There are also some fake [Iranian artworks] around without anyone being able to [tell the difference between] the real and the fake reproductions. With the recent high prices being fetched at auction for Iranian modernist and contemporary works, some people are being cheated and there's not much we can do about it.'

'Art is not fashion but in today's marketplace, Iranian art has become somewhat like the Paris season fashion shows. But where else in the region do you find such artistic passion and ferment?'

Kamran Diba

Born in Berkeley, California, to Iranian parents, Ala Ebtekar completed his Master of Fine Arts at Stanford University in 2006. As with many Iranian exiles, he feels torn between countries, but has found intriguing ways of combining the two different cultures.

Drawing is fundamental to Ebtekar's practice, and the starting point for any of his projects. It also features prominently in installations such as *Elemental*, which though modern in style and content, recall the wall paintings found in Tehran's coffee houses. Similarly important to Ebtekar's practice is the Persian carpet – he attributes his love of pattern to playing on precisely such carpets as a child. He also grew up with Persian mythology, and this has had its own impact on his work, as witnessed by the creatures that populate his works, often painted on top of either Farsi or Arabic texts.

this page
**From the 'Absent Arrival'
series**, 2006
Graphite and acrylic on paper
© Ala Ebtekar
Courtesy of Ala Ebtekar and
The Third Line Gallery, Dubai

opposite, above
Ascension, 2007
Acrylic and ink on book pages
mounted on canvas
131 x 205.5 cm
© Ala Ebtekar
Courtesy of Ala Ebtekar and
The Third Line Gallery, Dubai

opposite
Under the Indigo Dome, 2008
Acrylic and ink on book pages
mounted on canvas
Triptych
135 x 306 cm
© Ala Ebtekar
Courtesy of Ala Ebtekar and
The Third Line Gallery, Dubai

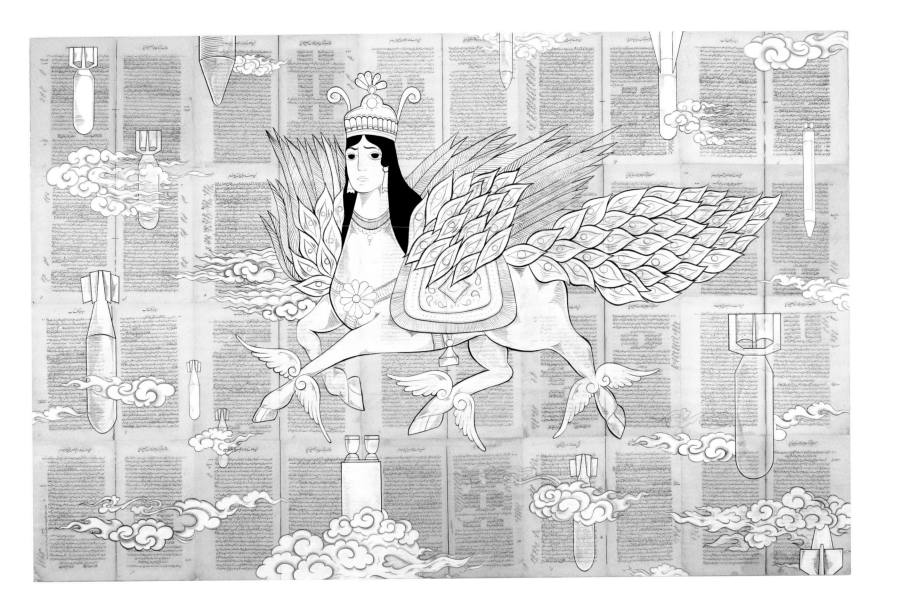

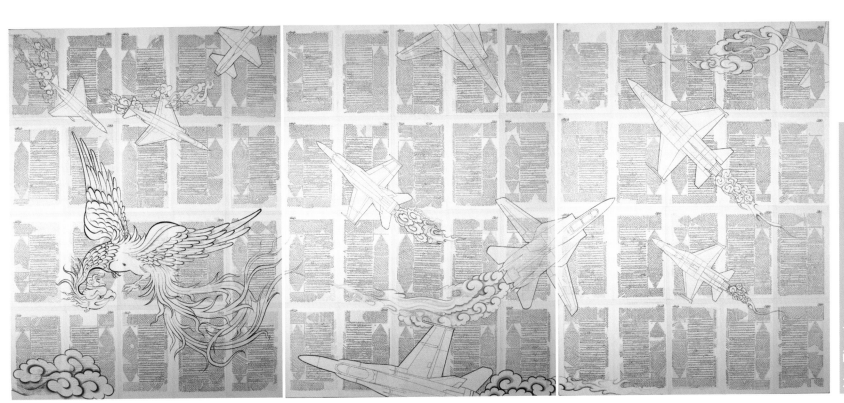

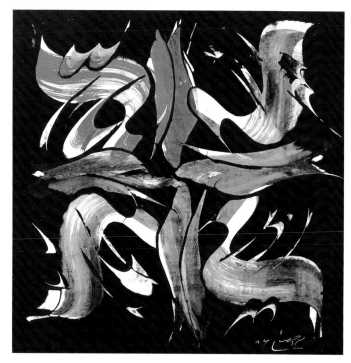

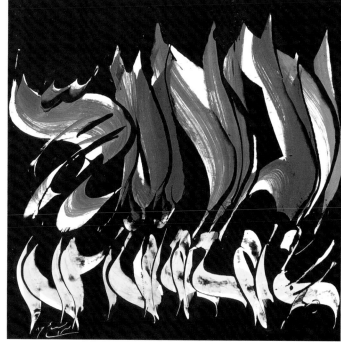

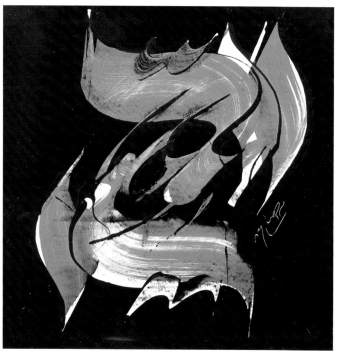

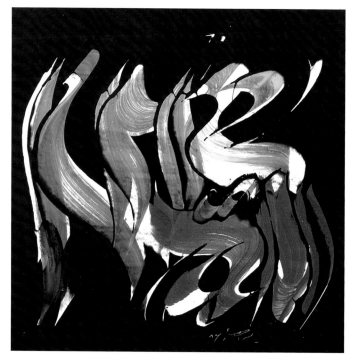

Born in Tehran in 1939, Mohammad Ehsai is one of Iran's greatest living calligraphers. He began his career designing the calligraphy and layout of schoolbooks, before studying at the Department of Fine Arts in Tehran University. He first exhibited at the Seyhoun Gallery, Tehran, in 1973, and throughout the 1970s continued to show widely around the globe, winning several awards.

Ehsai is perhaps most important today for being one of the first artists to successfully fuse modern painting with traditional calligraphy. Commentators have remarked that in its fluidity and broad strokes, his technique owes more to Japanese painting than to traditional Persian calligraphy.

Though a man of religious conviction, Ehsai sees letters as formal, visual elements, rather than as parts of a whole. As he himself has described the process, 'The theme of my work is [to] create compositions that look to the future at the same time as relying on the millennial traditions of my forefathers. The exoteric form of these letters is analyzed within my subjectivity, resulting in a fully abstract and personal aesthetic expression.'

On specific interpretations of his work, Ehsai is open: 'My discourse is a visual, not a literary one. The image is meant to provoke the viewer according to their own mood and imagination. Some see my work as related to traditional calligraphic exercises; others see it as meditation and prayer; yet others see elements of Escher – an artist I admire – in the way I defy dimensions and visual logic.'

This is not to say, however, that there is no symbolism in Ehsai's works. Certain words – for example, 'Allah' – appear frequently, repeated over and over, as in an incantation. These works, then, in spite of Ehsai's modern approach, remain part of a sacred tradition: 'Mine is a spiritual journey springing from the inner power and energy of letters, and their inherent philosophic vision,' he explains.

Colour, when it appears in Ehsai's compositions, can also be loaded with spiritual meaning. Some works, for example, are painted in black on a silver ground – silver being a colour traditionally associated with the moon as a backdrop for acts of devotion. Ehsai himself says of his use of colour: 'As a child I lived in a traditional house that used to be my grandfather's. Sunlight pouring through the painted-glass windows would refract into a kaleidoscope of colours over the rich, colourful patterns of our Persian carpets. The dazzle and intensity of these colours had such an effect on me that in my early years I actually sought the quiet and simplicity of black pen-and-ink on white paper. I had actually felt deprived of black and white, and sought it in my work! Monochrome seemed the ideal mode of expression. Later, however, I recaptured a love of colour and brought its richness to inform my calligraphic paintings.'

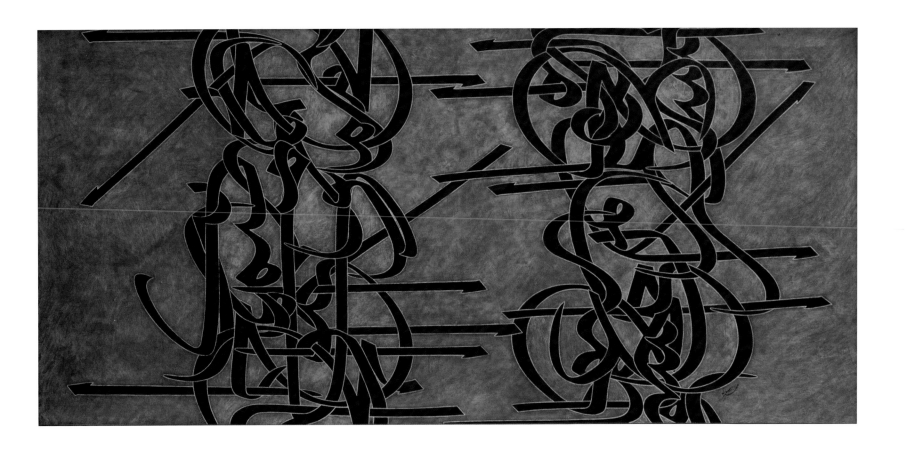

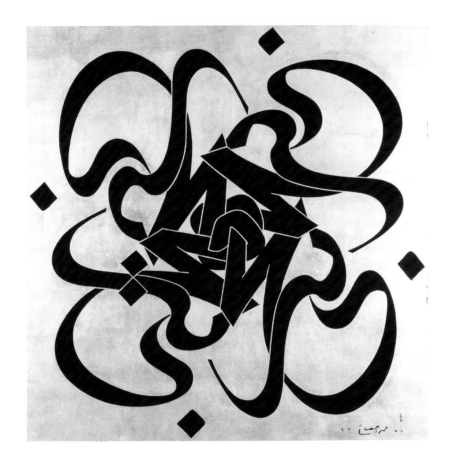

above
The Word of God, 1969
Oil on canvas
90 x 190 cm
© Mohammad Ehsai
Courtesy of Mohammad Ehsai and
Xerxes Fine Art, London

right
Mohabat, 2005
Acrylic on canvas
145 x 145 cm
© Mohammad Ehsai
Courtesy of Mohammad Ehsai and
Xerxes Fine Art, London

opposite
From the 'Allah' series
Oil layers on cardboard
Quadriptych
61 x 61cm (each)
Private collection, London

Mohammad Ehsai

Maryam Homayoun Eisler is an art enthusiast in all senses of the word. A notable patron and collector, in recent years she has turned her attention to work produced by Iranian artists.

Fluent in several languages, Eisler is a product of her Persian heritage combined with a Western education. Having left Iran in 1978 at the age of ten, Eisler studied in Europe and America, first at Wellesley College then at Columbia University where she completed her MBA in 1993. After working for a time in the worlds of banking and international marketing, in 1998 she settled down in London with her family, and turned her attention to a lifelong passion: art.

'Art is something I deal with every day of my life; it is an obsession!' says Eisler with enthusiasm. She vigorously denies that art is, or even should be, for the privileged few: 'Quite the contrary – art is a reflection of regular day-to-day life and of the community that one lives in and, as such, it needs to be accessible to all and should certainly not hold a privileged position. If anything, art should provide a platform to challenge the mind of each member of society.'

She does agree, however, that in the present-day Middle East and Iran, art is less accessible to a broad public than in the West. This Eisler attributes to weaker educational and curatorial programmes at the institutional level. 'Today in Iran people access art mainly through commercial ventures: galleries and international auction houses.' Nevertheless, she is optimistic and encouraged by the significant efforts being made in the Persian Gulf states to create new museums and artistic institutions. This, she says, 'can only have a positive spillover effect on the development of Iran's artistic platform, perhaps encouraging its longstanding cultural institutions to follow suit.'

There is a caveat, however: 'A museum cannot simply be an architectural masterpiece with "pretty" canvas-plastered walls. First, the art needs to have content... it needs to move you and make you think. Also, you need a strong, long-term commitment with regards to educational and curatorial programmes, research, private and public patronage, artist residencies, local community and parallel international initiatives.'

Eisler is adamant that art should not be 'ghettoized' geographically or philosophically. 'Art should be about vision, not division. Many contemporary Iranian artists have achieved this, experimenting...in both style and content while managing to remain personally rooted in their indigenous culture.'

Her homes in London and New York are packed with artworks from all over the world. Over the last two years, she has been assiduously building her collection of art produced by Iranian artists, both living in and outside the country. 'I have been won over by the vibrancy and the intellectually and emotionally charged content of their oeuvre, a result no doubt of their challenging social and political environment. These artists are constantly testing the limits of their freedom of expression...of their vision. That's the stuff of great art.'

Connecting with and supporting Iranian artists and gallerists has allowed Eisler to reconnect emotionally with her own roots. She is particularly drawn to the thematic content of contemporary Iranian art. 'Many of the works deal with identity and loss. I am a very melancholic and emotional person,' Eisler explains, 'and these themes resonate with me...I find myself drawn to the nostalgia and memories of my childhood.' In fact it is her deep interest in the contemporary art movement that is taking Eisler back to her homeland for the first time in thirty years.

She does, however, express some irritation at the idea of a sudden 'discovery' of Iranian art. 'How can you call this movement a "discovery" when it is in fact more accurately a recovery of artistic ideas? You're talking about a nation with 2,500 years of rich culture. The topic of modern art, both local and international, was buoyant during the 1960s and 1970s. Tehran was the first capital city in the region to construct a contemporary art museum of world standards.' She concedes, however, that international political events have helped make modern and contemporary Iranian art more newsworthy.

Often commented on in the West is the prominence in Iranian contemporary art of women. Eisler has her own thoughts on this subject: 'I believe that women are introspective and analytical souls. We are also good at expressing ourselves emotionally and verbally. This directness of feelings is clearly manifested in the visual message and content of some of these female artists' works...women tend to be more passionate, and passion often produces impactful art.' For Eisler women have always played a central role in Iranian society, and the current success of women artists in Iran and the region is simply testimony to this.

How does she see her role as an art patron? 'I would like to see myself as an ambassador for artists of Iranian origin. Due to my contacts with the Western artistic community, I would like to open doors for them where and when I can,' Eisler says. 'I also relish,' she adds, 'the thought of spotting new talent from the region. To find the next "art genie" and to share his or her work with the rest of the world...that is the exciting adventure that keeps me on my toes.'

Founded by Shirley Elghanian in 2004, Magic of Persia (MOP) is a United Kingdom-registered charity devoted to Iranian art and culture. Since taking off, it has grown in leaps and bounds and today offers education and support for Iranians around the world.

Elghanian supports the organization's ambitions through events in London and Dubai, and, more recently, through auctions of artworks donated by Iranian artists working inside and outside the country. A woman of huge energy and vision, she uses her international network of contacts to push forward non-profit projects such as the production of Persian history textbooks for kids or trying to bring the teaching of early Persian history into the British primary school curriculum. The organization also provides the expatriate Iranian community with opportunities to get together at venues such as the Victoria & Albert Museum or the British Museum, where upwards of 40,000 people have attended dedicated weekends.

MOP has also been pushing for the public display of the 2,500-year-old Cyrus Cylinder, the world's first recognized pronouncement on the rights of man, inscribed by the Persian King Cyrus the Great. In December 2008 it sponsored

an event at the British Museum to celebrate the 60th anniversary of the International Declaration of Human Rights; the keynote speaker was Dr Shirin Ebadi, the Iranian Nobel Laureate and human rights activist. 'We take our inspiration from the Cyrus Cylinder,' Elghanian says. 'MOP is a non-political, non-religious charity that promotes Persian art, culture and heritage in the UK and we will be launching our programme at the Smithsonian Institute in Washington, D.C., in 2009.'

Is it possible to remain apolitical in the current geopolitical climate, especially when operating in the West? 'It is difficult,' Elghanian concedes, 'but we do it by not promoting any programmes that have political or religious content. And through our avoidance of funding any particular professional group or institution with political, religious or non-cultural affiliations. People come to us for funding from all walks of life and so long as it is educational and Persian-based, we help promote it.'

MOP is led by Elghanian and run by a group of educated young Iranian volunteers and part-time employees, including lawyers, curators and art consultants. Its headquarters in London's Knightsbridge looks like an artist's studio turned

on its head: various helpers sprawled across floors working on computers, beds covered in correspondence and paper, the small kitchen serving as a canteen, with the living room a theatre of voices talking in multiple languages on different phones.

Elghanian is currently busy on preparations for the launch of MOP's most important project to date: Magic of Persia's Contemporary Art Prize (MOPCAP), scheduled to be awarded in October 2009. The prize is to become a biannual event promoting young Iranian artists both inside their country and within the wider Diaspora. Having already set up two bursaries for Iranian students at the London Film School and the Royal Court Theatre for their Masters programmes, MOP has gone international in wanting to bring Iranian art to a global audience.

Elghanian explains: 'When we decided to do the first MOP charity auction of contemporary Iranian art in Dubai in 2008, we had thirty artworks donated by Iranian artists, auctioned by Christie's auction house, which raised $1.1 million.' MOP has used proceeds from such fundraising events to promote its various programmes, channelling resources to build a major curatorial and selection committee for

MOPCAP. Notable London art scene figures such as Sheena Wagstaff (Chief Curator at Tate Modern), Venetia Porter (British Museum) and Julia Peyton-Jones (Director of the Serpentine Gallery) appear on the list of judges.

'What MOPCAP is trying to do is provide a platform for young emerging Iranian artists for international exposure,' Elghanian explains. 'The credibility of the prize depends greatly on the nominators, who are academics, artists, curators and the like. Then comes the twelve-member jury panel.' The ten shortlisted artists will have a show in London's Royal College of Art at the same time as the Frieze Contemporary Art Fair in 2009. The winner will be given a two-week solo exhibition at one of London's leading contemporary art galleries.

The idea behind the whole enterprise is to strengthen the links with artists, curators and cultural institutions in Iran through scholarships and exchange programmes. 'The value added of doing anything in Iran is much higher, given the shortage of artistic support and facilities there, compared to those available in Europe and America,' say Dr Sahar Rad, an economist and a principal volunteer for MOP. 'It makes what we do all the more meaningful.'

Samira Eskandarfar was born in Tehran in 1980 and continues to work in Iran. Between 1997 and 2001 she studied Ceramic Engineering, before going on to study filmmaking and finally take a Master of Arts in Animation. She has done workshops with the legendary Iranian filmmaker Abbas Kiarostami, and has shown extensively both in Tehran and outside Iran at various film festivals.

Eskandarfar produces both paintings and film and video works. The paintings are almost exclusively portraits, and often have a dark tinge to them. Faces are distorted or discoloured; some even appear mask-like, with hollow, black eyes. The compositions are awkwardly cropped, to heighten the feeling of tension, or sometimes to create a sense of narrative. Occasionally bordering on the sinister, and yet often fragile, Eskandarfar's paintings are strangely moving.

all images
Untitled, 2008
Oil on canvas
© Samira Eskandarfar
Courtesy of Samira Eskandarfar
and Azad Gallery, Tehran

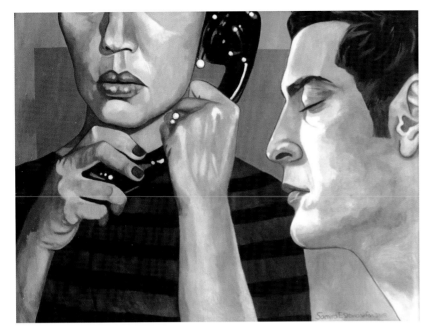

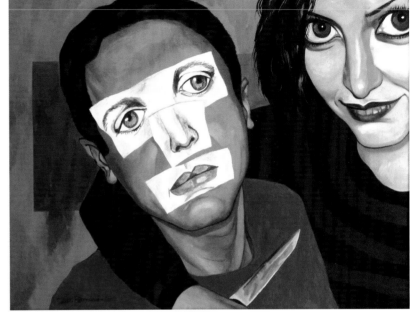

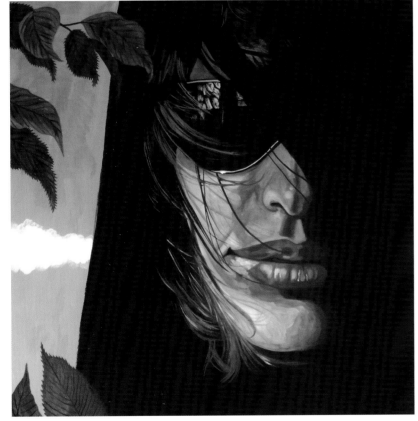

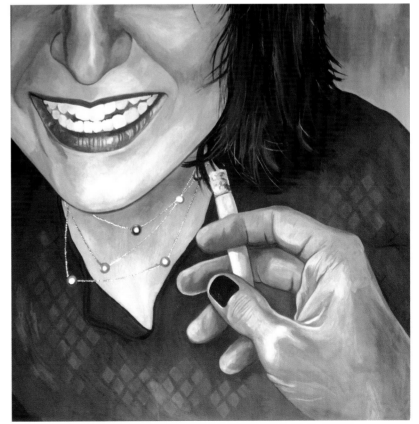

Born in 1957 in Arak, Iran, Mohammad Hossein Emad is one of Iran's leading sculptors. Exhibiting almost exclusively in Tehran, he has also installed some public works across the city. He also won the Fourth Tehran Biennial Sculpture Award, and is a life member of the Society of Iranian Sculptors.

Emad's sculptures use natural materials, most often wood, which he begins by cutting roughly with a chainsaw. Earlier works included anthropomorphic forms, reminiscent of heads or bodies, but more recent works tend to be resolutely abstract, and sometimes almost conceptual. Alongside wood he uses metal, which offers a contrast of texture – Emad explains that the wood stands for tradition, and the metal for modernity.

top
Untitled, 2007
Wood and metal
700 x 25 x 25 cm
© Mohammad Hossein Emad
Courtesy of Mohammad Hossein Emad
and Assar Art Gallery, Tehran

above
Untitled, 2006
Wood and metal
56 x 56 x 37 cm
© Mohammad Hossein Emad
Courtesy of Mohammad Hossein Emad
and Assar Art Gallery, Tehran

Loom, 2006
C-print photograph
© Roya Falahi
Courtesy of Roya Falahi and
LTMH Gallery, New York

Roya Falahi was born in 1980 in Washington, D.C., to Iranian parents, and grew up in San Diego, California. She received her Master of Fine Arts from the University of California, Los Angeles, in 2006, and since then her work has appeared in several group exhibitions across southern California.

Falahi's photographs deal with issues of disguise and veiling, as well as making reference to her own Iranian-American background. In her own words, 'My photographs use the strategies of disguise and concealment to play with the conventions of photography, beauty and display, while creating a dialogue concerned with identity politics.' In the arresting photographic self-portrait *Loom*, for example, Falahi hides her face completely, creating a black void by veiling her face with that which is normally veiled itself – her hair.

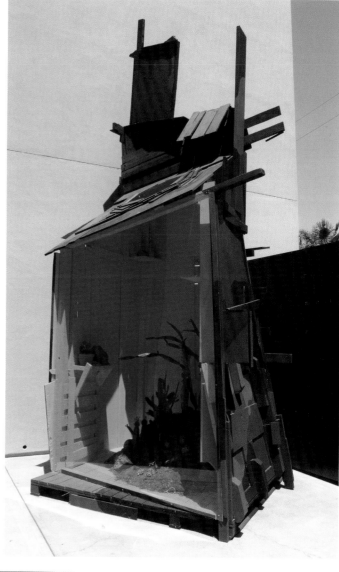

Painter, publisher, sculptor, installation artist, Amir H. Fallah's distinctive aesthetic manifests itself across a broad cross-section of projects. Born in 1979, Fallah studied at the Maryland Institute College of Art, and then received a Master of Fine Arts from the University of California, Los Angeles. He has exhibited his work both within the United States and internationally, including at The Third Line, in Dubai.

His paintings are instantly recognizable, combining fresh, fluorescent colours with depictions of ramshackle constructions. Pieces of collage crop up in unexpected places: in *Master Of My Universe (Pump It Up)*, we find cut-out figures that look as though they've escaped from a Richard Hamilton work, perched on shelves attached to a tottering construction. Stylistically these works have been compared with everything from Philip Guston to computer graphics. Alongside these larger works, Fallah also produces delicate drawings that have something in common with ancient Persian miniatures.

The same makeshift shelters or homemade forts that appear in Fallah's paintings also crop up in three-dimensional form in his sculptural installations. Again, the works are dominated by bright colours – see the startling red interior, or garish fabrics – and again there is a surreal, 'readymade' air to the art. As with the paintings, Fallah eagerly combines elements of 'high' and 'low' culture to create an art that is entirely his own.

Fallah is also the publisher of *Beautiful/Decay*, an international contemporary arts magazine that focuses on innovative talent from the different creative worlds in which he moves. In this he employs a unique blend of distinctive covers, attention to design detail and provocative content. In fact, his insider's perspective into trends from the creative community comes directly from his experience as a practising artist.

above
Sheltered (DM, TC, JS), 2008
Paint, found wood, plexiglass, soil, cacti and succulents, ceramic pots and panties
Dimensions variable
© Amir H. Fallah
Courtesy of Amir H. Fallah and
The Third Line Gallery, Dubai

top left
Venice Beach The First and Last Kiss, 2007
Mixed media on canvas
91 x 119 cm
© Amir H. Fallah
Courtesy of Amir H. Fallah and
The Third Line Gallery, Dubai

left
Robbie Conal, 2007
C-print
61 x 61 cm
© Amir H. Fallah. Courtesy of Amir H. Fallah
and The Third Line Gallery, Dubai

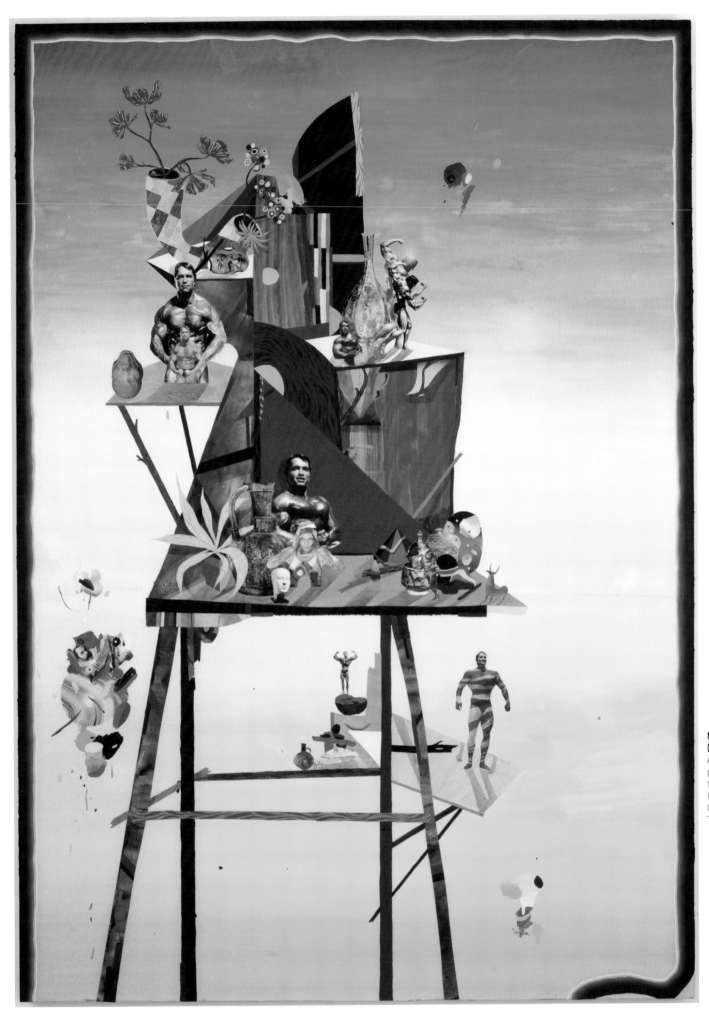

**Master Of My Universe
(Pump It Up)**, 2008
Acrylic, ink, pencil, collage on
paper mounted on canvas
18 x 13 cm
© Amir H. Fallah
Courtesy of Amir H. Fallah and
The Third Line Gallery, Dubai

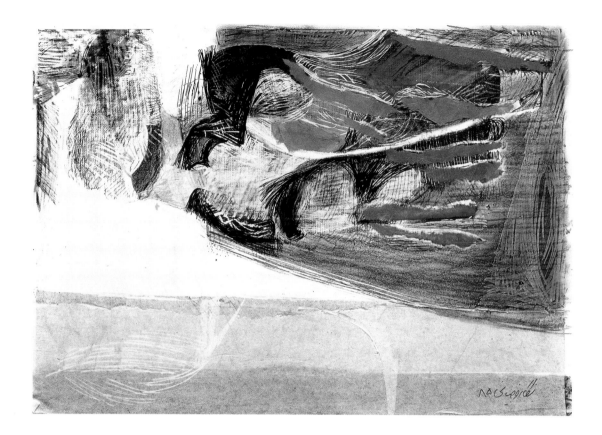

Negar Farajiani was born in Yazd, Iran, in 1977. After taking a diploma in painting at the School of Fine Arts in that city in 1995, she studied for a degree in Graphic Design at Tehran, which she completed in 2000. Her painting style is instantly recognizable: described by some as an abstract version of nature, Farajiani herself sees her works as 'images of the world around us as seen through a kaleidoscope,' in which, 'what appears to be a colourful, diverse and changing setting...gradually turns into a familiar form.... One image reminds us of...a puppet theatre mask, another as a set table or a stone shelter, a worried woman, perilous mountains, someone taking hesitant steps, a faceless man conversing with nature....' Farajiani draws the viewer's attention to the beauty of their surroundings.

top
Untitled, 2007
Mixed media and collage on photo paper
21 x 30 cm
© Negar Farajiani
Courtesy of Negar Farajiani and
Assar Art Gallery, Tehran

above
Untitled, 2007
Mixed media on cardboard
26 x 48 cm
© Negar Farajiani
Courtesy of Negar Farajiani and
Assar Art Gallery, Tehran

opposite
Untitled, 2007
Mixed media and collage on cardboard
29 x 25 cm
© Negar Farajiani
Courtesy of Negar Farajiani and
Assar Art Gallery, Tehran

Negar Farajiani

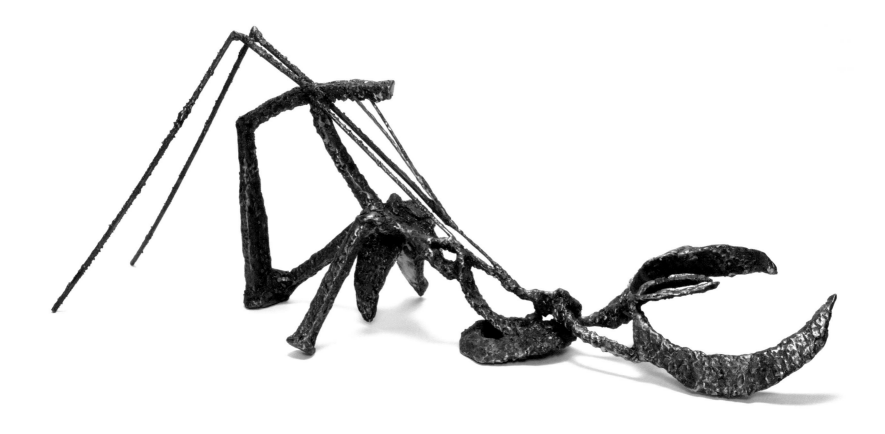

The sculptor Roya Farassat was born in Tehran and currently lives and works in New York. She studied welding at the Sculpture Center and received a degree in painting from Parsons School of Design. Her art stems in part from her childhood experiences of life in Iran, where 'not hearing women express their point of view was a cultural reality and an expected social behaviour. This led me to believe that beneath my surface lies something powerful that needed exposure.'

Farassat's sculptures, which formally are strongly reminiscent of early Giacometti, evolved from 'a love of working with metal and the meditative process of welding.' She aims to capture in her work 'an eerie sense of confinement', related to living in 'a suppressed culture...under the veil'. She also addresses issues of permanence and decay, isolation and unpredictability through combined elements of humour and violence.

Untitled
Bronze
© Roya Farassat
Courtesy of Roya Farassat

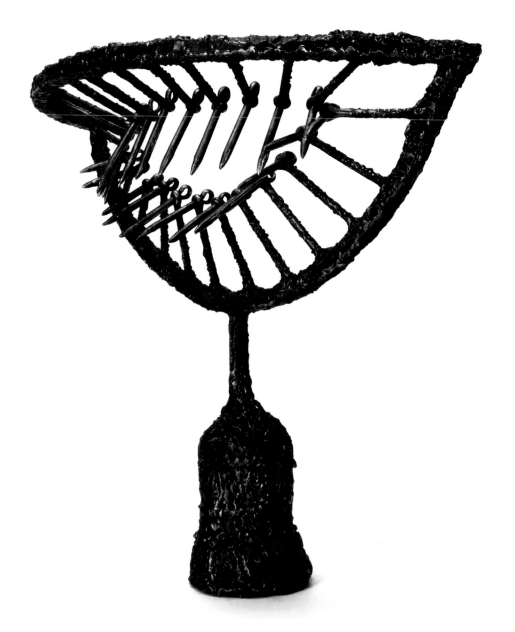

above
Eye of a Needle
Bronze
© Roya Farassat
Courtesy of Roya Farassat

left
Mother Tongue
Bronze
© Roya Farassat
Courtesy of Roya Farassat

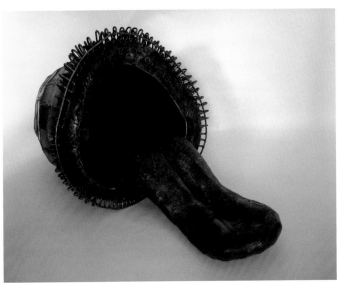

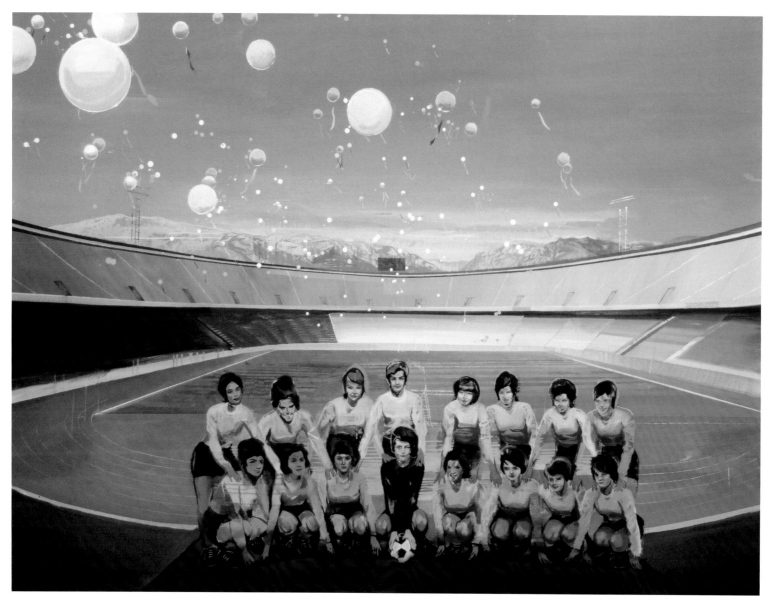

Born in Tehran in 1980, Mehdi Farhadian studied for a Master of Fine Arts at Tehran University. Using a vivid palette, he creates melancholic, nostalgic images of 1970s Iran – dreamlike visions that often bring to mind old photos.

So, we find a slightly surreal 'Pop'-like vision mixed with a childlike creative imagination: stewardesses emerge from the ocean, a team of beautiful women footballers appear in the Azadi – meaning 'freedom' – Stadium (something unthinkable in today's Iran), and women in 1970s dress enjoy a carefree afternoon in a public park, unfettered by social constraints.

Other paintings – for example, Mehrabad, from 2008 – reverse the images out, emphasizing what is not there. Again, this refers to the transience of memory. Mehrabad, which takes its name from the airport in Tehran, specifically seems to refer to the exodus from Iran caused by the 1979 Islamic Revolution – represented, perhaps, by the ferocious tiger on the floor.

above
Azadi Stadium, 2008
Acrylic on canvas
150 x 200 cm
Private collection, London

right
Mojezeh Mamouli, 2008
Acrylic on canvas
150 x 200 cm
Private collection, London

opposite
Mehrabad, 2008
Acrylic on canvas
180 x 130 cm
© Mehdi Farhadian
Courtesy of Mehdi Farhadian
and Mah Art Gallery, Tehran

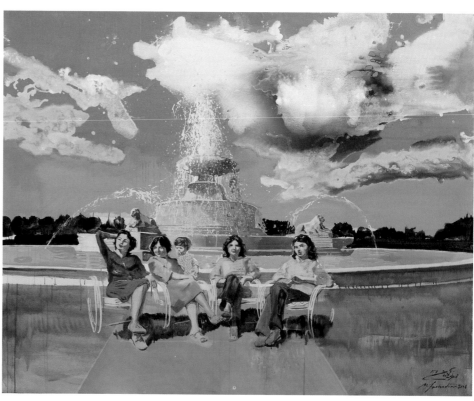

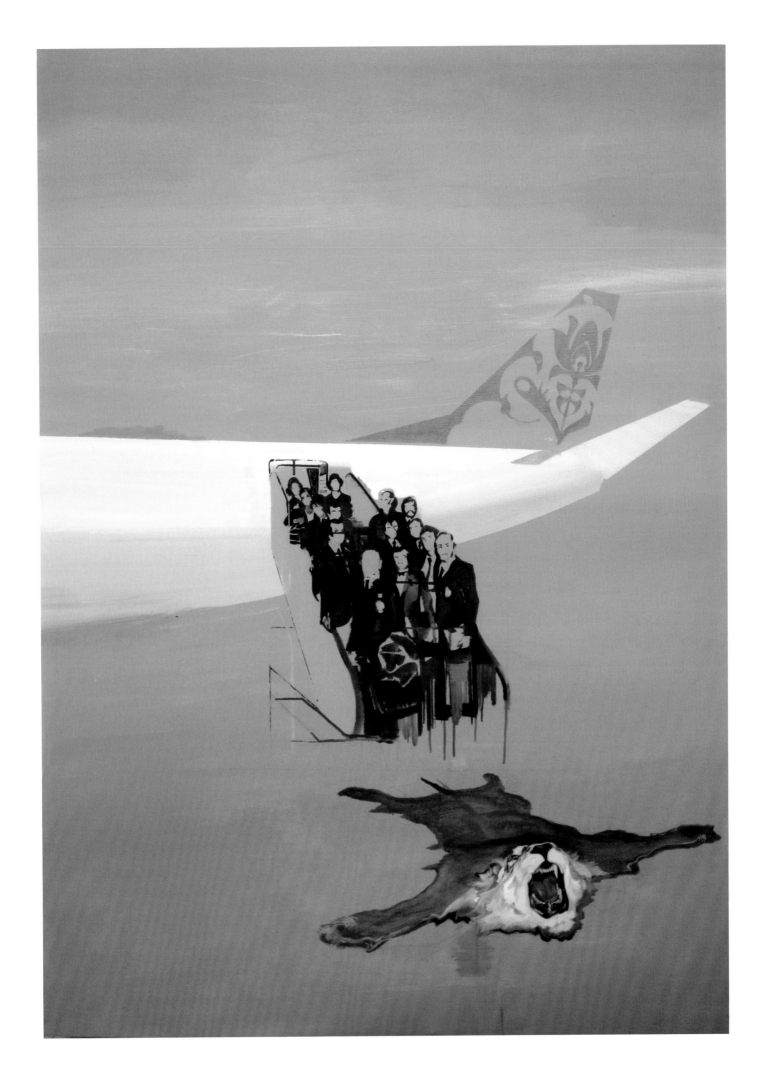

Mehdi Farhadian

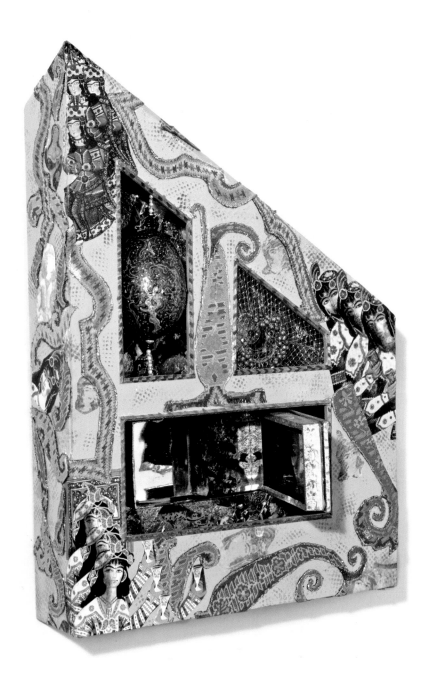

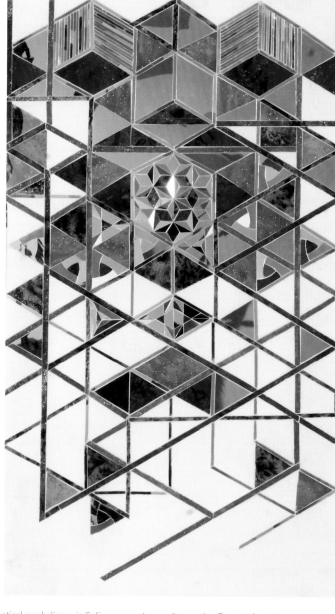

Born in Qazvin, Iran, in 1924, Monir Farmanfarmaian has enjoyed a remarkably long and impressive career. She originally studied Fine Arts at Tehran University, before going on to Cornell University in New York, and then graduating from the Parsons School of Design in 1949. After working for a while as an illustrator, she returned to Iran, where she worked until the Islamic Revolution of 1979, at which point she was forced into exile in New York.

Farmanfarmaian received serious international recognition as early as 1958, when she won a gold medal for her work in the Iranian pavilion in the Venice Biennale. In the 1970s she exhibited regularly at the Iran-American Society, which was a focus for modernism in Iran at the time.

Her works often use mirror, especially in the form of the particularly Iranian technique of mirror mosaic. Various traditional techniques, materials and motifs are then deftly combined with an overall modernist aesthetic to create one of the best expressions of genuinely modern, and genuinely Iranian, art. The effect has often been described as 'kaleidoscopic'. She developed this approach in the 1960s and 1970s, coinciding with her growing interest in traditional Iranian crafts and arts. She would travel extensively around the country, documenting and collecting coffee house paintings, reverse glass paintings and other examples of traditional arts. Sadly much of her collection was confiscated during the Islamic Revolution.

Farmanfarmaian's works have always had a strongly autobiographical content, combined with an innate mystical symbolism – in Sufi poetry, for example, mirrors are equated with life, light and hope. Some of her works, especially the mirror mosaics, are also rigidly geometric – in fact, Farmanfarmaian even hired a private tutor to teach her the mathematical bases of the traditional mirror mosaic designs. For Farmanfarmaian, however, this rigid geometry was just the beginning, a point of departure for her explorations of form. Alongside these traditional techniques, she has also often incorporated found objects, such as photographs, toys and pieces of textile. In the 1990s her work became more three-dimensional, often taking the form of decorated boxes.

In 2003 she was able to return to Iran for the first time, which prompted a new artistic direction – or rather a revisiting of some of her earlier works. Geometric patterns once again came to the fore, and she experimented with materials such as glitter. Her most recent mirror mosaics, such as *Mirror and Gatch*, bring fresh life to this ancient technique and have captured the imagination of a new generation.

With this new work (and the growth of interest in Iranian contemporary art) have come fresh exhibitions and a broader revival of interest in her work, with important exhibitions at the Victoria & Albert Museum in London, the Niavaran Cultural Centre in Tehran in 2006, The Third Line in Dubai and Leighton House Museum in London. And in 2007, Farmanfarmaian found new fame as an author, when she published her memoirs – appropriately titled *A Mirror Garden*.

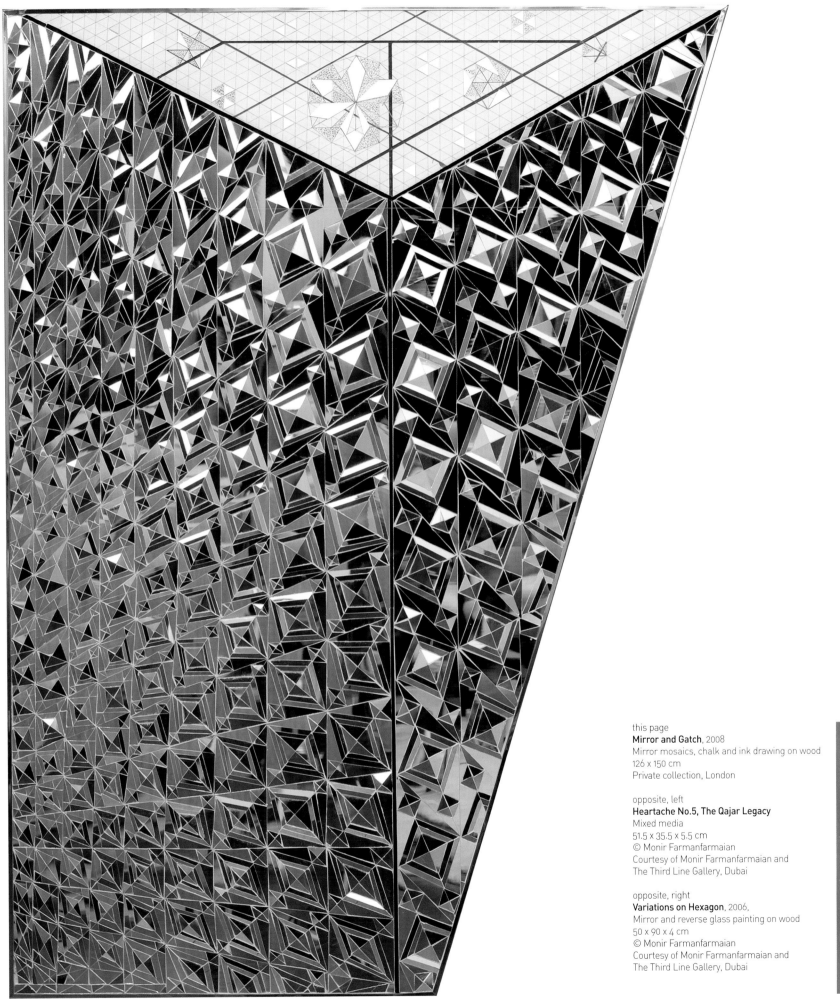

this page
Mirror and Gatch, 2008
Mirror mosaics, chalk and ink drawing on wood
126 x 150 cm
Private collection, London

opposite, left
Heartache No.5, The Qajar Legacy
Mixed media
51.5 x 35.5 x 5.5 cm
© Monir Farmanfarmaian
Courtesy of Monir Farmanfarmaian and
The Third Line Gallery, Dubai

opposite, right
Variations on Hexagon, 2006,
Mirror and reverse glass painting on wood
50 x 90 x 4 cm
© Monir Farmanfarmaian
Courtesy of Monir Farmanfarmaian and
The Third Line Gallery, Dubai

Monir Farmanfarmaian

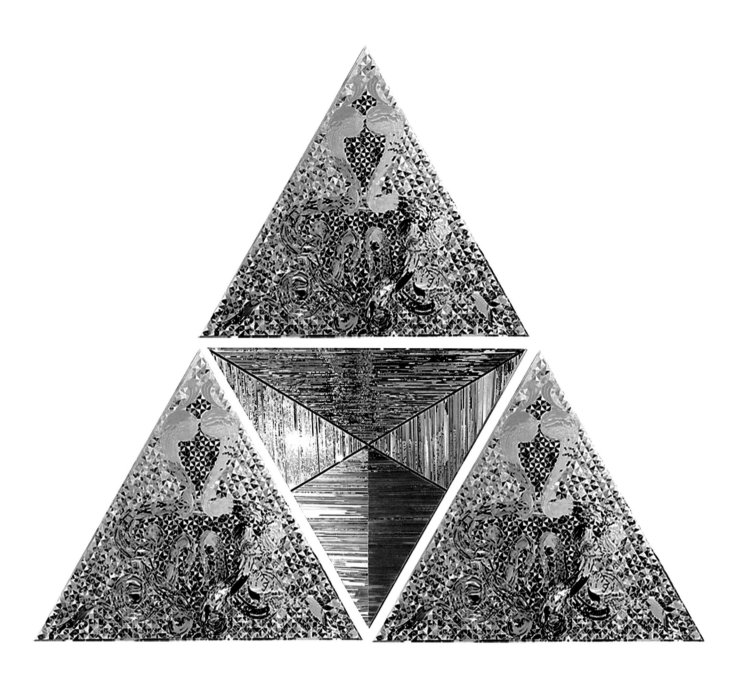

Trianglesin1, 2008
Mirror and reverse-glass painting
160 x 160 x 160 cm
© Monir Farmanfarmaian
Courtesy of Monir Farmanfarmaian and
The Third Line Gallery, Dubai

Monir Farmanfarmaian

134

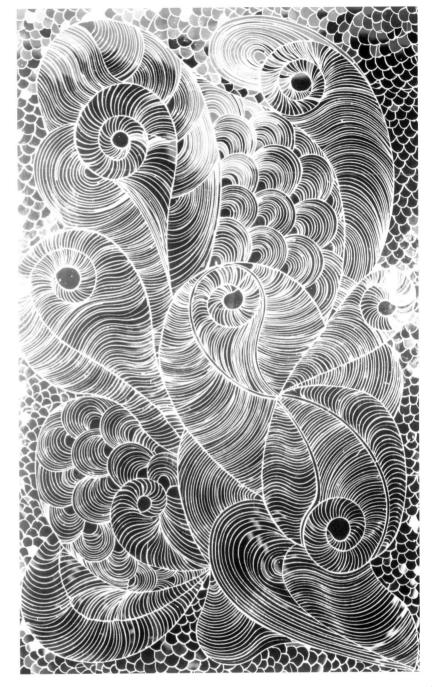

above
Under the Sea, 2007
Mirror mosaic and chalk on wood
100 x 70 cm
© Monir Farmanfarmaian
Courtesy of Monir Farmanfarmaian and
The Third Line Gallery, Dubai

left
Yazd, 2005
Mirror, stainless steel, reverse-glass
painting and plaster on wood
130 x 75 cm
© Monir Farmanfarmaian
Courtesy of Monir Farmanfarmaian and
The Third Line Gallery, Dubai

Monir Farmanfarmaian

'I'm an artist and an artist needs first of all to love beauty,' says Golnaz Fathi. 'First its beauty, and then comes the mind.'

Thirty-six years old and a rising star in the contemporary Iranian art movement, Fathi's recent success has allowed her the luxury of travel across Europe and America in search of inspiration. But Fathi is adamant as to the source of her true inspiration: Iran. 'There is no particular place outside my country that [is]

more important than any other. It's the moment, the place, that counts...I need to feel the soul of a place.'

Fathi was born into a professional middle-class Iranian family and was educated at a boarding school near New York. Returning to Iran, she studied for a degree in Graphics at Azad University in Tehran and then in 1996 for a diploma in Calligraphy at the Iranian Society of Calligraphy. Art was always part of the family outings. 'I was five years old and visiting a museum in London with my parents and they lost me. I had just stopped dead in my tracks in front of a sculpture.'

'I don't love art, I live it. I breathe it. I've been painting since the age of fifteen,' Fathi continues. 'At school I would spend my Saturday afternoons at the Sotheby's showrooms on Madison Avenue.' Fathi has gone on to develop radical new ways of using traditional Iranian calligraphy, an art form integral to the Persian culture. In fact, Fathi sees herself as having

helped usher in a new approach: 'What Cy Twombly did for the Latin script, I have done for Iranian calligraphy,' she claims. While her forms are calligraphic, they are also deliberately indistinct, blurred and abstracted into elegant swirls. Thick, flowing painterly lines are juxtaposed against spidery pen marks. Stripped of legibility, all that is left is beauty.

Golnaz Fathi, like her sister Nazila (who is the *New York Times* correspondent in Tehran), is the model of the newly assertive Iranian woman. Though to some it may seem paradoxical, Fathi believes that: 'The fruit of the Iranian Revolution has been the maturing of Iranian womanhood. In education, in the languages, the arts...in their financial independence. Look at the incidence of divorce and single mothers bringing up their children after divorce, backgrounds permitting. Elevation of intellect is the most important development for Iranian women in the last thirty years.'

above left
Untitled, 2007
Acrylic on canvas
120 x 120 cm
© Golnaz Fathi
Courtesy of Golnaz Fathi and
Xerxes Fine Art, London

above
Untitled (Yellow), 2007
Acrylic on canvas
120 x 120 cm
© Golnaz Fathi
Courtesy of Golnaz Fathi and
Xerxes Fine Art, London

opposite
Untitled, 2007
Acrylic on canvas
120 x 120 cm
Private collection, London

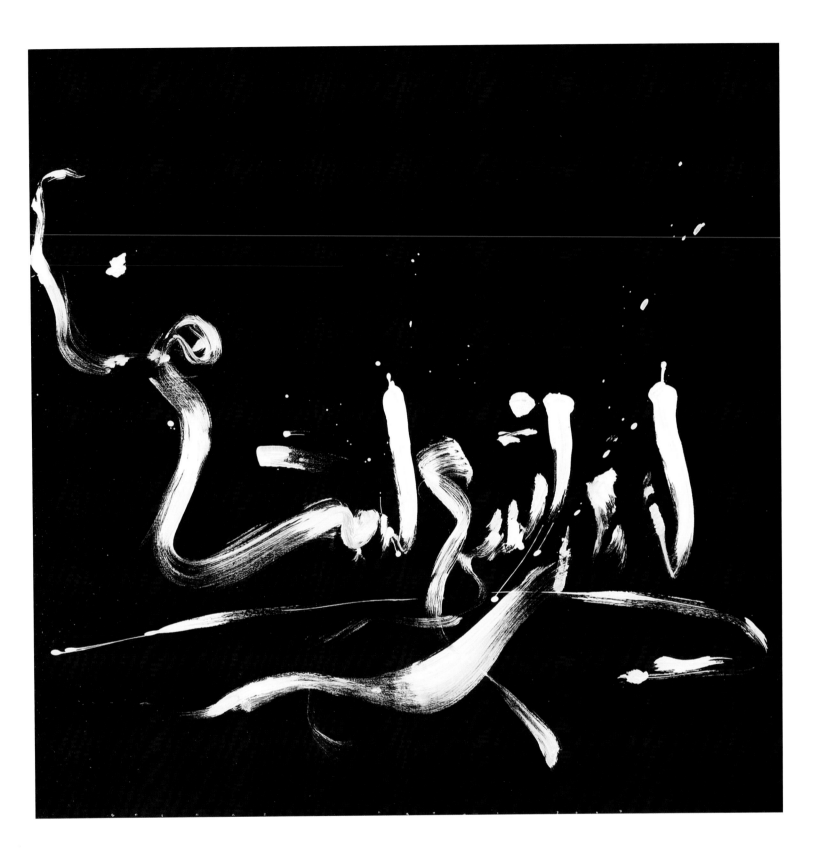

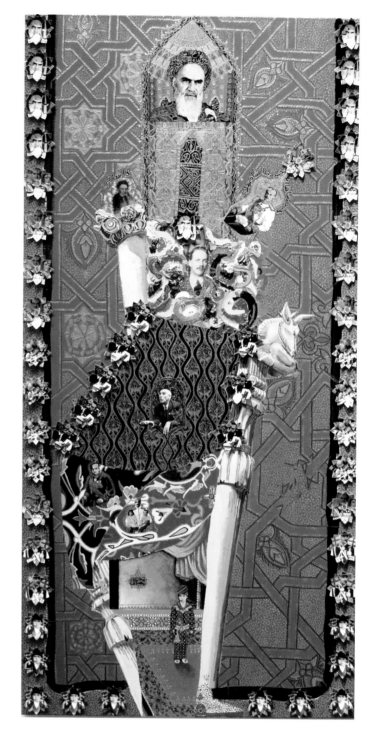

One of the youngest artists in this book, Asad Faulwell was born in Caldwell, Idaho, in 1982, to an Iranian mother and an American father. Raised primarily in California, Faulwell developed a strong interest in art while still young, and in 2002 transferred to the University of California, Santa Barbara, to study for a BA in Fine Art. While at university, Faulwell became intensely interested in the history and culture of the Middle East and for a short time pursued a degree in Middle East Studies. Though he didn't finish this degree, what he learned in the classes he fed back into his artistic approach.

After finishing his degree in art in 2005 Faulwell began to pursue his current body of work while working on a Master of Fine Arts at the Claremont Graduate University in Claremont, California. This work attempts to construct visually the modern political history

of the Arab world while at the same time looking at the nationalist struggles in Iran and Afghanistan.

Through this work Faulwell examines the relationship between Islam and governance, between prophets and politicians and between colonial kings and leftist revolutionaries. In particular the work focuses on the powerful movements catalysed by leaders Gamal Abdal Nasser and Mohammad Mossadegh. In Faulwell's words, 'My work challenges pre-conceived notions of nationality and cultural identity, creating an experience in which established labels become blurred and iconography from seemingly contrasting cultures occupy the same visual space. This combination leads to a simultaneous rejection and embrace of the old and the new, creating an environment that is in constant flux. Religion,

politics, nationality and culture are treated as the building blocks of identity, depicted and dissected to varying degrees. Through painting and collage I examine the way in which power is gained, consolidated and communicated.'

Aesthetically, Faulwell's work – what he calls 'mixed-media paintings' – blends photographic collage with elements of American contemporary painting and Islamic design. Thus we find snatches of Farsi prose next to photographs of leaders from the Second World War that have been manipulated on the computer into Islamic patterns.

above left
Mujahidat #3, 2009
Mixed media
61 x 76 cm
© Asad Faulwell
Courtesy of Asad Faulwell

above
Pillars – Iran (1882–1989), 2009
Mixed media
61 x 122 cm
© Asad Faulwell
Courtesy of Asad Faulwell

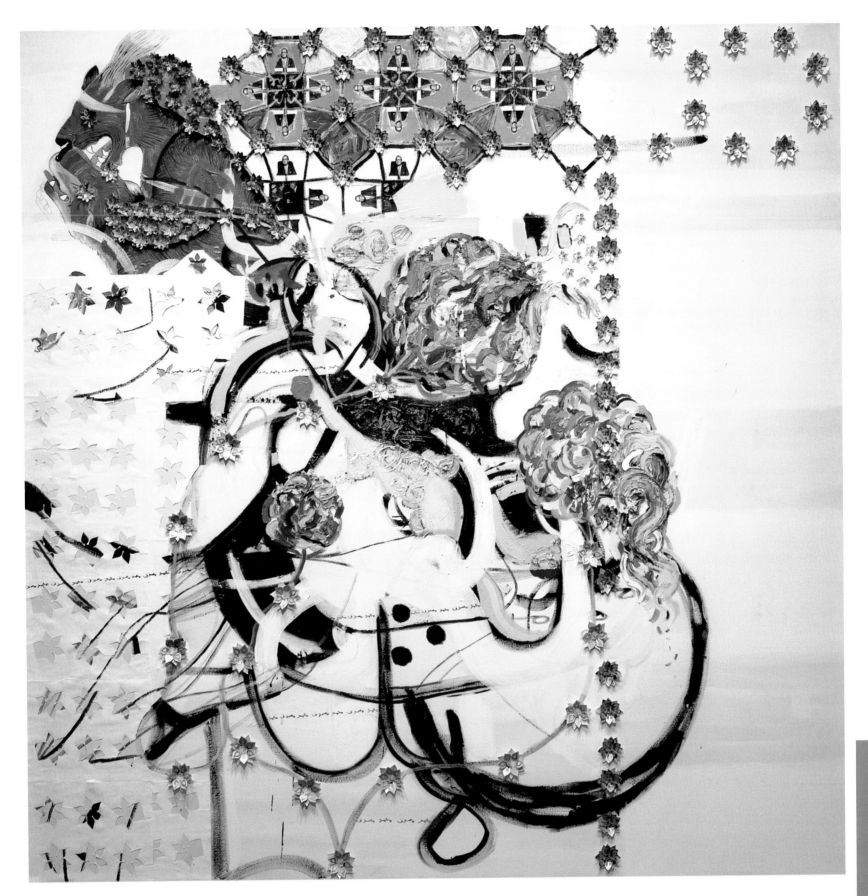

Second Coming, 2008
Mixed media
183 x 183 cm
© Asad Faulwell
Courtesy of Asad Faulwell

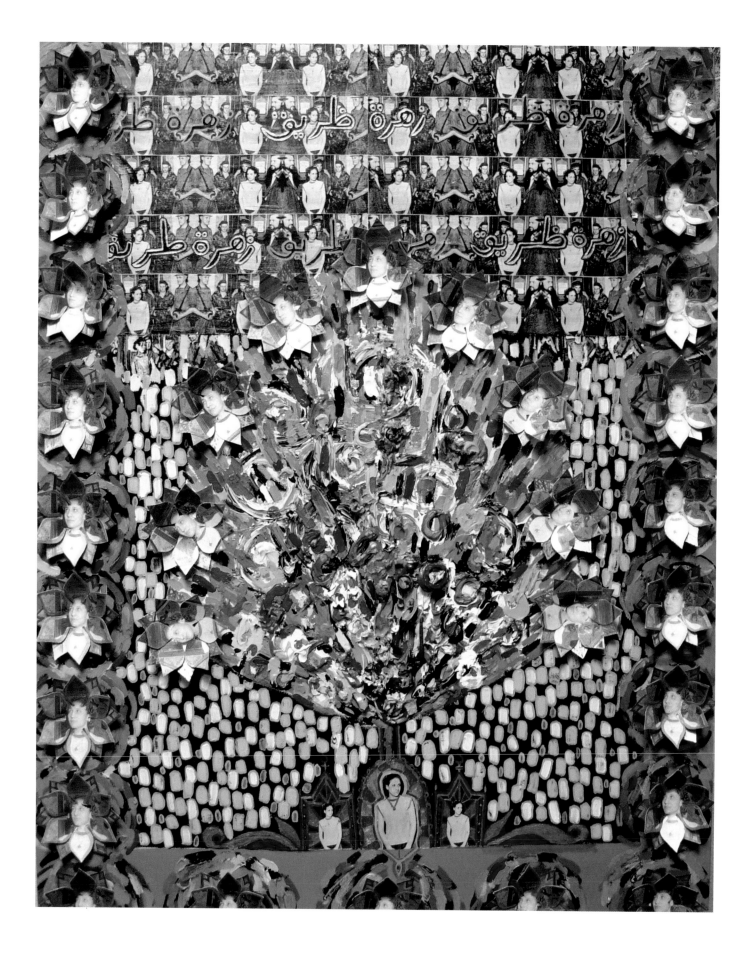

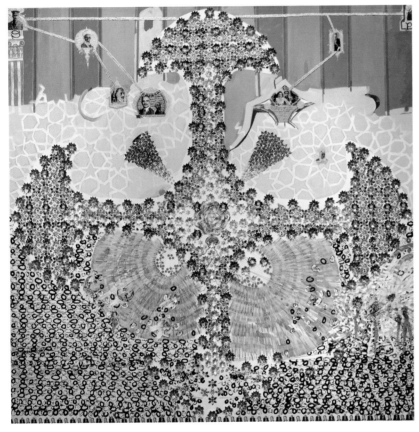 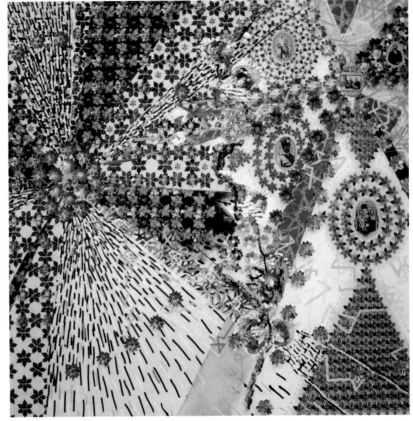

opposite
Mujahidat #1, 2008
Mixed media
61 x 91.5 cm
© Asad Faulwell
Courtesy of Asad Faulwell

above
Core, 2008
Mixed media
260 x 260 cm
© Asad Faulwell
Courtesy of Asad Faulwell

above right
Collision, 2008
Mixed media
173 x 173 cm
© Asad Faulwell
Courtesy of Asad Faulwell

Born in Tehran in 1984, Arash Fayez is at the time of writing still studying for a BA in Architecture at Sooreh University, in Tehran. However, it is as a photographer that Fayez is gaining an international reputation, as well as winning several awards. 'My first experiments, as for many other photographers, were inclined towards…nature,' he says of taking up photography. 'However, [humanity] motivated me to [try] documentary photography.' This interest soon spread to video art, installation and multimedia as Fayez explored subjects such as 'national currency and Islamic designs', the identity crisis of his generation and 'ex-girlfriends'. The attention, however, has not always been welcome: in 2008, one of Fayez's artworks was removed from an exhibition in Tehran due to the 'failure to comply with the Iranian Ministry of Culture and Islamic Guidance's code of ethics'.

above
Nudity in Tehran
© Arash Fayez
Courtesy of Arash Fayez

opposite, above
Persian Haiku
© Arash Fayez
Courtesy of Arash Fayez

opposite
Tarantists, An Underground Band in Iran – a Photo Story
© Arash Fayez
Courtesy of Arash Fayez

VI

Parastou Forouhar was born in Tehran in 1962, and has spent much of her career in Germany. Relentlessly inventive, she has developed several distinct strands of artistic production that combine technology with traditional Persian script. Drawings, calligraphy, digital manipulation, film and installation all come together in an exploration of identity.

Perhaps most striking is Forouhar's concept of the 'written room' – essentially a room covered in writing. In this, the flowing Persian script is turned into an ornament, covering the white walls, ceilings and floors of the museums where it is installed. Since the text is largely illegible for Western viewers, the script becomes a decorative pattern, pure ornament – in fact, even with an understanding of Persian the

text is difficult to follow, being disjointed and incoherent, a collection of broken syllables. Within the room are ping pong balls, also covered in script – while they, too, are illegible, they can at least be grasped physically.

Writing and space are connected in a different way in *Safari* (2004), in which a giant sack is covered in characters and ornaments. The title promises adventure, wilderness and exotic worlds, but as in the 'written room' the signs remain imprecise, vague. For the Western viewer, the writing refers only to the 'other'. Woven into the sack are rich chador fabrics, as well as brightly coloured materials used for Shi'ite mourning ceremonies. The Persian text is a dirge for the Shi'ite martyr Imam Hussein: 'This king without army accompanied by tears

and sorrow, the wounds on his body are more numerous than the stars in the sky...this fish, sunk in a sea of blood, is your Hussein.' Forouhar has also produced a series of 'digital drawings', called *RED is my name, GREEN is my name*. These beautiful, colourful squares play with repeated and disrupted patterns. More conventional drawings can be found in the 'Take off Your Shoes' series, which were used in a short film. These specifically deal with the murders of Forouhar's parents in Iran in 1998. Both were members of the opposition, and so their deaths were widely seen inside and outside the country as politically motivated. The stark images and the Kafkaesque dialogue show the facile nature of bureaucracy as Forouhar attempts to get information on what happened to her parents.

above left
Body Letter Quadripartite, 2000
Digital print
© Parastou Forouhar
Courtesy of Parastou Forouhar

above
Installation view, 2000
Morgen Gallery
© Parastou Forouhar
Courtesy of Parastou Forouhar

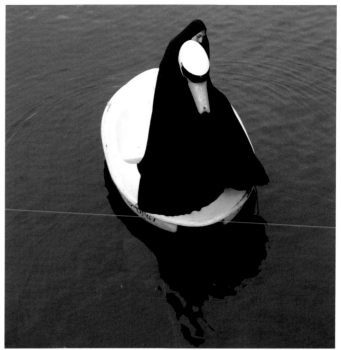

above
From 'The Swanrider' series,
2004
© Parastou Forouhar
Courtesy of Parastou Forouhar

far left
Warten, 2000
From the 'Take off Your Shoes'
series of drawings
© Parastou Forouhar
Courtesy of Parastou Forouhar

left
Akten Lesen, 2000
From the 'Take off Your Shoes'
series of drawings
© Parastou Forouhar
Courtesy of Parastou Forouhar

Parastou Forouhar

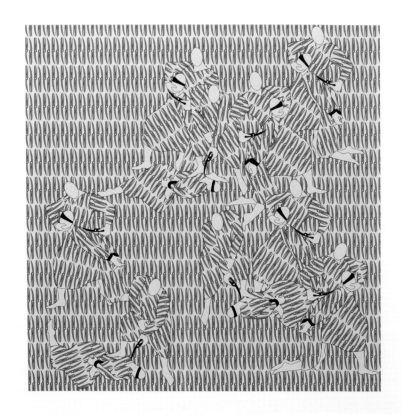
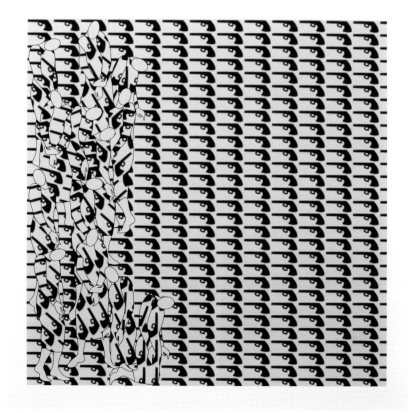

RED is my name. GREEN is my name, 2008
Digital drawings – Serigraph
40 x 40 cm (each)
Private collection, London

146

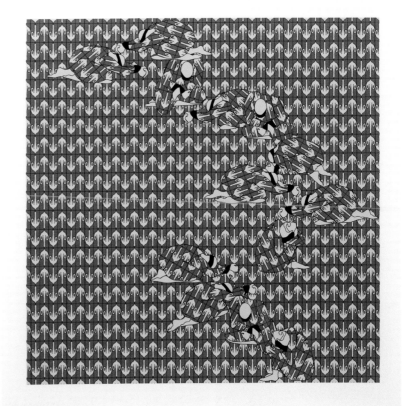

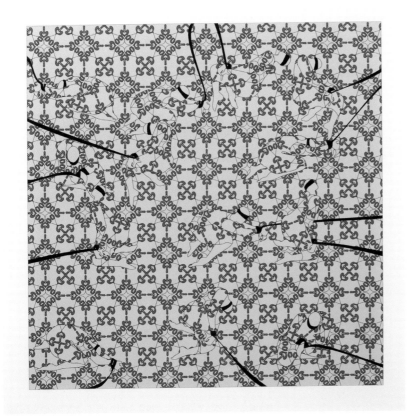

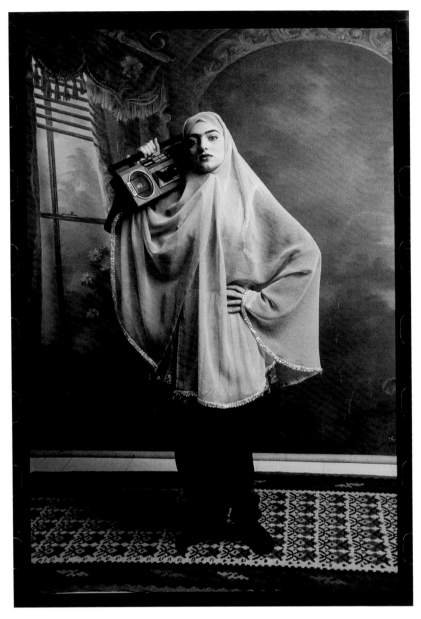

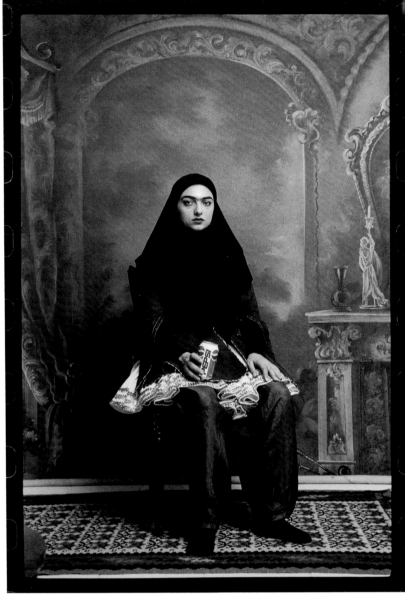

Shadi Ghadirian is one of the most celebrated contemporary Iranian photographers of her generation. A pre-Revolution child (just), she was born in 1974, five years before the political whirlwind that changed the country so dramatically.

Her earliest works were inspired by traditional images of Qajar women from the mid-19th century. In them, she adds a clever, witty and contemporary twist to the very staged portraits by associating the women with modern Western products and ideas. This work, whose objective was to highlight the stark contrast between tradition and modernity in Iranian society, propelled Ghadirian into the spotlight of the international art scene. They were shown extensively throughout the Middle East, Europe and the United States, in both commercial galleries and museums, and the artist has never looked back since.

Ghadirian draws inspiration both from her own life and also from the lives of women around her in Iran, upon whom are imposed strict guidelines, expectations and behavioural patterns: 'I try to project a snapshot of life and the community I live in, especially focusing on the social matters that concern and inspire me.' She is fascinated both by feminism and by femininity, as well as the paradox that governs Iranian women's experiences in the public and private arenas – the great divide between appearances and reality.

Both photography and its close relation, film, have always had keen followers in Iran. The country itself, thanks to its rich culture, history, traditions and landscape, has proven a great source of inspiration for many artists in this field. However, in 1998, when Ghadirian graduated from Azad University, she was one of only a few to receive a degree from the photography department – most of those studying photography were more interested in journalistic-style photo-reportage, focusing on news and political developments in the country.

More recently in Iran, however, there has been a focus on artistic photography that carries a strong message. Both Ghadirian and her husband, Peyman Hooshmandzadeh – a popular photographer in his own right – were early pioneers in this field. Ghadirian says that she chose to study photography because she is 'an extremely impatient person. The act of taking a photograph allows me to gain instant satisfaction. I can then decide on the spot whether I have achieved my desired goal or not.' She continues by saying that, 'even though my photographs are mostly staged in interior surroundings, they deal with reality. Through them, I try to convey a strong social message. I know I cannot change the world with my pictures but what I can do is make people think.'

In the series 'Like Every Day' she explores and critiques the traditional expectations of married women in Iranian society, confined to a life of domestic chores such as cleaning, serving, cooking and ironing. To this body of work belongs the 'Chador' series, in which women have their faces – and thus their identities –masked by household objects such as pots, pans and kettles. Ghadirian laughingly says: 'I myself was faced with the stark reality of these expectations and routine chores when I got married to my husband. It was a reality I was not accustomed to before!' The women in her works are thus squeezed in a polarized world of tradition and modernity, reality and choreography. Perhaps these women also have 'veiled' emotions and desires, which they won't allow themselves to show in public?

When asked if she would ever contemplate collaborating with her husband, she is quick to respond: 'My husband and I have never cooperated on a project. We do, however, use each other as sounding boards for our ideas. He is the first person I go to when I think of a new project. He is also the first person I request constructive criticism from.' She then adds: 'Also, the direction of our individual projects

seems to have taken opposing routes. He tends to focus mostly on men's issues set in the exterior environment, whereas so far I have focused on women's issues set within interiors.'

As to whether she plans to continue in this vein, she responds: 'Women's issues have taken centre stage in my work till now. Even in my latest bodies of work, 'Nil, Nil' and 'White Square' based on the theme of War, you sense female presence even though you don't physically see it.' However, she continues: 'My daughter is one-and-a-half years old today and it is amazing how preoccupied and intrigued I am with her every move, her every thought...so don't be surprised if she or children will be the focus of my work in the future!'

Ghadirian has one final thought on her home: 'I derive immense pleasure from the experience of living in Iran, with all its simultaneous challenges and beauty. I don't enjoy too calm a life. I need the challenge to make me think and generate good ideas.'

Shadi Ghadirian

above
From the 'Nil, Nil' series
C-Type photograph
© Shadi Ghadirian
Courtesy of Shadi Ghadirian

right
From the 'Ctrl+Alt+Delete' series
C-Type photograph
© Shadi Ghadirian
Courtesy of Shadi Ghadirian

above
From the 'Nil, Nil' series
C-Type photograph
© Shadi Ghadirian
Courtesy of Shadi Ghadirian

left
From the 'White Square' series
C-Type photograph
© Shadi Ghadirian
Courtesy of Shadi Ghadirian

Born in Tehran in 1976, Dariush Gharahzad trained in painting and drawing and today concentrates on extremely realistic paintings that are often mistaken for photographs. He has exhibited in several shows in Tehran, and one in London.

Gharahzad's work concentrates first and foremost on the social and urban life of modern-day Tehran. Colour and atmosphere are everything in his compositions: women walk by wearing vivid red headscarves, set against a blue wall; graffiti, a new form of expression among the Tehran youth, is reinvented as something beautiful. Gharahzad is especially interested in the booming youth culture, and the ways in which it quietly contravenes the rules of Islamic society: 'I think the message [of my art] is the people have changed – especially the young people,' he says. 'They need something more interesting than whatever is inside their culture – the traditional culture.'

above and right
Untitled, 2007–2008
Acrylic on canvas
120 x 180 cm
© Dariush Gharahzad
Courtesy of Dariush Gharahzad and
Day Art Gallery, Tehran

Dariush Gharahzad

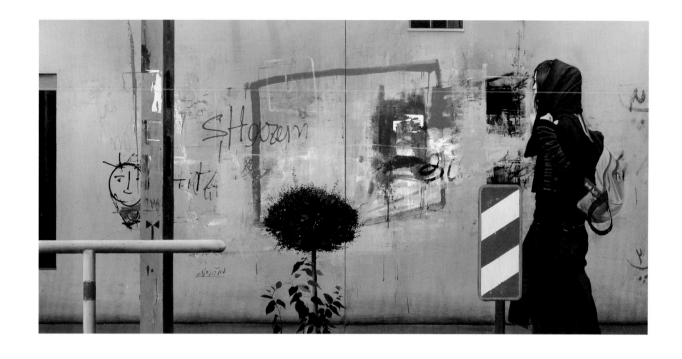

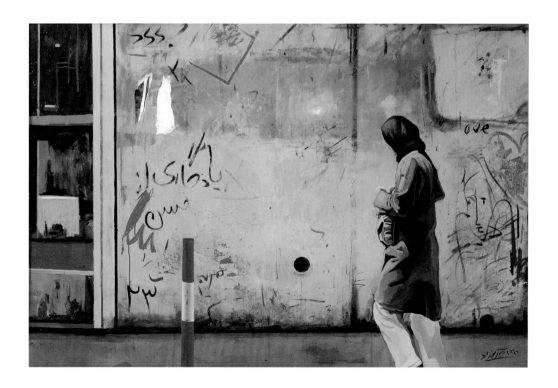

above
Untitled, 2007–2008
Acrylic on canvas
120 x 180 cm
© Dariush Gharahzad
Courtesy of Dariush Gharahzad and
Day Art Gallery, Tehran

left
Untitled, 2007–2008
Acrylic on canvas
120 x 180 cm
Private collection, London

Dariush Gharahzad

 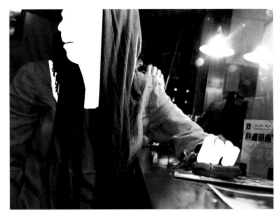

Amirali Ghasemi, born in Tehran in 1980, is at once an artist, graphic designer and curator. He studied Graphic Design at the Azad University in Tehran, graduating in 2004, and since then has had a phenomenally busy career. His work as a graphic designer has featured widely in surveys of young Iranian design, and through his online, web-based work he has been able to build up a strong international profile.

Ghasemi's work is in one sense very simple, yet at the same time remarkably powerful. He takes photos of Tehran's youth enjoying themselves – whether at parties, in coffee houses or out on the streets – and then removes every trace of exposed skin, reducing them to clothes and hair. Speaking about one of the most striking series, 'Coffee Shop Ladies', Ghasemi has said: 'Due to the absence of public places, cafes are a symbol of social freedom in Iran. They are the only places where young people, intellectuals and journalists can interact. The faces of the young ladies portrayed in these photos are

hidden by a blank space.... By reducing the level of information that each photo can offer to visitors, I wanted to prevent the media from misusing and/or manipulating the images on a mass scale.'

If this seems dehumanizing in any way, Ghasemi actually – literally – gives these women a voice: 'The connection with the real characters isn't lost completely. When 'Coffee Shop Ladies' is presented as part of an interactive programme, viewers are free to find out more about the characters by clicking on the blank spaces, then listening to what the ladies have to say.' Thus new media can be used as a genuine art form that can add new layers to the work.

Alongside his own artistic production, Ghasemi also has a growing reputation as one of the leading curators of young Iranian artistic talent. In 1998 he set up the successful parkingallery, which shows the work of up-and-coming artists, and in 2002 established a platform for Iranian artists at parkingallery.com.

The 'Coffee Shop Ladies' series, Tehran,
2004–2005
Treated photographs
© Amirali Ghasemi
Courtesy of Amirali Ghasemi and
the Azad Gallery, Tehran

Babak Ghazi was born in London in 1976 and continues to live and work in that city. He studied drawing and painting first at Edinburgh College of Art, and then at Chelsea College of Art and Design, in London, graduating in 2000. He has exhibited extensively in Europe.

Ghazi's work tends to focus on assemblages of found material, often referring to well-known artists (Warhol, Koons), or even pop icons (David Bowie in the case of *Heroes*). Fame and celebrity seem to be important subjects for him. Other works – for example, *Creative Review* – make us look afresh at everyday objects, teasing out subversive messages.

above
Heroes, 2006
Perspex cubes, record cover,
magazine cutout, wood,
tinsel wig, microphone
106 (approx.) x 32.2 x 32.2cm
© Babak Ghazi
Courtesy of Babak Ghazi

right
Creative Review, 2005
Magazines
56.6 x 56.6 x 0.4 cm
© Babak Ghazi
Courtesy of Babak Ghazi

Babak Ghazi

156

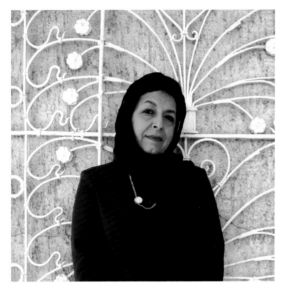

Lili Golestan is considered by many to be the 'grande dame' of Iranian contemporary art gallery owners and promoters of culture in general. Founder and owner of Tehran's Golestan Gallery, she has been at the heart of the Tehran art scene for two decades.

'Art and culture have always taken centre stage in my life, even from a very young age,' Golestan says. The daughter of the renowned writer and filmmaker, Ebrahim Golestan, and a ceramicist mother, she grew up in a home that often doubled as a sort of 'salon', attracting poets, writers and artists. She went on to study textile design in Paris, while her brother, Kaveh Golestan, became a renowned photojournalist whose life was tragically cut short while covering the recent Iraq war.

In 1988, Golestan transformed her Tehran home into an art gallery with a dual purpose: first and foremost, she wanted to help discover young artists, but secondly she had a desire 'to spread art into peoples homes'. 'My objective was to create the need and appreciation for art in ordinary people's lives.' By helping to develop

a 'collector's mentality' among Tehran's post-Islamic Revolution middle class, she hoped to revive the spirit of Persian culture with which she had grown up in the 1960s and 1970s.

Today there is no doubt as to the central role she has played in Iranian contemporary art of the last two decades. 'Many of today's most successful artists started with me and with my support,' she claims. 'People wanted to buy art but couldn't afford to. I made it possible for them by accepting payments in installments or with post-dated cheques.... Some of these same people are today among the biggest collectors of Iranian contemporary art!'

Golestan's days are action-packed. 'I wake up in the mornings with a large cup of coffee and a couple of blood pressure pills, as I know I have a hard day ahead of me,' she jokes. 'What I like most about my work is seeing the energy and excitement with which the young artists work...to be there for them when they need someone to talk to and to encourage them to hang in there when the going gets tough. That's ultimately what makes me tick.'

She is, she says, 'constructively critical about the artists that I choose to support.... When I first started, I used to dig around for new talent. Today the artists come to me themselves. I look for artists who do art for art's sake and not those who are after quick fame and money. What I most look for in an artist is a sense of audacity, as well as innovation.'

Golestan is a great supporter of the arts in the broadest sense of the word. She would, she says, much prefer it if society were to move away from the idea of giving art a 'nationality' or branding art as 'good' or 'bad'. Art, she says, should be purely subjective. 'Working as a gallerist in Iran is not all sugar and spice and all things nice,' Golestan says. 'There are many frustrations and challenges, not least of which is the constant interference of the authorities who think of themselves as the custodians of our art and culture. We don't need custodians. We need patrons,' she states boldly.

She has also witnessed first-hand the development of the art scene since the Revolution. 'After the Iranian Revolution we

saw the creation of many art schools and consequently we had a significant increase in the numbers of art students,' Golestan explains. 'Before the Revolution, there were only ten galleries. Today, we have some 85 galleries.... My gallery is booked full for the next three years! And each show lasts only a week.'

Golestan is delighted that so many foreign buyers and collectors are flocking to Tehran to buy Iranian artists' works, even if, with all these galleries running after talent, the Tehran art scene can sometimes resemble a bazaar. Golestan, though, believes that professionalism will win out at the end of the day: 'We have a good working relationship with other galleries, but there is also a lot of competition. There are more and more collectors and every gallery owner wants to get to them first.' She continues: 'We have maintained our position by practising a fair pricing policy and by treating our clients professionally. But it is a daily struggle. I sometimes don't know where to find the energy and strength to continue doing things my way.'

Golestan Gallery

'Wars came to Kaveh Golestan's door', as Carlos Guarita wrote in the obituary of the Iranian photojournalist and documentary filmmaker published by *The Independent*, in 2003. Golestan covered the 1979 Iranian Revolution, the Iran–Iraq War, the Iraqi campaign against the Kurds and both Gulf Wars (1990–91 and 2003). He photographed the triumphant return of Ayatollah Khomeini to Iran, shot the only picture in existence of the Ayatollah smiling and then in 1989 captured the riotous scenes at his funeral – images published in newspapers and magazines around the world. Golestan documented the immediate aftermath of Saddam Hussein's chemical attack on Halabja in Kurdistan in 1988 – images that were ignored by major news agencies in a pro-Saddam Hussein political climate.

Golestan was a committed social realist who never flinched from taking intimate portraits of Tehran's disenfranchised, such as prostitutes and migrant workers. His iconic black-and-white photography brought him worldwide attention. For his coverage of Iran, in 1979 he received a Robert Capa Gold Medal – an award he only claimed thirteen years later, in order to avoid accusations from his countrymen of supporting the West. A regular contributor to *Time* magazine, he also became a noted documentary filmmaker. His 1991 film about journalists in Iran, 'Recording the Truth', resulted in two years' house arrest in Tehran. Stripped of his journalist's credentials and barred from leaving the city, he lectured at the University of Tehran Art College and in the end inspired a generation of fine Iranian

photographic artists and photojournalists who have since gone on to international recognition. During this period he continued a lifelong project, photographing the city's dispossessed – this time an asylum for mentally ill children, a challenging exposé that was published by the *Observer*. In 1999 Golestan joined the BBC's Tehran bureau as a cameraman. On 2 April 2003 on assignment, covering war in the way he always did – close up and without fear – he stepped on a landmine and died in Kifri in northern Iraq. He was 52 years old.

above and opposite
From the 'Bloodland' series, 1980–1988
Black and white photographs,
digitally coloured in 2002
© Kaveh Golestan
All courtesy of Hengameh Golestan

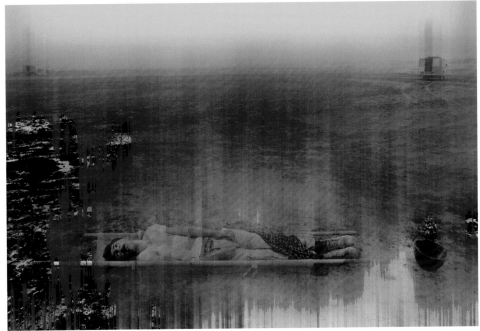

Barbad Golshiri is not afraid of controversy: 'I'm anti-replication. I'm not commercial. I don't adapt to the market, particularly the Dubai market which has changed the works of many of my contemporaries.' Born in 1982, Golshiri is a child of the Iranian Revolution. He knows his own mind and has no time for the stereotypes that he sees as being detrimental to the integrity of the new wave of contemporary Iranian art.

Golshiri travels the world freely but has chosen to live in Iran. Recently featured in London's controversial Saatchi Gallery show 'Unveiled: New Art from the Middle East', his works have been shown abroad as the symbol of cutting-edge Iranian art, but Golshiri disdains publicity and cares nothing for the money, vanity and ego that, according to him, have become a hallmark of the contemporary art market.

'It's... "exoticism",' Golshiri explains. 'Iranian calligraphy formalized with abstractions and the other stereotypes like the chador...aestheticizing doxas and façades like the works of Shirin Neshat.... The auction houses come round and

say they can't sell controversial work and the artists change their styles to suit the market. Same thing applies to the collectors.'

But where is there an unadulterated art market? 'In Europe, there is a depth of expertise and a discursive environment,' he replies. 'In Iran, it is in a transitory state, the artists producing art that is neutral, pretty and not dangerous.' But does art need to be dangerous to be effective? 'Not necessarily,' Golshiri concedes. 'Recently the so-called "Iranian art" pretends to be provocative, but it is really self-propaganda.... Look at Neshat and [Marjane] Satrapi, who live outside the country and don't see the layers beneath the surface.' Of course, if such artists were to return to their homeland, their receptions would be far from friendly.

Golshiri likes to quote philosophers in refining his argument: 'When you aestheticize stereotypes, it is intended for mass appeal, just like state propaganda.... Nietzsche said: "Whoever fights monsters should see to it that in the process he does not become a monster.

And if you gaze long enough into an abyss, the abyss will gaze back into you."…. Art has always existed in my country…it takes a war to get the cameras to focus,' the artist complains, referring to the recent interest in Iranian art based on geopolitical circumstances.

Golshiri chooses to stay in Iran, despite the difficulties and security issues, because he loves to come back to his country. 'Even crossing the street is a security issue in Tehran,' he says. 'We need clean hands in the business of Iranian art. The artists are not all compromised, we're not all self-centred,' Golshiri pushes the point, regretting that the political impact of fine arts is less than the written word. 'How many people visit galleries in Iran?' he asks rhetorically.

'The art of the [former president Mohammad] Khatami period is inevitably different from that of [President Mahmoud] Ahmadinejad's period,' Golshiri says. 'The zeitgeist penetrates whether we like it or not!' Golshiri says there is relatively free intellectual discourse in Iran, but only at the private level

– artists won't put their words into print. The censorship is not confined to Iran when it comes to Iranian contemporary art: 'I couldn't even get my work depicting the chain murders of Iranian intellectuals shown in "Underground", an exhibition in Gothenburg in Sweden. All I got was an apology. Just an apology!'

'The desires of the Iranian people today are pretty much the same as their desires a hundred years ago at the time of the Constitutional Revolution [1906–11]. This is the endemic sickness that persists. People will vote for whoever represents their sentiments, just as people voted for other Führers.' Golshiri believes that the social and cultural underpinnings of any society determine the art. He refers to the concept of 'zan zalili' in Iran. 'Any man who behaves well towards his wife is called weak and henpecked in disdain, even in our educated households. Each family is a leitmotif of the system, the politics of the land.' We may not have any dealings with politics, Golshiri concludes, 'but politics will have the final word.'

Barbad Golshiri

161

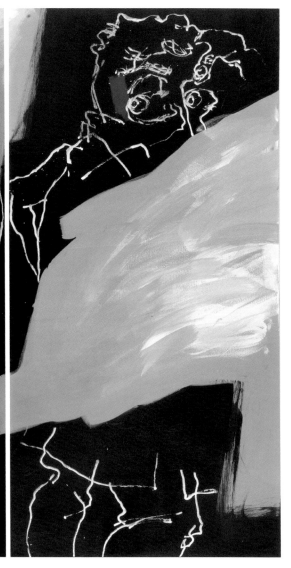

Born in 1979, Neda Hadizadeh studied at the Azad University in Tehran. She has shown at the Golestan Gallery in Tehran and The Third Line Gallery in Dubai.

Ghosts, fragmented bodies, bony hands and giant eyes are all recurring subjects in Hadizadeh's paintings. Rapidly executed in acrylics and broad brush strokes, they get their power from their sheer scale, as fractions of bodies are blown up to huge size. The hands in particular often appear to be concealing or hiding something, giving the pictures a sense of dark, psychological drama. Colour is used sparingly, while most of the figures are outlined in black on white, or white on black.

above
Untitled, 2007
Acrylic on canvas
Triptych, 120 x 180 cm
© Neda Hadizadeh
Courtesy of Neda Hadizadeh and
The Third Line Gallery, Dubai

right
Untitled, 2007
Acrylic on canvas
120 x 120 cm
© Neda Hadizadeh
Courtesy of Neda Hadizadeh and
The Third Line Gallery, Dubai

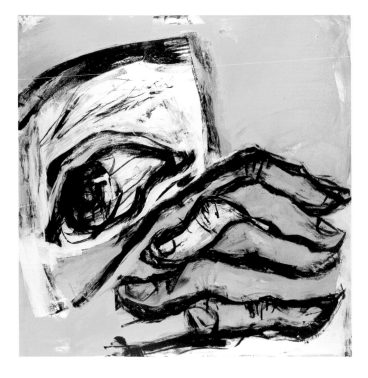

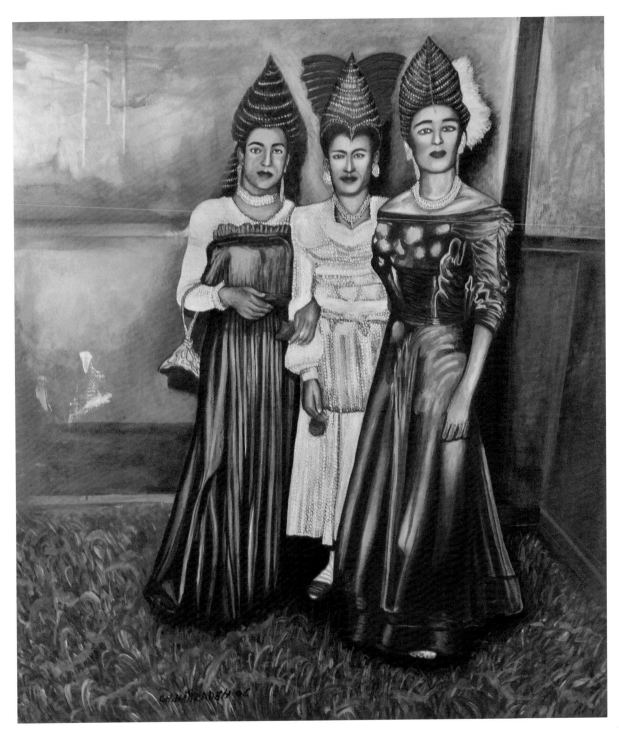

Untitled, 2006
Mixed media on paper
85 x 92 cm
© Ghassem Hajizadeh
Courtesy of Ghassem Hajizadeh and
LTMH Gallery, New York

Ghassem Hajizadeh was born in Lahijan, Iran, in
1947. In 1967, he moved to Tehran to study at the
High School of Fine Arts, and in time became a
very successful painter, especially in the 1970s.
Unusually among artists, he chose not to leave
Iran at the time of the Islamic Revolution, but
did eventually move to Paris in 1986, where he
continues to live and work. His work is clearly
influenced by certain Western painters (for
example, Renoir and 'Le Douanier' Rousseau),
but the sitters are frequently Persian. In fact,
Hajizadeh typically paints from photographic
portraits, a habit that dates back to when he
worked in his father's photographic archive.
However, rather than producing works of
photo-realism, he uses these images to project
feelings of nostalgia.

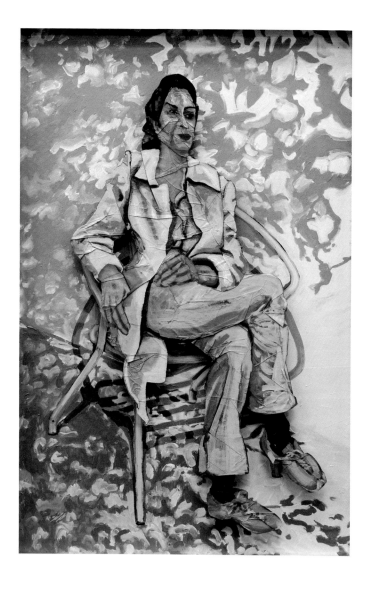

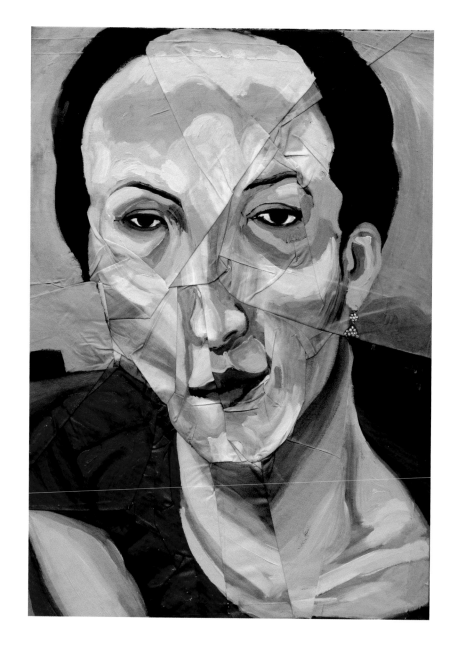

Born in Tehran in 1963, Mohammad Hamzeh studied art in the same city and has been exhibiting in Iran since the early 1990s. His paintings – mostly portraits of people who surround him in everyday life – are made in a naturalistic manner, to scale and in proportion; however, Hamzeh then deliberately crumples and distorts the works, an act by which he hopes to 'capture the subject's inner soul'. This fragmented effect, though interesting from a formal point of view, can also suggest unease and dislocation.

More recently, Hamzeh has begun to experiment with the opposite process: producing the 'correct' painting, and then stretching it out of shape. The effect is a little like looking into a convex mirror. Hamzeh has also branched out into a form of painted sculpture – or perhaps that should be three-dimensional painting – that takes his ideas to the next level.

above
Untitled, 2006
Acrylic on wood with paper
148 x 97 cm
Private collection, London

right
Untitled, 2007
Mixed media
125 x 90 cm
© Mohammad Hamzeh
Courtesy of Mohammad Hamzeh and
Mah Art Gallery, Tehran

Mohammad Hamzeh

Recreational Area
Digital drawing, 9 Diasec prints
70 x 100 cm
© Arash Hanaei
Courtesy of Arash Hanaei

Arash Hanaei was born in Tehran in 1978, and in 2002 graduated with a degree in Photography from the Azad University. He has had solo shows in Iran and Germany, and has taken part in group shows in several other countries. Commenting on his practice, Hanaei has said: 'I think my works are products of a muddied and demented effusion of media information. Bits of political news accumulate in brain folds – news of wars, sports, social and ethnic concerns, George Bush, student demonstrations at Sorbonne against vocational laws, racism, long-range North Korean missiles, images of terrorist groups on Al Jazeera, the Ski Dubai Snowdome, an airplane crash in Russia, David Beckham's monthly salary, the setting off of a bomb in Iraq, the avian flu statistics and a myriad of short or long info-particles.'

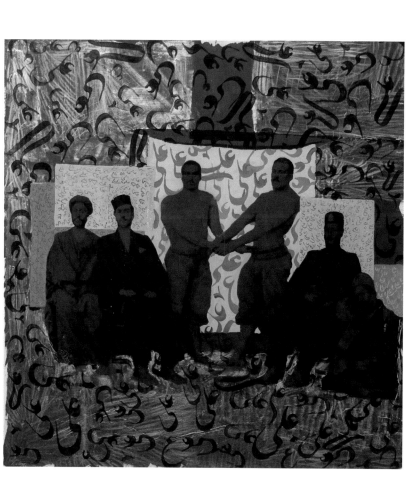

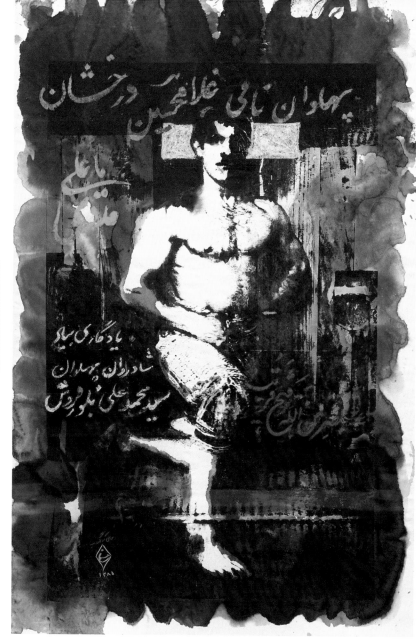

Born in 1963 in Tehran, Khosrow Hassanzadeh studied painting at Mojtama-e-Honar University and then Persian Literature at Azad University, finishing in 1999. Today he combines a career as an actor with another as a visual artist, living and working in Tehran. His work is represented in the collections of the British Museum, London, and the Tehran Museum of Contemporary Art.

As an artist, Hassanzadeh is best known for producing what appear to be little shrines. Originally these were 'dedicated' to people who might often not be recognized – his mother, for example – but gradually the focus has shifted to Iranian celebrities, such as singers from the past or even the famous Persian wrestler Takhti. He calls them 'ready to order' boxes, referring to the Tehran tradition of pre-ordering

certain services for special occasions such as weddings. In them, old black-and-white photos have been loosely coloured with paint or ink, and overlaid with twinkling lights, writing and small found objects such as fake flowers, badges and ribbons. The format is a clear reference to the small commemorative boxes containing images of martyrs that can be bought on Tehran's streets, though it is more respectful than ironic.

Complementing the series of boxes, Hassanzadeh has also produced a series of silk-screen paintings of Pahlevan wrestlers. Around the edges of these works he has written a blessing used by Ali, the originator of the Shi'ite branch of Islam. As ever, Hassanzadeh knows instinctively how to position his art within the Iranian cultural consciousness.

Religion and the different ways in which it is perceived in East and West has always been a key theme of Hassanzadeh's work. His early series dealt with perceptions of the chador in the West; he then moved on to the 'Terrorist' series that explored different definitions of 'terrorism'. His 'Prostitutes' series, from 2002, cemented his reputation in the West as a voice of the Iranian counterculture, but in fact Hassanzadeh is actually more interested in the West's attitudes towards Islam. And as the Middle Eastern and Iranian art markets have grown over the past few years, these concerns have grown too, as convenient branding takes over from the more complex reality.

above, left
From the 'Ya Ali Madad' series, 2008
Acrylic and silkscreen on canvas
200 x 200 cm
Private collection, London

above
Untitled, from the 'Pahlevan' series, 2006
Silkscreen and mixed media on cardboard
184 x 119 cm
Private collection, London

opposite
Takhti, 2007
Mixed media
150 cm high
Photo courtesy Khosrow Hassanzadeh and Trustees of the British Museum

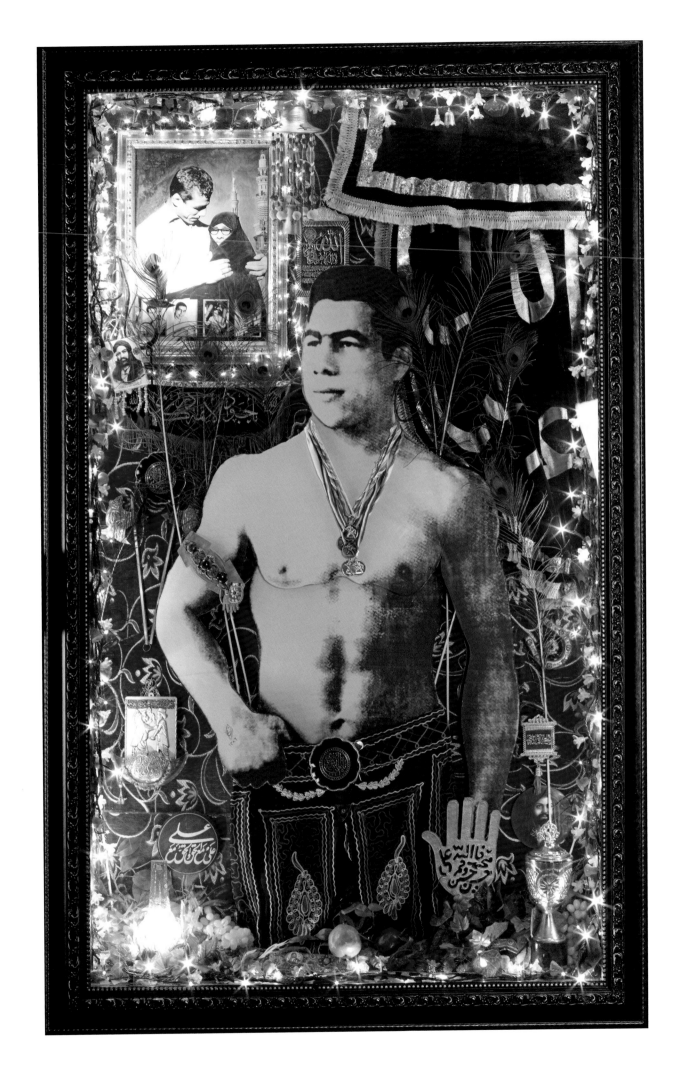

Khosrow Hassanzadeh

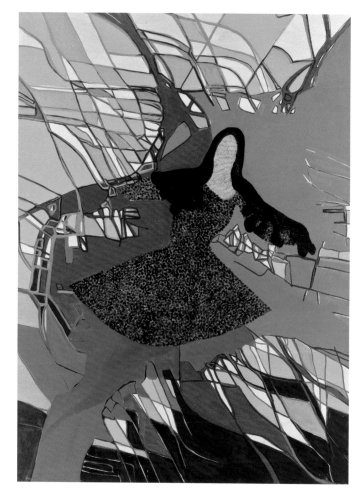

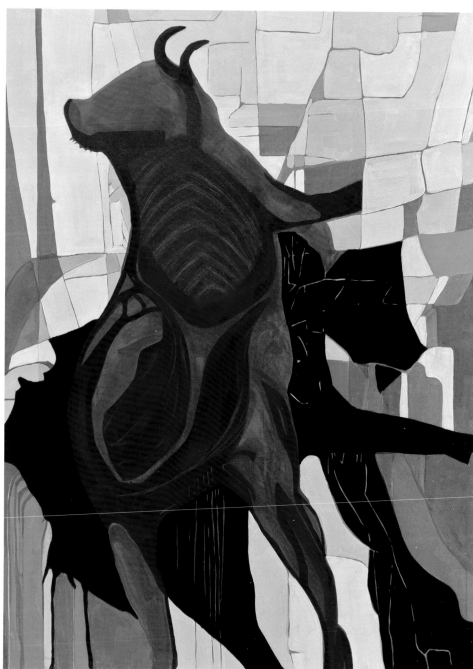

Born in Tehran in 1979, Narges Hashemi studied Painting at Tehran University, graduating in 2003. Since 2002 she has had several solo shows in Tehran, and has participated in many group shows internationally, including in London and New York.

Hashemi's main subject is women, often gathered, conversing in groups. Her earlier works tended to be monochromatic or more muted, but more recently she has used brighter, more cheerful colours. Most strikingly, she has begun to experiment with imagery from Zoroastrianism, a Persian religion that pre-dates Islam. Focusing on the myth of origins, she has depicted the Evakdad Cow, who helped Ahura Mazda create the cosmos.

above
Today is a gift
Acrylic on canvas
190 x 140 cm
© Narges Hashemi
Courtesy of Narges Hashemi
and Aaran Art Gallery, Tehran

right
God's gift
Acrylic on canvas
160 x 140 cm
© Narges Hashemi
Courtesy of Narges Hashemi
and Aaran Art Gallery, Tehran

The founder and owner of one of New York's most important galleries, Leila Taghinia-Milani Heller has been at the forefront of promoting modern and contemporary Iranian art in the United States for more than a quarter of a century.

Born in Tehran in 1955 to a Persian-Turkic mother and a Russian-Turkic father (who himself had been born in Samarkand), Leila left Iran in 1972 to study in the United States. After finishing a degree in Art History and French Literature at Brown University, she went on to do a Masters in Art History and Museum Management at George Washington University; this was followed by Sotheby's Masters programme and stints as an intern at the Hirschhorn Museum and the Guggenheim Museum in New York.

By 1982, Heller was ready to strike out on her own, and so she founded the Leila Taghinia-Milani Heller (LTMH) Gallery in New York. Here, she could begin to show artists, promote them at art fairs, sell their works and develop a group of collectors of Iranian modern and contemporary art. Today's big-name Iranian artists such as Charles Hossein Zenderoudi, Monir Farmanfarmaian, Nicky Nodjoumi and Y. Z. Kami were barely recognized in the New York market at the time. In 1985 she created, with Jeffrey Deitch, the groundbreaking exhibition 'Calligrafitti', which mixed a group of Middle Eastern calligraphy artists with New York's finest graffiti artists. In 2008, the gallery moved to its present location on the corner of Madison Avenue and East 78th Street,

What brought Heller to the art world? 'You could say for the love of it, for as sure as hell there hasn't been any money in it,' Leila replies. 'I wanted to promote Iranian artists alongside Western artists, because they're as good as any Western artist.' She also wanted to explore the links between the art and the 'cross-fertilization between Eastern and Western artists, and the influences of one on the other.'

Leila began to seek out new talent, discovering unknown Iranian artists and promoting them internationally. LTMH Gallery can be found in such diverse spots as the Asian Art Fair in New York, ArtDubai in Abu Dhabi or ArtParis. Leila has also for some time now been exploring the idea of establishing a Middle East art fair in New York.

She is presently helping to organize the 'Art of the Revolution' show at the Chelsea Art Museum in 2009, part of the East–West Dialogue series. Meanwhile, LTMH Gallery advises individuals, corporations and banks on developing Middle Eastern or Iranian art collections.

When new markets, such as this one for Iranian art, emerge, it can be difficult to tell whether they are all hype or whether they might actually be sustainable. 'If handled well Middle Eastern art will be the next Chinese art,' Leila says. 'Only if the auction houses and collectors don't go for the quick buck. The last two major auctions in Dubai saw some major artists' prices crash, but the younger ones did well.' She believes that the market should move slowly and prove itself, which means not encouraging collectors to buy sixty works from an artist while bidding up prices at auction and expecting all the work to have similar values. 'Iranian art is good and should one day speak for itself. Look how Gagosian, Barbara Gladstone and Salon 94 [all major New York galleries] treat their Iranian artists. They don't flood the market looking for a quick kill.'

'Its no good just having a select group of buyers in a small market,' she continues. 'I hear stories of Tehran shows being sold out, people queueing to buy in bulk.' Speculation is rife in both the Tehran and Dubai markets, but Leila is careful to straddle the gallery owner's roles of diplomat and marketer, careful not to tread on sensitive egos in a marketplace facing a slowdown.

'Look at Shirin Neshat,' Leila says. 'Shirin's done a great deal for platforming Middle Eastern artists in the West. She has developed and maintained a steady international clientele, not just local or regional markets.' Leila's gallery is well known for its themed shows, whether curated by her or by prominent guest curators. Such shows feature Middle Eastern artists alongside established, well-known Western artists such as Andy Warhol, Jean-Michel Basquiat, Tom Wesselmann, Damien Hirst and Cy Twombly. As such, she can claim to have done as much as anyone else to promote Iranian art: 'I have promoted some of the leading internationally recognized Iranian artists in the last quarter of a century, and have helped place them in major museums, corporate and private collections.'

Leila Taghinia-Milani Heller

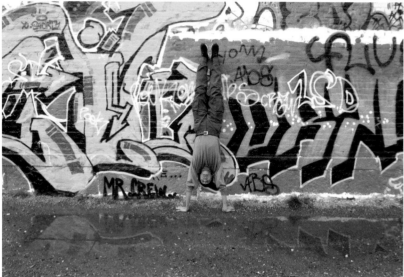

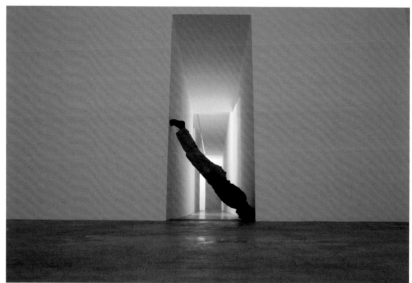

Peyman Hooshmandzadeh was born in 1969 in Tehran, and studied for a degree in Photography at Azad University. He is a founding member of the 135 Photos agency in Iran, and has been a photojournalist for many daily newspapers and press agencies both in Iran and abroad. His work has been shown nationally and internationally, and in 2007 he participated in Photoquai, the international biennial of images in Paris.

Hooshmandzadeh's photographic works, whether figurative and architectural, are at once witty and perceptive, reflecting on our place in the instant-gratification, mass-produced, man-made world. Others have seen in his work an attempt to experiment with the new

in order to shed more light on the old, and as Hooshmandzadeh himself says, 'We live in the present, and the present is full of so many old things.... New things tend to push themselves into our lives, [changing] everything...our actions and styles....' In Hooshmandzadeh's vision of the world, paradox is everywhere.

Hooshmandzadeh has also become an inspirational figure among a new generation of photographers in Iran, through his lectures and workshops. Recent work, from 2008, includes the 'Banished' series, which shows women standing behind car windscreens; on the screens are written slogans, with the woman's posture reflecting the theme of the slogan.

All from the 'Upside Down' series
C-Type photographs
© Peyman Hooshmandzadeh
Courtesy of Peyman Hooshmandzadeh

opposite, above
Ali from the 'Banished' series, 2008
C-Type photograph
92 x 122 cm
© Peyman Hooshmandzadeh
Courtesy of Peyman Hooshmandzadeh

opposite
Zohre from the 'Banished' series, 2008
C-Type photograph
92 x 122 cm
© Peyman Hooshmandzadeh
Courtesy of Peyman Hooshmandzadeh

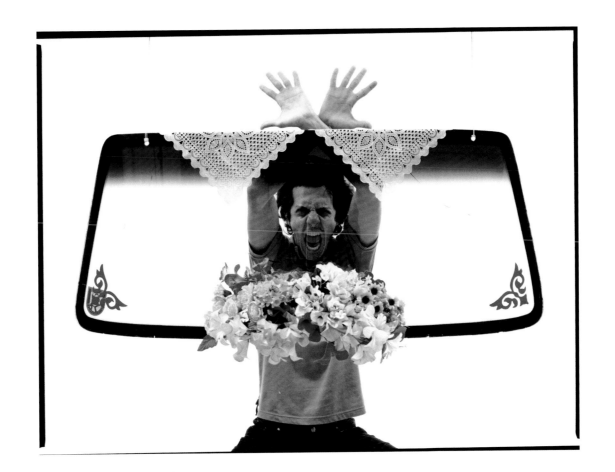

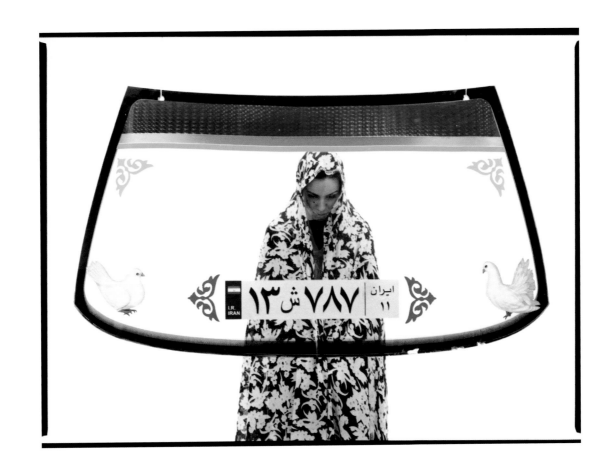

Born in Iran in 1955, Shirazeh Houshiary moved to London in 1974, where she studied at Chelsea School of Art and then at Cardiff College of Art. She belongs to a generation of UK-based artists, including Richard Deacon, Antony Gormley and Anish Kapoor, who have explored the place of sculpture as an expressive medium and its capacity to render bodily sensation and presence through both abstract and figurative forms. Shortlisted for the Turner Prize in 1994, Houshiary remains at the forefront of artists working in the UK today.

Her own work takes many forms – including drawings, paintings, sculptures, animations and installations – and is notable for its disciplined concentration and refinement. Her deliberately restricted colour palette – pale and dark blues, greys, white, silver and rose – implies a chromatic debt to traditional Persian culture, especially its ceramic tiles, glass and manuscript illuminations. Her themes, however, are not necessarily culturally specific and

instead take on central strategies emerging from Minimalism and conceptual art.

Employing a refined approach to surface – particularly evident in both her paintings and her sculptures, for all their size and implicit material strength – she avoids gestural brushwork and the heroic intent associated with it. Instead, she relishes surface and form as a means of considering what might lie beyond them: in her paintings, she employs veil-like devices, sometimes made up of minutely interwoven words from Farsi or repetitive abstract motifs, that assert the significance of the painting's surface while suggesting its role as a stepping stone to a contemplation that goes beyond both surface and the physical world itself.

The resulting images in Houshiary's paintings and animations – the latter of which take further the creative and spiritual implications of the former – present worlds that would not be alien to quantum physicists. They can be interpreted (or rather 'felt') as

representations that are either analogous to microscopic or astronomical images. This huge divergence of scale enables Houshiary to bring a poetic sensibility to the simplest of painterly strategies, one in which the viewer's presence as both the scopic subject and medium is a crucial ingredient to her work. Her work is therefore spatiotemporal in its ambition, integrating the space of the viewer into the work itself.

Houshiary's Iranian-ness as an artist is not obviously stated, but her love of Persian poetry – Rumi especially – remains strong and something of its mysticism and that of Sufism in general permeates her work. The avowed secularism of her work should not be read as an aversion towards the spiritual, however. Longing, distance, separation, an acceptance of the futile and infinitesimal significance of man and yet a keen affirmation of the vitality of individual presence, remain core themes.

Her most recent public work in the United Kingdom – a new installation forming the east window of the newly restored church of St Martin-in-the-Fields, London (2008) – takes further her interest in permeating surface and traversing boundaries. Consisting of etched mouth-blown clear glass and a stainless steel framework, the window presents the promise of the ineffable (a world beyond, invisible yet somehow tangible) while complementing the rather puritan stained glass aesthetic of much post-Reformation Classicist ecclesiastical architecture in England. It is a highly intelligent, restrained response to the site and its enduring qualities will become more evident as time passes. It offers an intriguing reading of her statement about the liminal quality that pervades all of her work: '"Home" for me is like being at the threshold of the door. One could move outside or inside from this vantage point.'

Shirazeh Houshiary

top
Untitled, 2004
Mixed media on paper
50 x 50 cm
Private collection, London

above
Fracture, 2007
Aquacryl on canvas
© Shirazeh Houshiary
Courtesy of Shirazeh Houshiary

top
Untitled, 2004
Mixed media on paper
50 x 50 cm
Private collection, London

above
Cocoon, 2008
Aquacryl on canvas
© Shirazeh Houshiary
Courtesy of Shirazeh Houshiary

left
Undoing the Knot, 2008
Anodized aluminium bricks and polished
stainless steel
658 cm (height)
Ellipse 99 x 75 cm
© Shirazeh Houshiary
Courtesy of Shirazeh Houshiary
Photo: James Morris

above
Shirazeh Houshiary and Pip Horne
Commission for St Martin-in-the-Fields,
London, 2008
Etched mouth-blown clear glass and
shot peened stainless steel frame
© Shirazeh Houshiary
Courtesy of Shirazeh Houshiary
Photo: James Morris

Rose Issa is a name that crops up regularly in the modern and contemporary Iranian art world. Of Iranian-Lebanese origin, Issa was born in 1948 in Tehran and sent to study in Beirut at the age of thirteen, graduating with a degree in Mathematics from the American University there. Fluent in Farsi, Arabic, French and English, Issa's rich and varied career in the arts spans forty years and several creative fields, constantly bridging the cultural divides between the Middle East and the West.

Though her family background was not especially artistic, her mother and aunts were painters. 'I didn't really consider them as artists. Perhaps I should have,' she says. Today she is one of the best-known curators of Middle Eastern contemporary art, and the author of several books on artists such as Shadi Ghadirian, Khosrow Hassanzadeh and Monir Farmanfarmaian. She has worked with London's National Film Theatre, and also with the Berlin and Rotterdam film festivals (one of her favourite artists is the Iranian filmmaker Abbas Kiarostami). She has also organized seminal exhibitions around the world on subjects relating to Middle Eastern and North African art (including several at London's Leighton House), and appears regularly at international conferences on these subjects.

She is also a gallerist and an art dealer with a wide circle of friends among both Iranian and Arab artists.

Issa has very specific ideas about what she looks for in art: 'Something original, something that surprises me. I trust my instincts, my eyes. A lot of artists from Iran and the Middle East have something to say…. I like messages. Western art is becoming completely… conceptually abstract. An artistic exercise for its own sake, and nothing more. They used to say "art for art's sake", but look at what is happening today in the Western art world. Damien Hirst is the modern academician who is still doing Duchamp!'

'Some say that the 19th-century English artist Lord Leighton was the most expensive in his time, but was he an artist?' Issa questions the long-term viability of many leading present-day artists. 'They're good marketers, that's what they are.' Issa says that she had a good art teacher with whom she would constantly attend exhibitions to differentiate between an artist and a painter. For me a good shoemaker can be an artist if the shoe is made well…with passion and no concession to trends or current styles. You need integrity to have conviction, and a good artist needs both.'

'I feel depressed when I see bad art, or

a bad film. I become angry and I don't like being angry,' Issa says. 'It's all about vision, through which great artists open doors. Cheap exploitation of themes is an insult to my intelligence…it is an insult to think that people as a whole are not intelligent.'

Issa believes that the Iranian contemporary art movement is going in all directions, both good and bad. 'The market is leading the movement, encouraging more and more Iranian artists, but I don't think you can have a million artists in a country. However,' she adds, 'there is a genuine buzz around the Iranian contemporary art scene. In the 1950s it was Cairo until the 1956 Nasser revolution. Beirut was the centre in the 1960s until the Lebanese civil war put a stop to that. Tehran became the centre during the mid-1970s with the Shiraz Art Festival commanding major international attention, until the 1979 Islamic Revolution.' War and revolution have moved the art scene across the Middle East. 'Today Dubai is the regional prototype of marketing, including in art.'

'Things go up and down in the art world,' Issa continues. 'There is fashion in art…. If you ask me whether Damien Hirst or Jeff Koons will be remembered as great artists a hundred years from now, I would say no…. The great thing about art is that anything can be called art, and

the worst thing about it is that anything can be art. There is a duality,' Issa explains. 'Things can change. What is seen to be art today won't be received as such a generation or two from now'.

Asked whether she believes that art has a 'God factor', she replies: 'I don't know God. I know what I see, what inspires me. I like beautiful things…I like beautiful people. It is all about ideas, about charm…it is about atmosphere, about generosity. It is also about projection…about the impression that people leave on you.' 'Art has to move you. Life is art, and art is life,' she continues in a philosophical vein. 'I don't consider ordinary work as life. If I can't do what I want to – my art – I wouldn't want to be around. I've given a lot of my time and life and money to promote artists.'

Aside from art, Issa is a lover of Persian poetry. Hafiz, Saadi and Rumi are her favourites. 'They're about life, love, lust…it is about loss, of honesty…of accountability. It is a very privileged world, to be around artists. I'm a visual person and one word alone can open up a visual world all of its own. To be with people that I like and respect and admire…that is art.'

Untitled from the 'Image of Imagination' series,
2003–2005
Silver bromide print and etched mirror
70 x 70 cm
Private collection, London

Born in 1944, Bahman Jalali originally studied economics at Melli University in Tehran, before becoming a photographer for *Tamasha* magazine in 1972. Since then he has continued to practise photography alongside teaching in various Iranian universities, and through his position as curator of Iran's first museum of photography raised the status of the discipline as an art form in the country; in 2007, his long, distinguished career was recognized with a major retrospective at the Fundació Antoni Tàpies, in Barcelona. Today he is member of the editorial board for the influential Tehran photography magazine *Aksnameh*.

Jalali is probably best known for his documentary photographs from the 1979 Islamic Revolution. More recently, however, he has produced series of work – for example, 'Image of Imagination' – that incorporate old Qajar photographs, combined with images of flowers and Iranian calligraphy. As Jalali has explained, 'I have been exposed to many images by little-known photographers around the country. Those that I could keep, I have held as mementos, and others have left their marks on my imagination.'

above
Ballet Oceanique Noir, 2008
C-Type photograph
© Iran Issa-Khan
Courtesy of Iran Issa-Khan and
LTMH Gallery, New York

left
Untitled, 2008
C-Type photograph
© Iran Issa-Khan
Courtesy of Iran Issa-Khan and
LTMH Gallery, New York

Iran Issa-Khan left her native Tehran in 1977, just a couple of years before the Islamic Revolution. Looking for a new career in her new home in the United States, she took up photography and soon became part of the social scene of the 1980s, photographing everyone from Nancy Reagan to Paloma Picasso. After a break in the 1990s following the death of a friend, she took up photography again in 1999 when she began photographing flowers.

Looking at her photographs, it is easy to understand why she has been called the 'Georgia O'Keefe of photography'. There is a degree of artifice in the composition, as Issa-Khan attempts to tease out the character of the flower; a *Monstera deliciosa*, for example, she describes as looking 'exactly like a woman in a chador', while the titles range from the prosaic (*Rouge*) to the playful (*Ballet Oceanique Noir*). Nevertheless, the aim of her photography is simple: to capture beauty.

right
Ecstasy, 2008
C-Type photograph
© Iran Issa-Khan
Courtesy of Iran Issa-Khan and
LTMH Gallery, New York

opposite
Rouge, 2008
C-Type photograph
© Iran Issa-Khan
Courtesy of Iran Issa-Khan and
LTMH Gallery, New York

Pouran Jinchi

Pouran Jinchi was born in 1959 and initially studied Engineering before obtaining a degree in Painting from the University of California, Los Angeles. This was then followed by some time at the Art Students League in New York in 1993. Today she lives and works in New York.

Jinchi's work has always been based around Persian calligraphy, which she turns into near-abstract patterns through repetition of letters. She sees her work as essentially meditative and holistic, and rooted in the tradition of Persian poetry – a fusion of Persian and Western traditions. More recently, this fusion between East and West has become more explicit, as she has begun to incorporate calligraphy into designer or luxury items by Chanel, Christian Dior and so forth. Thus a piece decorated with traditional Iranian designs evokes the United States flag, while the distinctive Burberry tartan is overlaid with Persian motifs and patterns.

above
Flag 4, 2002
Acrylic on canvas
91 x 122 cm
Private collection, London

right
Dual pattern 4, 2007
Gouache on cardboard
35.5 x 28 cm
© Pouran Jinchi
Courtesy of Pouran Jinchi and
The Third Line Gallery, Dubai

opposite
Untitled, 2007
Acrylic and mixed media
on canvas
183 x 122 cm
Private collection, London

Y. Z. Kami's studio is located on the West Side of Manhattan. Occupying a large space filled with huge finished and unfinished canvases, the visitor is first greeted by the artist's cat, Khanoum Puchi – a Farsi play on words meaning 'hollow lady'.

'I came to New York in January 1984 to spend a week and fell in love with the city,' explains Kami. 'It was a great time, the 1980s, with lots of young artists doing different stuff. It was the sheer energy that I fell for.'

In fact, it wasn't Kami's first stay in the United States. Born and raised in Tehran, when he decided to leave Iran in 1974 he headed for Berkeley, California, where he began a Masters in Philosophy on Western and Islamic studies, focusing on Sufism. He then found his way to Paris and the Sorbonne, where he completed his course. After his trip to New York in 1984, however, he immediately returned to Paris to pack up his belongings.

It was during his time studying philosophy that Kami realized what it was he wanted to do. 'When I left Iran I didn't want to be a painter and started studying. But it wasn't long before I came to realize that I was too visual and really started to paint as a professional,' Kami explains.

Kami's mother, Mahin Youssefzadeh, had been his childhood inspiration and the idea of art came to him at an early age. 'I've been painting since I was a child,' Kami recounts. 'My mother was a painter who worked in a traditional artist's studio in Tehran tracing its origins to Kemal al-Mulk [the father of modern art in Iran].'

'When I get an idea into my head I won't let go,' he says. Kami professes to have too many ideas racing around in is head, 'but I still look for inspiration from museums and Old Master paintings.'

'You have to listen to your inner voice rather than what is out there in the [art] marketplace, regardless of trends or fads,' Kami says of his

work. 'It took a while before my work started to sell, but I never starved as I used to paint commission portraits. You have to eat and it beats waiting on tables.'

'I was still struggling as an artist but started to show and exhibit around New York,' Kami remembers. After changing galleries five times during the last twenty-five years, Kami has settled with Larry Gagosian for the past three years, first showing with them in Los Angeles in 2008.

However, even in such a long and distinguished career he can remember the most exhilarating moment: 'When the Met [New York's Metropolitan Museum of Art] bought two of my paintings in 1993...that was the great moment,' Kami remembers with enthusiasm. 'I'd left for Paris and Barbara [of Barbara Toll Fine Arts] called to give me the news. That,' he adds, 'was pure excitement!'

Exhibitions at the Museum of Modern Art in New York in 1997 and 2006 have followed since,

along with participation at the Istanbul Biennale (2005), Venice Biennale (2007) and a major retrospective at the Parasol unit foundation in London (2008).

'What has been a constant presence in my life since childhood,' Kami explains of his work, 'has been a connection with Persian poetry. With Hafiz, Rumi, Attar, Jami and Nezami. Some people are very drawn to my portraiture, some are drawn to the way I use oil paint and some are drawn to the way I use architecture and poetry.'

A Sufi at heart, Kami's painting is imbued with a sense of spirituality that transcends frontiers in art and human space. 'When I finish a work I'm not worried about others' opinions, but I am very curious as to what each person sees in it. Each person brings their own baggage and art in many ways is the best extrovert expression of our mental baggage,' Kami reflects. 'At the end of the day I'm not interested in people finding a specific thing in my work.'

Yet artistically, Kami has forged his own path, in many ways distinct from that of other Iranian artists. 'For me, the genius of Iranian art is in its spirituality. That's my reading of it. But Iranians don't know me, I think,' Kami explains. 'And I'm not very familiar with the younger artists' work, to tell you the truth. I know the work of some of the older generation like [Hossein] Zenderoudi and [Parviz] Tanavoli, and am friends with Shirin Neshat.'

'For me to make art is a goal in itself...an end in itself. But there is never an end in art. For me a painting is never really finished, like when you eat a good meal. There is always a hunger, never complete satisfaction...there is always an undercurrent of doubt somewhere.'

Untitled, 2005
Oil on linen
325.1 x 233.7 cm
© Y. Z. Kami
Photo courtesy of Y. Z. Kami and
Gagosian Gallery, New York

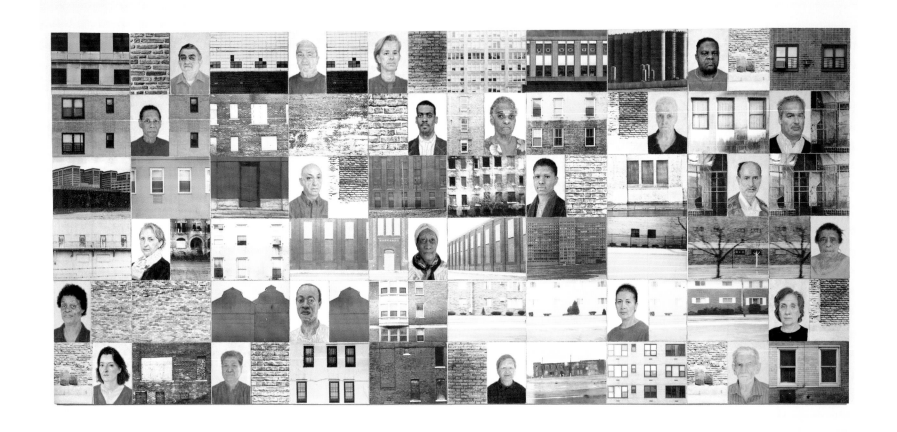

Dry Land, 1999–2004
Iris printed photographs and oil painting
on arches paper
340.4 x 751.8 cm
© Y. Z. Kami
Photo courtesy of Y. Z. Kami and
Gagosian Gallery, New York

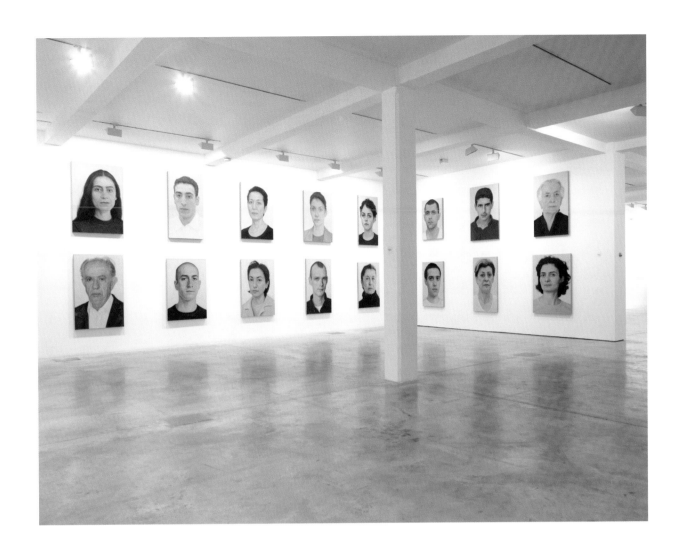

above
Installation view of the Y. Z. Kami exhibition
'Endless Prayers' at the Parasol unit foundation
for contemporary art, London
© Y. Z. Kami
Photo by Stephen White

left
In Jerusalem, 2006
Oil on linen (5 panels)
114 x 61 cm, 61 x 43.2 cm, 147.3 x 73.7 cm,
101.6 x 78.7 cm, 119 x 58.4 cm
© Y. Z. Kami
Photo courtesy of Y. Z. Kami and
Gagosian Gallery, New York

Rumi – The Book of Massnavi E Manavi IV, 2007
Mixed media on linen
228.6 x 251.5 cm
© Y. Z. Kami
Photo courtesy of Y. Z. Kami and
Gagosian Gallery, New York

above
Konya, 2007
Oil on Iris printed photographs on arches paper
408.9 x 221 cm
© Y. Z. Kami
Photo courtesy of Y. Z. Kami and
Gagosian Gallery, New York

left
Endless Prayers VII, 2006
Mixed media on paper
106.7 x 75.6 cm
© Y. Z. Kami
Photo courtesy of Y. Z. Kami and
Gagosian Gallery, New York

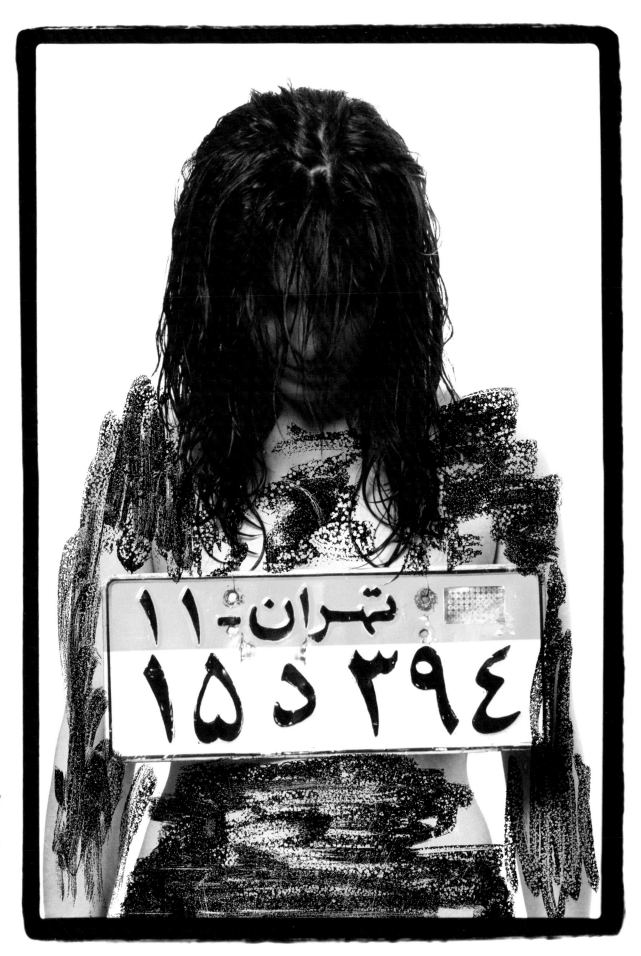

Born in 1967 in Tehran, Katayoun Karami studied at the Middle East Technical University in Ankara, Turkey. Since 2002 she has exhibited her work in a number of Tehran galleries, as well as outside of Iran. For Karami, photography is a tool with which she can explore issues of culture, identity and perception in a simple, straightforward way.

The recent 'Censorship' series shows naked female bodies overpainted with broad black brush strokes, the subjects' hair pulled down over their faces. Another recent series, 'The Other Side', shows double-sided self-portraits – the blurred front image 'veils' the back image of the subject's hair. The back image, unseen and forgotten, is covered with silver gelatine emulsion so that the hair, when exposed, appears limp, wasted and useless.

From the 'Censorship' series
Photograph
© Katayoun Karami
Courtesy of Katayoun Karami and
Silk Road Gallery, Tehran

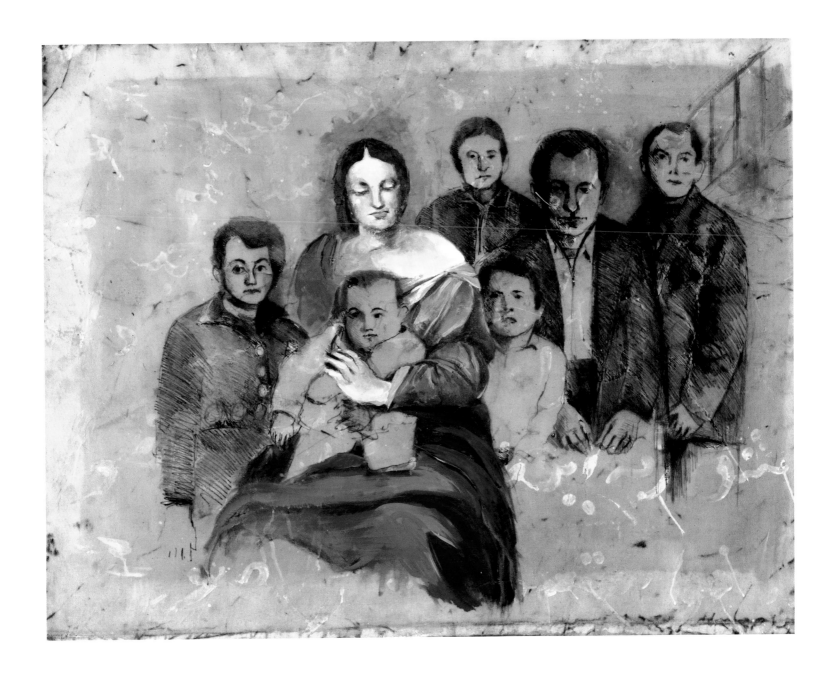

The Family, 2007
Oil on canvas
125 x 80 cm
© Shahram Karimi
Courtesy of Shahram Karimi

Shahram Karimi was born in Shiraz, Iran, in 1957. Since 1988, he has lived and worked in Germany and New York. Working mostly in paint, he produces intriguing pieces that often have a subtle political message. Some, such as *Traces* (which celebrated Iran's intellectuals, past and present) were presented alongside a video work. More recent paintings such as *The Family* clearly incorporate bits of Western iconography, with the central figure dressed as the Virgin Mary.

Karimi has also collaborated with Shirin Neshat as production designer on films such as 'Women without Men', as well as for two films by Shoja Azari. He has also collaborated with Azari on their 'video paintings', in which moving images are projected onto paintings by Karimi, bringing the surface to life.

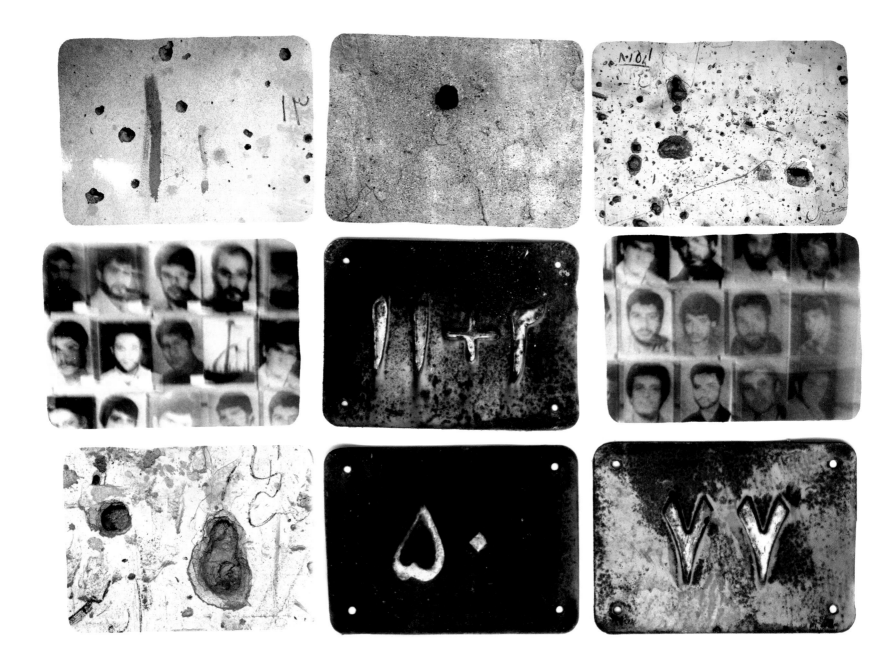

Born in Ahvaz, Iran, in 1983, Babak Kazemi is
both a photographer and a graphic designer.
He has won various design awards in Iran, and
has been showing his work in solo and group
exhibitions since 1996. His subjects tend to have
some sort of message or inherent symbolism:
recent works have played with the layering
and repeating of images, creating curious
juxtapositions as images appear on bags or on
the flanks of cattle. Other photographs – which
are typically black and white or sepia-toned
– have examined dead fish or butterflies.

Untitled
Photographs and mixed media
© Babak Kazemi
Courtesy of Babak Kazemi and
Silk Road Gallery, Tehran

opposite
Untitled
Photograph
© Babak Kazemi
Courtesy of Babak Kazemi and
Silk Road Gallery, Tehran

Babak Kazemi

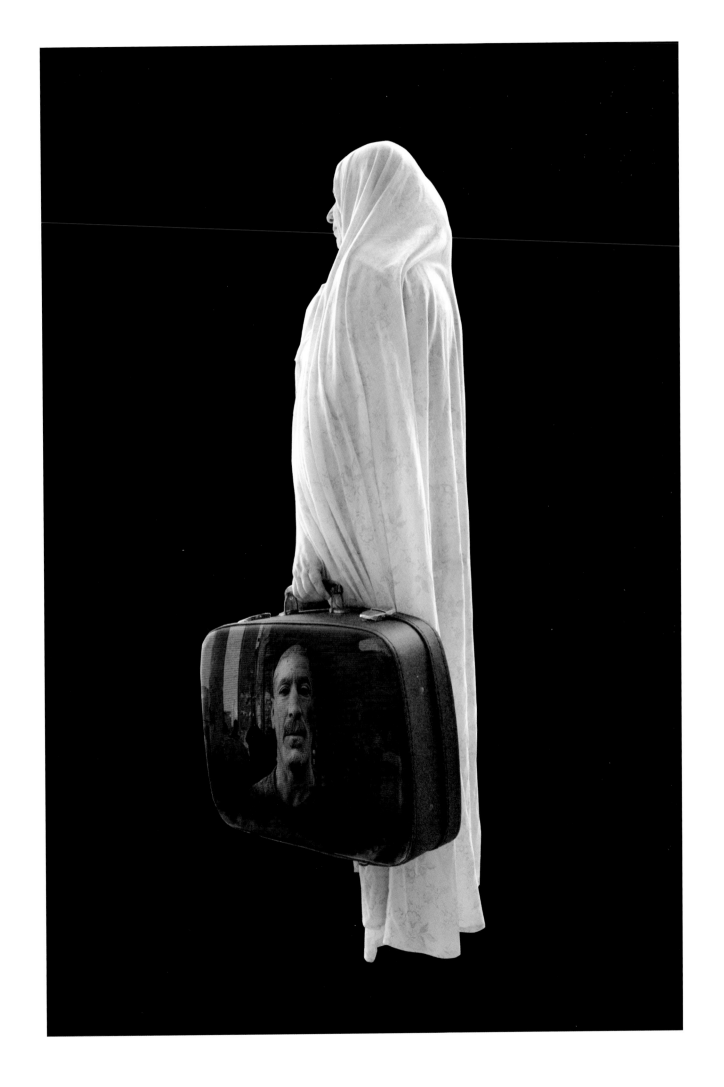

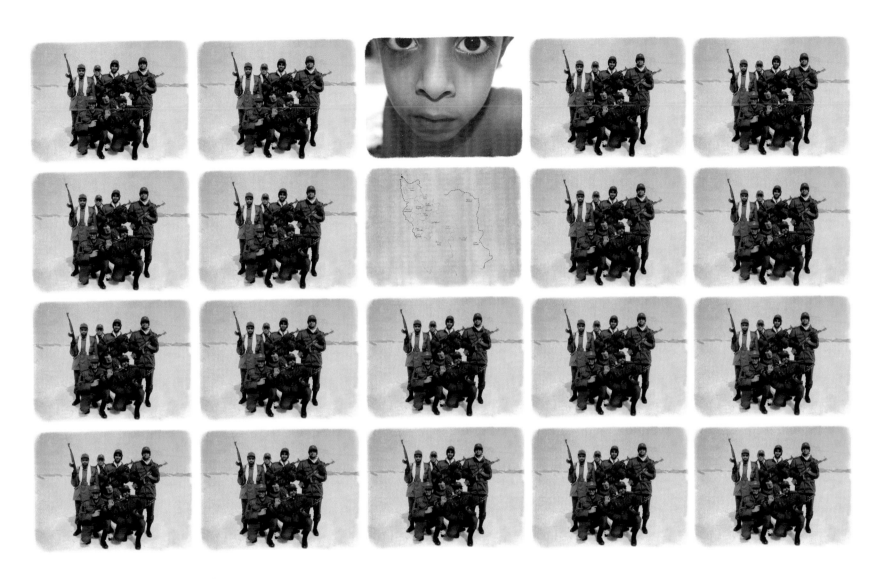

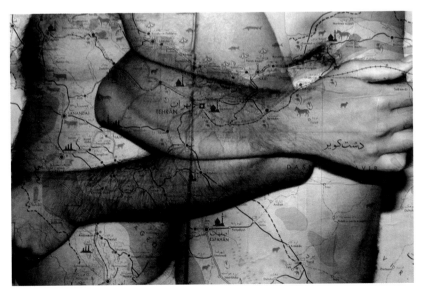

above
Untitled
Photograph
© Babak Kazemi
Courtesy of Babak Kazemi and
Silk Road Gallery, Tehran

left
Untitled
Photograph
© Babak Kazemi
Courtesy of Babak Kazemi and
Silk Road Gallery, Tehran

opposite
Untitled
Photograph
© Babak Kazemi
Courtesy of Babak Kazemi and
Silk Road Gallery, Tehran

Babak Kazemi

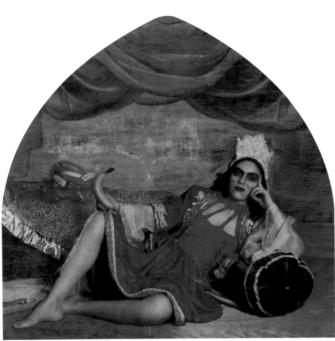

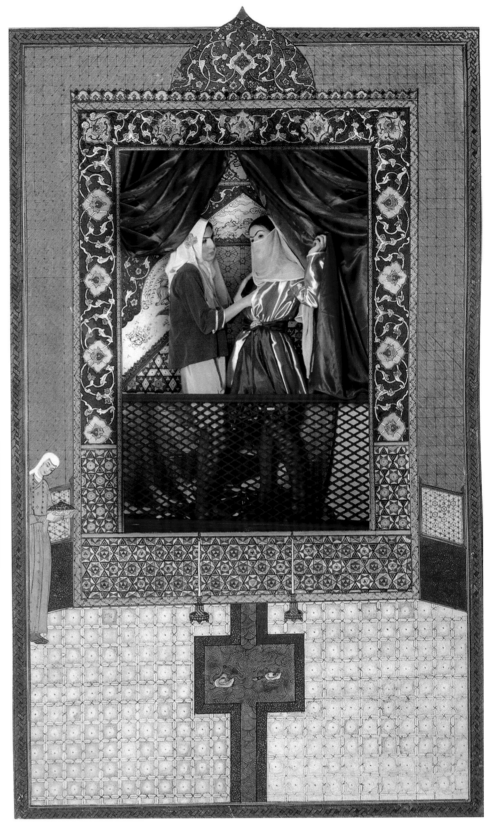

Born in Tehran in 1966, Afshan Ketabchi originally studied Graphic Design, before moving on to study for a Master of Fine Arts in Azad University. She has been exhibiting her work since the mid-1990s, and has been active in promoting the work of Iranian contemporary artists abroad in her capacity as Head of the International Department of the Iranian Society of Painters.

Ketabchi's work often reinvents Western artistic prototypes – for example, one series included images of Iranian authority figures and celebrities in the style of Andy Warhol's silk-screen prints. A recent series of photographs, 'Harem', includes images that play on the West's obsession with this restricted area and what might go on inside it, while drawing inspiration from Qajar miniatures – and throwing in the occasional absurd prop, such as a suggestive banana. The photographs are then printed onto canvas to give them a timeworn feel, transporting them to the past.

above
Banana, 2008
from the Harem series
100 x 93 cm
Mixed media and print
on canvas
© Afshan Ketabchi
Courtesy of Afshan Ketabchi
and Mah Art Gallery, Teheran

right
Behind the Hatch, 2008
from the Harem series
Mixed media and print
on canvas
88 x 57 cm
© Afshan Ketabchi
Courtesy of Afshan Ketabchi
and Mah Art Gallery, Teheran

Since the inauguration of her Los Angeles gallery in 2008, Leila Khastoo has made it her mission to bring the best Iranian artists to the United States: 'For the first time, a private commercial gallery has put talent above trend, and art history beyond borderlines,' she says. While other galleries may dispute this, what is certain is that her approach is both inclusive – with artists from the Middle East, the United States and the Persian Diaspora all sitting side by side – and radical.

Born in California to Iranian parents, Khastoo's home life was a rich blend of East and West, and as for most of her peers in Southern California, Iranian nationalism was a 'complicated maze with infinite pathways'. While studying for a degree in Art History at New York University, Khastoo also did stints at the Gagosian Gallery in Chelsea, New York, and at the Whitebox not-for-profit art space.

Her initial focus on modern movements of the West was complemented by research projects on European and South American art. 'It wasn't until I began working on a presentation on post-revolutionary art in Cuba in 2002 that I began to express an interest in contemporary Iranian art,' she explains. In the process of exploring ideas surrounding post-revolutionary behaviour in Cuban art and artists, Khastoo found herself 'forming geographic links and drawn to investigating the aesthetic changes in a culture much closer to home.'

One of Khastoo's aims is to bring new and emerging artists to the attention of seasoned collectors. While working at Westreich Thea Art Advisory in SoHo, she learned the importance of scholarship in art investment and how to train one's eye to recognize quality and talent. 'A close friend once advised me: "If you want to succeed in this business, become an expert. Know what you're talking about." ... I am constantly looking and studying.' With encouragement from her professors, Khastoo began to look at Iranian art, initially relying on limited written resources, and

contact with artists working in New York, such as Shirin Neshat and Y. Z. Kami. 'Becoming frustrated by the lack of resources, I initiated contact with artists and curators in Tehran, and finally took my first adult trip to the country in 2003.' Once again, her travels hugely amplified her insight on the subject, she says. Annual trips to Tehran and throughout the country brought new artists to her attention, and each visit opened another closed door.

After time spent in Buenos Aires, Argentina, and a couple of years as Director of the Mary Goldman Gallery in Chinatown, Khastoo returned to following the careers of a group of emerging artists in Tehran, from Shahab Fotouhi and Mahmoud Bakhshi Moakhar, to Vahid Sharifian and Behrang Samadzadegan. At about the same time a frenzy was developing around Iranian art; as Khastoo comments: 'When I first started researching Iranian contemporary art nobody really cared much about it. Then all of a sudden, politically, culturally, artistically, there

was a shift in interest levels. I find it fascinating as a phenomenon, but irrelevant to my business decisions as I was already weeding out the good from the bad....'

Khastoo has, however, identified one major problem in the current obsession with Iranian art: 'People are looking for this uniqueness...to continue the discussion around Iranian contemporary art as "other and different", a very generic explanation for the exhaustion of the "veil" theme here in the West. Then desire enters the subconscious of the subject and we encounter an East perpetuating the Orientalism that was put on them. They don't even realize that they are restricting themselves with the shackles of exoticism; it's a lack of detached awareness.' Instead, Khastoo seeks complexity and depth of meaning. 'The work that I find interesting has many layers. You have to peel away, and each new surface brings more questions than answers.'

Leila Khastoo

Avish Khebrehzadeh was born in Teheran in 1969. After studying Mathematics in Azad University, she made her exhibition debut in 1990 at the Seyhoun Gallery. A little later she moved to Italy, where she studied painting at the Accademia di Belle Arti in Rome, and also put on her first solo show (at the Galleria S.A.L.E.S., in the same city). She then moved to the United States, where she studied Photography at the Corcoran College of Art and then Philosophy. Today she lives and works in Washington, D.C., and Rome, and exhibits around the world, from Mexico to Japan. Over the course of her career, she has acquired various awards, including a coveted Golden Lion at the 2003 Venice Biennale.

Khebrehzadeh's simple, delicate and raw drawings try to tease out hidden, basic emotions, and have an ephemeral, dreamlike and incomplete feel. In certain respects her works are reminiscent of early Renaissance artists such as Fra Angelico or Masaccio – perhaps a result of spending time in Italy. And while there

is often a sense of interaction between her figures, of narrative, they are curiously mute – Khebrehzadeh's humans have only eyes, no mouths with which to communicate (though some do, at least, play instruments). Feelings are demonstrated through the relationship between man and either animals or his environment.

Just as interesting is that way that she alternates between graphite on a light ground in her drawings and luminous figures on a dark ground in her paintings. The light ground works are particularly curious since they are produced using olive oil, which Khebrehzadeh applies as though it were a colour. This increases the transparency of the paper, making it seem even more delicate. The dark-ground paintings have a completely different feel, portentous and slightly sinister.

She also produces drawn animations, which tell more concrete, yet equally simple, stories. In 'Sweet Child in Time', from 2005, a young child sits on a stool, dangling his legs, singing.

Another shows circus performers, a scene remembered from her childhood in Tehran. Nostalgia is clearly an important part of her work – as is the pervading sense of melancholy. Transparency, too, is critical to her animations, with people constantly appearing and fading. Her works are poetic, but in a very spare way; in her own words: 'I like to be frugal in giving the visual information to viewers. I want each viewer to participate and finish the story with his or her own imagination.'

Other works act as a bridge or point of contact between her various media – for example, Acrobats, from 2008, which belongs to a series of works that show projections in theatres. In this two figures – as though from one of her animations – appear on screen, though the seats remain empty. Again, the narrative is sparse, the poetry lyrical, the scene utterly compelling.

Solace, So Old, So New, 2007
Animation
12:45
Installation view at Albion, London, 2008
© Avish Khebrehzadeh
Courtesy Avish Khebrehzadeh and Albion, London and New York
Photo © 2008 Ed Reeve

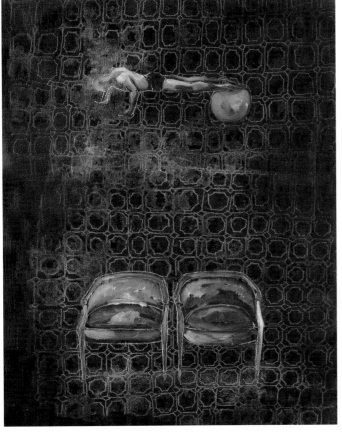

above
The Acrobats, 2008
Oil and gesso on board
117 x 92 cm
Private collection, London

left
Push Ups and Two Chairs,
2006
Oil and gesso on board
51 x 40.5 cm
Private collection, London

Avish Khebrehzadeh

197

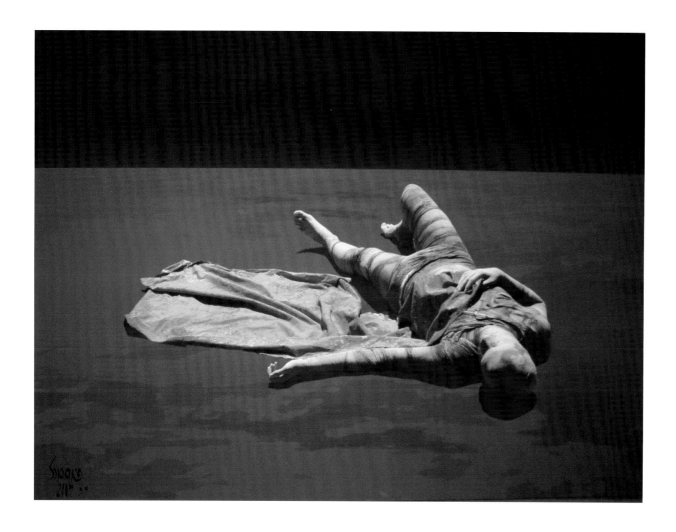

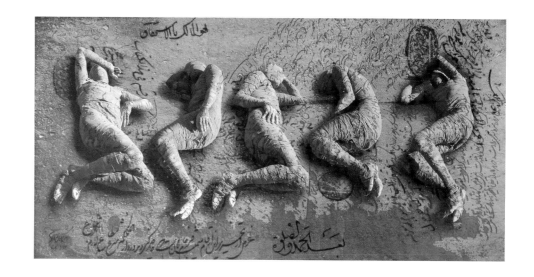

Hossein Khosrojerdi was born in Tehran in 1957. Educated at art college in Tehran, he received his diploma in 1975 and then a degree in Fine Arts from Tehran University in 1985. In between this time, however, he took an active political role in the Islamic Revolution, and after 1979, was named the official artist of the newly established Islamic Republic. Since then, he has won various awards, including the Grand Prize of the Sharjah Biennial in 2001.

Khosrojerdi's canvases oscillate between the surreal and the expressive. His stylistic influences are resolutely Western, while the subjects that he paints deal with notions of remorse, regret and introspection – and, perhaps above all else, humility and self-awareness. As might be expected from a revolutionary artist, there are parallels to be made, in socio-cultural and political terms, with those two masters of political painting, Jacques-Louis David and Kazimir Malevich.

above
Eternal Rest, 2005
Digital print on canvas
110 x 150 cm
© Hossein Khosrojerdi
Courtesy of
Hossein Khosrojerdi and
Xerxes Fine Art, London

right
Sleep of Five, 2006
Digital print on canvas
150 cm x 170 cm
Private collection, London

opposite
Green Peace, 2005
Digital print on canvas
© Hossein Khosrojerdi
Courtesy of
Hossein Khosrojerdi and
Xerxes Fine Art, London

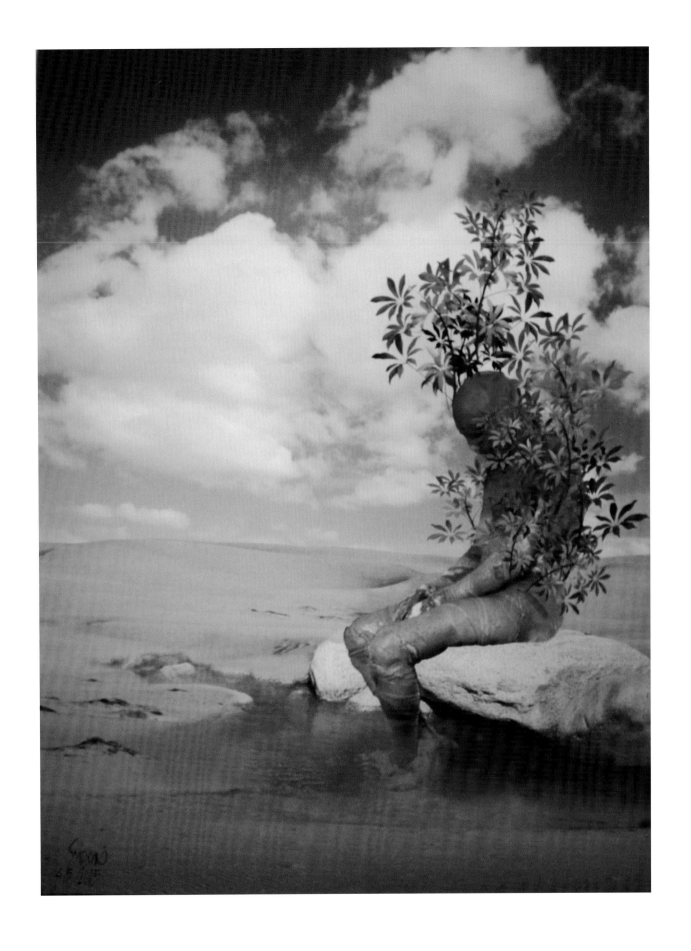

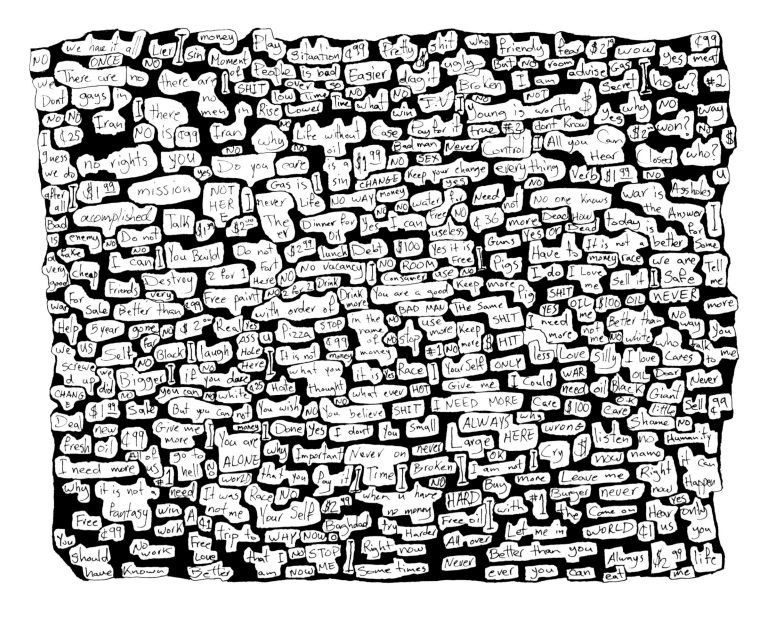

Word Drawing
Collage
© Farzad Kohan
Courtesy of Farzad Kohan

Farzad Kohan is a self-taught artist based in Los Angeles, who began carving in his teens. His output is nothing if not varied, including sculptures, collages, installations, paintings, photographs and drawings.

He began making his characteristic sculptures of attenuated figures in 2003. Reminiscent of Giacometti's figures (though perhaps slightly livelier), they are braided from a mixture of clay and wood chips laid over a wire frame, and represent, in Kohan's words, 'our human core, free of gender, race, culture or anything else that we use to judge one another.'

Kohan also continues to make art works out of objects that he finds in his immediate environment, whether natural or manmade. Some of his recent drawings have used coffee, tea, milk and oil: in fact, Kohan uses anything that will, in his words, 'ignite thoughts in the mind of the viewer that makes them step back and view their own being.'

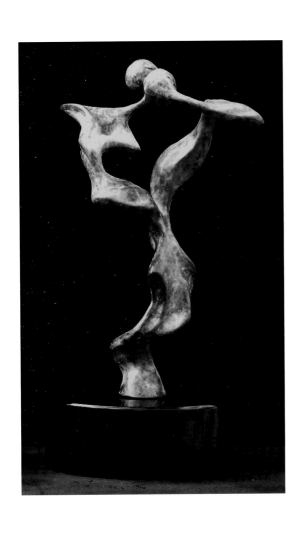

above
Puppeteer
Wire, clay and wood chip
© Farzad Kohan
Courtesy of Farzad Kohan

left
Lovers
Bronze
© Farzad Kohan
Courtesy of Farzad Kohan

Farzad Kohan

201

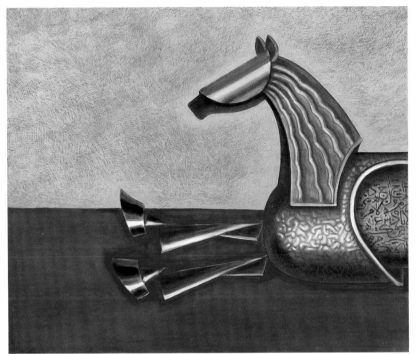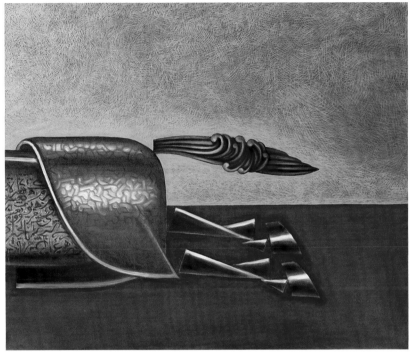

The graphic designer, painter and sculptor Reza Lavassani was born in 1962 in Tehran. He studied Painting at the Faculty of Fine Arts, Tehran University, but felt after graduating that his degree had not been enough to put him on 'the true path of painting'.

For this reason, he spent 'years studying philosophy in general, and mysticism in particular, all the time wondering about the basic meanings of mythology, sociology, religion, history and so on....' This gave him: 'a new understanding of time, human beings and their inner needs. I then tried to apply this new understanding to painting and drawing, so that others could benefit from it too.'

Having begun to understand what it was that he wanted to say, Lavassani had to decide how best to convey his message: 'In order to give a modern expression to my works, I searched for materials that would represent them more effectively. At last, I realized that all materials

and their functions are only secondary to drawing and spatial presentation, for as one reaches a modern understanding of spatial presentation, one will most probably find its suitable material.'

Lavassani's paintings and sculptures readily betray his interest in universal symbols and mythological legends. Ancient symbols are recreated in papier mâché to form horses, birds, women – the things that fascinated the very first artists, thousands of years ago. The same motifs appear in his paintings, signs of timelessness. The horse represents speed and nobility, the women fertility of the sacred, the bird a messenger between Heaven and Earth. Here Lavassani's philosophical training comes to the fore. At the heart of his works, however, is the belief that modern life distances us from nature and reality; as he says: 'reality and truth manifest themselves in the intellect and the heart and comprise the attributes which create mankind.'

above
Untitled Diptych, 2007
Oil and acrylic on canvas
100 x 150 cm
Private collection, London

opposite
Untitled, 2007
Mixed media on canvas
210 x 140 cm (9 panels)
© Reza Lavassani
Courtesy of Reza Lavassani and
the Assar Art Gallery, Tehran

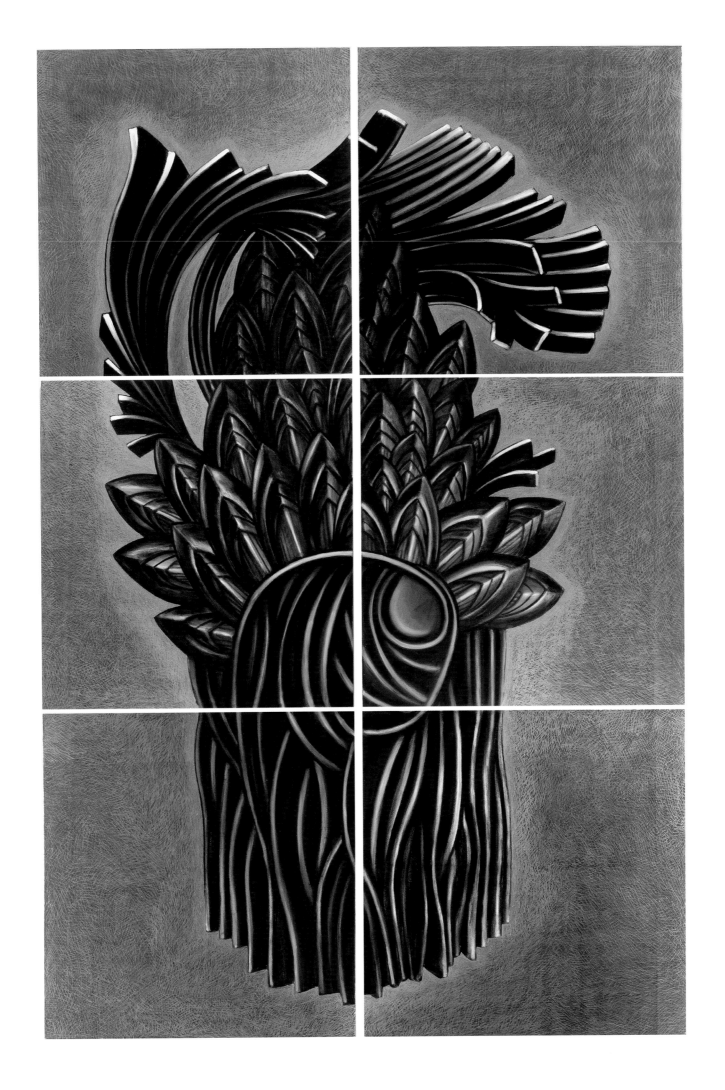

Reza Lavassani

Apple Job, 2008
Oil on panel
24.8 x 30.5 cm
© Tala Madani
Courtesy of Tala Madani and
Lombard-Freid Projects, New York

Born in Tehran in 1981, Tala Madani moved to the United States aged ten to study but ended up staying. After studying for a BA in Political Science at Oregon State University, she then made the move to Visual Arts, and thereafter did a Master of Fine Arts in Painting at Yale, which she completed in 2006. Today she lives and works in Amsterdam, The Netherlands, and has exhibited in New York, London and Amsterdam, including in the important 'Unveiled' show at the Saatchi Gallery, London.

Madani's paintings are highly distinctive. They tend to be based around two themes: stereotypes of Middle Eastern men, and birthday cakes. The men more often than are engaged in homoerotic – or at least rather ambiguous – activities. They groom each other, cover each other with paint, fight with each other. Their features are buffoon-like, simplified and cartoonish. They parade around in various states of undress, and engage in pointless

sports. They humiliate one another, and mutilate themselves. And they eat cake, which serves as an emblem of the male ego.

The other thing that makes Madani's paintings so distinctive is her technique, which is deliberately crude. Features are kept to an absolute minimum, being flattened out and oversimplified. The palette is similarly pared-down and childlike; the bright pinks and oranges have led some commentators to make a connection with Persian miniatures.

What is certain is that many have found the wanton abandon of Madani's paintings strangely liberating. She seems to be articulating something that many others fear to – whether making reference to suicide bombers, to homosexuality in the Middle East, or merely to what one critic called 'the patheticness of a world without women'. In any case, her paintings have a dark undertow of humour that is more than welcome.

Tala Madani

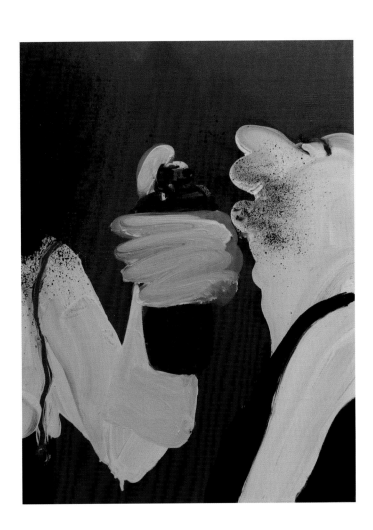

above
Dirty Stars, 2008
Oil on linen
195 x 195 cm
© Tala Madani
Courtesy of Tala Madani and
Lombard-Freid Projects, New York

left
Spray, 2008
Oil on canvas
40 x 30 cm
© Tala Madani
Courtesy of Tala Madani and
Lombard-Freid Projects, New York

Tala Madani

above
White Heads Burning Hands, 2006
Oil on canvas
30.5 x 30.5 cm
© Tala Madani
Courtesy of Tala Madani and
Lombard-Freid Projects,
New York

top
Seeking Cake Inside, 2006
Oil on canvas
24.1 x 30.5 cm
© Tala Madani
Courtesy of Tala Madani and
Lombard-Freid Projects,
New York

above
Embodying Cake, 2006
Oil on canvas
35.6 x 27.9 cm
© Tala Madani
Courtesy of Tala Madani and
Lombard-Freid Projects,
New York

top
Shrimp, 2006
Oil on canvas
30.5 x 30.5 cm
© Tala Madani
Courtesy of Tala Madani and
Lombard-Freid Projects,
New York

above
Rip Image, 2006
Oil on canvas
25.4 x 20.3 cm
© Tala Madani
Courtesy of Tala Madani and
Lombard-Freid Projects,
New York

top
No Cake – Suffocate, 2006
Oil on canvas
25.4 x 20.3 cm
© Tala Madani
Courtesy of Tala Madani and
Lombard-Freid Projects,
New York

above
Cake Wash, 2006
Oil on canvas
22.9 x 30.5 cm
© Tala Madani
Courtesy of Tala Madani and
Lombard-Freid Projects,
New York

above
Cake Silence, 2006
Oil on canvas
30.5 x 35.6 cm
© Tala Madani
Courtesy of Tala Madani and
Lombard-Freid Projects,
New York

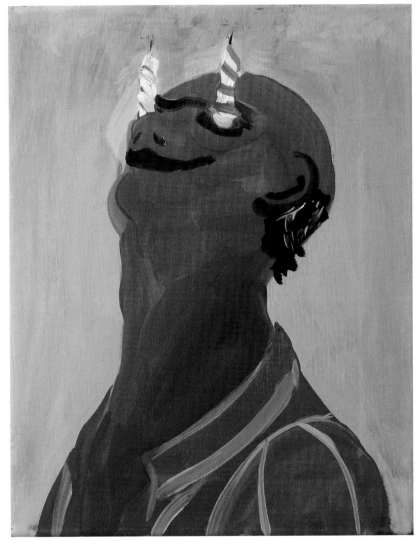

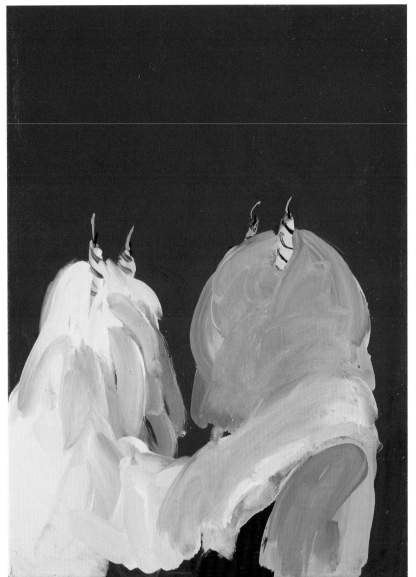

above
Blue, 2008
Oil on canvas
35.6 x 25.4 cm
© Tala Madani
Courtesy of Tala Madani and
Lombard-Freid Projects, New York

left
Bright Eyes, 2007
Oil on linen
24 x 30 cm
© Tala Madani
Courtesy of Tala Madani and
Lombard-Freid Projects, New York

The Mah Art Gallery was set up in 2004 by Shahnaz Khonsari, an intrepid Tehran art 'mover and shaker' who had worked in the visual arts, television and public relations. Already counting many artists among her friends, she was often complimented on her 'good eye', and one day decided to try to capitalize on this by embarking on a new venture. She now runs one of the most successful galleries in Teheran, with her roster of artists including many big, established names. She is also known and respected for her ability to scout, spot and nurture talent, and has established career platforms for many emerging young artists.

As a gallery owner operating in the current tumult and frenzied activity of the art market in Tehran, Khonsari is under no illusions as to the challenges that she and her fellow gallerists face in their field. 'Most galleries are forced to operate on their own,' she says. 'Not only is there very little intra-gallery support...but there are also no parallel synergistic programmes with...government-backed artistic institutions such as museums.'

In addition, today's younger artists generally do not feel as beholden – or even as loyal – to galleries as do their older counterparts. 'The grass is always greener elsewhere and money talks. This makes it very difficult for most galleries to develop or nurture the artist's career.'

'As for the collectors,' Khonsari says, 'we have many genuine and respectable collectors both inside and outside Iran. These people truly love art for art's sake...the difficulty lies with those who call themselves "collectors" but who are in reality secondary market "dealers" with only one objective in mind: profit.... In my own career, I have tried to emphasize the placement of the art into the right collections.'

If this sounds unduly negative, Khonsari is just as quick to offer a more positive slant: that 'contrary to many of her colleagues', she has been lucky not only with most of her collector base, but more importantly with her artists, since most have stayed with her from the beginning of their careers. 'I have been able to develop and nurture their careers to the best of my ability through national and international exposure, especially across the Persian Gulf in Dubai and the United Arab Emirates,' she says.

Khonsari underlines the importance of her artists' career development paths and management of their artistic make-up: 'I make sure that merit is deserved...not grown overnight, but over a period of time and maturity.... The prices especially need to be managed. I always encourage my artists not to be lured by quick returns. Instead, I insist that they work hard at their career, that they take time to think and grow proper perspective and depth; to develop their technique and be daring in their work, producing new and different styles. It is easy to produce work to a formula that appeals to market trends. It is much harder to have the guts to take a chance on a new idea.... One thing is for sure: that being technically good is not enough. It is simply the first prerequisite. The real difference between a good and an amazing artist lies in his or her ability to visualize their own personal and unique viewpoint. Only then will the artist have a chance at surviving in the shark-infested waters of the regional art scene.'

'Nothing gives me more pleasure than to see the look of joy on my artists' faces after a successful opening night,' Khonsari says. 'That is what I work for. Ultimately, it is the only thing that matters.'

The designer, curator and translator Vali Mahlouji is a passionate man, conscious of his words and careful to make each one count. Today he is widely recognized as one of the shrewdest observers of Iran's post-Revolution contemporary culture scene.

Born in Tehran, Mahlouji moved to London as a teenager in 1983. There he went on to study Iranian art and archaeology at the School of Oriental and African Studies (SOAS) in the University of London, as well as taking an MPhil in Old Iranian Philology. He subsequently established his own art gallery before training in fine art and theatre design, and while he is currently concentrating on his curatorial career, Mahlouji continues to engage with his artistic work. His recent design credits include stage sets for Maeterlinck's 'The Blind' and Dvorák's 'Rusalka', and he has been active as a consultant in period design: one recent project was the restoration of the Renaissance interiors of the Palazzo Doria Pamphilj, in Rome.

In 2005 Mahlouji returned to Iran to conduct research on the contemporary art scene. Over a period of two years he conducted in-depth interviews with artists in their studios and homes, and met with gallerists, directors of the Tehran Museum of Contemporary Art and others involved in the art world there.

'What I was doing was putting together an art map of Iran,' Mahlouji explains of his time in Iran. 'The first project to evolve from this research was the 2008 "Iran: New Voices" show at the Barbican, in London. What came out of the show was a composite presentation that involved a season of live performances in theatre and screenings in video art, panel discussions and a symposium on performance art in Iran.'

There were two objectives behind the study, Mahlouji explains. 'One was [to gain] exposure... in order to fill a gap in relation to contemporary Iranian reality, as [in Britain and Europe] we only get to see Iranian cinema.... The Barbican show was important as it presented live performance and video art as new genres of expression from Iran.' It also allowed the Barbican to expand its interest in the art of the country, first seen in its 2001 show on contemporary Iranian art.

'The second objective was to experiment with a specific approach to Iranian culture generally.' Mahlouji is keen to emphasize his bigger ideas: '[For the Barbican show] we chose a conceptual approach with ten video artists inside and outside of Iran and across several generations. It was an attempt to promote critical discourse, bring to the fore diverse perspectives...and allow dialogue between Iranian artists themselves, something that hasn't really existed until now. I am interested in self-analysis and self-critique and in examining the historical process.'

Mahlouji regrets that Iran does not have a culture of curators and art historians. 'But now is the time to produce our own,' he says. 'The analytic and critical viewpoint on contemporary Iranian art is lacking!'

What, in his opinion, is propelling the current artistic movement in Iran? 'There is a double transformation,' Mahlouji explains. 'On the one hand, it is the manifestation of the rekindling of energies that are rooted in millennia of creativity and are undisputedly an integral and primary component of Iranian culture. I say rekindling because the injuries inflicted by the ferocity of the Revolution...combined with the real and psychic scars of a ruthless eight-year war, not only affected artistic production but also brought it to a near standstill for a period.... The relative healing of those assaults has unleashed an insatiable desire to communicate and reflect, a rejuvenation of expression, and an unprecedented multiplicity of approaches to an aesthetic view of life.'

In Mahlouji's view, contemporary culture in Iran is negotiating a crisis or a kind of cultural disorientation. 'This crisis is directly caused by attempts to impose an ideological and concrete interpretation of society. This kind of thinking, which results in the negation of the plurality of culture, is inherently at odds with the nature of Iranian existence, which is multi-layered and heterogeneous in its essence.' Mahlouji contrasts the current growth in Iranian visual culture with officially sanctioned attempts at homogenization: 'The vitality that we observe at present in the Iranian historical process is, in fact, the manifestation of a deep-rooted resistance to such monistic and discolouring visions of existence.... We are negotiating a challenge and this vitality and creativity not only reinstates the possibility of a spectrum of expression, a heterogeneity of identities, but it also emphasizes that modern phenomenon – the individual.'

Mahlouji has a thorough knowledge of Iranian history. 'Being a hybrid is in the essence of Iranian culture, a survival mechanism that pre-dates the modern historical moment. It is a quality resulting from the archaeological layering of accumulated identities across a long process of evolutionary history.' Mahlouji sums up his argument: 'The proliferation of diverse, hybrid and individual expressions within Iranian visual culture is a natural process that reinstates a kaleidoscopic picture of the individual and society.'

The other transformation that has affected the Iranian art scene, according to Mahlouji, is 'the transformation of the global cultural scene, which has now opened up to allow cultures from the so-called periphery...access to the global art centre, which until recently was entirely dominated by Western culture.'

Mahlouji speaks of 'a certain fragmentation, a multiplicity in Western thinking, attitudes and trends, which has allowed cultural expression from the outside to move towards the centre.... It is a globalization of art, if you will.'

'In this evolving global cultural climate,' Mahlouji continues, 'there is room for side-by-side expression by previously divided cultures. There is hybridization and a mixing of aesthetics...of attitudes and concerns towards a more universal truth.'

'The raging discourse today concerning the local and the global will soon be a thing of the past and ethnographic attitudes to art will be diminished,' Mahlouji argues. Above all else, he is enthusiastic about the future: 'We are observing a cultural change and the current Iranian artistic movement is both the driving force and the product of this cultural change.'

Vali Mahlouji

Born in Tehran in 1977, Mahmoud Bakhshi Moakhar studied first Graphics and then Sculpture at the Faculty of Fine Arts, Tehran University, graduating in 2001. Today, he continues to live, work and exhibit in Tehran. Alongside his art practice, he has also written a textbook on sculpture, and has been the editor of one of Iran's leading sculpture magazines.

Moakhar's recent work covers a range of subjects and emotions, from the fairly polemical (for example, doormats or Persian carpets dyed to look like the flag of the United States), through to the poetic (a cabinet of preserved flowers). Meaning is everywhere, however; of the recent series on the four elements, for example, Moakhar says: 'The sacred fire falls upon the revered cypress. Water, the mirror under people's feet, is shattered. And the wind is not a fertile and refreshing breeze…. It is the trumpet of an unwanted war.'

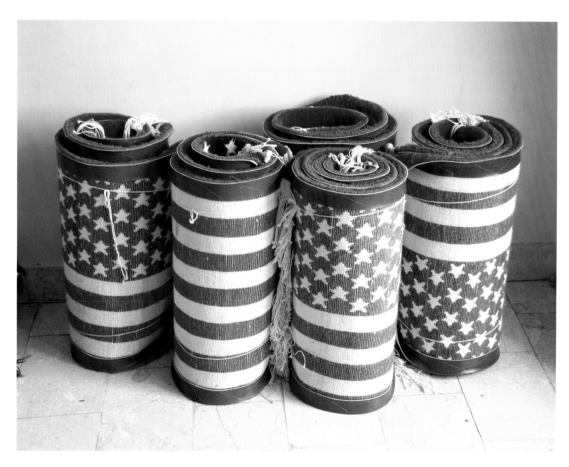

opposite, above
**Tulips Rise From the Blood
of the Nation's Youth**
From the 'Industrial Revolution' series, 2008
Group of sculptures in neon, tinplate, wood,
plastic, electric engine
135 x 35 x 30 cm
Edition of 3
© Mahmoud Bakhshi Moakhar
Courtesy of Mahmoud Bakhshi Moakhar
and Khastou Gallery, Los Angeles

opposite
Doormat, 2008
Handmade carpets, dyed wool
53 x 115 cm
Edition of 15
© Mahmoud Bakhshi Moakhar
Courtesy of Mahmoud Bakhshi Moakhar
and Khastou Gallery, Los Angeles

above
Rose Garden, 2008
Mixed media
19 x 23 cm (each)
© Mahmoud Bakhshi Moakhar
Courtesy of Mahmoud Bakhshi Moakhar
and Khastou Gallery, Los Angeles

Mahmoud Bakhshi Moakhar

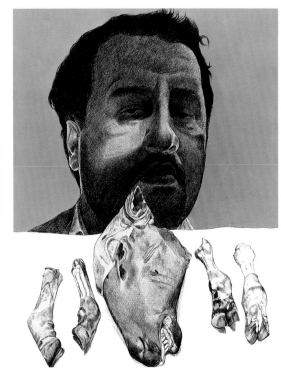

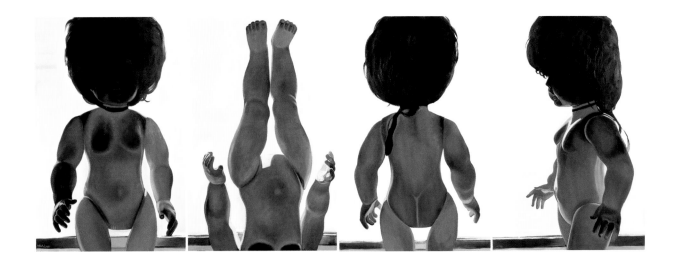

Born in 1973 in Mashhad, Iran, Ahmad Morshedloo is one of Iran's most original painters. He studied first at the Azad University in Tehran, and then in 2001 completed a Master of Arts in Painting. Since then he has exhibited widely, including several solo shows in Tehran and group shows in Europe and the United Arab Emirates. He also teaches at a number of universities in Iran.

Morshedloo's main subject is the human figure, and many of them are depicted naked. In his own words, 'Their nakedness represents their detachment from this world. Sometimes we see some naked children on the street, for instance, to whom nakedness is not an issue for they don't live in this world really.' Some critics have commented that his figures appear to be

burdened and yet tranquil at the same time – ambiguity pervades the works.

The style of these images has been described as 'neo-realist', though there is also a touch of caricature, of exaggeration. What is certain is that Morshedloo is able to handle a large range of media, from charcoal to oil, watercolour to pen, and that his works show considerable technical prowess. However, instead of creating images that are strictly true to life, he attempts to conjure up works that have some humanity, or even humility. There is also a sense of death or morbidity hanging around some of the works: for example, in the sheep's heads that crop up in certain paintings. Even some of the 'live' sitters appear to be only half-alive.

Most of his works, even when relatively simple on the surface, have some symbolism. Of one painting of a man and woman, for example, Morshedloo says that they signify the 'union and solidarity in the Iranian society'. And as for many other Iranian artists, art is also a vital form of self-expression: 'All these paintings portray the emotions and inner feelings of the painter towards human figures,' Morshedloo says. But ultimately, the artist – like some of his figures – carries a heavy burden: 'The artist...is an inevitable presence in society's evolution or its degeneration. His selective gaze puts him in a decisive position.'

top left
Untitled, 2007
Pen and acrylic on cardboard
120 x 90 cm
© Ahmad Morshedloo
Courtesy of Ahmad Morshedloo and the Assar Art Gallery, Tehran

top centre
Untitled, 2007
Pen and acrylic on cardboard
120 x 90 cm
© Ahmad Morshedloo
Courtesy of Ahmad Morshedloo and the Assar Art Gallery, Tehran

top right
Untitled, 2007
Pen and acrylic on cardboard
120 x 90 cm
© Ahmad Morshedloo
Courtesy of Ahmad Morshedloo and the Assar Art Gallery, Tehran

Ahmad Morshedloo

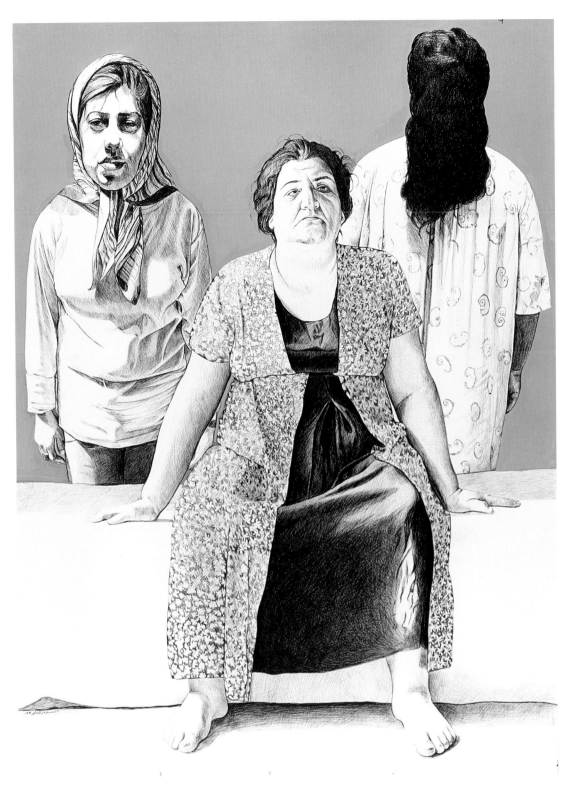

above
Untitled, 2007
Pen and acrylic on cardboard
120 x 90 cm
© Ahmad Morshedloo
Courtesy of Ahmad Morshedloo and
the Assar Art Gallery, Tehran

opposite, below
Untitled, 2007
Oil on canvas
150 x 400 cm (4 panels)
Private collection, London

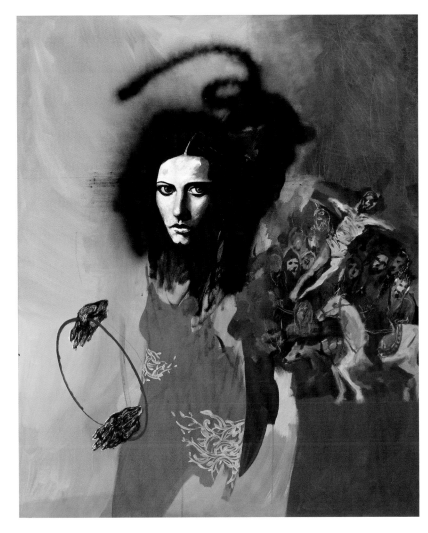

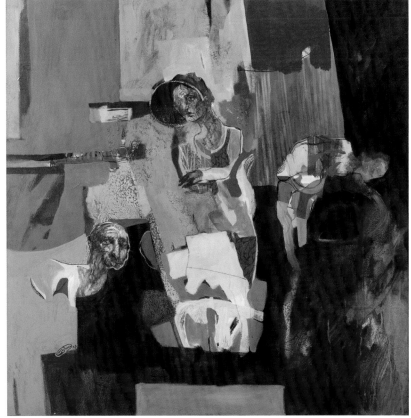

Mohammad Mosavat

Mohammad Mosavat was born in 1983 in
Tehran, and studied at the Azad University.
He has exhibited widely in Tehran, and has
already had two solo shows. His canvases are
richly coloured, and show figures dissolving
into, or merging with, semi-abstract space.
Disembodied heads and hands float in a sea
of purples, pinks and olive greens. Mosavat's
compositions occasionally call to mind those
of Francis Bacon, even if the carefully balanced
colours are more typically Persian. Bits of
imagery from other works somehow creep into
the composition – for example, a fragment of a
crucifixion, with a horse – while other patches
seem almost textured or textile-like. It all makes
for an intriguing, dreamlike mix.

above
Untitled, 2008
Acrylic on canvas
150x 120 cm
© Mohammad Mosavat
Courtesy of Mohammad Mosavat and
Day Art Gallery, Tehran

right
Untitled, 2008
Acrylic on canvas
100 x 100 cm
Private collection, London

opposite
Untitled, 2008
Acrylic on canvas
100 x 100 cm
Private collection, London

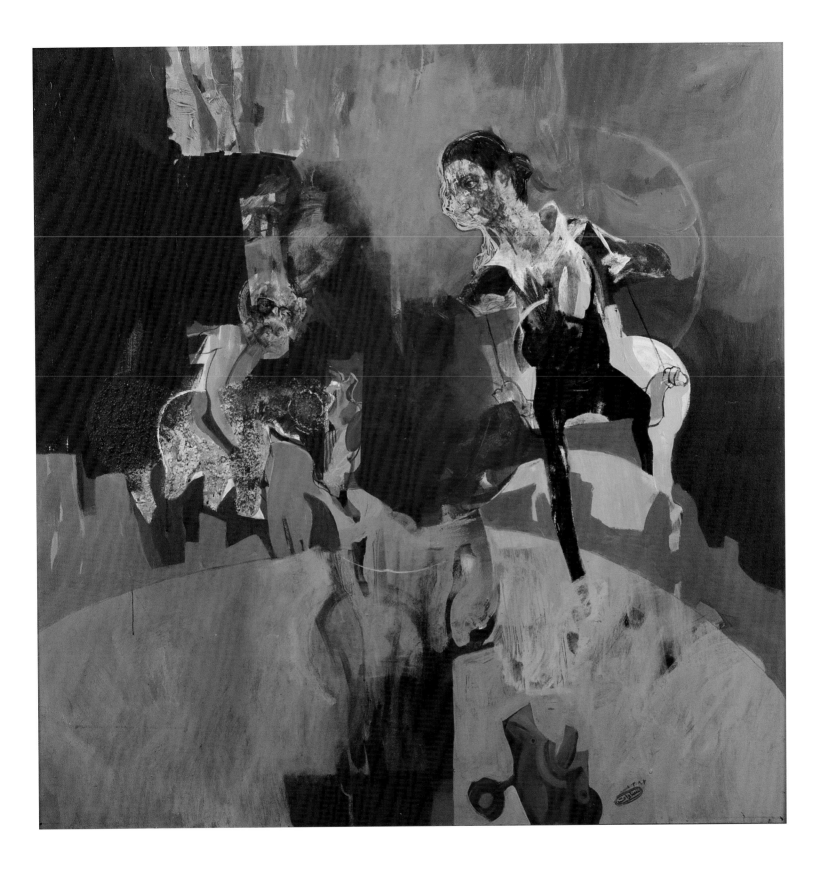

Farhad Moshiri was born in Shiraz, Iran, in 1963, and studied Fine Art and Filmmaking at the California Institute for the Arts. While in the United States he began to experiment with installations, video art and painting, before returning to Tehran in 1991. Today he is incredibly active both nationally and internationally, with over twenty solo exhibitions to date.

Moshiri is well known for his ironic juxtapositions of traditional Iranian forms and those of consumerist and globalized popular culture. Witty and satirical, yet often profound and unafraid to be beautiful, it is an appealing combination that has led to him regularly being cited as one of the region's most exciting artists.

In the early 2000s, Moshiri was most readily associated with his paintings of jars, which are decorated with traditional Iranian sayings and poetic verse, written in Farsi calligraphy. These monumental containers have been described as receptacles of life, memory and desire, and reflect a fascination with archaeology; their

varying colours refer nostalgically to childhood foods and drinks. Thus, in Moshiri's hands something very simple – and very Iranian – becomes a vessel or vehicle for a whole host of issues. His canvases can also have an aged look reminiscent, once more, of ancient earthenware.

However, Moshiri also enjoys constantly experimenting with new materials and techniques; thus, he makes pictures of brides, soldiers and flowers out of frosted fondant, applied with cake-decorating tools; or he adds glitter, Swarovski crystals and textiles to give his paintings an increasingly textured and sculptural appearance. More recently, works such as *Run Like Hell* (2008) have even used kitchen knives to spell out words on the canvas.

Moshiri has also produced a series of very beautiful calligraphic and numeric works, which he began in 2003. Painted most often in black on silver or gold, and again employing a weathered surface, they show the reference marks for

verses in the Qur'an as well as talismanic codes and symbols. The dramatic effect of the distressed, cracked surface Moshiri achieves by folding the canvas, flaking off the paint, and then afterwards sealing it to prevent further paint loss. The final product, with its folds, is reminiscent of tiles.

Moshiri is also interested in the repetition of numbers and letters in scripts for their intrinsic beauty as opposed to any literal meaning or sense they might hold. He has also drawn inspiration from calligraphic practice sheets in which the page is gradually turned black with the ink of the repeated letters. It is this profound understanding of the Iranian visual vernacular, combined with an acute awareness of popular culture and art history, that makes Moshiri stand out from many of his contemporaries.

Currently, however, Moshiri is possibly best known in his home country as the first Iranian artist to achieve a price of over $1 million at auction. The piece in question, *Eshgh (Love)*,

which was sold in 2008, is a black canvas with the word 'love' spelled out in Farsi calligraphy in Swarovski crystals. Works such as this take Moshiri into the luxury market territory, a little like Damien Hirst's diamond-studded skull. However, thanks to Moshiri's skill the piece is both beautiful and still retains a certain knowingness – indeed, the work can almost function as a critique of the luxury market that it was sold into. As Moshiri himself has said on the subject: 'To blur the boundaries between merchandizing and art making has become an essential part of my work. Growing up in L.A., I was constantly forced to compare "High Art" and "Hollywood-style commoditization". At one point, I gave up. Let's be real. As object makers, we're all packaging our ideas. I just laugh when people criticize me for commodifying exoticism!'

In fact, Moshiri explores something similar in his gold-leafed furniture-sculpture (sometimes referred to as the 'fantastic' work), which he began to produce around 2002, and

which he showed at the 2003 Sharjah Biennial. Of this, he has said: 'There's always been an element in my work that's self-ridiculing – I play with the idea of marketing and commodification, and this feeds my practice. After all, the idea of making work that is about the packaging of art has been there since pop art.'

Pop art was also obsessed with celebrity, and Moshiri has his own take on the subject. In *Kennedy's Salt and Pepper Shaker*, from 2005, he presents the instantly recognizable Kennedy couple in the form of salt and pepper shakers. His kitsch approach recalls something of Jeff Koons, but coming from an artist working in Iran the message inevitably is different, a sign of the fetishization of the West in the Middle East – perhaps Moshiri is even drawing a subtle parallel with the Shah? As with all of Moshiri's works, what at first glance appears to be a simple exercise in kitsch imagery is soon shown to have many, many more layers of meaning.

above
Untitled, 2004
Oil and acrylic on canvas
195 x 154 cm
© Farhad Moshiri
Private collection, London

opposite
Kennedy's Salt and Pepper Shaker, 2006
Oil and acrylic on canvas laid on board
Diptych 210 x 160 cm (each panel)
© Farhad Moshiri
Private collection, London

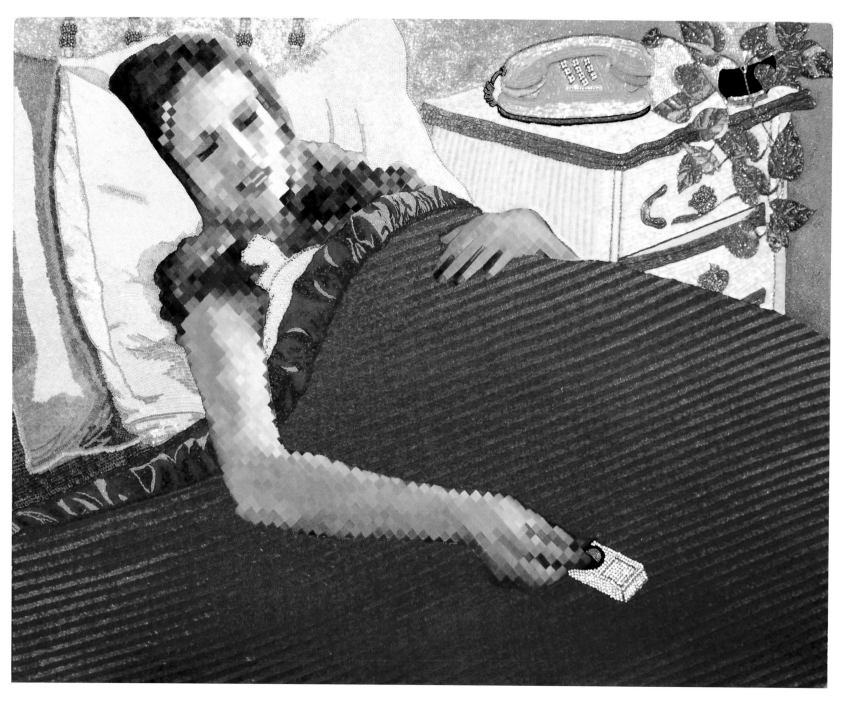

above
Woman under Electric Blanket, 2007
Embroidery, glitter and oil on canvas
mounted on MDF
120 x 160 cm
© Farhad Moshiri
Private collection, London

opposite
Love Letter, 2008
Oil, crystal and metal hooks on canvas,
mounted on board
189 x 148 cm
© Farhad Moshiri
Private collection, London

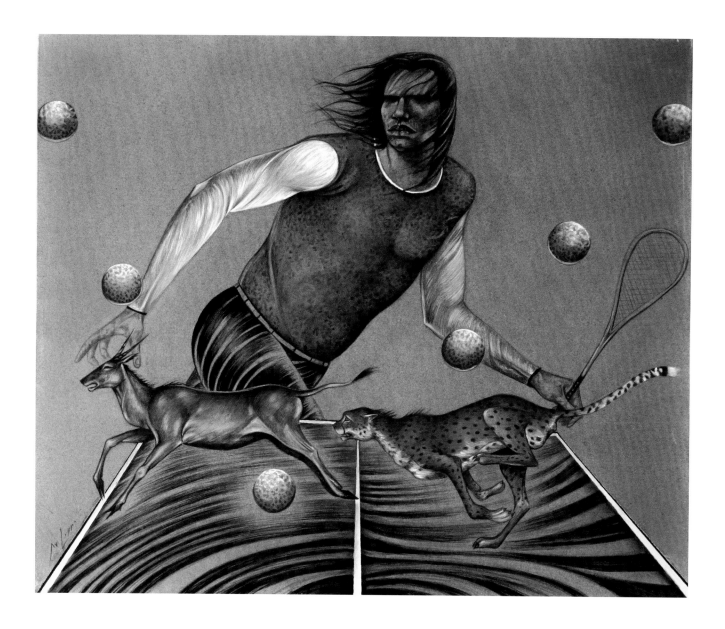

Nazar Moussavinia was born in 1979, the year of the Islamic Revolution, in Abadan – one of the cities most affected by the Iran–Iraq War. The bombardment by Iraqi forces meant that he was moved first to Isfahan and then to Tehran. There, he studied for a degree in Painting, and has gone on to have two solo shows in the city, as well as participating in various group shows.

Moussavinia is above all else a draughtsman, and even his paintings place an emphasis on clean lines and a very pared-down palette that allows for strong modelling. The imagery is at once disturbing and surreal; human sports are equated with the savagery of nature, while a girl is assailed by miniature missiles. The viewer is almost invited to decide for him or herself what it means, and it is the sheer wealth of possible readings that make these canvases so intriguing.

Untitled
Acrylic on canvas
100 x 120 cm
© Nazar Moussavinia
Courtesy of Nazar Moussavinia and
Mah Art Gallery, Tehran

Nazar Moussavinia

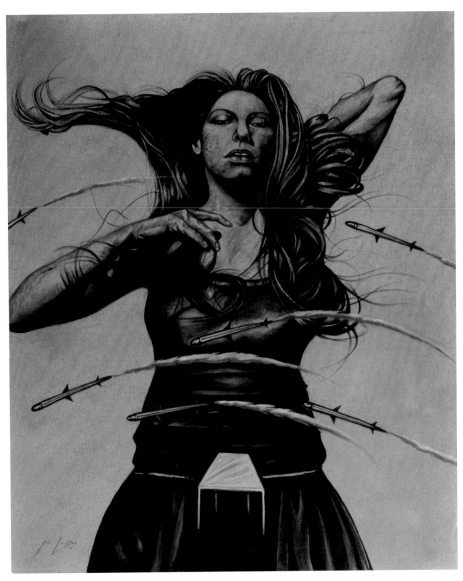

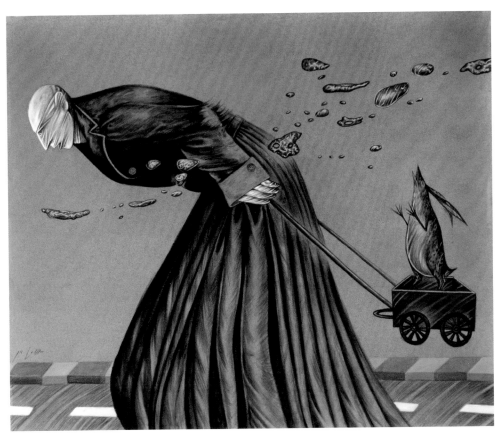

Nazar Moussavinia

Sirous Namazi remembers the trauma of escaping from Iran, along with his family, when he was fourteen. Persecuted for practising the Baha'i faith, the family settled in Stockholm, Sweden, in 1986 and Namazi has been painting and sculpting ever since.

The artist does not like to talk about those early years in Iran, living through the turmoil and persecution of the Islamic Revolution. He likes to say that he had both good and bad experiences in the country, and leaves it at that. Namazi doesn't hold grudges, however. 'In some ways I'm close to my history and I remember the experience of entering a new country [Sweden] was difficult…. There's no question that my background has influenced my work,' he adds. 'Though my work should speak for itself, the two issues are related to each other.'

Many Iranian artists, especially exiled ones, produce overtly political works. Namazi's tend to be a little more subtle: 'Some of my art is more [clearly political] than other pieces. I have interests in different issues…social and political issues inform my work deeply, but at the end of the day it's quite a mixture.' Namazi goes on to describe one particular series of works ('Periphery') executed in 2002 and shown at the Stockholm Modern Art Museum. They depict parabolic satellite television antennae on neighbourhood balconies, representative of immigrant communities' longing for their homeland.

The pieces caused quite a stir in Sweden when they were acquired and shown, since they raised issues around non-Swedish minorities' integration into society: why, for example, did these minorities choose to live apart in ghettoized communities, linked virtually to their home cultures through satellite television? Namazi explains the issue from his own perspective: 'It was all about finding an identity in a new country. The problems of cultural communications are increasing exponentially with the rapid change of technology,' he says. In a video installation Namazi made in 1996, he is seen cracking jokes in Farsi to a European audience unfamiliar with the language. He says: 'I was trying to explain how it feels to come to a new culture and all the problems that can arise from it.'

His other works tend to have strong formal qualities: for example, his modular box sculptures, which play with repetition and subtle use of colour, remind one of the minimalism of Sol LeWitt. Others again are quasi-architectural, elaborate structures with no obvious use, while others – such as the 'Patterns of Failure' series of ceramic columns – are clearly beautiful for the sake of it.

Namazi confesses that he is not especially informed about the contemporary art scene in Iran, though he knows and admires several Iranian artists. 'Art,' he says, 'is a mirror reflecting society and pointing out certain issues.' For him, art that is interesting is art that is about issues and addressing the problems of the day: 'It has to feel important, for artists are sounding boards in society.'

top
Container, 2007
Sheet metal, lacquer paint
773 x 736 cm
© Sirous Namazi
Courtesy of Sirous Namazi
Welfare-Fare Well, Nordic Pavilion
Venice Biennal, Italy
Photo by Per allsten, Moderna Museet

above
Structure, 2004
Wood, corrugated plastic, wheels, aluminium
170 x 500 x 120 cm
© Sirous Namazi
Courtesy of Sirous Namazi
Momentum, Moss, Norway

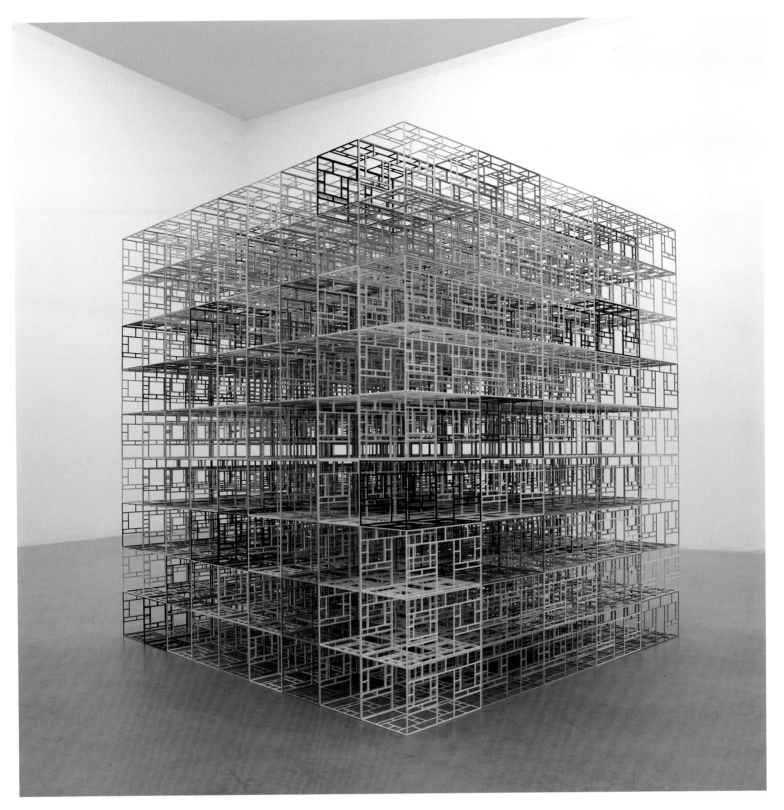

Untitled (modules)
Laser-cut sheet metal, lacquer paint
126.7 x 125.2 x 130.4 cm
© Sirous Namazi
Courtesy of Sirous Namazi
Galerie Nordenhake, Stockholm, Sweden
Photo by Carl Henrik Tillberg

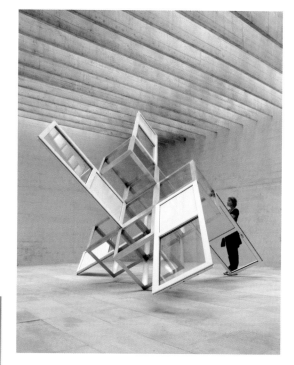

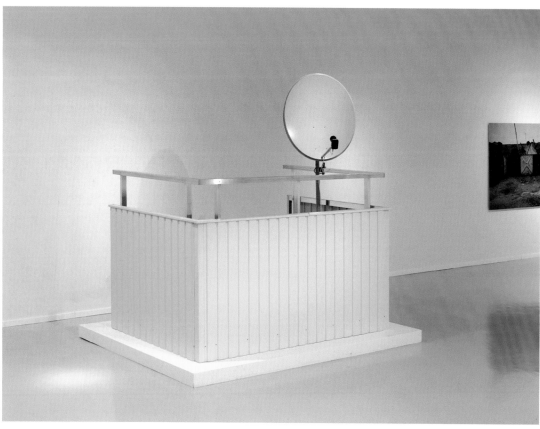

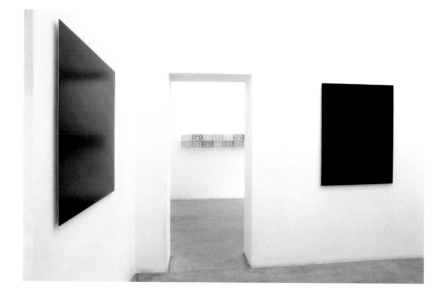

above right
Untitled, 2007
Aluminium, PVC doors
410 x 500 x 500 cm
© Sirous Namazi
Courtesy of Sirous Namazi
Welfare-Fare Well, Nordic Pavilion
Venice Biennale, Italy

above
Periphery, 2002
Aluminium, wood, plaster, corrugated sheet
metal, parabolic antenna
150 x 220 x 190 cm
© Sirous Namazi
Courtesy of Sirous Namazi
Udda veckor, Museum Of Modern Art,
Stockholm, Sweden
Photo: Albin Dahlström, Moderna Museet

right
Interior, 2007
Lambda print, Diasec
88 x 110 (3), 110 x 88 (4)
Installation view
© Sirous Namazi
Courtesy of Sirous Namazi
Galleria Suzy Shammah, Milan, Italy

opposite
Patterns of Failure, 2005
Porcelain, epoxy glue
Installation view
© Sirous Namazi
Courtesy of Sirous Namazi
Galleria Suzy Shammah, Milan, Italy

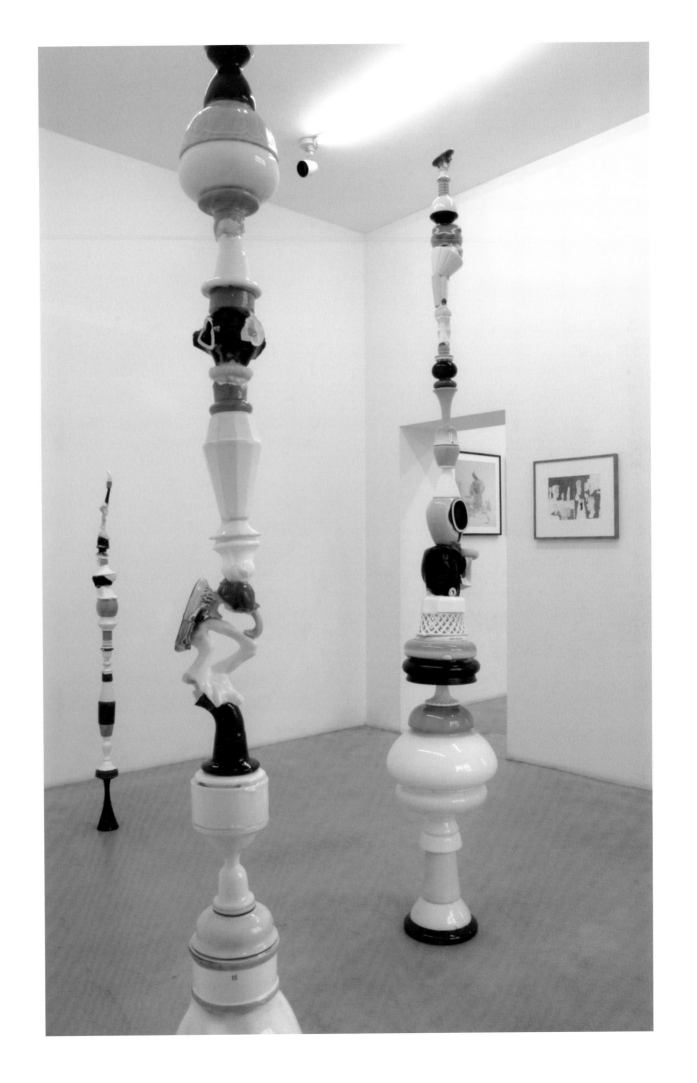

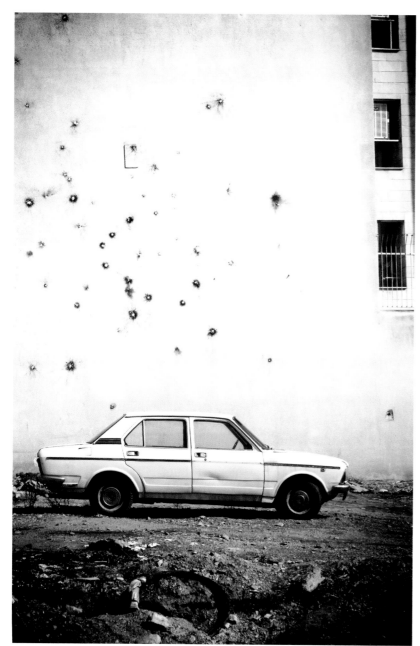

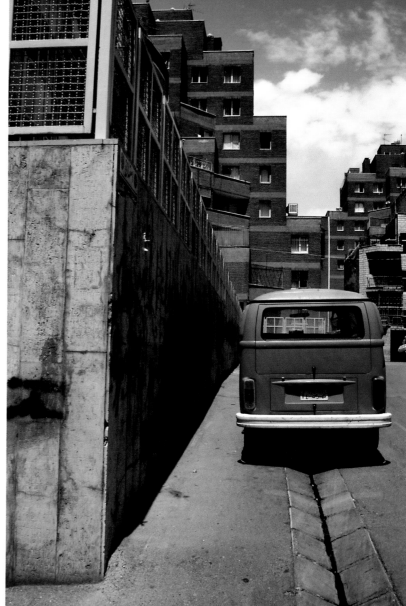

Born in Tehran in 1978, Mehrdad Naraghi switched from Metallurgy to Fine Art at university, initially studying calligraphy, but then concentrating on photography. In 2000 he began the VARA arts group with some friends, and since 2004 has worked as a solo artist.

Naraghi enjoys taking photos in his native Tehran, especially the neglected or overlooked spaces – one particularly striking series looked at the city at night. Another recent series explored the role of cars in the city, and became an interesting exploration of what we choose to see – or not to see – in our everyday environments: 'During my urban photography and street walking, I'd tried to omit from my work everything that was a sign of human beings. Cars were one of these elements that I'd preferred to put out of my frames. After a while I became increasingly aware of the role of cars in different scenes. In fact these human-made machines invaded my compositions and became a part of my photos that I couldn't ignore....'

above
From the 'Cars' series
Tehran, 2006
Colour photograph
© Mehrdad Naraghi
Courtesy of Mehrdad Naraghi and
Silk Road Gallery, Tehran

right
From the 'Cars' series
Tehran, 2006
Colour photograph
© Mehrdad Naraghi
Courtesy of Mehrdad Naraghi and
Silk Road Gallery, Tehran

Mehrdad Naraghi

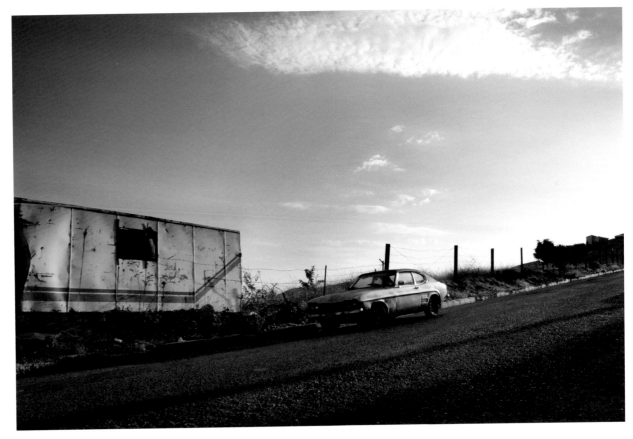

above
From the 'Cars' series
Tehran, 2007
Colour photograph
© Mehrdad Naraghi
Courtesy of Mehrdad Naraghi and
Silk Road Gallery, Tehran

top
From the 'Cars' series
Mazandaran, 2006
Colour photograph
© Mehrdad Naraghi
Courtesy of Mehrdad Naraghi and
Silk Road Gallery, Tehran

right
From the 'Cars' series
Tehran, 2006
Colour photograph
© Mehrdad Naraghi
Courtesy of Mehrdad Naraghi and
Silk Road Gallery, Tehran

Mehrdad Naraghi

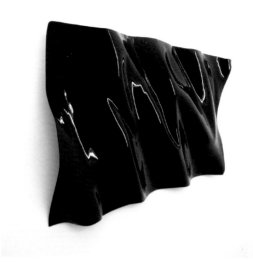

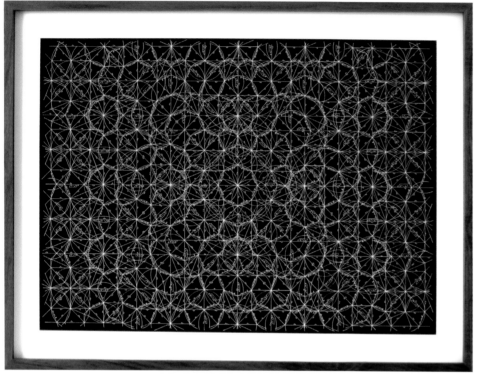

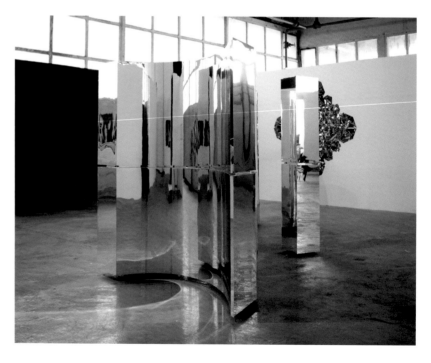

Born in Berlin in 1972 to a German mother and an Iranian father, Timo Nasseri began his art career as a photographer. However, he gradually made the transition to sculpture, beginning with the mural sculpture *Flag*, which played on the ambivalence between surface and volume. Since then his work has explored machines of war and, in particular, Islamic architecture. Thus we find in his work examples of *muqarnas* (a honeycomb vault-like structure), as well as various geometric, non-repeating patterns. However, these architectural decorations are removed from their historical contexts, and fashioned out of new, alien materials, such as stainless steel. Their shiny surfaces now reflect the world rather than represent it, thus pandering to the modern obsession with self-image.

Nasseri also exhibits the beautiful drawings used to calculate the geometry of the *muqarnas*. In these, the lines interwine against a black background, gradually drifting from an architect's plan into an intuitive abstraction.

above right
Flag II, 2006
Resin and varnish
185 x 98 x 20 cm
© Timo Nasseri
Courtesy of Timo Nasseri and
galerie schleicher+lange, Paris

above
One and One #1, 2008
White ink on black paper
63 x 83 cm
© Timo Nasseri
Courtesy of Timo Nasseri and
galerie schleicher+lange, Paris

right
Fadjr II, 2007
Polished stainless steel
200 x 500 x 160 cm
© Timo Nasseri
Courtesy of Timo Nasseri and
galerie schleicher+lange, Paris

Timo Nasseri

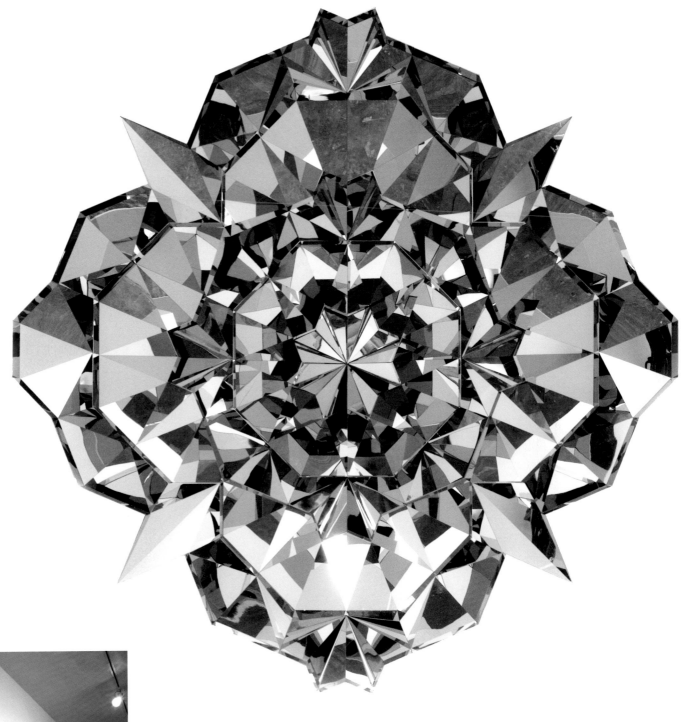

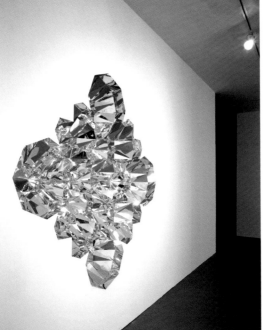

above
Epistrophy #1, 2008
Polished stainless steel
150 x 150 x 100 cm
© Timo Nasseri
Courtesy of Timo Nasseri and
galerie schleicher+lange, Paris

left
Muqarnas, 2007
Mirrors, wood and plaster
220 x 220 x 160 cm
© Timo Nasseri
Courtesy of Timo Nasseri and
galerie schleicher+lange, Paris

Timo Nasseri

Shirin Neshat
Photo: Lina Bertucci, 2006

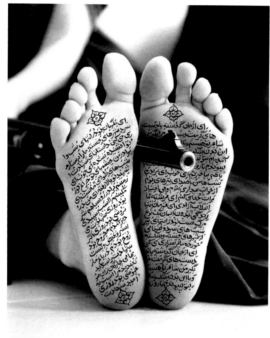

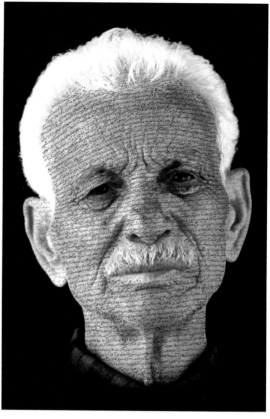

left
Allegiance with Wakefulness,
1994
Gelatin silver print and ink
35.5 x 28 cm
Edition of 10 + 1 AP
© Shirin Neshat
Courtesy of Shirin Neshat and
Gladstone Gallery, New York

above
Haji, 2008
C-Type photograph and ink
152.5 x 101.5 cm
Edition of 5 + 2 APs
© Shirin Neshat
Courtesy of Shirin Neshat and
Gladstone Gallery, New York

Shirin Neshat

Shirin Neshat is perhaps the most internationally recognized and widely acclaimed of all contemporary Iranian artists. Over the past decade she has been instrumental in placing the Iranian contemporary art movement squarely into the global spotlight, exhibiting everywhere from New York to Auckland, London to Japan.

Born in Qazvin, Iran, in 1957 into a well-to-do family, Neshat was encouraged in her individuality by both her mother and her physician father. She left Iran to study in Los Angeles in 1975, four years before the Islamic Revolution, and did not to return to her homeland for several years. In 1978 she moved to the San Francisco Bay area to attend the University of California at Berkeley, where she took a series of undergraduate and graduate programmes, including a Master of Fine Arts that she completed in 1983.

Moving to New York, Neshat began to engage with art on the periphery, working with non-profit organizations including the Storefront

for Art and Architecture. This experience gave her exposure to a wide variety of cultures and societies, preparing the groundwork for her artistic vision.

Perhaps surprisingly, Neshat produced little art during this time, and that which she did produce she later destroyed. However, her return to Iran in 1990 sparked her artistic passions. The enormous gulf between her pre-revolutionary upbringing, coupled with the intervening years spent in the West, and daily life in the Islamic Republic led her to execute the highly acclaimed 'Women of Allah' series, in which Persian texts were displayed on the bodies and faces of women. Since then almost all of her work has dealt with the social and moral codes of Islamic societies, typically through video installations, photography and film.

'When it comes to the creative flow I believe in my subconscious first,' Neshat says of her work. 'I'm constantly conflicted between my "inner" and "outer" worlds, so the art I make

is really about finding a balance between what goes on inside of me, and what goes on in the outside world.'

'Things develop organically so I never try to analyze them immediately...often someone else comes along and begins to interpret and triggers cognition,' she continues. 'There have been times that some commentaries written about my work have made me realize certain patterns and connections for the first time.'

When she makes an appearance in her own works, Neshat generally seems somber. 'What we reveal to the public as our personalities is often a façade,' she says of personas and demeanors. 'Whereas our work – our art – is a way to truly let out the self. I feel that my work is a better representation of who I am as a person, with all my human vulnerability, than I could explain through words myself.'

'I feel like some of the best work that I've ever done was when I wasn't really sure what I was doing,' Neshat continues. But she is

interrupted at this point by her partner Shoja Azari, who reminds her of the certainty she has in her own work. Azari explains in detail Neshat's meticulous methodology, planning and execution, revealing that Neshat never does her own photography, but instead uses professionals to shoot the artwork that she herself has created down to the tiniest detail. A revolutionary film and video maker, Azari is himself increasingly recognized internationally for his video and installation artworks.

Neshat first met Azari when she was working on her video installation *Turbulent* in New York in 1997. 'We work together, talk together, cook together...we do everything together,' she says. 'We influence each other artistically and intellectually. We're always interacting. When I make a new work, or come up with a new concept, I'm always anxious as to whether Shoja likes it or not.' When they first met, Neshat had been distant from the Iranian community, but '[Shoja] was so tuned

230

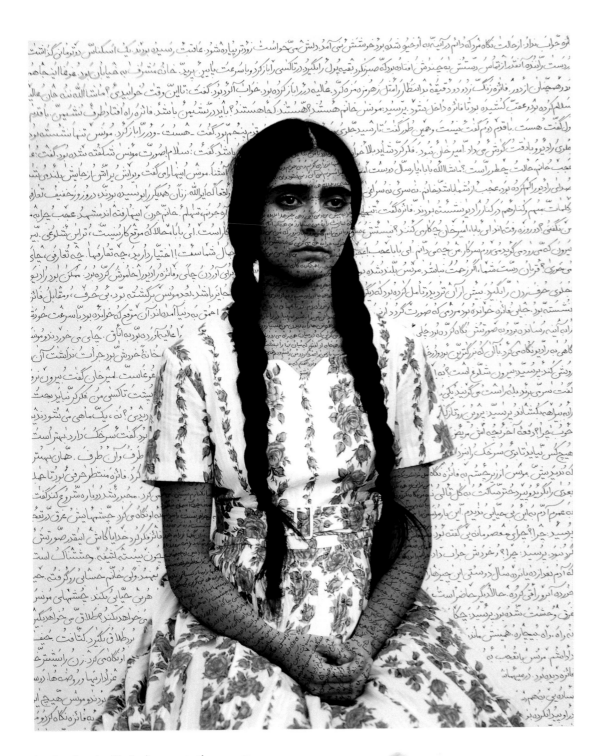

in culturally and politically...it was a way of reconnecting to the Iranian community through him...he pulled me back in.'

Neshat gained official recognition when she was awarded the Golden Lion International Prize in the 1999 Venice Biennale for the work *Rapture* (a large-scale video and photographic piece that involved 250 extras). She muses on the origins and the methodology of her art work. Her Iranian childhood was spent in a what she has referred to as a 'Westoxicated' household, which slowly dissolved her family's Iranian identity. Then there were the years abroad, the alienation. She has not returned to Iran since 1996.

'I can't sit before you and claim that I've made great work. I just don't know if I really have, to tell you the truth. All I know is that I have felt with an urge to be an artist and one day when that urge leaves me, I will stop being an artist.'

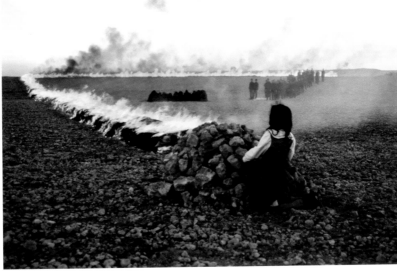

above
Shirin Neshat from the 'Faezeh' series, 2008
C-Type photograph and ink
34 x 27 cm
Edition of 15
© Shirin Neshat
Courtesy Shirin Neshat and
LTMH Gallery, New York

left
Passage Series, 2001
Cibachrome print
39 x 60 cm
Edition of 10 + 2 AP
© Shirin Neshat
Courtesy of Shirin Neshat and
Gladstone Gallery, New York

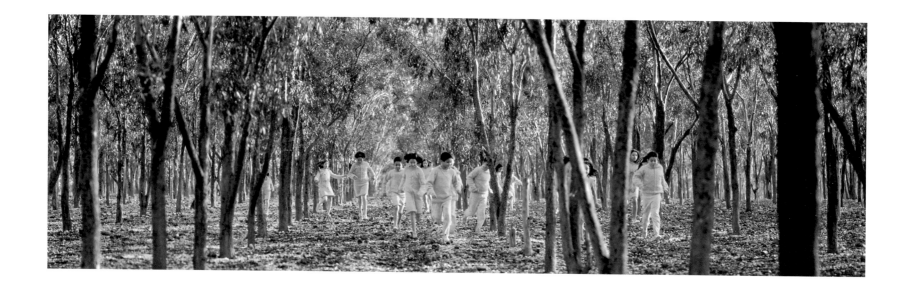

Shirin Neshat

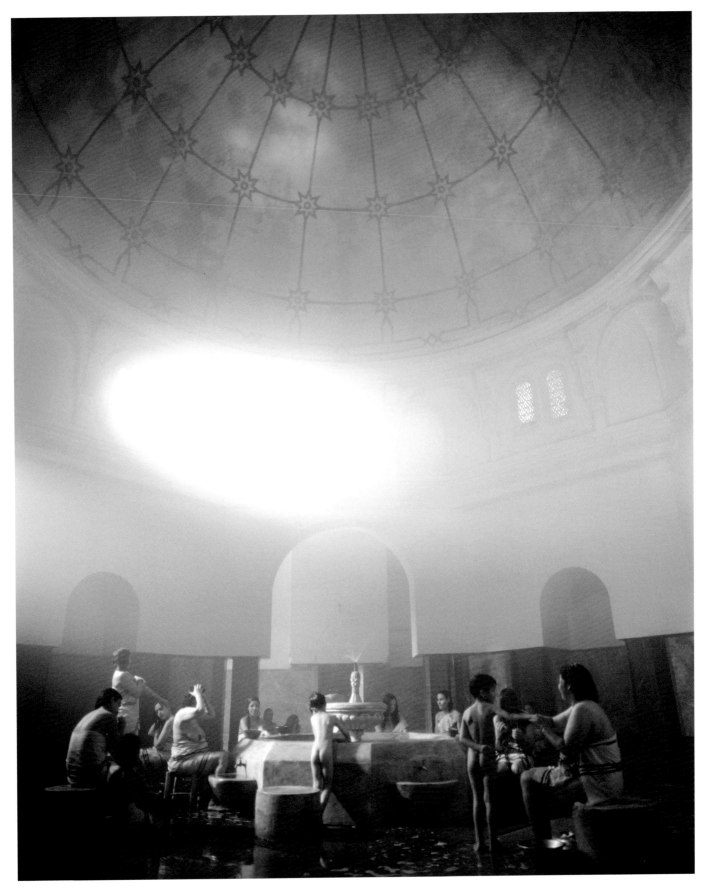

Pari, 2008
C-Type photograph and ink
183 x 126 cm
Edition of 5 + 2 APs
© Shirin Neshat
Courtesy of Shirin Neshat and
Gladstone Gallery, New York

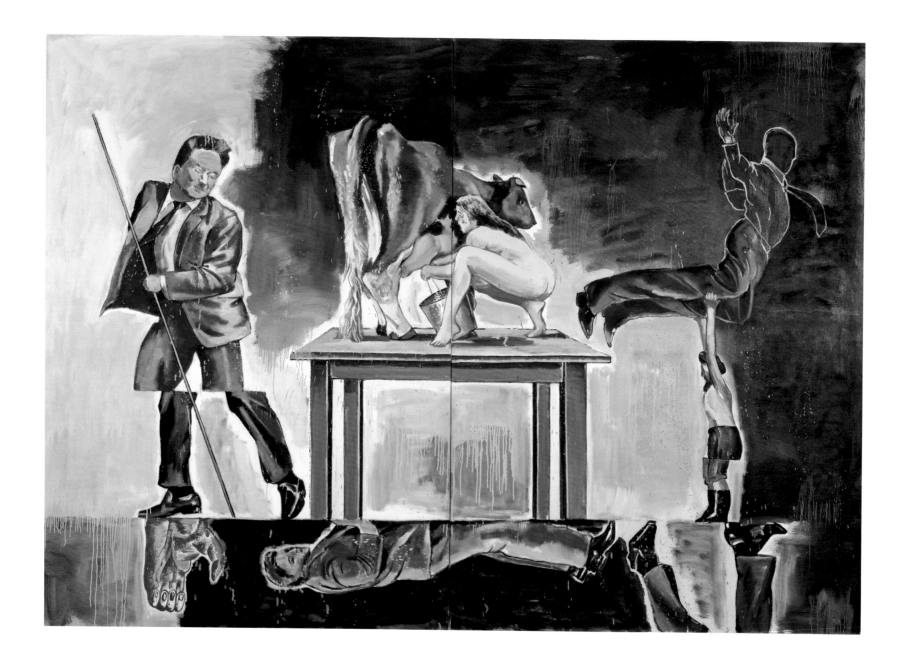

Nicky Nodjoumi was born in Kermanshah, Iran, in 1942 and earned his BA from Tehran University of Fine Arts. He then went on to study for a Master of Fine Arts at the City College of New York, which he was awarded in 1974. At the time of the Islamic Revolution in 1979 he was in Tehran, and along with several other artists designed political posters; the following year he had a retrospective exhibition at the Tehran Museum of Contemporary Art. However, in time he fell out with the new Iranian government, forcing his return to the United States. There, working in Brooklyn, he has continued to enjoy a healthy career, exhibiting regularly. He has also recently co-curated (with Shirin Neshat) a retrospective at the Asia Society and Museum, New York, of the work of Iranian illustrator Ardeshir Mohassess.

Nodjoumi's style is very much his own. His works are figurative narratives, produced using a pared-down palette and a style reminiscent of political cartoons, but with significant unexpected and surreal twists. Presidents carry frogs; men are burdened down carrying huge roses; naked women appear alongside Islamic leaders, though sometimes they seem barely aware that they are sharing a canvas.

Nodjoumi straddles East and West, playing with ambiguity, allegory and irony. Many of his works are about power, pitting Mullahs and Ayatollahs against Western bureaucrats in suits (or even placing them on top of each other, as happens in one of his paintings). In the words of Neshat, 'At first look...Nodjoumi's politically charged paintings read as a poignant critique of people of "power", whether religious or governmental, Muslim or American. These obscure narratives intelligently and humorously confront the viewer with the absurdity and hypocrisy behind those characters who control our lives.'

Stylistically, Nodjoumi is working in a tradition of political satire, though elevated to the status of 'high' art. There is also a clear delight in the absurd – more recent works, for example, give figures mismatched tops and bottoms, a technique that brings to mind the Surrealists' games of 'Exquisite Corpse'. Ambiguity seems to be the goal.

The Smell of Sour Milk, 2008
Oil on canvas
178 x 254 cm
© Nicky Nodjoumi
Courtesy of Nicky Nodjoumi and Priska C. Juschka Fine Art, New York

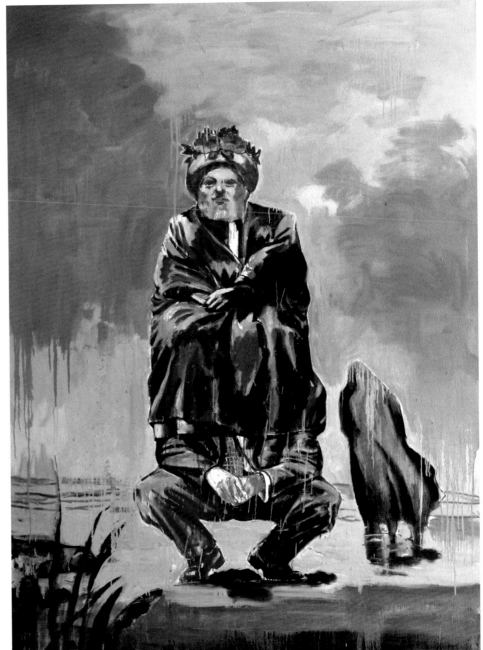

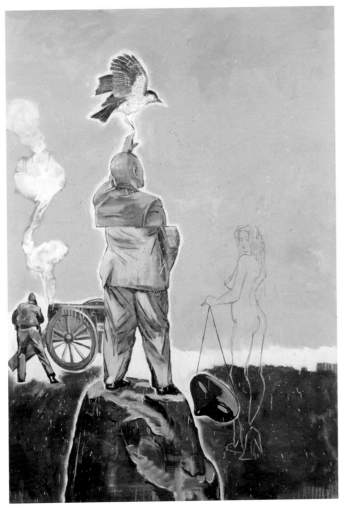

above
Celebration of Power, 2006
Oil on canvas
173 x 127 cm
© Nicky Nodjoumi
Courtesy of Nicky Nodjoumi and
Priska C. Juschka Fine Art, New York

left
Early Morning after the Party, 2007
Oil on canvas
183 x 127 cm
Private collection, London

Fereydoon Omidi was born in 1967 in Roudbar, Iran. He attended the Azad University in Tehran and is a member of the Iranian Society of Painters. Since 1995 he has exhibited widely in Tehran, as well as participating in many group shows internationally, including in Japan, Venice and Paris. He currently lives and works in Tehran, and teaches at the Azad University.

Omidi's paintings are at once elusive and seductive. His basic subjects are the letters of the Farsi alphabet, which he dissects into their constituent cursive elements, and then repeats over and over again, to create rhythmical patterns. Their meaning slips away, and the viewer is left with waves of forms floating across the canvas. Though he sometimes uses colour to dramatic effect, many of his works are black and white, increasing their contemplative aspect.

above
Untitled
Oil on canvas
160 x 200 cm
© Fereydoon Omidi
Courtesy of Fereydoon Omidi and
Mah Art Gallery, Tehran

right
Untitled, 2008
Oil on canvas
150 x 150 cm
Private collection, London

Leaving politics to one side, Farah Pahlavi, the former Empress of Iran, was without doubt the most influential figure in the promotion and propagation of modern Iranian art from the 1960s to the collapse of the monarchy in 1979. Whether buying artworks for herself to support Iranian artists, or by encouraging the government to support art in Iran, she was, quite simply, the country's principal patron.

Farah Pahlavi was born Farah Diba in 1938 to an upper middle class Tehran family; her father, a graduate of France's St Cyr Military Academy, died when she was nine years old, and she spent her early youth in Iran before leaving to study in France in 1957. It was as a student of architecture at the Ecole Spéciale d'Architecture in Paris that she first caught the eye of the Shah of Iran. Diba continued to return to Tehran each year for her summer vacations until, in 1959, she married the Shah and became Empress of Iran. Twenty years later, in 1979, the Shah and his family left for exile, leading to the collapse of the 2,500-year-old Persian monarchy.

Exile seems not to have stunted her love for either the art of her country or the Iranian artists she got to know – and indeed, she has learnt to appreciate many new ones. For Pahlavi, art has been a lifelong passion: 'I was interested in art from an early age and liked drawing and painting. But it was really after I returned to Iran and got married to His Majesty that my interest in Iranian art grew.'

Pahlavi remembers the first painting she ever bought – 'It was a Nasser Ovissi' – and how she took it to their home in Babol, near the shores of the Caspian Sea. Naturally, many organizations were keen to attract royal patronage: 'I would receive regular requests to inaugurate exhibitions and openings.' Pahlavi always tried to oblige.

However, her patronage soon also extended to museums. 'We'd meet with artists at the Café Shahrdari [in Tehran's City Park] in a small building, and it was from there that we first started talking about the idea of building a permanent architectural space for modern art in Iran. That's where the idea for Tehran's Museum of Contemporary Art was originally born and I assigned the Ministry of Culture and Kamran Tabatabai Diba to draw up the plans. There were the usual problems with the budgets and politics, so I decided to take the project under my own direct patronage and to supervise it through my office.' The National Iranian Oil Company provided the funding.

'We converted an old military parade ground into a public park where two museums were built, the Tehran Museum of Contemporary Art and the Carpet Museum. There were plans for several other major art centres scattered across the country, but revolutionary turmoil put a stop to those.'

Pahlavi liked the artists of her time. 'I liked them for being fellow Iranians, my countrymen and women...I liked their art, I enjoyed their company. Iranians are creative in many ways: art, poetry, handicrafts and architecture. A nation that builds such beautiful mausoleums to their poets cannot be bad, can it?'

'I remember I had almost to beg the Government to buy an important collection of Qajar [19th-century] paintings from an English collector in the mid-1970s.' She had to approach the Shah to intercede personally with the Prime Minister in order to obtain the two million dollars plus needed to save the collection from being broken up. 'We managed to buy the 63 paintings in the end,' she says with satisfaction. Pahlavi then adds with a chuckle: 'I remember trying to argue that with increasing oil revenues, buying art from abroad could stave off internal inflation.' That argument may not have gained purchase, but the paintings still remain in their dedicated Negaristan Museum in Central Tehran.

'I did what I thought was positive for art and artists at the time. We even took Iranian artists' artworks on travelling shows around the world, in military transports would you believe?'

Would she do it differently if she had it to do again? 'I don't think I would do anything differently. It's up to Iranians to determine my contribution to the country's arts. When I think of art I remember all the artists I knew...it's as if I'm back there again.' The former Empress is in touch with several artists inside and outside of Iran, through email and phone contact. When asked whether she would consider helping young Iranian artists, she responds that they seem to be doing pretty well by themselves: 'Look at some of the auction prices being fetched by Iranian art!'

Suddenly silent, Pahlavi raises her head with a mischievous smile to recount the story of the latest art work that she has acquired from some unknown compatriot inside Iran: a small seashell painted with a tiny golden Pahlavi crown sent to her New York office from Kish Island in the Persian Gulf. 'This is more important than a Monet!', she exclaims.

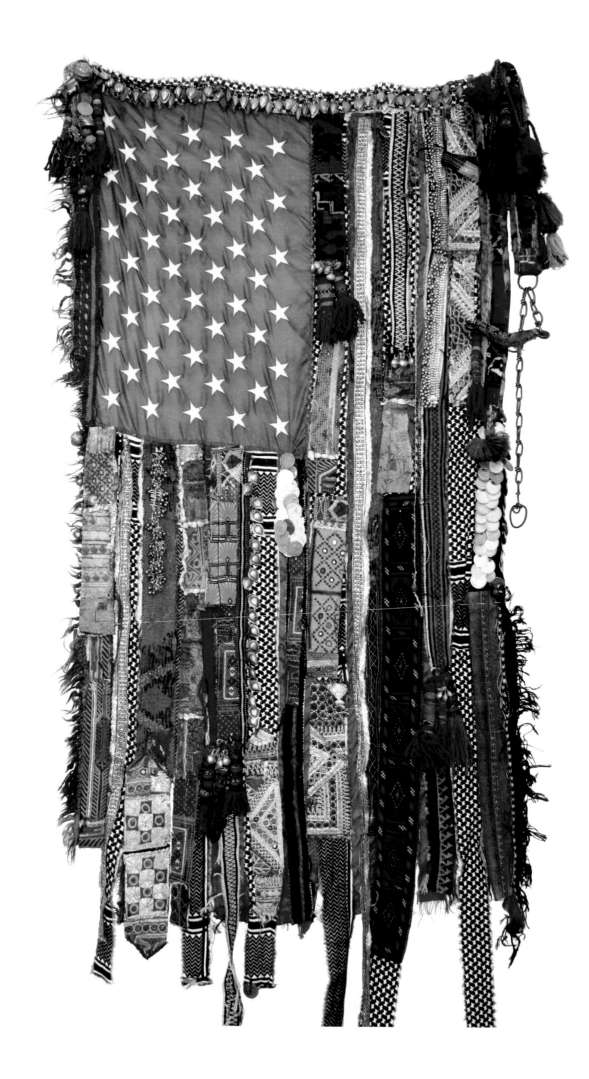

Sara Rahbar

Sara Rahbar was born in Tehran, Iran, in 1976, but the Islamic Revolution and the start of the Iran–Iraq War forced her to leave her country. Rahbar went on to study Design in New York, and then Fine Art at Central Saint Martin's College in London. She has worked in various film roles, and has also been a freelance photographer in Iran for several years. Her work has been shown in galleries and museums worldwide, and she shows regularly. She currently lives and works between New York and Iran.

Much of Rahbar's work concerns the issues of patriotism and identity, most often taking the form of a flag. Of this, she says: 'A flag means so much to someone and absolutely nothing to the next. It's a piece of meaningless fabric and yet it carries such a strong message. So many of us associate ourselves with banners, flags and symbols; it's a role we play, a mask we wear.... I want to know what is behind that mask...'

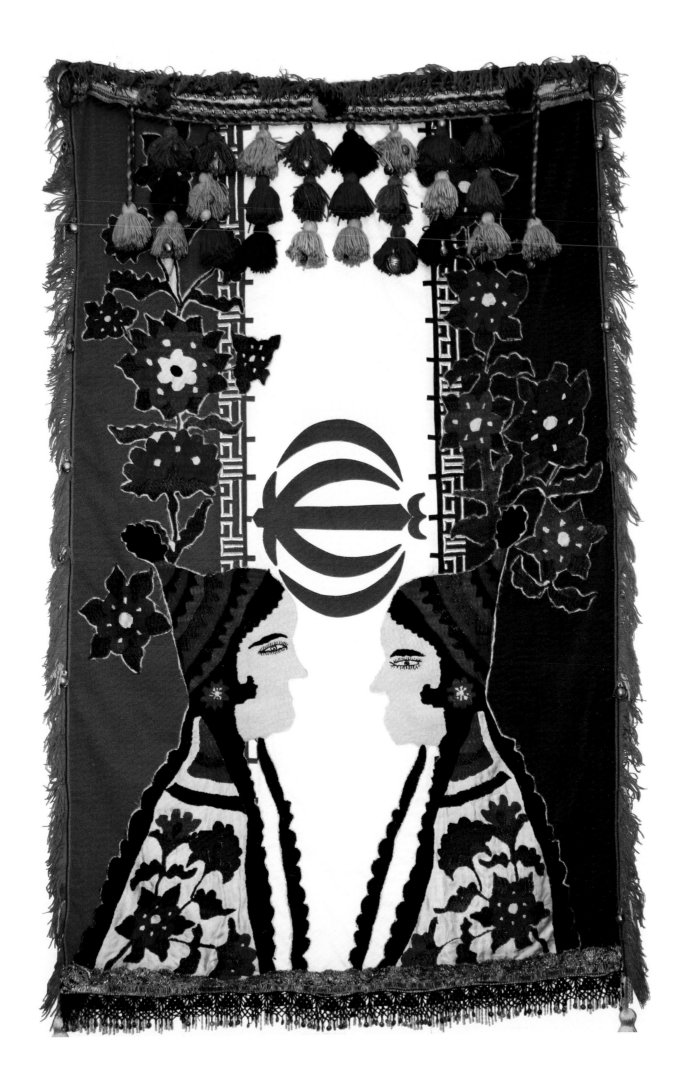

Sara Rahbar

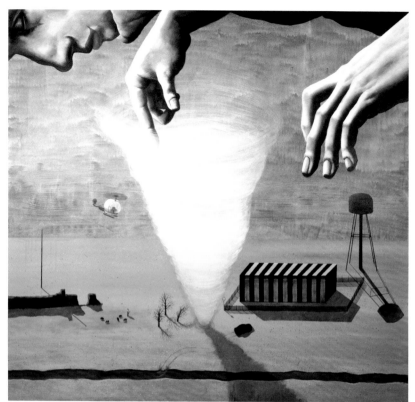 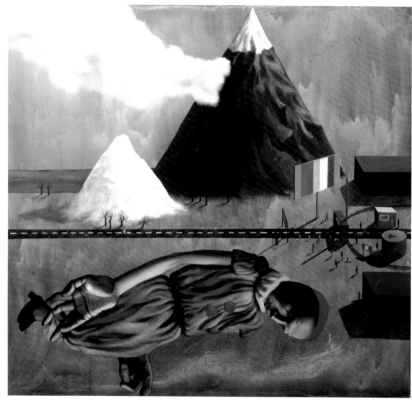

Born in 1980 in Tehran, Hamed Sahihi is one of Iran's most intriguing painters. Trained in Tehran and graduating with a Master of Arts in Painting in 2003, he has since gone on to enjoy considerable success in Iran, with several solo shows in Tehran and participation in over twenty group exhibitions.

His style is easily recognizable. From early on his figures have tended to float in space, giving a dreamlike feel to his works. In fact one haunting series produced in 2004 was called simply 'Dreams'. Since then he has painted series of people reading books, of distorted close-up portraits, of aerial views of cities that make them look like toys, and most recently

of clowns. In this last series, huge clowns float above cities or in space, while towns end abruptly, sitting on the edge of painterly nothingness. One godlike clown even creates a tornado with his finger, while another drifts in the firmament. There are strong surreal elements running throughout his work, and from time to time one senses the influence of Magritte, Ernst or even Miró.

Sahihi has also enjoyed some success as a filmmaker, having made several short films and video animations over the past five years, and having attended workshops with the legendary Iranian filmmaker Abbas Kiarostami.

All from the 'Marco Polo' series, 2009
Acrylic on canvas
170 x 180 cm
© Hamed Sahihi
Courtesy of Hamed Sahihi and
the Azad Gallery, Tehran

Hamed Sahihi

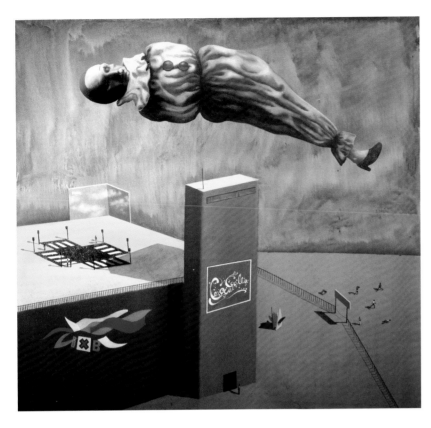

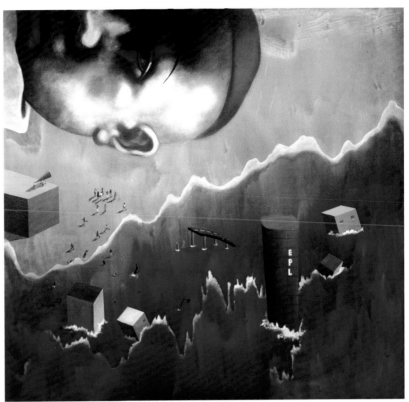

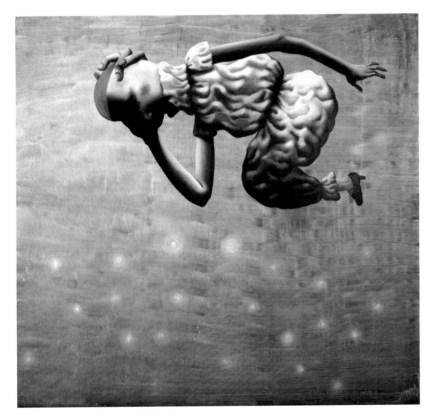

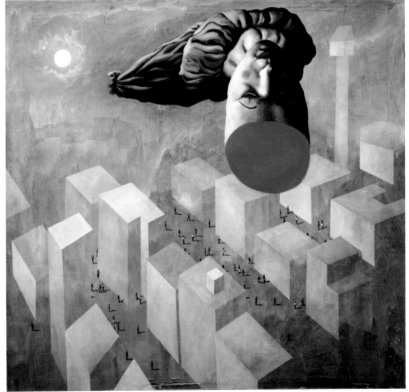

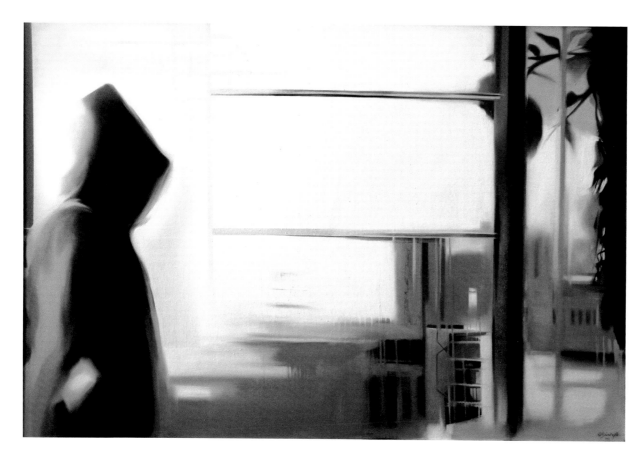

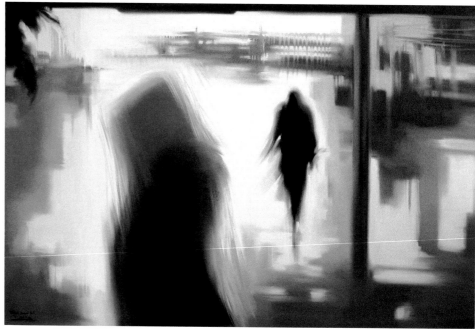

Tahereh Samadi Tari was born in Iran in 1981. After obtaining a Diploma from the Academy of Visual Arts, Tehran, in 2000, she studied for a Master of Arts in painting at the Azad University; she completed this in 2008. Since then she has exhibited several times in Tehran and London, and in 2008 her work was included in a major London auction.

Samadi's paintings are already causing a lot of interest. There is something photographic or even cinematic about her compositions, even if they are deliberately out of focus. Often her canvases – which typically show figures either with hoods or walking along under umbrellas – border on a sort of geometric abstraction. The colour range is severely restrained, limiting itself to blacks, browns, dark reds and blues. Strong and sombre, her works evoke both a distant past and an uncertain future.

top
Untitled, 2007–2008
Acrylic on canvas
120 x 150 cm
© Tahereh Samadi
Courtesy of Tahereh Samadi Tari and
Day Art Gallery, Tehran

above
Untitled, 2007–2008
Acrylic on canvas
120 x 150 cm
© Tahereh Samadi
Courtesy of Tahereh Samadi Tari and
Day Art Gallery, Tehran

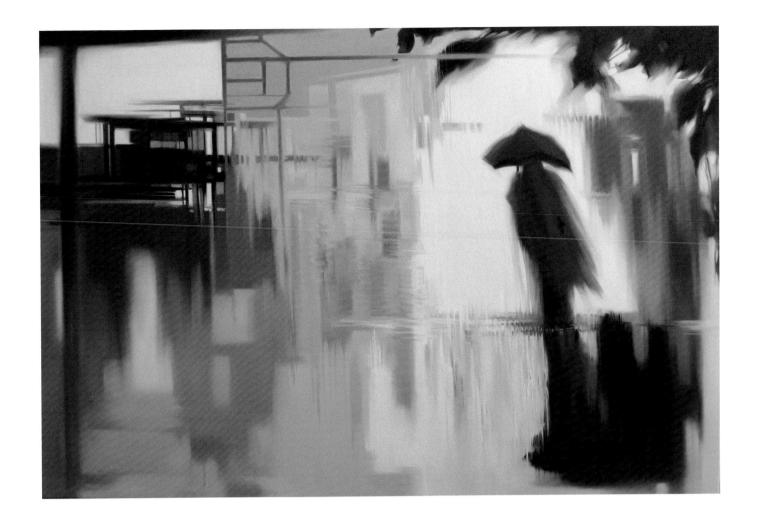

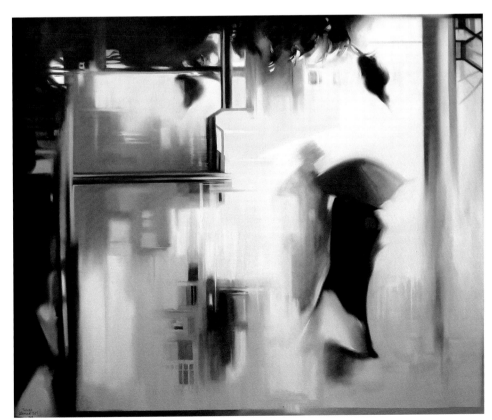

above
Untitled, 2007–2008
Acrylic on canvas
120 x 150 cm
© Tahereh Samadi
Courtesy of Tahereh Samadi Tari and
Day Art Gallery, Tehran

left
Untitled, 2007–2008
Acrylic on canvas
120 x 150 cm
Private collection, London

Tahereh Samadi Tari

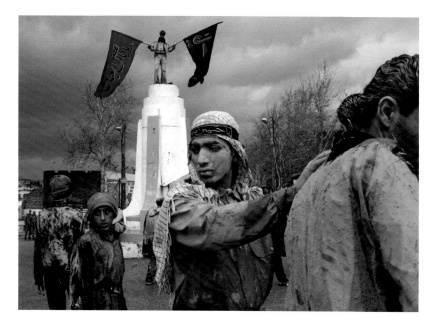

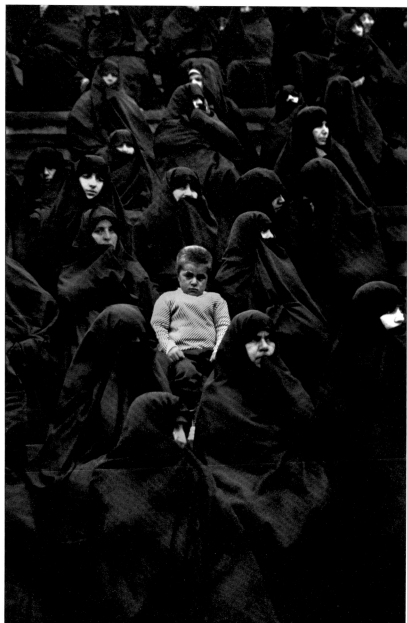

Born in Iran in 1954, Seifollah Samadian is an accomplished artist, photographer and cinematographer. As a cinematographer he has worked with such figures as Martin Scorsese and Abbas Kiarostami, while as a photographer Samadian became Professor of Photojournalism at Tehran University and has shown at World Press Photo, the Barbican Art Gallery, the Victoria & Albert Museum and the Museum of Contemporary Art, Vienna. Today, he is also Publisher and Editor-in-chief of the Iranian cultural magazine, *Tassvir*.

It is often said that Samadian's genius lies in capturing the very instant when an otherwise day-to-day scene tells a story. His most recent series, 'Days of their Lives', shows normal Iranians going about their daily business. Remarkably unaffected, it includes the work *Martyrdom*. Always beautiful – as witness the formal purity of *Women of God* – his works nevertheless possess subliminal musings on social issues.

above
Martyrdom, 2007
Digital print on photographic paper
120 x 160 cm
Edition of 5
© Seifollah Samadian
Courtesy of Seifollah Samadian and
Xerxes Fine Art, London

right
Women of God, 2007
Digital print on photographic paper
160 x 120 cm
Edition of 5
© Seifollah Samadian
Courtesy of Seifollah Samadian and
Xerxes Fine Art, London

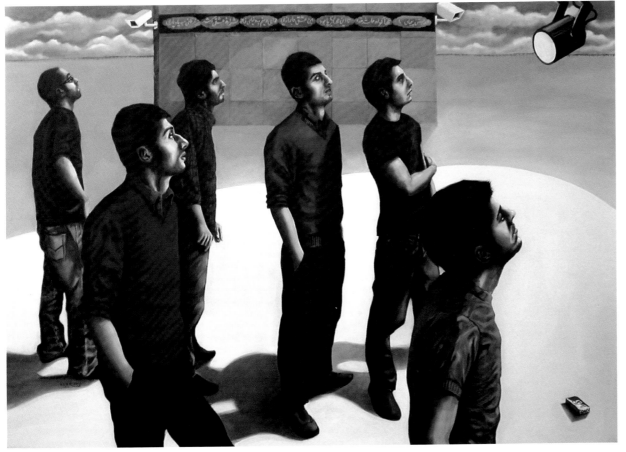

above
Heaven & Hell 2
© Behrang Samadzadegan
Courtesy of Behrang Samadzadegan

left
Under the Spotlight, 2008
Acrylic and oil on canvas
140 x 200 cm
© Behrang Samadzadegan
Courtesy of Behrang Samadzadegan

Behrang Samadzadegan was born in Tehran in 1979, and studied for Master of Fine Arts in the same city, graduating in 2007. In 2008 he won a Golden Feather at the International Media Art Festival, in Cairo. An active member of the Tehran arts scene, he is also the visual editor of the electronic magazine tehranavenue.com and a member of the Iranian Society of Painters.

His paintings are remarkably finished, and tend to deal with weighty issues – for example, the 'Healthy Society' series of portraits that deals with the wearing of the headscarf. Some are slightly cheeky – the reinvention of Manet's *Olympia*, for a more religious audience, for example. Others are more ambiguous: does *Under the Spotlight* refer to Western scrutiny of Iran, or could it even refer to the international obsession with celebrity that Samadzadegan tackles elsewhere? Samadzadegan himself says that he decides on a subject by asking himself a simple question: 'What's going on around town? ... The main issue I usually focus on is the current situation of my region.'

Behrang Samadzadegan

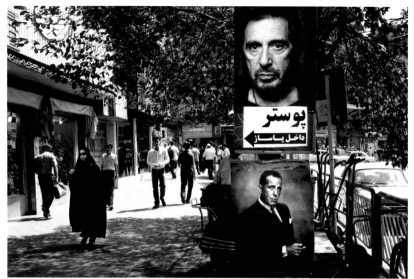

Born in 1968 in the city of Tabriz, Hassan Sarbakhshian is one of Iran's foremost photographers. Known above all else for his documentary work, since 1999 he has been the photographer in the region for the Associated Press news agency, with photographs published in *Newsweek*, *Time*, *Economist*, *Novel Observator*, *New York Times* and *Washington Post*. His work is regularly exhibited in Tehran.

Sarbakhshian's approach to photojournalism has been described as 'blunt' and 'vivid'. He has covered conflict zones such as Afghanistan with compassion but also with honesty. Even in death and destruction, Sarbakhshian's lens has been focused as an instrument of social and political expression. He says: 'My regard has to be social rather than reportage, to allow my images to stand the test of time.' Life, he believes, changes attitudes and attitudes determine tastes: 'A photographer has always to keep abreast of, or be in the forefront of change.'

His own country, of course, has seen plenty of changes, and is as challenging a subject as any for a photographer, but Sarbakhshian manages to capture its quirks and paradoxes with a clear head. Certainly he is not afraid to find the humorous angle in an image, especially in his photographs of politicians, which are often demystifying and remarkably open.

Many of his images have been turned into books, the best known of which is *Time Pulse*, a compilation of his best photography from the period of the Khatami presidency (1997–2005), including his coverage of the Athens Olympics in 2004.

More recently he has been working on *Iranian Jewish*, which explores the lives of the significant Jewish community in Iran since the Islamic Revolution. Travelling the length and breadth of Iran for eighteen months, he has photographed Jews in their own historic environments – environments that sometimes

date back millennia. This was not about making a statement, he emphasizes, but rather just to record the realities on the ground. 'The question of Iranian Jews has become a sensitive issue since [President Mahmoud] Ahmadinejad came to power. I wanted the world to know what is happening with Jews in Iran, who live normal lives and feel themselves more Iranian than any other religious grouping in the country.' The book will be self-published, since Sarbakhshian does not want any outside interference with his work.

However, Sarbakhshian's work has not been confined to Iran; in fact, some of his most remarkable photos are those that he took of the Hajj – the annual pilgrimage to Mecca that all able-bodied Muslims are expected to undertake at least once in their lives. Particularly mesmerizing is the image of the swirling sea of pilgrims circling the Kaaba.

Sarbakhshian's photographer hero is Abbas [Attar], the world-famous Iranian

photojournalist whose books have brought home the brutal realities of war and social conflict. Sebastian Salgado is another role model in documentary photography, and his illustrious compatriots Bahman Jalali and Kaveh Golestan, who was killed in Iraq, complete his small pantheon of greats. In fact, in 2004 Sarbakhshian was the first recipient of the award for photojournalism established in honour of Kaveh Golestan.

Sarbakhshian reflects that his forty-one years have been filled with revolution, war, death and destruction. 'It almost makes people numb to death,' he says. 'The world wants the truth to some extent, but always a sanitized version.' The artist photographer is not impressed with the hypocrisy in the West: 'They've asked me to help curate a photographic exhibition in Paris, but the organizers want only "gentle images of war". How can you treat war gently?'

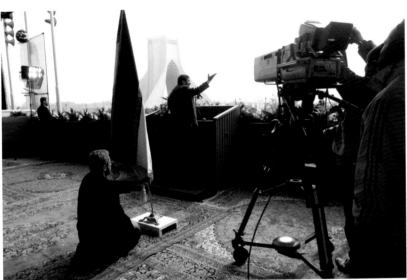

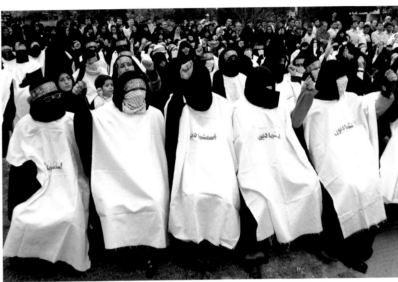

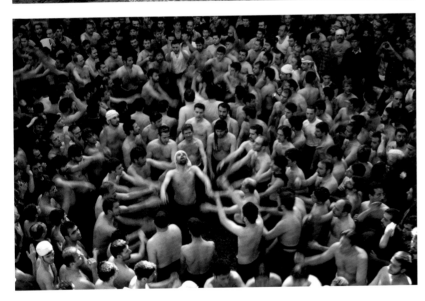

opposite, top right
From the 'Athens' series, 2004
Photographs
© Hassan Sarbakhshian
Courtesy of Hassan Sarbakhshian and
Silk Road Gallery, Tehran

From the 'Daily Life' series
Photographs
© Hassan Sarbakhshian
Courtesy of Hassan Sarbakhshian and
Silk Road Gallery, Tehran

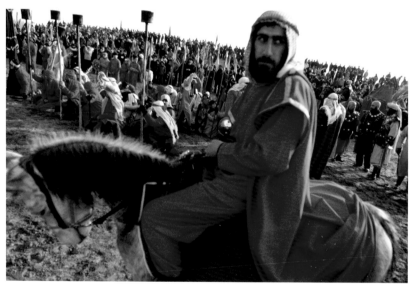

above and opposite, top
From the 'Hajj – Mecca' series
Photographs
© Hassan Sarbakhshian
Courtesy of Hassan Sarbakhshian and
Silk Road Gallery, Tehran

all others
From the 'Daily Life' series
Photographs
© Hassan Sarbakhshian
Courtesy of Hassan Sarbakhshian and
Silk Road Gallery, Tehran

Hassan Sarbakhshian

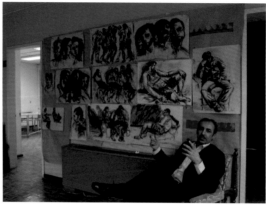

The recent growth of Iranian art can be attributed to many things and many people, but the one individual whose role is in no doubt is Ali Reza Sami Azar. Born in 1961 in Tehran, he originally trained as an architect, first at Tehran University, and then at the University of Central England, where he read for a PhD. In the early 1980s he was briefly director of the Niavaran Cultural Centre in Tehran, and in the 1990s was Professor of Fine Arts at Tehran University. His most influential position, however, was as Director of the Tehran Museum of Contemporary Art, between 1998 and 2005.

Today he is seen as perhaps the most liberal Director of that remarkable museum since its foundation shortly before the Revolution, in 1977. In retrospect, perhaps it was a golden age, a happy coincidence of his directorship with the relatively open atmosphere brought about by the election of Mohammad Khatami as president (1997–2005).

Of course, even in the relatively relaxed Iran of Khatami, there were limits and boundaries to test. In 2004 Sami Azar arranged the important loan exhibition of modern British art, 'Turning Point', which raised some eyebrows (it included work by Henry Moore, Tony Cragg, Anish Kapoor and Damien Hirst). However, even more groundbreaking was the 'Modern Art Movement' exhibition he organized in 2005, which featured many of the museum's astonishing collection of Western modern paintings: important works by Monet, Renoir, Picasso, Pollock, Warhol, Bacon, Rothko, de Kooning, Gauguin and Moore all came out for the first time since the Revolution. There were also other events that in magnitude and quality surpassed any exhibitions previously held in Iran. Chief among these were 'The Masterpieces of Persian Painting' and 'Gardens of Iran'.

'Modern Art Movement' proved to be the most popular show ever held at the museum. Sami Azar, however, referred to it as his 'goodbye show', and with good reason: early 2005 had seen the election of a new, more hardline, Iranian government headed by Mahmoud Ahmadinejad, and Sami Azar knew that he would be subject to tighter and tighter restrictions.

While his role in opening up Western art to the Iranian public grabbed the attention of the press, perhaps more important was his championing of home-grown talent. Indeed, it is probably no coincidence that his tenure as director coincided with the tremendous growth of international interest in Iranian art seen over the past decade. He also worked hard to build contacts with his counterparts in other international galleries, promoting Iranian artists in the West.

Even more critically, he changed the role of the museum, which went from controlling artists to promoting them. Galleries were no longer required to obtain permits to hold exhibitions, and Sami Azar arranged for Iranian works to be loaned overseas. Part of the museum's budget was set aside to pay for scholarships for artists to travel to other countries, and he facilitated the creation of artists' groups. The painter and Professor of Art, Pariyoush Ganji, said in an interview with the *New York Times*: 'What happened under [Sami Azar's] tenure will be remembered in our history of art…. He valued artists and did everything in his power so that they would find direction and identity to their work.' Sami Reza himself says that his greatest achievement as Director was 'creating an unprecedented environment, in which artists found dignity, got organized, influenced society and simply had a voice.'

After resigning from the museum in 2005, Sami Azar began to teach courses in Contemporary Art at the Mahe Mehr Institute in Tehran, which he enjoys greatly. He describes his students as 'very enthusiastic about art and its future in this country', and in spite of some frustration at the current socio-cultural situation, they are keen to learn about the latest international trends. Many of his students see art as 'probably the best way they can communicate with the surrounding world… their art is becoming increasingly issue-based involving socio-political problems of their society…. Even when it comes to painting, they tend to create a figurative and kind of expressionist picture that refers to their concerns more strongly than a modernist abstract canvas could. So this is probably a new phenomenon in our country, that art has now become a tool by which artists can raise their quest for a better society.'

Untitled, 2008
Watercolour on paper
190 x 75 cm
© Arash Sedaghatkish
Courtesy of Arash Sedaghatkish and
Aaran Art Gallery, Tehran

Born in 1972 in Tehran, Arash Sedaghatkish
studied painting at Tehran University, and is
currently completing a Master of Fine Arts in the
same institution. His work, strikingly realistic
and direct, has already attracted plenty of
attention, and has been exhibited in the United
Kingdom, as well as extensively in Tehran.

According to the artist, the main subjects
of his work 'urban environments and their
occupants'. As he explains, 'Through my work
I explore and comment on a variety of social
exchanges and tensions which underline
contemporary Iranian society, particularly among
its youth.' Of his unusual, tall format he says: 'My
work is created and viewed in series and in many
ways resembles sequences of a movie.'

Primarily Sedaghatkish uses drawing and
painting, though from time to time he also turns
to photography; in fact he is currently working
on a series of photographs of youths who have
tattoos of famous paintings.

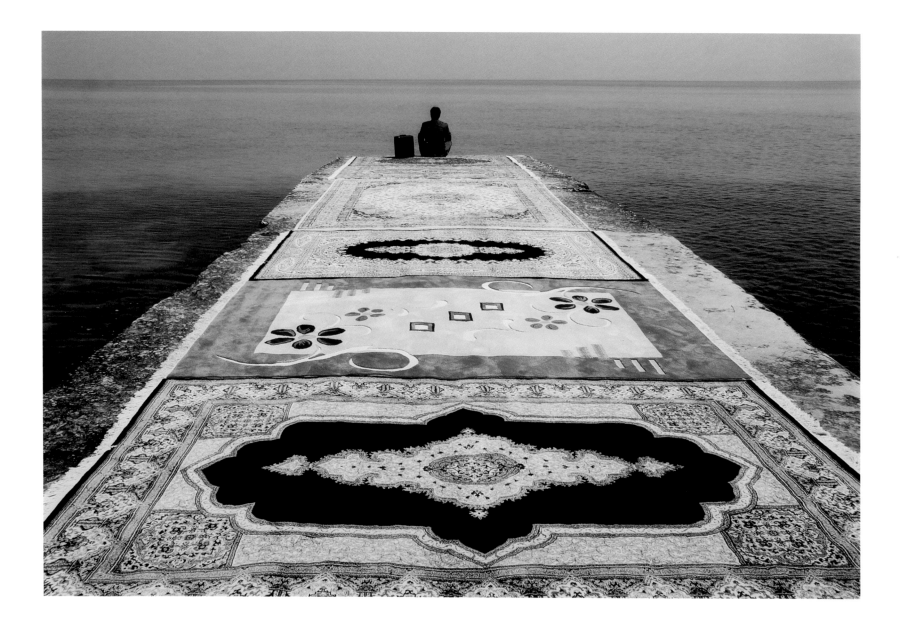

Born in Tehran in 1968, Jalal Sepehr began his photographic career with a course in Tokyo, Japan, in 1994. Since then he has photographed ports, wildlife, architecture, and has been a manager of the Fanoos photo website.

A recent series, called 'Water and Persian Rug', has explored precisely that theme, with the carpets spread across a concrete jetty that recedes into the sea. At the end of this luxurious catwalk sits a figure, staring out to sea. The carpets, with their geometrical patterns, accentuate the sense of recession, the vanishing point coinciding precisely with the horizon. It is a work of great formal beauty and cultural integrity.

Untitled, 2004
From the 'Water and Persian Rug' series
C-Type photograph
76 x 100 cm
Edition of 10
Private collection, London

Jalal Sepehr

Massoumeh Seyhoun has been a mainstay of the Iranian modern art scene for nearly half a century. Massoumeh opened the Seyhoun Gallery on Tehran's Shah Avenue in 1966 and she has been going strong ever since; now 75 years old, she may be confined to a wheelchair, but her spirit and wit have not deserted her.

The Seyhoun Gallery has played several different roles in Iranian culture throughout its long life. In the 1960s and 1970s it was instrumental in introducing to Iran the latest Western art, organizing exhibitions of key figures such as Andy Warhol. Since the Revolution the gallery has dedicated itself to Iranian artists, putting on exhibitions of the work of leading figures such as Sohrab Sepehri, Faramarz Pilaram, Massoud Arabshahi, Maryam Javaheri, the miniaturist Susanabadi, the calligrapher Reza Mafi and the prominent calligraphic abstractionist Hossein Zenderoudi, as well as self-taught 'outsider' artists such as painter Mokkarameh and sculptor Esmail.

In 2004, the Seyhoun Gallery embarked on a new project when Massoumeh's daughter Maryam opened a sister gallery on Melrose Avenue in Los Angeles. This continues to show art produced by Iranian artists, whether working in Iran or in other countries – in fact, several of the artists today come from Los Angeles' own huge Iranian community. In spite of these new challenges, Massoumeh remains as passionate as ever about her work: 'I've never shied away from a challenge and art has been the challenge and inspiration of my life,' she says. 'Art is a marriage for me and an artist has to preserve their best works until death.'

Certainly Massoumeh's life has been full of challenges. She has been persecuted since the beginning of the Islamic Revolution, not least for her close associations with artistic circles in the old order of the Shah. Her former husband, Houshang (one of the pre-eminent figures of the Iranian modern art movement, and the country's leading architects), has lived and taught in Canada and America since the revolution.

Despite all that has happened since 1979, however – including fifteen months' confinement in a revolutionary prison complex – Massoumeh remains completely unbowed. 'I never closed the gallery for a single day,' she boasts. 'Not even when they threw me into Evin Prison [a notorious complex often used for political prisoners]. It was the best time of my life! ... If I can do something positive for Iranian art, even at such heavy cost to myself, I will not hesitate,' she continues. A born rebel, Massoumeh is quick to vent her feelings, regardless of the current climate. 'I've never liked dictators,' she says.

Mamali Shafahi was born in Iran in 1982. After studying photography and video in Tehran, he moved to France to study in Limoges and Paris-Cergy. His work brings together drawing, painting, photography, video, installations and performance in long-term, themed projects. He has been exhibiting in Tehran since 2004, and frequently works in France.

A lot of Shafahi's work explores the role of the artist in contemporary society: 'The themes I've been looking into over the last couple of years are taboos and breaking them, fame and narcissism, intimacy and the invasion of privacy, the media, Iran and the US and so on.' Two current projects are 'Wonderland: 2,500 years celebrations', which takes its name from the 2,500-year celebration of Iran's monarchy staged in Persepolis in 1971, and 'Mamali and his Doves in Art', an installation consisting of large-scale self-portraits in 'artistic' poses with doves, which again explores the themes of identity, display and narcissism. Another recent series, 'Freedom', focused on conflicting official and exile media coverage of Iran.

top
Mamali and his Doves in Art, 2008
Photographic print
110 x 150 cm
© Mamali Shafahi
Courtesy of Mamali Shafahi and
Aaran Art Gallery, Tehran

above
My Magic Box, 2005
Light box photo print
70 x 100 cm
© Mamali Shafahi
Courtesy of Mamali Shafahi and
Aaran Art Gallery, Tehran

opposite, above
Freedom, 2008
Poster: photograph on plastic tarpaulin
160 x 250 cm
© Mamali Shafahi
Courtesy of Mamali Shafahi and
Aaran Art Gallery, Tehran

opposite, below
Freedom, 2008
Improvised performance at Art Athina 2008
in Athens, Greece
© Mamali Shafahi
Courtesy of Mamali Shafahi and
Aaran Art Gallery, Tehran

Mamali Shafahi

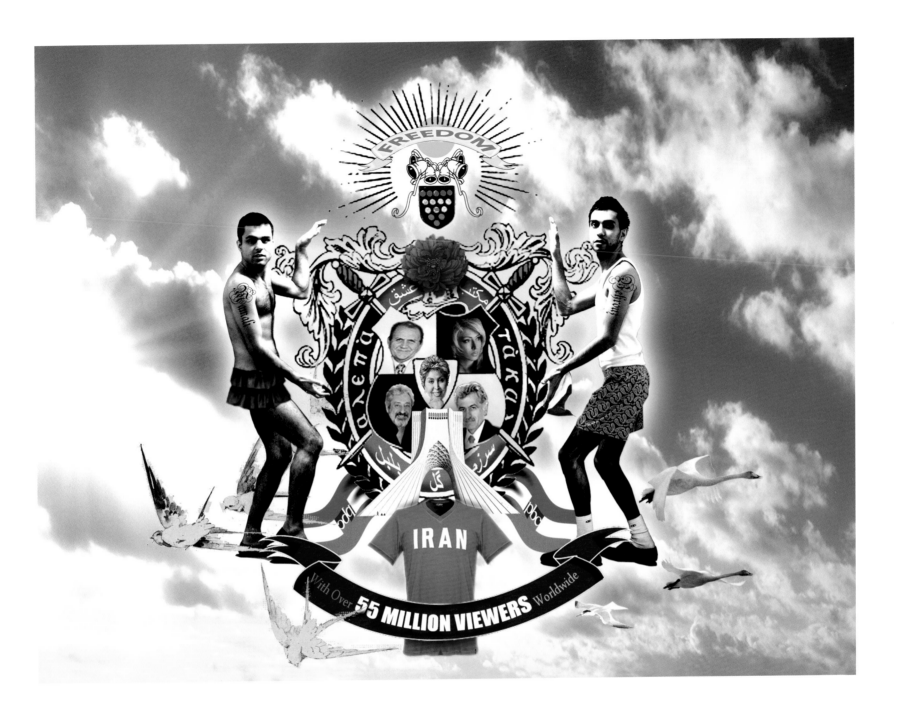

Rozita Sharafjahan, apart from being the founder of the Azad Gallery, is also a very well-established artist. Born in Tehran in 1962, she originally studied Sculpture at Tehran's School of Visual Arts; later, she studied Painting at Tehran University, and in 1995 obtained a Master of Arts in Art Research from the same institution.

Her first solo exhibition, of her painting, was held in 1986, and since then she has continued to exhibit regularly in Tehran, as well as participating in several group shows outside of Iran. Over the years her output has grown to include video art and photography.

Perhaps her most exciting work so far has been the 'Street' series, from 2002, which combines photography, drawing and painting to reinvent the streets of Tehran. By painting or drawing over her photographs – and then re-photographing the results – she is able to impose her own views onto the city. Some of her photographs have been combined into spectacular montages that create immersive environments that the viewer can walk through.

top left
From the 'Street' series, 2002
Digital print of drawing and photography
240 x 270 cm
© Rozita Sharafjahan
Courtesy of Rozita Sharafjahan and
Azad Gallery, Tehran

top
From the 'Street' series, 2002
Digital print of drawing and photography
240 x 270 cm
© Rozita Sharafjahan
Courtesy of Rozita Sharafjahan and
Azad Gallery, Tehran

above
From the 'Street' series, 2002
Digital print of drawing and photography
270 x 360 cm
© Rozita Sharafjahan
Courtesy of Rozita Sharafjahan and
Azad Gallery, Tehran

above
From the 'Street' series, 2002
Digital print of drawing and photography
270 x 360 cm
© Rozita Sharafjahan
Courtesy of Rozita Sharafjahan and
Azad Gallery, Tehran

left
From the 'Street' series, 2002
Digital print of drawing and photography
270 x 240 cm
© Rozita Sharafjahan
Courtesy of Rozita Sharafjahan and
Azad Gallery, Tehran

top left
From the 'Street' series, 2002
Digital print of drawing and photography
240 x 270 cm
© Rozita Sharafjahan
Courtesy of Rozita Sharafjahan and
Azad Gallery, Tehran

top
From the 'Street' series, 2002
Digital print of drawing and photography
270 x 240 cm
© Rozita Sharafjahan
Courtesy of Rozita Sharafjahan and
Azad Gallery, Tehran

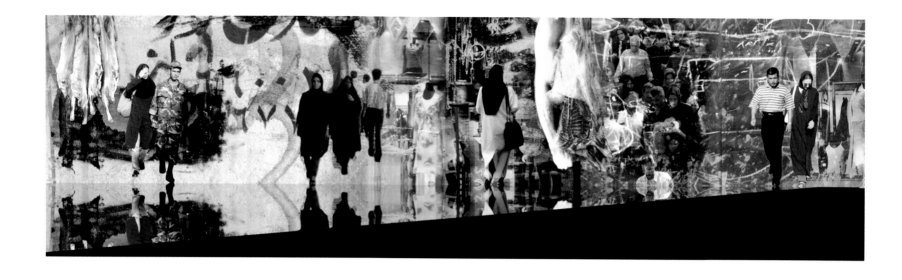

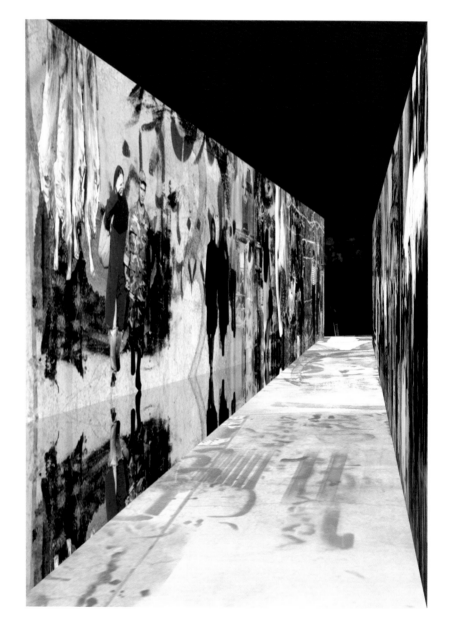

Untitled
Digital print
© Rozita Sharafjahan
Courtesy of Rozita Sharafjahan and
Azad Gallery, Tehran

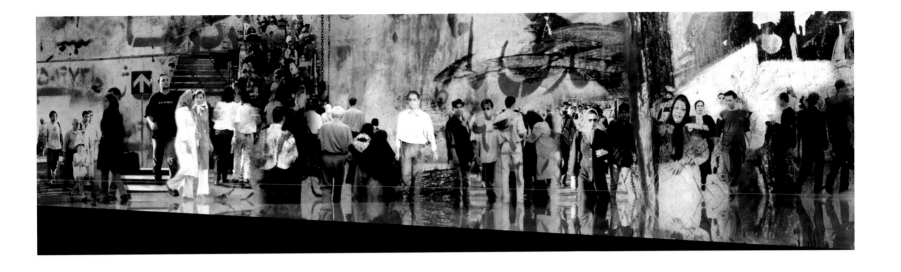

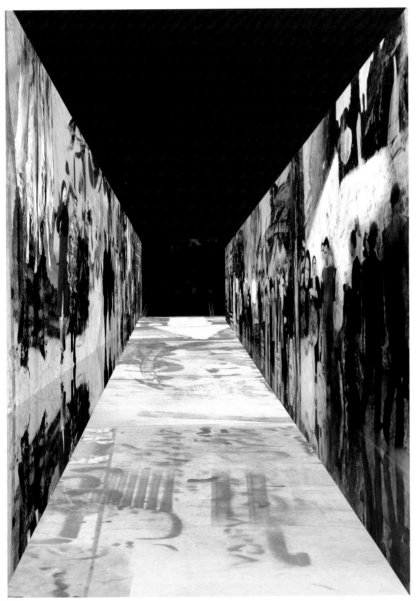
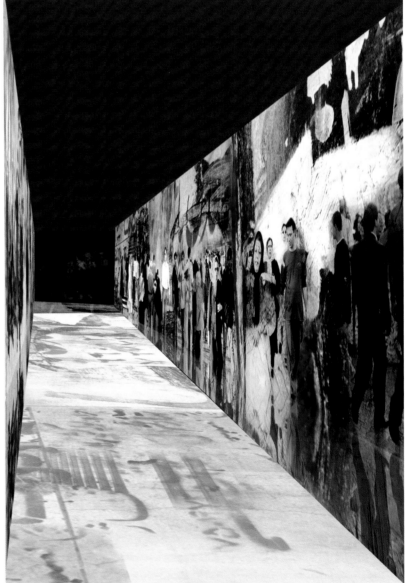

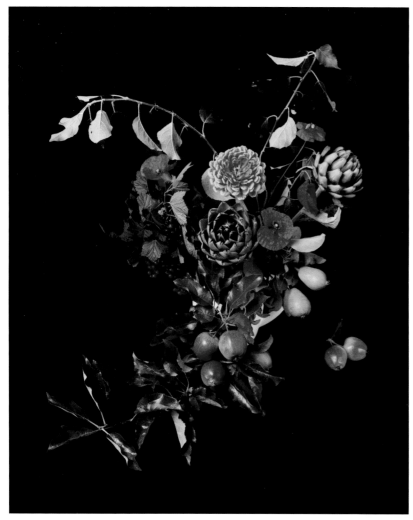

above
**From the 'Flowers, Fruits and Portraits'
series**, 2008
C-print on aluminium
Sizes variable
© Shirana Shahbazi
Courtesy Shirana Shahbazi and Bob van Orsouw
Gallery, Zurich, and Salon 94, New York

right
From the 'Landschaften' series, 2008
Gelatin silver print
on aluminium
Sizes variable
© Shirana Shahbazi
Courtesy Shirana Shahbazi and Bob van Orsouw
Gallery, Zurich, and Salon 94, New York

Shirana Shahbazi

What is the relationship between art and oddness? 'Maybe being an artist is just a good excuse for being a little bit freaky,' Shirana Shahbazi says. 'I tried exploring that side of me in the past but it's not my character...I'm a little like a schoolgirl. If I take a step back and look at what I do all day long, over and over again, then it is either very funny, or very freaky!'

Her works are certainly unusual. Trained originally as a photographer, Shahbazi tends to take portraits, landscapes and still lifes, but then presents them in unusual ways. Recently she has blown her images up to huge size, had them copied by billboard painters, and (most intriguingly of all) had them woven into traditional carpets.

Shirana Shahbazi was born in Tehran in 1974 and left the country when she was eleven years old. 'I grew up,' she explains, 'in a family of creatives with a great deal of respect for art.

My dad is an architect who painted, and both my sisters are in the arts – one a video artist and the other making digital drawings and installation work. It's all in the family, so I ended up in art school. By the way,' she interrupts herself, 'I didn't want to become an artist, but a journalist.'

Inspiration, commitment, devotion, obsession and her Iranian background – how do such psychological factors and background emotions relate to art? 'Anybody's creativity always seems to come out of his or her biography but my Persian-ness is something that has come about since my success in the art world. My inspiration comes more from the medium of photography than my biography. My work has a two-dimensional character.'

What about the sense of alienation and exile common to many Iranians who live outside their country? 'Why would I be alienated?' she asks. 'I left Iran when I was eleven years old...

eleven years in Iran, twelve years in Germany and now twelve years in Switzerland. This is as much of a clear identity as my original roots and background. I don't miss that feeling of belonging to a specific country. I wouldn't want to be stuck to any particular place, to miss any part of my background – the whole story is my heritage.'

'The Iranian approach to art comes with considerable pathos, a romantic look at feelings. My art is very much Western-rooted. I only think about good or bad art.' Shahbazi then adds: 'I'm sure there are lot of facts which can influence your art, so if your definition of true art is what is authentic, then success can bring into play a lot of surreal elements...you have to try to stay focused. This is my job and this is my business.... That's why I don't want to take business calls at weekends, just like any other job.'

Shahbazi is not overly impressed with the recent hype surrounding contemporary Iranian

art: 'Iranian artists are more concerned with their traditions and their Persian roots, which is weird for me. It's nationalistic in a way; the developments are very similar to Chinese contemporary art. Let's just say that it is very unlike Swiss or German art.' Shahbazi is not against classifying art per se: 'There are categories in every kind of art. I hear about the chatter about the Iranian art scene but I don't want to be a part of it. It doesn't excite me, though it does make me curious.'

Shahbazi does confess to a certain amount of fascination with the Iranian art scene's development in the Dubai art market. 'I look at it with curiosity but I don't understand, or have an opinion about it.' She is also fascinated by all the new museum projects, built and planned in the Persian Gulf, with their huge dimensions. 'I guess a new type of art needs to be born. Who is going to fill all these spaces?' she asks.

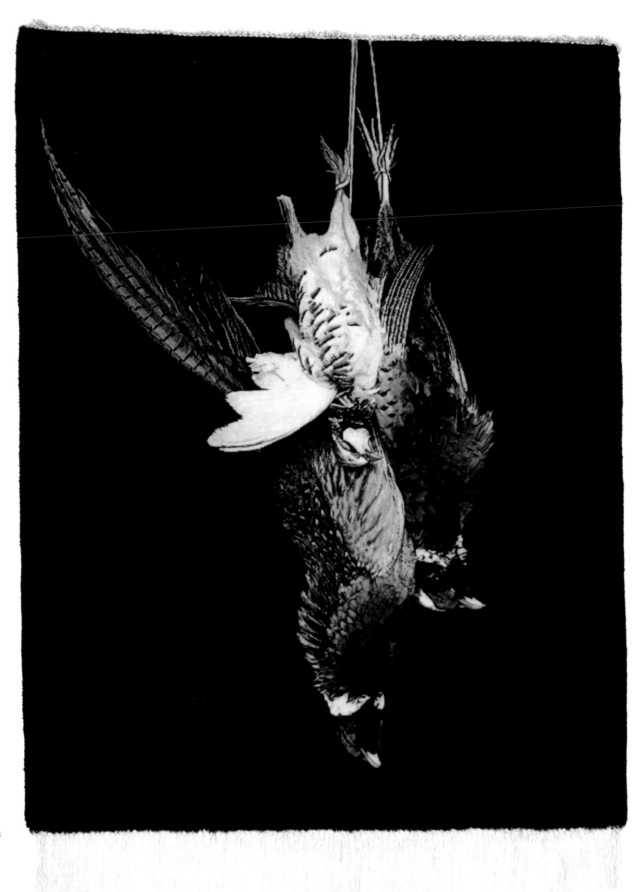

**From the 'Farsh/Teppiche'
series**, 2008
Handknotted rug, wool on silk
Approx. 105 x 81 cm
© Shirana Shahbazi
Courtesy Shirana Shahbazi
and Bob van Orsouw Gallery,
Zurich, and Salon 94, New York

From the 'Flowers, Fruits and Portraits'
series, 2007
C-print on aluminium
Sizes variable
© Shirana Shahbazi
Courtesy Shirana Shahbazi and Bob van Orsouw
Gallery, Zurich, and Salon 94, New York

above
From the 'Landschaften' series, 2003
C-print on aluminium
Sizes variable
© Shirana Shahbazi
Courtesy Shirana Shahbazi and Bob van Orsouw
Gallery, Zurich, and Salon 94, New York

left
**Installation view of the exhibition
'Shirana Shahbazi'**, 2008
The Curve, Barbican Centre, London
© Shirana Shahbazi
Courtesy Shirana Shahbazi and Bob van Orsouw
Gallery, Zurich, and Salon 94, New York

Shirana Shahbazi

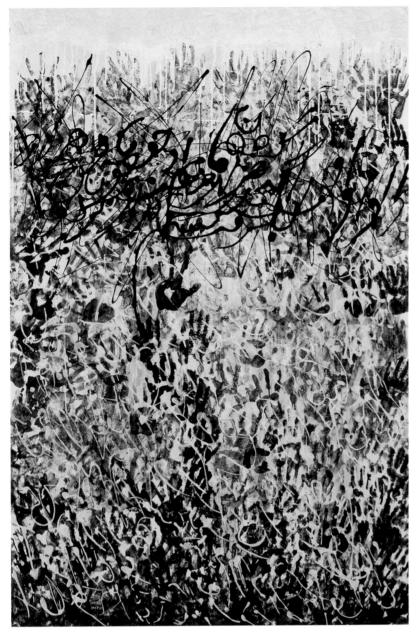

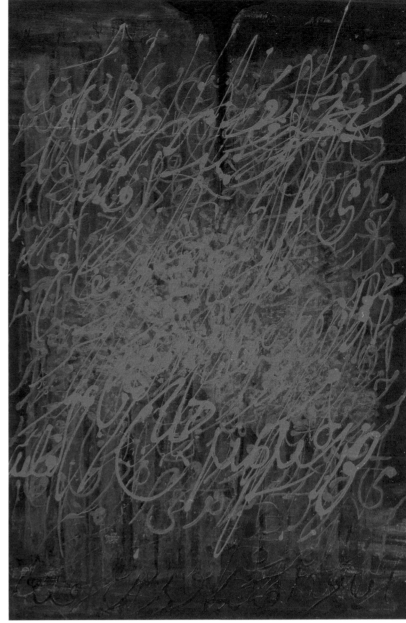

Born in 1966, Maryam Shirinlou is one of the latest generation of Iranian artists to focus her work on script. Her interest in drawing and painting began at an early age, when she found them to be a vital outlet for her feelings. After the Islamic Revolution she moved to France, then to the United States; she returned to her home country aged twenty-four, having studied Graphic Design and having developed a passion for yoga and the healing arts. Feeling torn between two possible career paths, she decided to reconcile her twin interests, to create art that could help people.

Earlier in her career, Shirinlou tended to paint figuratively, but on returning to Iran she rediscovered the Farsi script; this coincided with another rediscovery, of Persian plays and poetry, and led to the current series of what she calls 'script paintings'. These involve 'using script as a bold uncontrolled form of writing which is anything but calligraphy, in which I have no training.' For Shirinlou, meaning is secondary to form: 'Often I use the letters as form without any specific meaning at all; at other times I use poetry, which for the most part remains illegible, trying to convey its meaning.'

above left
Sought Him with One Thousand Hands, 2007
Mixed-media
180 x 120 cm
Private collection, London

above
Blazing Dawn, 2007
Mixed-media collage
180 x 120 cm
Private collection, London

opposite
Words of Wisdom, 2006
Mixed-media
90 x 60 cm
© Maryam Shirinlou
Courtesy of Maryam Shirinlou and
Xerxes Fine Art, London

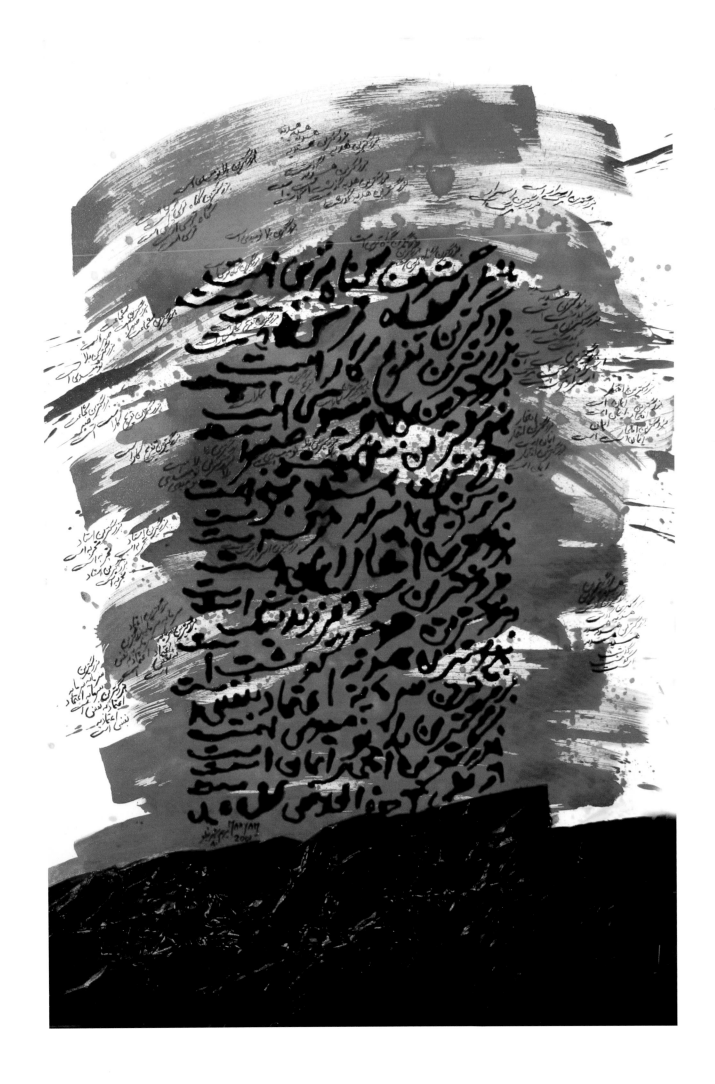

In His name
memory is mute.
History speaks
in the quickening
of the dead.

Born in Tehran in 1959, Mitra Tabrizian moved to London in 1977, just two years before the Islamic Revolution, and has remained there since. Today she is considered one of the most important artists working in Britain, a fact recognized in 2008 when Tate Britain hosted a widely acclaimed retrospective of her recent work, 'This is That Place'. Nevertheless, Tabrizian has always distanced herself from the art 'scene', treating it with (at best) suspicion. In fact she even memorably satirized the hype of the art market in a photograph in her 'Beyond the Limits' series (2000–2001), which shows a gallery filled with dealers instead of art. Aside from her art practice, she is also Professor of Photography at the University of Westminster.

A filmmaker by preference, Tabrizian uses photography as a means of capturing the filmic essence of bleak settings, blurring the lines between fact and fiction, creating narratives of loneliness in the lives of ordinary people in their everyday settings. In fact her love affair

with photography began when she was a child, when she would go out to photograph people in Tehran. Unlike some other Iranian artists, however, her works have also dealt with many non-Iranian subjects, such as the tedium of daily commuting in London, or the play between public and private in modern life.

One recent monumental photographic series, 'Border' (2005–2006), does, however, deal with the issue of Iranians living in exile. 'I wanted to deviate from the usual approach to exile – that is, portraying people as victims,' she explains. 'Rather, I was interested in the concept of survival as a "strategy of resistance". An ex-engineer sells carpets, a former sportsman makes a living as a painter and decorator, a doctor works as an interpreter, a journalist had to work as a cleaner. These individuals had to shift their status, not only culturally and politically, but in other ways, yet they survived. They survived oppression, loss of families, poverty and change of status. And they survived with dignity, refusing victimization.

To survive is ultimately to have the capacity to negotiate new positions; which means the necessary redefinition of the past and present. To survive is also not to give up...not to give in to whatever ordeal one is facing; it is, in a less orthodox way, to resist!'

Tabrizian has no time for the current hype surrounding Iranian art. 'One of the things happening in the current art market is the interest in the "exotica", which since Edward Said's seminal text on "Orientalism", three decades ago, the critics have been trying to dispute!' Neither does she put much faith in art's ability to bring about massive change: 'I don't believe art can change things that much in society, especially in the current climate. I think there is a great deal of idealization of artists in the art world today, which I'm not that convinced about.'

Tabrizian has always been interested in class divisions, whether as a teenager taking photographs in pre-Revolution Iran or more recently in Britain. The art is focused on the

street and on ordinary lives: the cab driver, housekeeper, servant or out-of-work graduate – in short, people who are struggling. She was surprised, she says, by the therapeutic effects of her portraits. 'The reactions of some of the participants who saw themselves larger than life spread across the walls of the Tate was extraordinary.' A woman started to cry after seeing herself so visible after so many years of invisibly living in exile.

'This sort of reaction does make you feel momentarily as if you are doing something worthwhile,' Tabrizian concedes. But ultimately, she says, 'art is a bit of a self indulgence'; elsewhere she has described it as a 'glamorous hobby'. In spite of this, there can be little doubt that through series such as 'Tehran' (2006), Tabrizian's work has been critical in bringing some of the paradoxes of daily life in Iran to the attention of Western audiences.

Surveillance, 1988–9
91.5 x 305 cm
Edition of 3 + 2 AP
© Mitra Tabrizian
Courtesy of Mitra Tabrizian

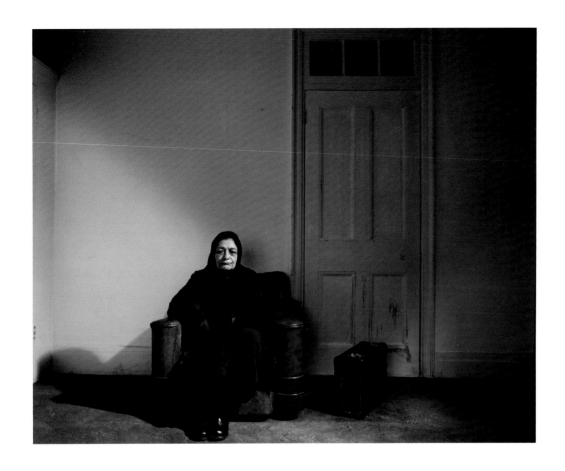

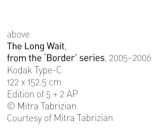

above
The Long Wait,
from the 'Border' series, 2005–2006
Kodak Type-C
122 x 152.5 cm
Edition of 5 + 2 AP
© Mitra Tabrizian
Courtesy of Mitra Tabrizian

right
Solitude of a Dreamer,
from the 'Border' series, 2005–2006
Kodak Type-C
122 x 152.5 cm
Edition of 5 + 2 AP
© Mitra Tabrizian
Courtesy of Mitra Tabrizian

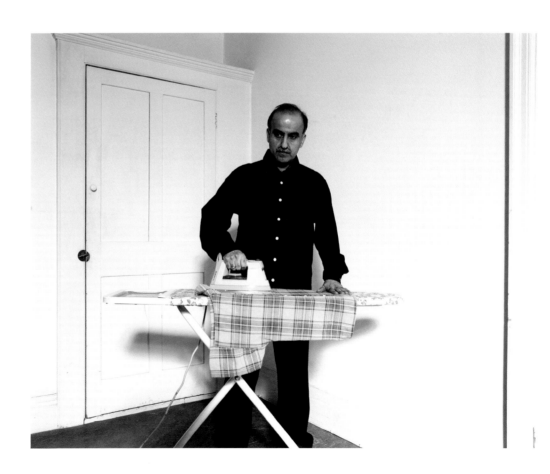

Mitra Tabrizian

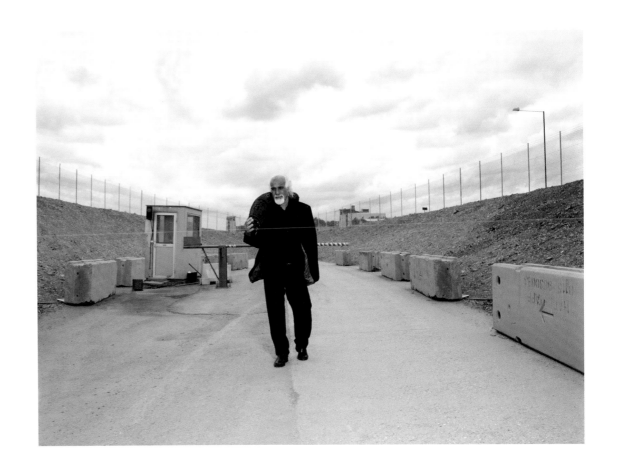

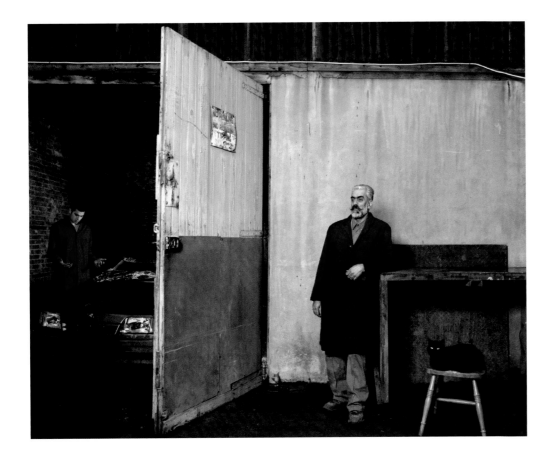

above
Road to Nowhere,
from the 'Border' series, 2005–2006
Kodak Type-C
122 x 152.5 cm
Edition of 5 + 2 AP
© Mitra Tabrizian
Courtesy of Mitra Tabrizian

left
Deadly Affair,
from the 'Border' series, 2005–2006
Kodak Type-C
122 x 152.5 cm
Edition of 5 + 2 AP
© Mitra Tabrizian
Courtesy of Mitra Tabrizian

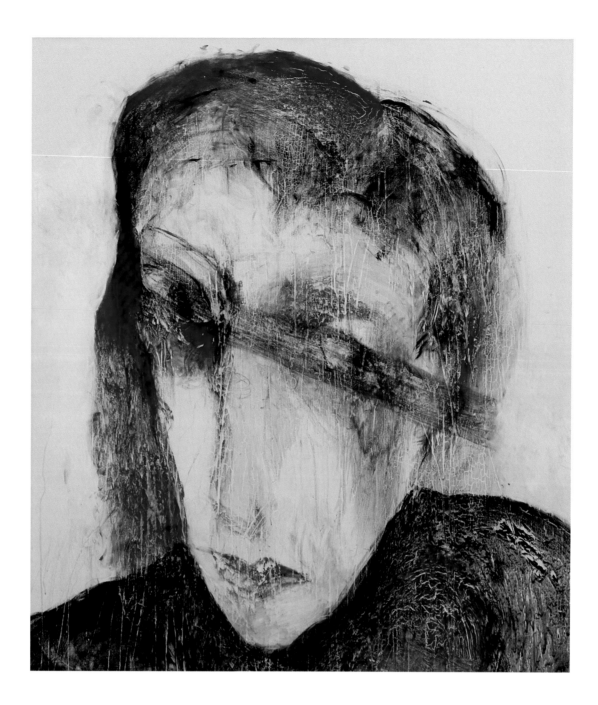

Born in Tehran in 1962, the painter and sculptor
Shideh Tami has been showing in her home city
and abroad since the early 1990s. Her paintings,
which are often self-portraits, are striking and
slightly unnerving, combining a highly worked
surface with contorted features. The colours
tend to be muted and faded, the faces downcast.
These portraits have often been interpreted
as expressing the frustration of women living
in Iranian society, where fundamental Islamic
rules limit their right to dress, express their
thoughts and act as they choose.

 Tami's sculptures share this interest in
disfigurement and distortion. More recently she
has bridged the gap between her two disciplines
by transfering her painting to objects, notably in
the conceptually based *Used*, in which her face
appears on crushed cans of soft drink. She has
also produced a cycle of work, called 'Women's
diary', which consists of fourty books of poetry,
again with an autobiographical theme.

above
Self Portrait, 2007
Acrylic on canvas
170 x 145 cm
Private collection, London

right
Self Portrait, 2007
Acrylic on canvas
170 x 145 cm
Private collection, London

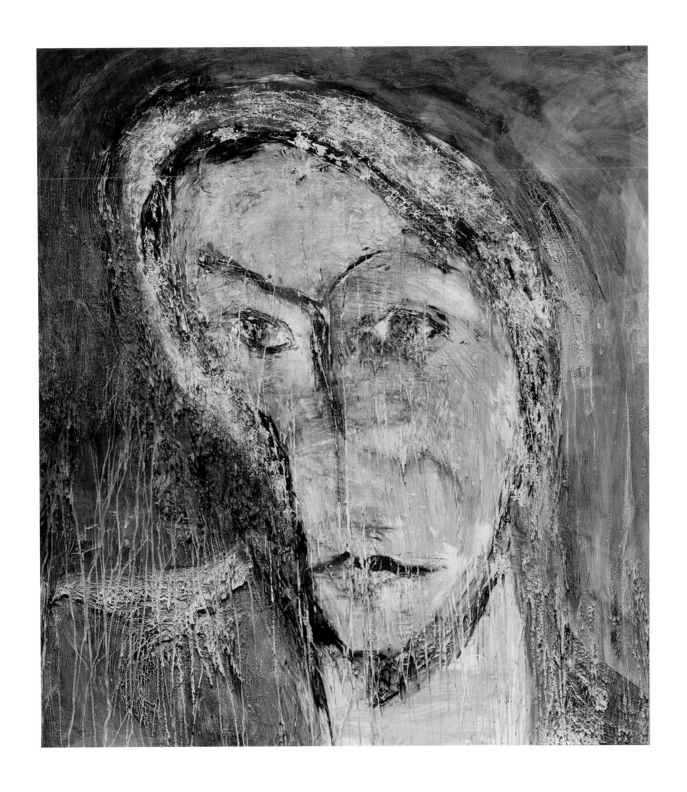

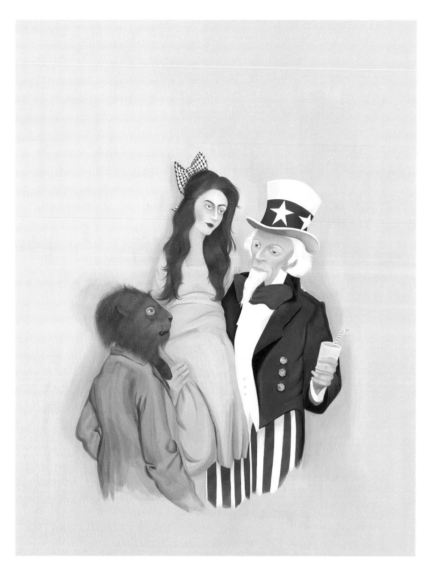

Born in 1979 to Iranian parents, and raised in Portland, Oregon, Taravat Talepasand has always felt that there were two sides to her life: the American part and the Iranian part. While studying for her degree at the San Francisco School of Fine Arts she took some time out to go to Iran to learn miniature painting; however, she lasted just three days, such was her desire to subvert and alter the imagery that she was expected to copy faithfully.

This playfulness, this desire to subvert the message, has not gone away. One of the things that outraged her in Iran was the way in which erotic Qajar miniatures had been censored and mutilated by later generations. She was determined to bring these savaged works back to life. So, using traditional egg tempera, she revived the tradition of miniature painting, but switching details when it took her fancy. Thus, a glass of wine becomes a bottle of whiskey, while a chador exposes more than it hides.

above
Cry Uncle!, 2008
Egg tempera and gold leaf on linen
56 x 43 cm
© Taravat Talepasand
Courtesy of Taravat Talepasand

right
Native Americans Beware of Native Influences, 2008
Egg tempera and gold leaf on panel
42.5 x 29 cm
© Taravat Talepasand
Courtesy of Taravat Talepasand

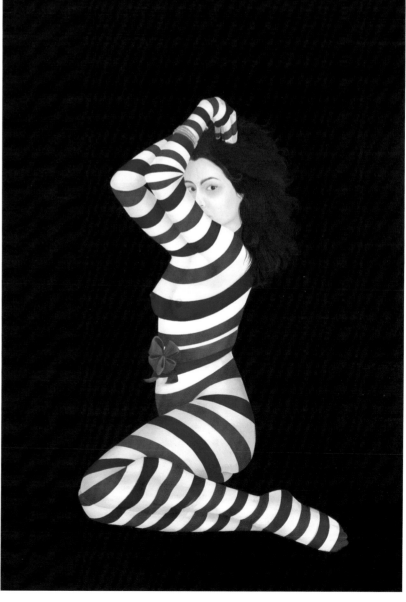

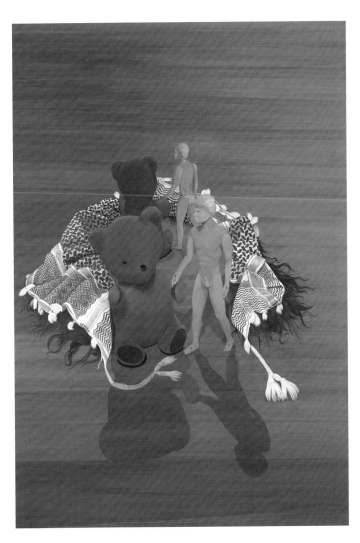

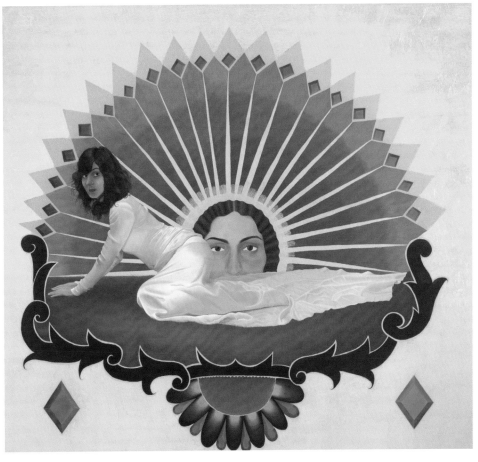

top left
Mohammad Meets Jesus
© Taravat Talepasand
Courtesy of Taravat Talepasand

above
The Order of the Sun and Lion, 2007
Egg tempera and gold leaf on panel
112 x 121 cm
© Taravat Talepasand
Courtesy of Taravat Talepasand

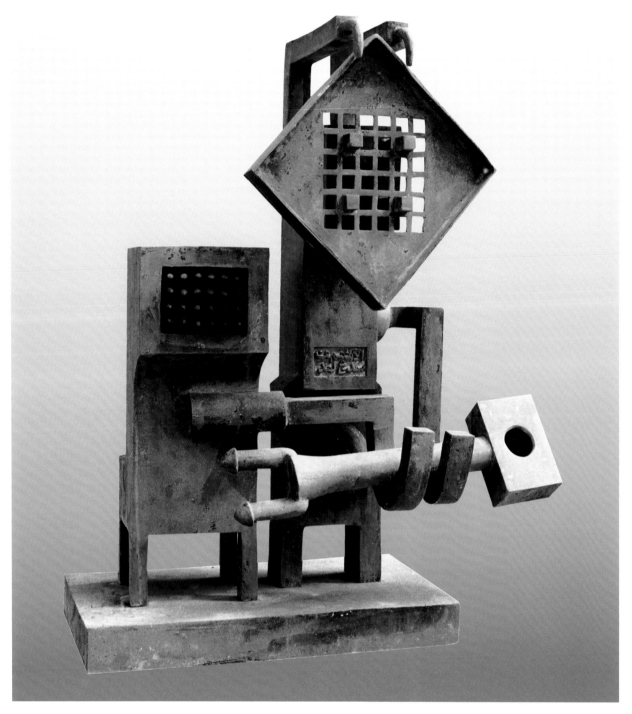

Parviz Tanavoli is a critical figure in Iranian modern art. Born in Tehran in 1937, he has almost single-handedly created, over the past fifty years, the region's modern sculpture movement. A mark of the high esteem in which he is held came in 2008, when one of his pieces, *The Wall (Oh, Persepolis)*, sold for 2.8 million dollars, the highest price ever paid for an Iranian modern or contemporary artwork.

It was not always thus, however. 'There was a lot of polemic and newsprint attacking my work when I first started sculpting in Iran,' Tanavoli remembers from the late 1950s and early 1960s. 'My first junk-assembly sculptures caused quite a stir, I recall. There were those who saw my work as an insult to Iranian culture in the traditional sense of the word.' In time, however, 'the openness of the Iranian mentality accepted my art warmly.'

For Tanavoli his career really began when in 1955 he received a scholarship from the Fine Art Administration to study sculpture at the Accademia di Belle Arti in Carrara, Italy. 'The

Government's Bureau of Art funded the rent of my studio on my return and I never went through the "starving artist" phase.'

Fortunately for Tanavoli, his parents were open-minded and let him pursue his dream. 'They were hoping that my Italian experience would change my mind and that I would study to become a doctor or an engineer, as was the norm in those days. Besides several statues of the Shah, there was no sculpture in Iran at the time,' Tanavoli explains.

Instead, on his return to Iran in 1959 Tanavoli threw himself into his work. The early 1960s saw Tanavoli's studio becoming a centre of the Iranian modernist movement, and his exhibitions and previews became focal points for budding artists looking for something fresh. Change was in the air and a nascent interest in all things new and modern was taking hold among the newly educated classes and those returning from studies in the West.

'The *Saqqa khaneh* movement was practically born in my studio, the "Atelier Kaboud",'

Tanavoli says. 'Artists like Ghandriz, Pillaram, Zenderoudi...would all come to see my works, which drew inspiration from very traditional Persian motifs, through objects which I searched out from bazaars and shrines: old locks, door knobs and other pieces of metalwork.'

Tanavoli explains that his work is both adaptive and adoptive, assimilating a thousand years of Iranian culture in order to create something new. He's done this by exploring every facet of Iranian street and religious culture and heritage, travelling to far-flung corners of his homeland, seeking out shrines, studying religious iconography, examining doors and locks from ancient houses. 'It became a part of my life going to these places, where people were still living lifestyles that hadn't changed in a millennium.'

In fact, although Tanavoli splits his time between Tehran and Vancouver, Canada, and has spent much time studying and teaching in the West (for example, at the Minneapolis College of Art and Design), it is to Iranian

culture that he returns time and time again for inspiration. 'To tell you the truth,' Tanavoli explains, 'what is happening in the [Western art world] doesn't do anything for me. We have such a rich base here [in Iran] that I never wanted to do anything else. I find Western ideas interesting but not inspiring.'

'I've always been fascinated by the culture of my Persian inheritance: poetry, architecture, and other arts,' he says. 'It wasn't as if there was nothing for me to see [in Iran]. We've had art in every century in every place throughout the history of Iran. The three-dimensionality of Islamic architecture, which is not just seen in the [buildings themselves], but also in details such as doors, doorknobs, grill-work...to me these were all forms of sculpture as good as any in the West.' Tanavoli's fascination with his own culture has also led him to publish several books on different aspects of Iranian arts and crafts.

Many Iranian artists touch upon the subject of religion in their works, either directly or indirectly. In Tanavoli's case, it informs the work

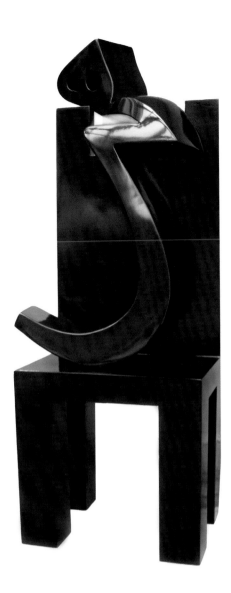

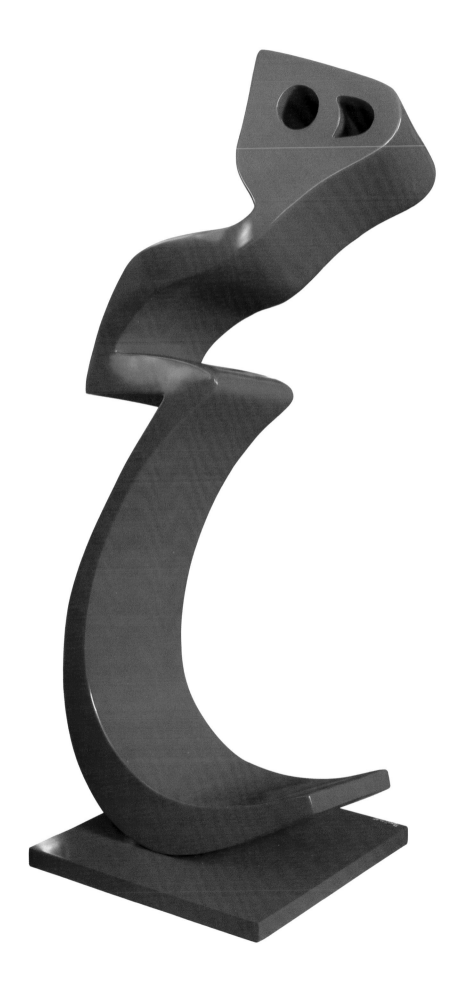

rather than being its subject. 'In every aspect of Iranian life there is a touch of religion, traces of mystical elements in everything we experience. Religion never stopped my work...on the contrary I've managed to adapt my work to my religion and drew my inspiration from it. Every shrine in Iran is like a little museum and I have visited thousands of them. The best of all artworks – tiles, woodwork, brass-work and textiles – are displayed in these shrines. These became my sources of inspiration.... These were so tastefully made by master craftsmen throughout the ages and they have all become the foundation for my sculptures.'

'I gave up all my early Italian training and influences centred on sculpting the human body. I found a new anatomy in the inanimate.' His ideas and principles have been consistent. 'I haven't changed my work drastically in the last fifty years,' Tanavoli says. 'I'm following the same ideas, the same themes, the same stories and the same poetry...my work is firmly rooted in Iran and its history.'

above
Heech on Chair, 2007
Aubergine fibreglass
200 cm (height)
Edition of 20
Private collection, London

right
Heech, 2003
Red fibreglass
180 cm (height)
Private collection, London

opposite
The Family of Poet II, 1971
Bronze
117 x 80 x 49 cm
© Parviz Tanavoli
Courtesy of Parviz Tanavoli

Parviz Tanavoli

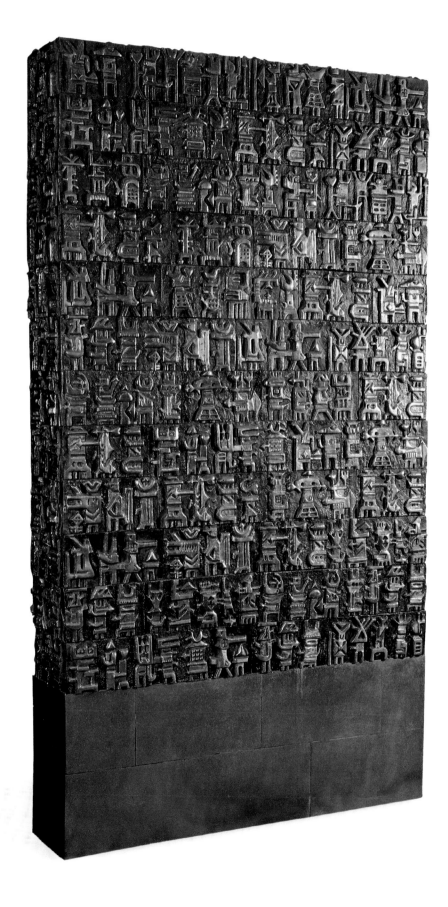

above
The Family of Poet V, 1979
Bronze
47 x 40 x 15.5 cm
© Parviz Tanavoli
Courtesy of Parviz Tanavoli

right
The Wall (Oh, Persepolis), 1975
Bronze
181 x 102 x 23 cm
© Parviz Tanavoli
Courtesy of Parviz Tanavoli

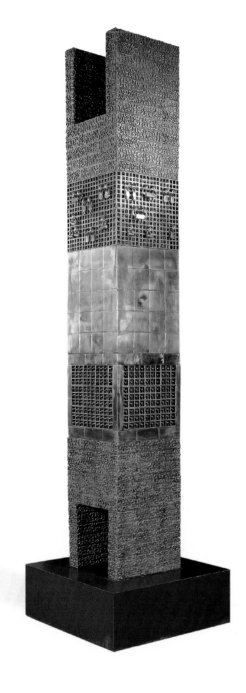

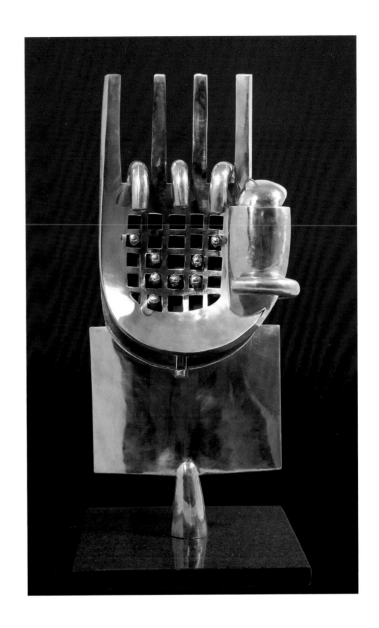

above
Hand on Hand, 2000
Bronze
51 x 25 x 12.5 cm
© Parviz Tanavoli
Courtesy of Parviz Tanavoli

left
A Shrine for the Last Poet of Iran I, 1975
Bronze
280 x 51 x 51 cm
© Parviz Tanavoli
Courtesy of Parviz Tanavoli

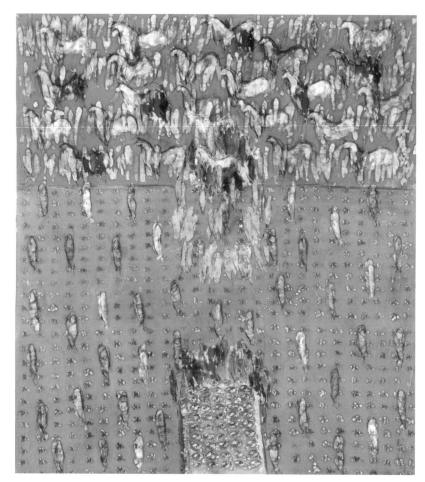

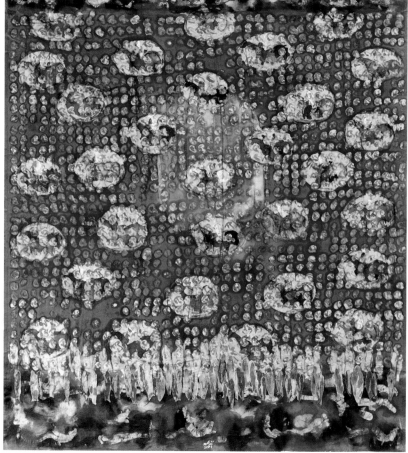

Born in 1956 in Gonbad Kavos, Iran, Aneh Mohammad Tatari studied painting at the Azad University in Tehran. Over the past couple of decades he has exhibited throughout Europe and in Jordan, Venezuela, India and the United Arab Emirates. His works feature in the collection of the British Museum, London, among various other museums.

Tatari's canvases are wonderfully colourful, a patchwork of textures. At a glance they look as though they might be covered in writing, but closer inspection reveals that the surface is instead covered in small lines, rapid marks that bring it to life. These vertical lines are often arranged into horizontal bands, giving an almost textile-like, woven effect. In addition, certain repeating animal motifs appear. Some of the canvases retain vestiges of a horizon, suggesting that they should be read as landscapes, whereas others look more like flags.

above
Untitled
Mixed media on fabric mounted onto canvas
155 x 142 cm
© Aneh Mohammad Tatari
Courtesy of Aneh Mohammad Tatari and
Mah Art Gallery, Tehran

right
Untitled
Mixed media on fabric mounted onto canvas
156 x 142 cm
Private collection, London

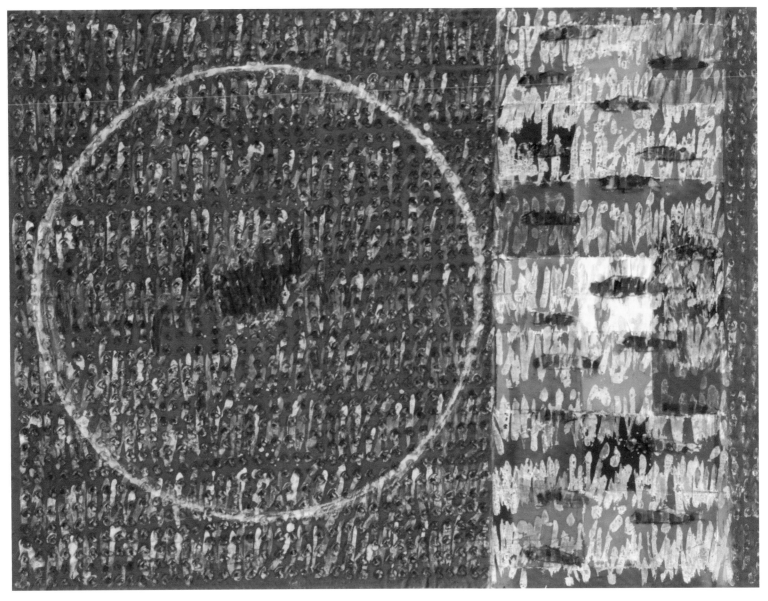

Untitled
Mixed media on fabric mounted onto canvas
134 x 180 cm
© Aneh Mohammad Tatari
Courtesy of Aneh Mohammad Tatari and
Mah Art Gallery, Tehran

Aneh Mohammad Tatari

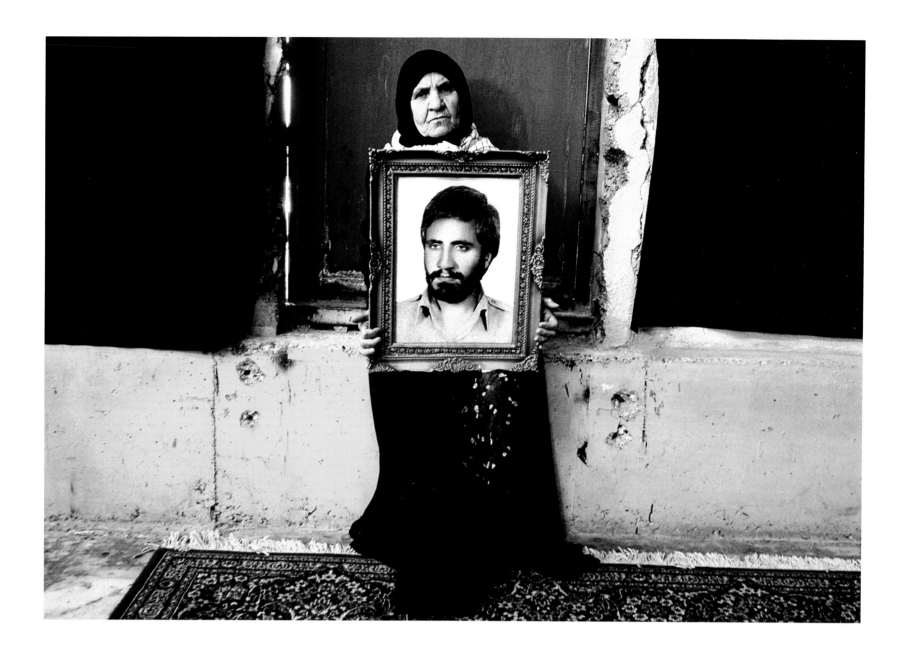

Newsha Tavakolian was born in 1981 and has been working as a photojournalist since she was sixteen. Today, though still young, she has had work published by *Time*, *Newsweek*, *New York Times* and *Le Figaro*. Tavakolian is also a member of Evephotographers, an all-women international photo group, and has taken part in many successful group exhibitions both in Tehran and internationally – for example, the '30 Years of Solitude' show at Cambridge University, United Kingdom, in 2007.

Aside from her on-going photojournalism, Tavakolian has also produced series of works that document everyday life in Iran, especially among women. One of her most fascinating and insightful series, 'Day I Became a Woman', deals with Iranian girls coming of age and adopting the restrictions of 'adult' women. Even more affecting, however, is 'Mother of Martyrs', which documents those women who lost sons during the Iran–Iraq War.

 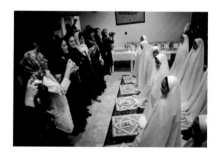

top
From the 'Mother of Martyrs' series, 2004
Photograph
© Newsha Tavakolian
Courtesy of Newsha Tavakolian and
Silk Road Gallery, Tehran

above
From the 'Day I Became a Woman' series
Photographs
© Newsha Tavakolian
Courtesy of Newsha Tavakolian and
Silk Road Gallery, Tehran

The Third Line in Dubai is one of the most professional independent art and educational entities in the Persian Gulf. Set up in 2005 by Sunny Rahbar and her two partners, Claudia Cellini and Omar Ghobash, the gallery has gone from strength to strength in the frenzied Dubai art scene.

Rahbar agrees that in certain respects what is happening in the art scene in the Gulf region is overblown, but explains that it has been confined mainly to the secondary market. 'As a whole, the movement is very real,' she says. 'Look at the production from Iran...that's all real. The contemporary Iranian art scene is as real as any other in the contemporary art world.'

Rahbar, who is of Iranian origin, was born in the United States where she attended the Parsons School of Design. After graduating with a degree in Fine Arts, she worked for a while at the Guggenheim Museum in New York. She then moved to London to train with Sotheby's contemporary decorative arts sales department before moving to Dubai in 2001 to work with young and emerging artists. The establishment of The Third Line was a natural progression.

Despite the hyped environment surrounding Middle Eastern art and Dubai's heady mix of bling and brashness, Rahbar emphasizes that she isn't in it solely for the money: 'I think...our best hope is to see what the artists do rather than treat them as a commodity. This business should be about the art and the artists, not about how much is paid for artworks.' Nevertheless, she is realistic about others' motivations: 'I think it is only natural that with the booming situation of the past few years in Dubai people want a piece of the action. You get all sorts who want to jump on the bandwagon, and often egos drive agendas.'

As with all boomtowns, the Dubai juggernaut has been significantly slowed down by the recent global economic crisis. Rahbar is sanguine about the economic challenges facing the regional art market given the sudden cooling of financial tempers. 'I think many people are in the art market for the right reasons...we'll see in a year or two who will still be around,' she says. 'We're still waiting to see how the crisis will affect the art scene here in Dubai.' The positive effect of the severe recession, as Rahbar sees it, will be to squeeze the speculators out of the market.

'Hype is not a bad thing when it grabs people's attentions, but it is not good when it inflates prices,' Rahbar explains. 'There has been hype around certain artists and we'll see which of the artists will still have a strong market standing. I've always maintained that good art will always have a market. But we'll see whether artists, collectors, galleries, auction houses and quick-set institutions will still be around.'

Are there any real modern or contemporary art institutions in the Gulf region? Rahbar cites the example of the splendid and recently opened Doha Museum of Islamic Art, but wonders whether any or all of the touted cultural behemoths planned on paper will be realized. She adds: 'Abu Dhabi has twelve museums planned, Dubai has announced a Middle East Museum of Modern Art and Doha has already been collecting for its Museum of Modern and Contemporary Art.' With the limited artistic production coming out of the Gulf, Rahbar questions the thinking behind so many projects.

Is regional art faddish? And is the market driven solely by social aspirations? 'People are becoming genuinely interested,' Rahbar claims. 'I see it from their attendance at the shows we organize at The Third Line; everything from film to theatre to fine art...there is a definite grass roots movement and now that the governments have become involved it can only get better.' Rahbar accepts that the bulk of the interest is still confined to a small, educated class. 'Things take a long time to develop. We're a very young region in terms of modern culture,' she says.

Rahbar herself originally wanted to become an artist, but chose first to become a curator: 'It is important for me to keep doing what I love to do. We put everything back into the business to grow the programmes that we have for Dubai and the region. But we have to be commercially minded to be able to survive...there are no grants or other support mechanisms yet in place to sustain such wide artistic ambitions as have been recently touted.'

Rahbar thinks that it is only a matter of time before the cultural infrastructure will become self-sustaining. She believes in the long-term vision that she and her partners have developed for The Third Line. 'I want to help build an environment in the Middle East where artists come and develop their skills and thrive,' she says with genuine enthusiasm. 'Where my kids can go into any bookshop and find works on Middle East artists, or visit museums and galleries. Art is a very important component of every society's makeup.'

But how can artists cope with blind censorship and enforcement of religious or social orthodoxies? Rahbar recognizes that censorship poses a obstacle: 'We need to challenge current thinking, which in itself is a controversial ambition in many ways. It's all very opaque and we still need to self-censor. It's all about religious sensitivities, social mores and political content. Should there be clearer guidelines from the authorities?' Needless to say, the question is rhetorical.

The Third Line Gallery

281

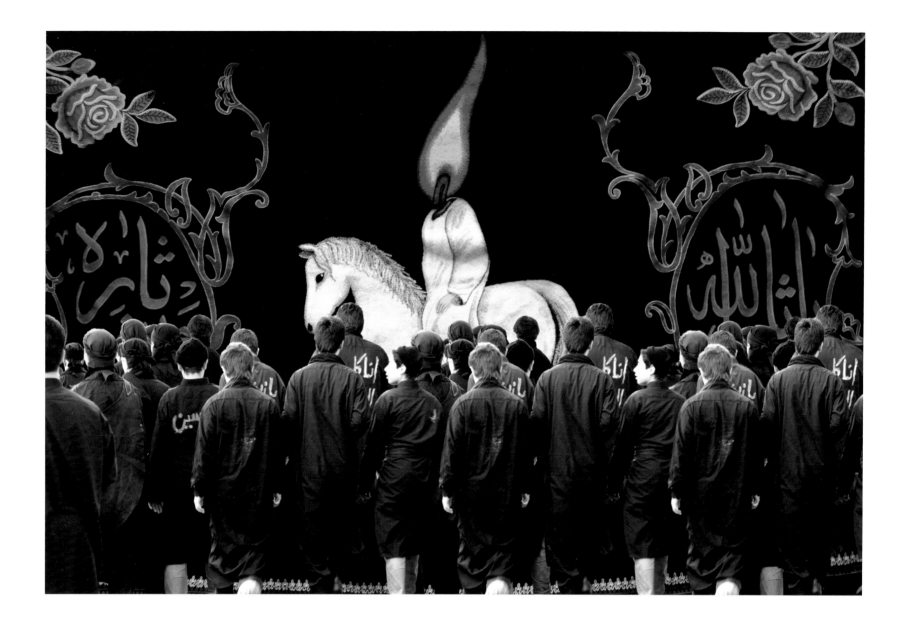

Sadegh Tirafkan was born in 1965 in Karbala, Iraq, to Iranian parents. In 1989 he graduated with a degree in photography from Tehran University and has not looked back since, thrusting his artistic vision onto the international stage early in the millennium. In a way he has become the vanguard of the Iranian artistic movement.

Tirafkan's work stretches across different media, though mostly he concentrates on photography, video installation and collage. An early photographic installation, *Iranian Man* (2000), was almost obsessive in its treatment of the role of masculinity in traditional Iranian society and culture. 'The roots of my art are Iranian-based because I'm an Iranian,' he says matter of factly. 'If I had been born in London or New York I would be doing Western art.'

Tirafkan has travelled widely during his career, but he always returns to Iran. 'I've lived in New York, Paris, Toronto, London...but altogether I've been out of Iran for only three years.' Independent-minded, he declares that he has no affiliation to government or cultural organizations. 'I'm my own artist,' he declares loudly and proudly.

Tirafkan is blunt, not afraid to express strong opinions about his work, his country and his compatriots. 'Iranians have always been beaten down throughout our history,' he says of the national paradox, the struggle between the new and the old. The Iranian national identity, he says, combines 'a longing for ancient Persian achievement on the one hand, and [on the other] a religiosity based on superstitious stereotypes which is at variance with a craving towards modernism.'

'Iranians look to their roots more than any other Middle Eastern country,' Tirafkan continues. 'The Turks don't want to know, they're Western-orientated. The Arabs' question of identity is a difficult one. When you talk about Arabs, the Palestinian question pops up. Where is the identity except for in the "victim"? The people in the Middle East are always stuck in the problems of identity repression imposed by the West.'

'Iranians have always been culturally rich. We have extended our influence beyond our borders, both east and west, and deep into the Indian Subcontinent.... We have absorbed cultures, but we have also created our own culture. Look at modern Iranian cinema and the visual arts in the past few decades. In the 1960s and 1970s we had the first ever museums and institutions for modern art in the region. We're not new to the international art market,' Tirafkan continues: 'Iranian artists represented our country in Art Basel and the Venice Biennale. The Islamic Revolution merely created an interruption, but we're back!'

Tirafkan believes that Iranians have a yearning for new things but also that they don't yet have the means to accomplish their ambitions. 'We don't think "quality",' he says. 'There is no finishing. I've always maintained that we Iranians should not be shallow in our approach to art. We only have to look back at Persian classical or Safavid art to measure the superb professional accomplishments in architecture, miniature painting and calligraphy.' And indeed, in his recent work *Whispers of the East*, Tirafkan has taken inspiration from Safavid miniatures, incorporating their timeless beauty into his politically charged work with a contemporary twist.

Perhaps one of the problems in contemporary Iranian art is opportunism? 'We have many talented artists with some great ideas,' Tirafkan points out. 'But the level and the techniques have to be raised higher. We're now playing on the international stage and should therefore match

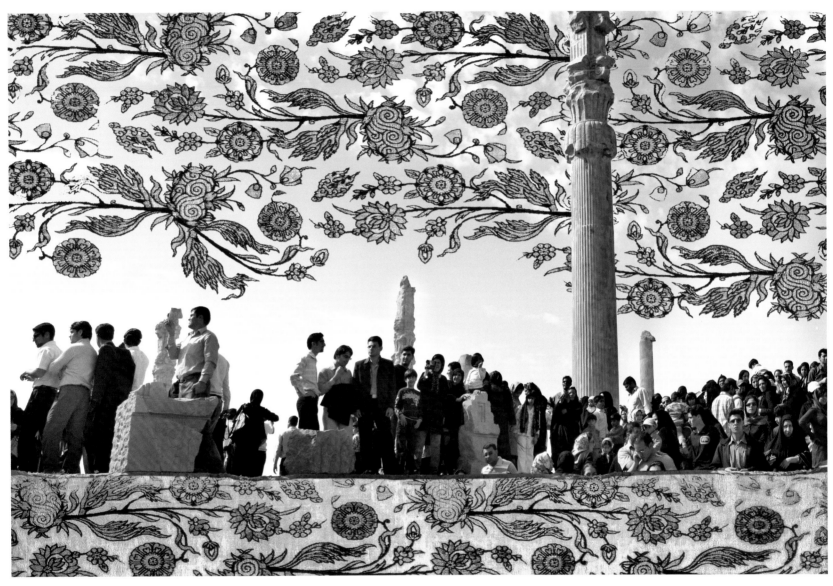

world standards.... Local standards are no longer
sufficient to qualify our work.'

'There really isn't any government or
institutional support for the arts in Iran,'
Tirafkan adds. 'It is truly an independent
movement from my personal experience of
things.' But at the same time he laments
contemporary Iranian art's 'lottery mentality',
as he calls it. 'There's no revolutionary art
movement in Iran, but more of a commercial
wave which is all right in its own way.'

Tirafkan remembers that until only recently
quality artists' materials such as paints were not
available in Iran. 'Time was when we could only
get Chinese paints and materials, but nowadays
Winsor & Newton sells its products across the
country. That's a sure sign of the significance of
art among the new generation of artists.'

above
Multitude #1, 2008
Digital photo collage, print on RC paper
Edition of 6
75 x 112 cm
© Sadegh Tirafkan
Courtesy of Sadegh Tirafkan

opposite
Multitude #5, 2008
Digital photo collage, print on RC paper
Edition of 6
75 x 112 cm
© Sadegh Tirafkan
Courtesy of Sadegh Tirafkan

Sadegh Tirafkan

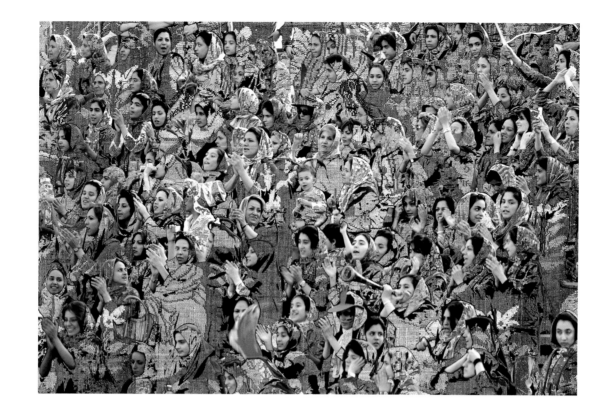

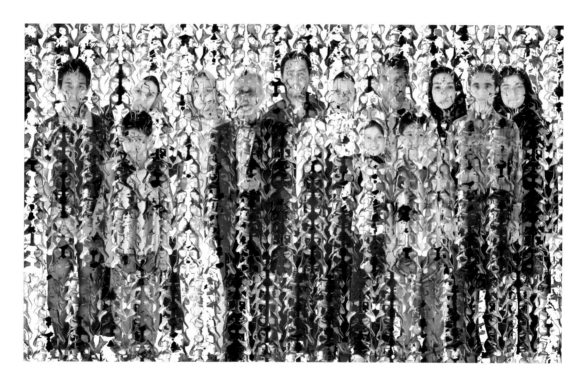

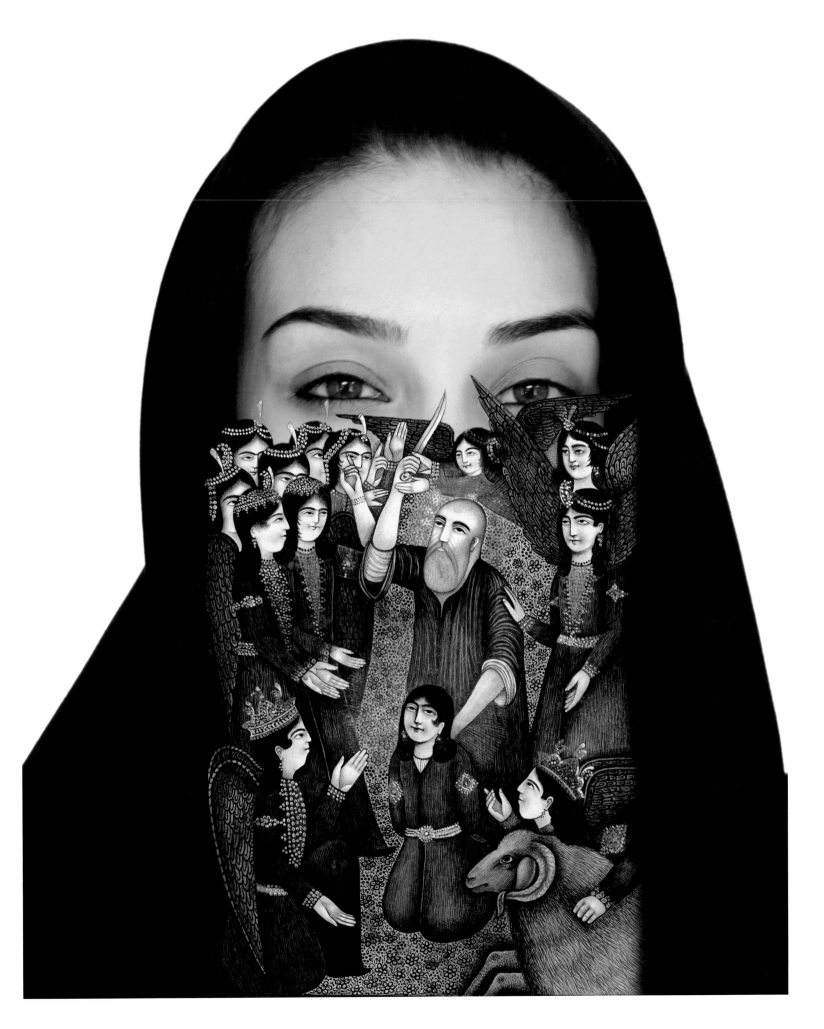

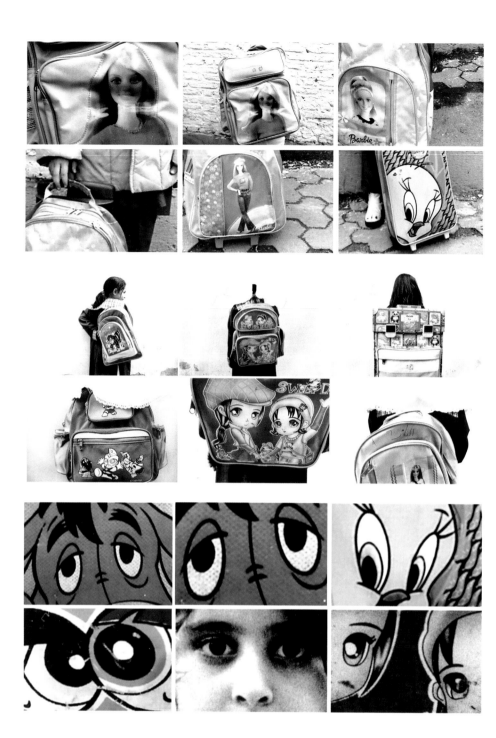

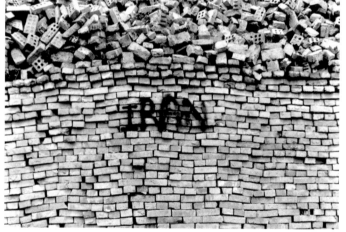

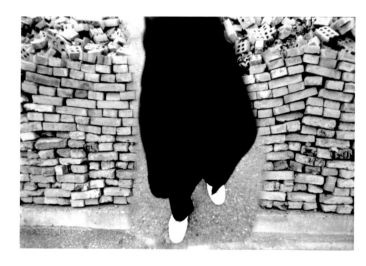

Hamila Vakili was born in 1979 in Tehran, where she continues to live and work. She studied Photography at Tehran University, and since 2001 has exhibited extensively both in Iran and abroad, including at Cambridge University, the De Santos Gallery in Houston, Texas, and the Gold Coast City Art Gallery, Australia.

Vakili offers an interesting new perspective on Iranian daily life, as well as on the role of women within it. Mixing media and using photomontage, as well as making use of mirrors to split images, she has explored themes such as the images on girls' schoolbags (with stickers and stencils of surprisingly Western figures such as Barbie) and the barriers that women have to negotiate.

above
Untitled
© Hamila Vakili
Courtesy of Hamila Vakili

right
Untitled
© Hamila Vakili
Courtesy of Hamila Vakili

opposite
From the 'Barbies' series
© Hamila Vakili
Courtesy of Hamila Vakili

Hamila Vakili

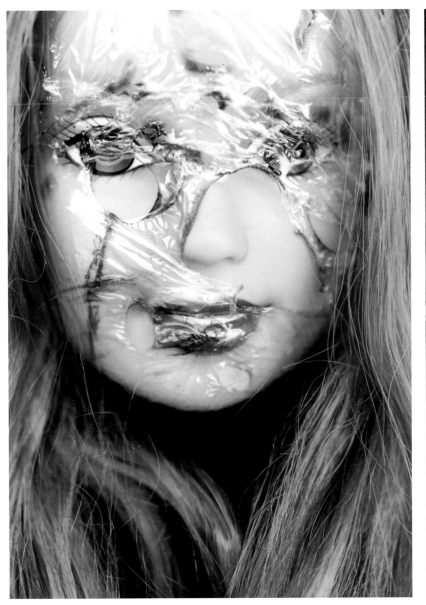
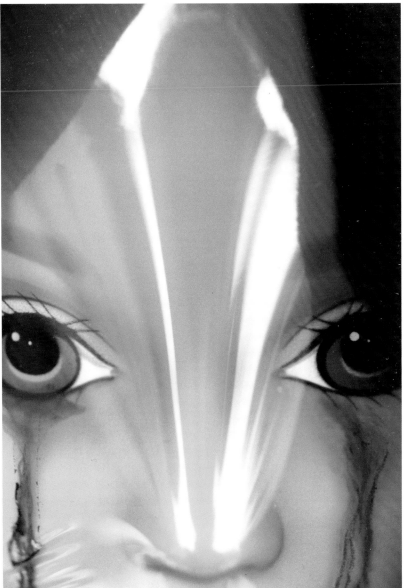

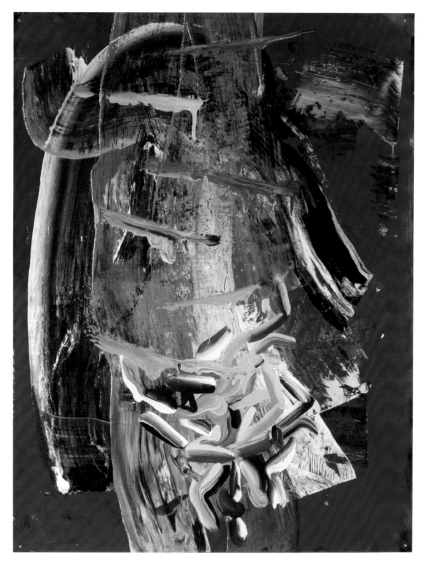

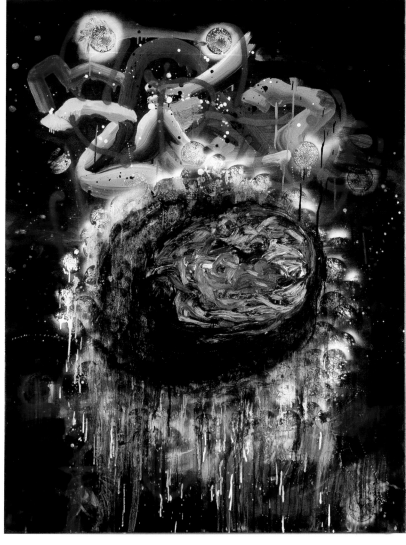

Growing up in Kansas, Anahita Vossoughi immersed herself in Middle America's 'vernacular culture of heavy metal, ripped jeans, and fast food restaurants', while back at home, her Iranian parents had fierce arguments about politics, women's rights and their very Americanized children. As with so many other children brought up with two cultures, the contrasts affected Vossoughi deeply.

Vossoughi studied Fine Art at the School of the Visual Arts, New York, and is currently working on her Masters at Yale. She lives in New York, and has been exhibiting regularly since around 2002. Her current set of paintings explores, thematically and stylistically, precisely those cultural conflicts that she grew up with.

Feeling slightly apocalyptic in their imagery, they are at once perplexing and surreal. Vossoughi explains them like this: 'By layering the smooth stylization of Middle Eastern and Indian imagery with rubble, fireworks, drips, blobs, sprays and splashes of paint, I've painted multi-limbed, contorted creatures that reside in apocalyptic, expressionistic landscapes. These colour-saturated figures...billow, smoke, shoot fire and disappear in and out of their hysteric and surreal environments. These scenarios are contextualized within a realm of mythology, science fiction and mysticism, and refer as well to war and cultural upheaval.'

Vossoughi's paintings are governed by a unique view of the world and a highly complex symbolism: 'My paintings have been influenced by contemporary Iranian writers impacted by Persian mysticism, such as Sharnush Parsipour. In Parsipour's novel *Touba*, intimate strife within the larger social context of Iran's turbulent history is explored. Like Parsipour's novels my paintings synchronize personal and social issues. The biomorphic forms in my paintings incorporate both male and female elements grappling internally, and refer to struggles within personal relationships. Simultaneously, the appropriated Eastern references and stylistic overlays of Western expressionism serve to explore conflict in a larger cultural, aesthetic and political context.'

above left
Date Palm Couples Series: #5, 2007
Oil on chromecoat paper
66 x 51 cm
© Anahita Vossoughi
Courtesy of Anahita Vossoughi

above
A Devil on Horseback, 2007
Oil and spray paint on linen
134.5 x 106.5 cm
© Anahita Vossoughi
Courtesy of Anahita Vossoughi

opposite
18 Shot Phantom Snake Finale, 2007
Oil and spray paint on canvas
203 x 155 cm
© Anahita Vossoughi
Courtesy of Anahita Vossoughi

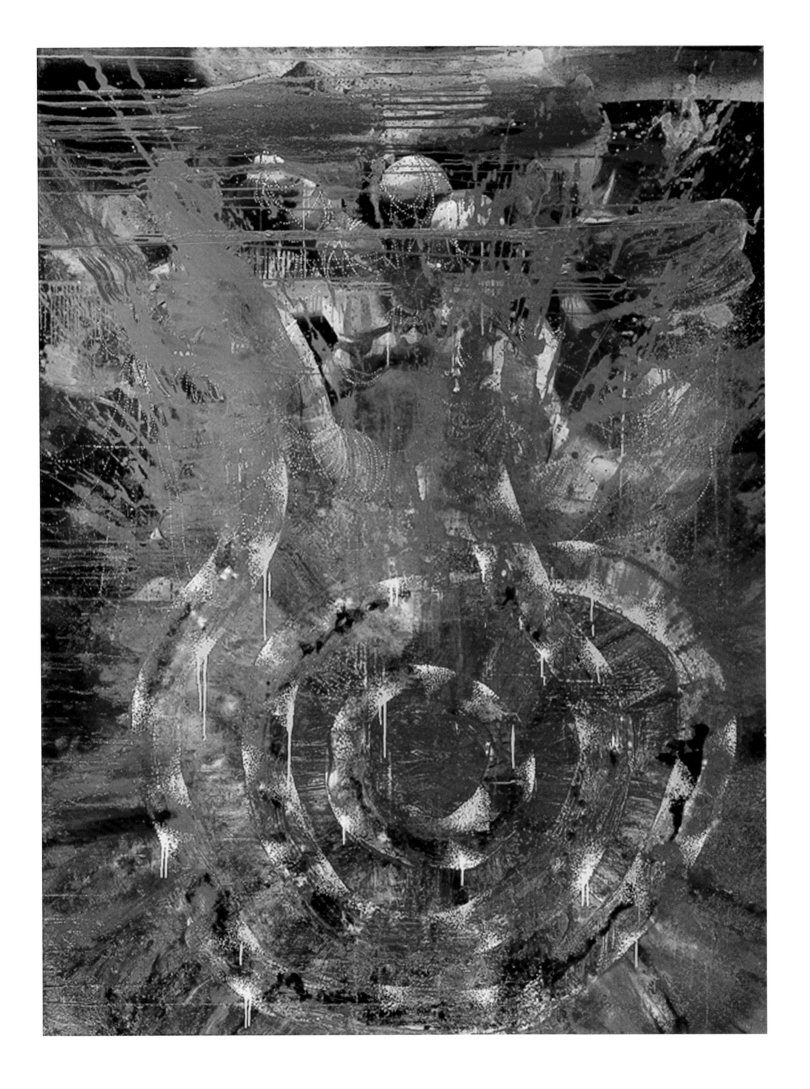

Ziba de Weck is the founder of the Parasol unit foundation for contemporary art, a not-for-profit organization and one of the newest additions to the creative resources that have made London, along with New York, one of the centres of global contemporary art.

Situated on Wharf Road in the northeast of the city, Parasol's impressive building (designed by Italian architect Claudio Silvestrin) has created quite a buzz in the area – indeed, *The Times* has described Parasol unit as helping to create the 'hottest centre of activity' in the Old Street area. Though she has lived and worked in both cities, de Weck herself has said that 'London is far more interesting than New York as an art centre.'

A powerful personality, de Weck started Parasol in 2005 with the intention 'to do something beautiful, to help artists and maybe to make a contribution to society.' 'We have now launched several artists who have gone on to bigger things,' she says with pride. The multimillion pound cost of the project was met in its entirety by de Weck and her husband.

De Weck is shy of publicity, and rarely gives interviews, preferring the route of experience before exposure. 'My idea was to create a very strong programme before going out for a profile,' she explains. 'We've been here three years and we've achieved a purpose and the reputation is solid. We can now move forward and expose Parasol to the world.'

Born Ziba Ardalan in Ahwaz, southern Iran, she left home in her teens to study in Switzerland. 'Not a Swiss finishing school,' she is quick to point out; rather, she studied for a PhD in Physical Chemistry at Geneva University, and then moved on to a post-Doctoral study at the Massachusetts Institute of Technology. De Weck's next move, in the mid-1980s, was to New York's Columbia University, where she did a Masters in Art History. After completing this, she worked on several projects for the Whitney Museum of American Art in New York, including an exhibition devoted to the work of the American painter Winslow Homer at the Whitney branch in Stamford, Connecticut.

What, though, inspired her to swap science for art? 'It may seem a big switch, but as a scientist I feel you have to be a creative personality. Science can be very creative. It's not only about numbers and formulas...science teaches you to be very analytical and this has helped me in the arts, as people generally tend to lose that analytic perspective in the creative world,' de Weck explains. Having climbed high up the ladder in her scientific profession, she felt the need to move on.

'You feel like you've touched your limits after a few years and yet there's no challenge you cannot overcome,' de Weck explains. 'Quantum Mechanics is not an easy field and you're pushed to your limits and begin to doubt your intellectual abilities...that is very good

because you become humble and you lose that flashiness, that kind of "I can do anything". Yes, to achieve something in life you need humility.'

'Being analytical helps me to select my programmes, to select my artists,' she argues. 'When you choose artists for your space you need to be intuitive and analytical at the same time. You need to read the right moment...it is all about timing. A good curator needs both an eye and good timing, but most important is the timing. As a kid I always had two sides to me: one was the organized analyst, and the other was the creative...that's why I've swung from science to art. One field is ordered and methodical; the other is, fanciful and creative, letting your imagination travel.'

De Weck's first experience of art was in Iran, when she was five years old. 'We were travelling with my parents near Khorramshahr and we visited the Bustan reliefs [dating to the 7th century AD]. Those monumental reliefs were really striking, but what I loved most about them was their timelessness,' she recalls. 'They had a modern air...but also an ancient feeling.'

'I'm not stuck in my art,' de Weck says after a pause for reflection. 'When I started in the 1980s people wondered why I was into contemporary art as opposed to ancient Persian art. But I was more interested in the aesthetics of art rather than its periods or its origins. We don't really know who created the Bustan reliefs, do we?'

'The aesthetic of art is universal and I hope people who like contemporary art will also appreciate ancient art.... It's necessary to visit museums from time to time to reflect on our origins, and the origins of art. After all, it all started with the cave dwellings,' she says. 'Art is basically a human expression...in poetry, writing, dance...any creative expression is art.'

Is curating as important as creating, though? 'You don't compare yourself to the artist. God is the artist, and the artist is in some ways godly. Humans create art, and God creates artists.' De Weck suddenly becomes contemplative: 'I'm not knowledgeable enough about creation to explain more clearly the links between creativity, science and divinity. In life the more you learn, the more you realize that you don't really know anything. I believe in God, so I believe that the world is God's creation.'

De Weck then adds another thought: 'I don't think that art is an escape...people have to express themselves. Artists, dancers, writers all want to express themselves...you're born an artist. Artists really touch things. It's not just about money. They don't make money until they're famous. Collectors, dealers and whoever handles art make money. But I'm in the not-for-profit business.'

'It's really a question of your take on art, whether you're passionate or not. I put myself in the group of passionate people.'

© Houra Yaghoubi
Courtesy of Houra Yaghoubi and
Silk Road Gallery, Tehran

Houra Yaghoubi was born in Tehran in 1979. She studied Photography at Azad University, Tehran, graduating in 2002 – her thesis project was an illustration of a poem by Rumi. In 2008 she took part in the landmark group exhibition, '30 Years of Solitude' at New Hall, Cambridge University.

Yaghoubi tends to produce works that have a semi-autobiographical slant. Her first major project, 'Me women here', dealt with her view of the situation of Iranian women. My next project, 'Who's my generation?', also dealt with Iranian women and their culture; in it, Yaghoubi fashioned some models of women and arranged the models as though they were in a theatre. More recently, she has produced photographs of clothes belted with chains, and lined with screws – yet more devices for keeping women (and their clothes) in their 'correct' place.

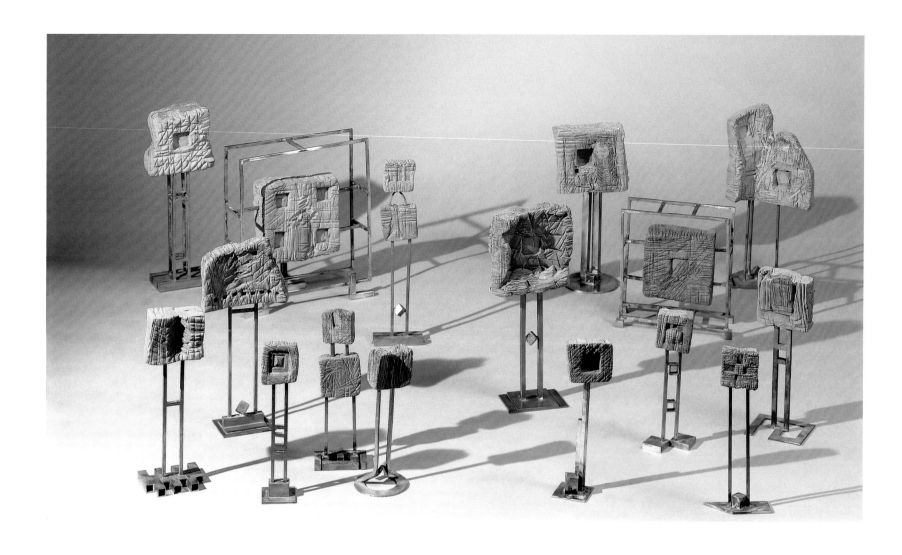

Some artists practise art for the sake of creating beauty; others look to money and fame. Reza Yahyaei is among the former group, a private man who has dedicated himself to art for the past 45 years. Famous for his sensuous female figures, Yahyaei is fond of statements such as: 'Imagination is the food of death. Death needs feeding, and art is the great chef...it brings life to death.'

'Art is a lie!' is another of his favourite pronouncements. Born in 1948 in Babol, near the Caspian Coast, Yahyaei left Iran at the age of twenty-one, travelling through the Near East until he finally settled in Florence. Self-taught and shy of publicity, Yahyaei has studios in Florence and Giverny (down the road from Claude Monet's house), devoting his life to painting and sculpting. (Some of his sculptures he displays in the prehistoric limestone caves that back onto his house.) Returning frequently to Iran, Yahyaei runs a small art foundation there that supports young talent in the arts.

Yahyaei's sculptural style is an attempt to break the old mould of Iranian art. As he explains: 'Traditional Iranian art has really been about our poetical visual expression, as well as our religious passions. I wanted to give my sculptures form, depth, substance, essence...almost a sense of sensuality inviting the viewer to touch and feel. That,' he adds, 'is the expression of my art.'

'Iranian culture is too self-involved in fantasy...it feeds off a deliberate distancing from reality,' Yahyaei says. 'The art avoids the conflicts of the present...the substantive issues of the day. Maybe that is the reason why we as a society have not been able to reconcile ourselves to the demands and strictures of individuality in the modern sense of the word.... We lose ourselves in passion and religion. We escape reality.'

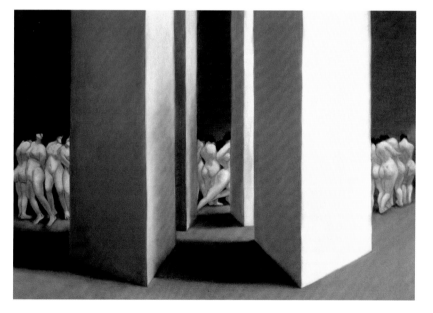

top
Totems, 2002
Ceramic and brass
Between 40 and 80 cm high
© Reza Yahyaei
Courtesy of Reza Yahyaei

above
Le Quadrige, 1989
Oil on canvas
© Reza Yahyaei
Courtesy of Reza Yahyaei

Reza Yahyaei

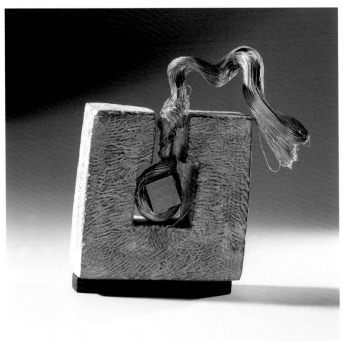

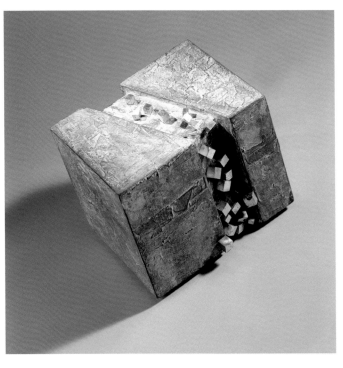

above
Introspezione, 2001
Wood and metal
© Reza Yahyaei
Courtesy of Reza Yahyaei

far left
Chained Heart, 2002
Ceramic, wood and metal
15 x 5 x 22 cm
© Reza Yahyaei
Courtesy of Reza Yahyaei

left
Mystere, 2001
Wood and brass
21 x 26 x 21 cm
© Reza Yahyaei
Courtesy of Reza Yahyaei

Firooz Zahedi has been on the masthead of *Vanity Fair* magazine since the late 1980s. One of America's top 'art' portrait photographers, Zahedi's work over the last thirty years adds up to a 'who's who' of international Hollywood celebrities. So how did a trainee diplomat from Tehran working in the Iranian Embassy in Washington, D.C., end up in Hollywood?

Zahedi has a reputation for bluntness: 'Hollywood is the centre of celebrity. Celebrity is big business and everybody's into this bullshit culture of fame. However, that's not why I'm here. I came to Hollywood because I loved film and cinema.'

Zahedi soon tired of the whole Hollywood 'shtick', as he calls it. 'In the last year or two I've come to realize that if you disregard the H-factor, life can be quite pleasant in the [Hollywood] hills.' He remembers Los Angeles as 'quite provincial' when he first arrived in 1978. 'There were no galleries and very little museum buzz,' he remembers. 'It's a different city now with all these artists and galleries.'

Zahedi's fame during the 1980s and 1990s forced him to commute constantly between New York, Miami and Los Angeles, working on major corporate shoots and photographing covers for magazines. Celebrities often asked for him by name to do their profiles. Which, then, is his favourite 'art' city of the three centres? 'New York,' he replies. 'There's such a huge artistic community there.'

These days, Zahedi is keen to do more art pieces between his commercial commissions. His images of flowers, as with his portraiture, bring out the essence of natural character. 'I've shifted to still life and abstract photography now.... You have always to explore the limits as an artist because people who pay for your work expect value in difference...*there* is value in difference,' he says. But Zahedi finds fault with the current fine art photography scene, claiming that there is too much repetitive work. 'They [the art photographers] keep feeding an audience by sticking to the same formulas.' He's happy to have started in commercial photography

because, 'I didn't have to be "creative" for money...I just want to be creative for my love of art.'

Zahedi is nearing 60 and spends more and more time reading, thinking about and reflecting on the culture of creativity in which he has been involved for the past three decades. Having started his career working with Andy Warhol in the cultural hotpot of 1970s New York, then going on to work with such big international names, Zahedi does not feel the need to pull his punches. 'Artists trip over each other struggling to make a name for themselves and then get lost in that whirl of fame and fortune. You think you're the best but don't really know how long it will last,' he reflects philosophically. 'Fame's stamp brings with it all these onerous responsibilities, and the insecurities that go with them. Who can I trust? Whom can I respect? There is resentment all around you and you become isolated. Not only does the artist have to deal with all this emotional baggage, but you have to be creative at the same time!'

above
Calla Lillies
© Firooz Zahedi
Courtesy of Firooz Zahedi

opposite, left
Dame Elizabeth Taylor, 1975
Vienna
© Firooz Zahedi
Courtesy of Firooz Zahedi

opposite, centre
Cate Blanchett, 1999
© Firooz Zahedi
Courtesy of Firooz Zahedi

opposite, right
Dennis Hopper, 1992
London
© Firooz Zahedi
Courtesy of Firooz Zahedi

Firooz Zahedi

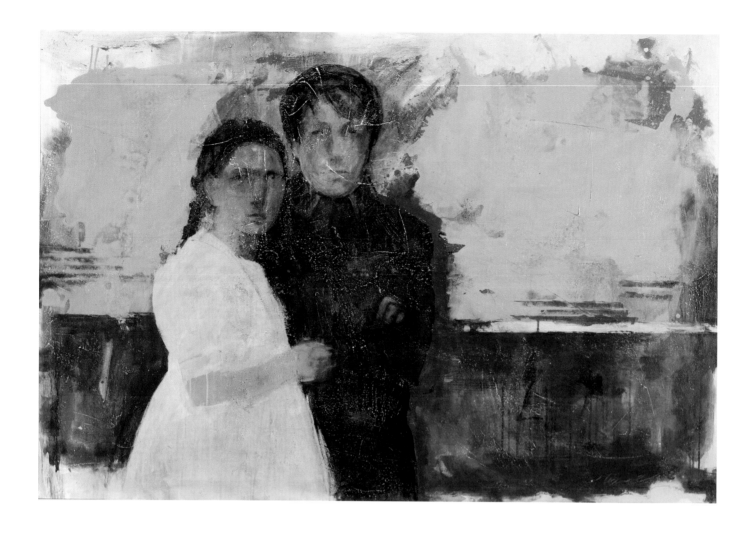

Amir Hossein Zanjani was born in 1980 in Isfahan, Iran. He studied for a degree in Painting from Azad University, Tehran, and then went on to do a Master of Fine Arts. He has exhibited widely in Tehran, and is a member of the Institute for the Promotion of the Visual Arts in Iran.

Zanjani gives his works cracked, textured surfaces, which he builds up in washes of paint. His recent 'Women Nostalgia' series show either single figures or couples in featureless landscapes. True to the title, these images have a weathered, timeworn look, while some of the costumes appear dated or even antique. Too indistinct to be conventional portraits, they instead call to mind a blurred photo – or even a blurred memory. Others have seen in them a throwback to 19th-century Romanticism – certainly his figures have both an inherent nobility, but also a terrible sense of isolation.

above
Untitled from the 'Women Nostalgia' series, 2008
Acrylic on canvas
100 x 150 cm
Private collection, London

right
Untitled from the 'Women Nostalgia' series, 2008
Acrylic on canvas
110 x 150 cm
© Amir Hossein Zanjani
Courtesy of Amir Hossein Zanjani and
Mah Art Gallery, Tehran

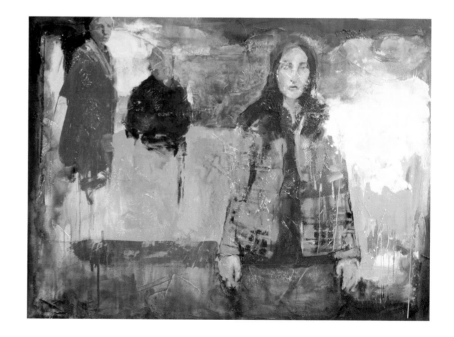

Amir Hossein Zanjani

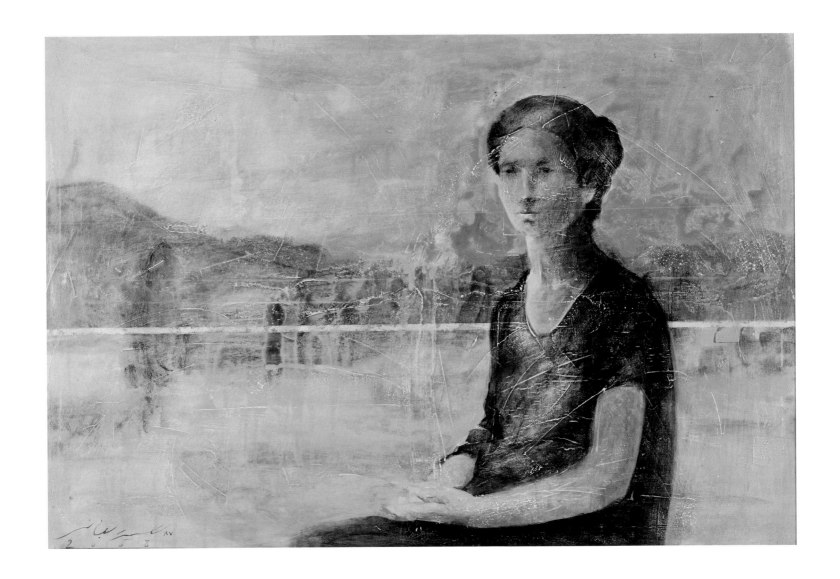

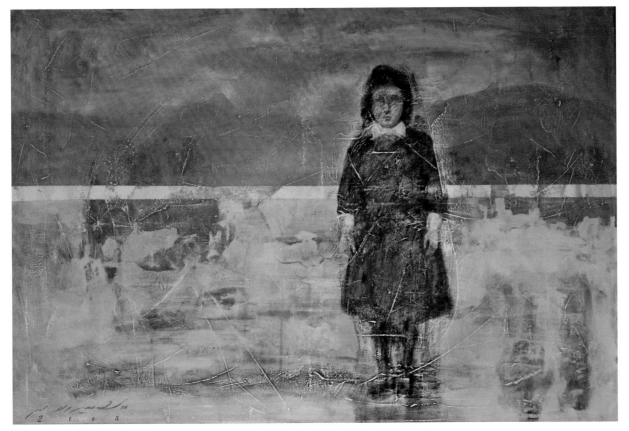

above
Untitled from the 'Women Nostalgia' series, 2008
Acrylic on canvas
80 x 120 cm
Private collection, London

left
Untitled from the 'Women Nostalgia' series, 2008
Acrylic on canvas
110 x 150 cm
© Amir Hossein Zanjani
Courtesy of Amir Hossein Zanjani and
Mah Art Gallery, Tehran

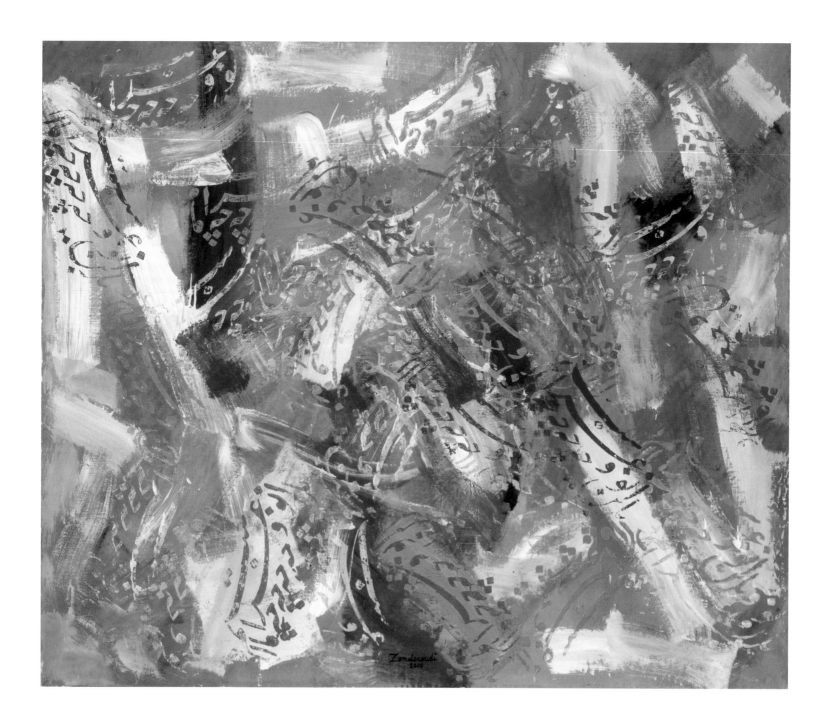

Born in Tehran in 1937, Charles Hossein Zenderoudi is possibly the best-known Iranian painter of his generation in the West, with examples of his work in the collections of the Centre Georges Pompidou in Paris, the British Museum in London, and the Museum of Modern Art in New York. One of the undisputed pioneers of Iranian modern art, he studied with Marcos Grigorian at Tehran's High School of Fine Arts, and along with Parviz Tanavoli was instrumental in the formation of the *Saqqa-khaneh* movement in around 1958. He left Iran for France in 1960; there he continued to win awards in international biennials. In the 1970s, he was nominated in *Connaissance des Arts* as one of the best-known living artists, alongside Frank Stella and Andy Warhol. He also won the UNESCO award for 'The Most Beautiful Book of the Year', for his cover design and lithographs for the Qur'an.

Zenderoudi works almost exclusively in paints – sometimes on canvas, sometimes on paper – and almost all of his production is based around scripts or calligraphy. His style has been described as 'an autonomous artistic language with universal roots'. This fascination with crafting a universal language marks Zenderoudi out as a modernist of the old school; as he says, 'People around the world are all the same and everyone is able to read my work. What matters is the harmonizing of the heart of the artist with the heart of the viewer.' Pierre Resany has said that 'a painting by Zenderoudi is sacred in its very essence.'

What is remarkable about Zenderoudi's career is the diversity of his approaches while remaining true to his central vision. His work has passed through many different aesthetic stages – from the rigid formalism of his earlier works, to the chaos and kinetic movement of his later works – while remaining conceptually pure.

In fact, Kamran Diba has called Zenderoudi 'a master of Arab and Farsi abstract calligraphy' and has said that he is 'without any doubt, the most prolific and versatile artist on the subject.'

In part Zenderoudi was helped by keeping a studio in Tehran throughout the 1970s – this allowed him to stay in touch with his roots, and also his friends. In the late 1970s, Zenderoudi embraced Sufism (a mystical branch of Islam), causing the work to become more inward-looking and mystical in itself. Since the 1980s, alongside his normal practice, he has also continued to produce illustrations for books.

Today, Zenderoudi, active as ever, has achieved the sort of recognition that all artists aspire to, and to which he is entitled as a seminal figure in Iranian modern art. In 2002 he had a retrospective at the Tehran Museum of Contemporary Art, and his work *Chahar Bagh* was sold at auction in Dubai for well over one million dollars.

above
Untitled, 2000
Oil on canvas
132 x 165 cm
© Charles Hossein Zenderoudi
Courtesy of Charles Hossein Zenderoudi and LTMH Gallery, New York

right
Untitled, 1981
Oil on canvas
129.5 x 96.5 cm
© Charles Hossein Zenderoudi
Courtesy of Charles Hossein Zenderoudi and LTMH Gallery, New York

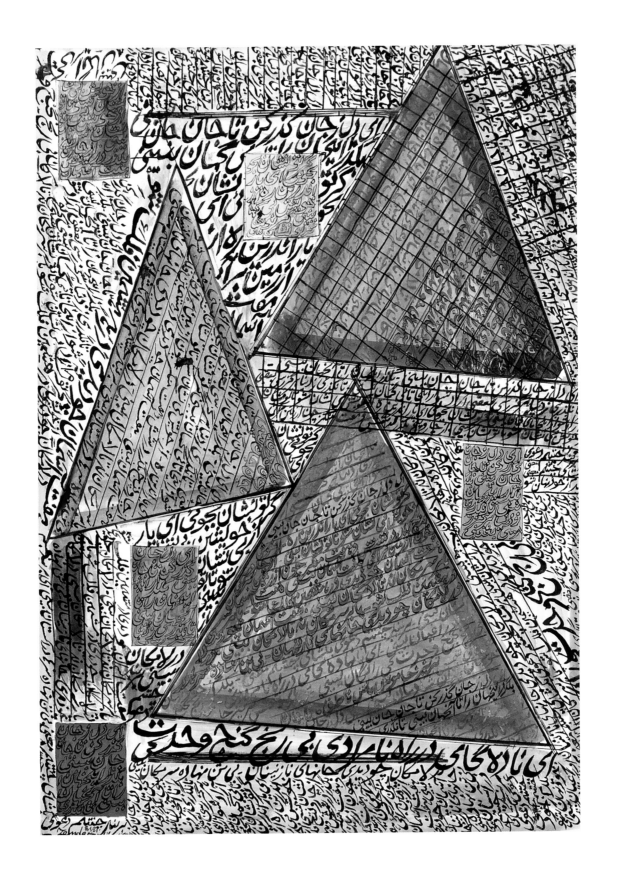

1 The *Dar al-Funun* was a college of (mainly military) education where future officers, engineers, doctors and also artists were taught. Founded in Tehran in 1851, many of the original tutors were European. The *Dar al-Funun* was to prove critical in the spread of European-style art education and production, and it was here that most of the leading late 19th-century Iranian court artists were trained, including Ismail Jalayer (d. 1893), Abu-Turab Ghaffari (1862–89) and, most famous and influential of all, Mohammad Ghaffari (Kamal al-Mulk).

2 S. Vernoit, *Occidentalism: Islamic Art in the 19th Century: The Nasser D. Khalili Collection of Islamic Art*, vol. 23, New York: Nour Foundation in association with Azimuth Editions and Oxford University, 1997, p. 10.

3 Ibid.

4 Ibid.

5 A. Soheyli Khansari, *Kamal-i hunar* (Perfection of Art: Life and Works of Mohammad Ghaffari Kamal-ol-Molk, 1847-1940), Tehran, Elmi Publishing Co., Soroush Press, 1989, p. 179.

6 It is worth mentioning that the introduction of photography and lithography in the later part of the 19th century had already impelled Iranian painting towards realism. Unlike their Western counterparts, Iranian artists were fascinated by detailed images taken by camera and turned their idealistic worldview of the Qajar style to a more objective and realistic 'photographic' style. The same happened with the introduction of lithography and the subsequent demand for realistic images for newspapers of that period.

7 *The Hall of Mirrors* is representative of his naturalistic style, and can be seen as a variation on royal 18th- and 19th- century European painting.

8 The Revolution took place in 1906 in the last year of Muzaffar al-Din Shah's reign. It proposed a country with a constitution modelled on the Belgian and French examples. It also resulted in the establishment of Iran's first parliament or *Majlis* on 30 December, 1906.

9 R. Pakbaz, 'Contemporary Art of Iran', *Quarterly Tavoos*, no. 1, Autumn 1999, p. 168.

10 A. Soheyli Khansari, *Kamal-i hunar*, p. 194.

11 Ibid.

12 M. Ekhtiar, 'From Workshop and Bazaar to Academy: Art Training and Production in Qajar Iran', in *Royal Persian Painting: The Qajar Epoch 1785-1825*, ed. Layla S. Diba, New York: I. B. Tauris, in association with the Brooklyn Museum of Art, 1999, p. 62

13 K. Rastegar Rastegar, 'Naqqashi ya'ni taqlid az zibayi-hay-i tabi'at', *Rudaki*, nos 37–8, October and November, 1974, p. 32.

14 Painters trained in Russian schools were also active in Tabriz, but their artistic and teaching methods were no different from those of Kamal al-Mulk and his pupils.

15 See J. Mojabi, *Pioneers of Contemporary Persian Painting: First Generation*, trans. K. Emami, Tehran: Iranian Art Publishing, 1997, p. 8.

16 She was French and this title referred to her Iranian husband, Dr Ashub Aminfar.

17 J. Mojabi, *Pioneers of Contemporary Persian Painting*, p. 7.

18 Ibid., p. 10.

19 It is also worth noting that there were painters of this generation who had studied art at Soviet academies. Their works demonstrated Impressionistic and Post-Impressionistic tendencies. These included Habib Mohammadi and Reza Forouzi. See Pakbaz 1974, p. 11

20 R. Pakbaz, *Naqqashi-i Iran az dir-baz ta imruz*, Tehran: Nashr-i Naristan, 2000, p. 205.

21 Yarshater 1979, p. 363.

22 See K. Emami, 'Art in Iran XI Post-Qajar,' in *Encyclopaedia Iranica*, vol. II, ed. E. Yarshater, London and New York: Routledge & Kegan Paul, 1987, p. 641

23 The artists whose works received attention on public display inside or outside the country were mainly Kamal al-Mulk's followers and some master miniaturists.

24 See J. Mojabi, *Pioneers of Contemporary Persian Painting*, pp. 19–20.

25 Ibid., p. 20.

26 In 1950 all of the government offices and departments dealing with arts and crafts were unified as one agency called the Department of Fine Arts of the Country, in the Ministry of Culture. In 1961, the Fine Art section came under the supervision of the prime minister. In 1964, based on a parliamentary resolution, the Ministry of Culture and Art was established. The Ministry of Culture and Art, which was the responsibility of the Shah's brother-in-law, Palebod, was in charge of preparing and supporting the development of art and culture, and presenting and conserving the ancient heritage of the country.

27 Among the new exhibiting artists were Ahmad Esfandiari, Mahmoud Javadi-Pour, Abdollah Ameri, Leili Taqipour, Shokouh Riazi, Fakhri Anqa, Houshang Pezeshk-Niya, Mehdi Vishkai and Hossein Kazemi, and, from a younger generation, Manouchehr Sheibani and Sadeq Barirani.

28 This association was founded in 1949 by a number of modernist artists and poets under the leadership of Jalil Ziyapour, Manuchehr Sheybani, Habib Gharib and Hassan Shirvani. A journal was published with the same name.

29 Apadana Gallery, 'Home of the Fine Arts', was the first private gallery in Tehran. It was founded in 1949 by Faculty graduates Mahmoud Javadi-Pour and Hossein Kazemi, with the collaboration of Houshang Ajoudani.

30 Saba Gallery joined Apadana a few years later in holding exhibitions of modernist works and in staging lectures and discussions on modern art.

31 R. Pakbaz, *Encyclopaedia of Art*, Tehran: Farhang-i Mu'asir Publisher, 1999, p. 594.

32 M. Grigorian, *The First Tehran Biennial Catalogue*, Idara-i intisharat va ravabit-i umumi-i kull-i hunar-hay-i zibay-i kishvar, Tehran, 1958, p. 1. Some artists selected by the Tehran Biennial juries subsequently received awards in the Venice or Paris Biennales. Zenderoudi and Tanavoli were awarded prizes at the Paris Universal Biennale, and Pilaram was successful in the Venice Biennale.

33 J. Sattari, *Dar bi dawlati-i farhang: Nigahi be fa'aliyyat-hay-i farhangi va hunari dar baz-pasin salhay-i nizam-i pishin*, first edition, Tehran: Nashr-i Markaz, 2000, p. 14.

34 For a comprehensive study of the context and parallels in culture and politics, see the author's article 'Neo-traditionalism and Modern Iranian Painting: The *Saqqa-khaneh* School in the 1960s', *Iranian Studies*, vol. 38,

no. IV, December, 2005, pp. 607–630; or the 'Saqqa-khana School of Art' in *Encyclopaedia Iranica*, London and New York: Routledge & Kegan Paul, no ref. yet.

35 See K. Emami, 'Modern Persian Artists', in *Iran Faces the Seventies*, eds Ehsan Yarshater and Richard Ettinghausen, New York: Prager Publisher, 1971, p. 362.

36 For a comprehensive study of the *Saqqa-khaneh* school, see the author's article 'Neo-traditionalism and Modern Iranian Painting: The *Saqqa-khaneh* School in the 1960s', *Iranian Studies*, vol. 38, no. IV, December 2005, pp. 607–630; or the 'Saqqa-khana School of Art' in *Encyclopaedia Iranica*, London and New York: Routledge & Kegan Paul, no ref. yet.

37 According to the Islamic belief, Zamzam is the name of the spring of eternal life, which flows in Paradise.

38 E. Yarshater, 'Contemporary Persian Painting', in *Highlights of Persian Art*, eds R. Ettinghausen and E. Yarshater, New York: Westview Press, 1979, p. 368.

39 K. Diba, 'Iran', in *Contemporary Art from the Islamic World*, eds W. Ali and E. Bisharat, Amman, London: Scorpion, on behalf of Royal Society of Fine Arts, 1989, p. 152.

40 See the author's article 'Neo-traditionalism and Modern Iranian Painting', p. 613.

41 E. Yarshater, 'Contemporary Persian Painting', p. 356.

42 K. Emami, *Saqqakhaneh School Revisited*, catalogue of the exhibition, Tehran: Tehran Museum of Contemporary Art, 1977, n.p.

43 According to Emami's declaration in the *Saqqa-khaneh* exhibition's catalogue, and also statements by such artists as Oveisi and Tabatabai, they were later not satisfied that their names should be included as members of the group. However, they are listed here because of the aesthetic affinities and similarities of their works to the *Saqqa-khaneh* style, the presence of their works in the formal exhibitions and above all their intentions identical with those of the *Saqqa-khaneh* group.

44 For further details see the author's article 'Saqqa-khana School of Art' in *Encyclopaedia Iranica*, London and New York: Routledge & Kegan Paul, no ref. yet.

45 R. Pakbaz, *Contemporary Iranian Painting and Sculpture*, trans. S. Melkonian, Tehran: Vizrat-i Farhang va Hunar (High Council of Culture and Art), 1974, p. 33.

46 E. Yarshater, 'Contemporary Persian Painting', p. 370.

47 R. Pakbaz, 'Biographies of artists', in *Iranian Contemporary Art*, ed. R. Issa, London: Booth-Clibborn Editions, 2001, p. 132.

48 In addition to the public sectors such as banks, ministries and museums, private collectors also emerged including the Behshahr Industrial Group, Ebrahim Golestan, Kamran Diba and Lajevardi family.

49 H. Ram, 'Multiple Iconographies: Political Posters in the Iranian Revolution', in *Picturing Iran: Art, Society and Revolution*, eds S. Balaghi and L. Gumpert, London: I. B. Tauris, 2003, p. 98.

50 M. K. Matsuda, *The Memory of the Modern*, New York: Oxford University Press, 1996, p. 36.

51 H. Ram, 'Multiple Iconographies: Political Posters in the Iranian Revolution', p. 98.

52 R. Pakbaz, 'Contemporary Art of Iran', p. 172.

53 P. Chelkowski and H. Dabashi, *Staging a*

Revolution: the Art of Persuasion in the Islamic Republic of Iran, London: Booth-Clibborn, 2000, p. 6.

54 For further discussion on this term and 1990s post-Revolution Iranian art, see the author's article 'Discourses on Postrevolutionary Iranian Art: Neo-traditionalism during the 1990s', *Muqarnas*, vol. 23, 2006, pp. 131–57.

55 The Society of Iranian Calligraphers was established in 1966 and supported by the Ministry of Culture and Art of the Pahlavi period. Despite the support they had received from the state during the pre-Revolution period, the Society and traditional calligraphers were able to continue to develop their role after the Revolution.

56 Apart from the Tehran Museum of Contemporary art, the major centres were the Niyavaran Cultural Centre and the Azadi Cultural Centre.

57 See the author's article 'Discourses on Postrevolutionary Iranian Art: Neo-traditionalism during the 1990s', pp. 131–57.

58 In his landmark book *Asiya dar barabar-i Gharb* [Asia Facing the West], Daryoush Shayegan, the prominent Iranian thinker and philosopher of the 1970s, for example, maintains that 'the past is still just around the corner. Even if it is buried, it can still be exhumed.' From Daryoush Shayegan, *Asiya dar barabar-i Gharb*, Tehran, 1977, p. 109.

59 D. Shayegan, *Cultural Schizophrenia: Islamic Society Confronting the West*, trans. J. How, London: Saqi Books, 1992, p. vii.

60 See D. Winnicott, *Maturational Processes and the Facilitating Environment: Studies in the Theory of Emotional Development*, London: Hogarth Press, 1965

61 H. Fouladvand, 'Cultivating a New Identity: A Self-referential Experience for Iranian-American Artists', in *Between Shadow and Light: Contemporary Iranian Art and Artists*, ed. H. Keshmirshekan, p. 58 (forthcoming)

62 Apart from the Barg Gallery and other major official galleries linked to the Tehran Municipality, more than sixty galleries were active in Tehran during this period and many more in other Iranian provinces.

63 After this period, under the Mahmoud Ahmadinajad's cultural administration, the requirement for approval before each exhibition was once again implemented.

64 R. Jalali, 'guft-u-gu ba ductur Namvar Motlagh dabir-i farhangistan-i hunar: tafakkuri khas nisbat beh jahan-i islam', *Sharq* [daily newspaper], no. ccclxxxii, 1383/2005, p. 14.

65 Ibid.

66 The first presence of contemporary Iranian art in the post-revolutionary period was in the 50th Venice Biennale in 2002.

67 In May 2006 Christie's held its first auction of International Modern and Contemporary Art in the Middle East. Since then, Christie's has gone on to sell over $100 million worth of art in Dubai and firmly established itself as the leading auction house in the region. Christie's currently hold sales in International Modern and Contemporary Art and Jewellery and Watches. Christie's sales in Dubai typically take place in April and October.

68 Barbad Golshiri in interview with the author, 2006.

69 Mohammad Hossein Imani Khoshkhoo during a seminar on revolutionary art, held at the Iranian Academy of Arts, 2007.

This list offers some suggestions for further reading on the history of Iranian art from the beginning of the 20th century to the present day. It also lists various key works relating to Iran's recent history referred to in the introductory essays.

Al-e Ahmad, J., *Gharb-zadigi*, Tehran, Ravaq, 1962.
—, *Occidentosis: A Plague from the West*, trans. R. Campbell, ed. H. Algar, Berkeley, Calif., Mizan, 1984

Balaghi, S., and L. Gumpert (eds), *Picturing Iran: Art, Society and Revolution*, London and New York, I.B. Tauris, 2003

Chelkowski, P., and H. Dabashi, *Staging a Revolution: the Art of Persuasion in the Islamic Republic of Iran*, London, Booth-Clibborn, 2000

Clark, J. A., *Modern Asian Art*, North Ryde, 1998

Diba, K., 'Iran,' in *Contemporary Art from the Islamic World*, eds A. Wijdan and E. Bisharat, Amman and London, Scorpion on behalf of Royal Society of Fine Arts, 1989

Emami, K., 'Modern Persian Artists,' in *Iran Faces the Seventies*, eds E. Yarshater and R. Ettinghausen, New York, Prager Publisher, 1971
—, *Saqqakhaneh School Revisited*, exh. cat., Tehran, Tehran Museum of Contemporary Art, 1977
—, 'Art in Iran XI Post-Qajar,' in *Encyclopaedia Iranica*, vol. II, ed. E. Yarshater, London and New York, Routledge & Kegan Paul, 1987: 641

Ekhtiar, M., 'From Workshop and Bazaar to Academy: Art Training and Production in Qajar Iran', in *Royal Persian Painting: The Qajar Epoch 1785–1825*, ed. L. S. Diba and M. Ekhtiar, New York, I.B. Tauris in association with the Brooklyn Museum of Art, 1999

Ettinghausen, R., 'An Introduction to Modern Persian Painting,' in *Iran Faces the Seventies*, eds E. Yarshater and R. Ettinghausen, New York, Prager Publisher, 1971, pp. 341–8

Fouladvand, H., 'Cultivating a New Identity: A Self-referential Experience for Iranian-American Artists', in *Between Shadow and Light: Contemporary Iranian Art and Artists*, ed. H. Keshmirshekan (forthcoming)

Gheissari, A., *Iranian Intellectuals in the Twentieth Century*, Austin, Texas, University of Texas Press, 1998

Hooglund, E. (ed), *Twenty Years of Islamic Revolution: Political and Social Transition in Iran since 1979*, Syracuse, New York, Syracuse University Press, 2002

Issa, R., *Iranian Contemporary Art*, London, Booth-Clibborn Editions, 2001

Katouzian, H, *The Political Economy of Modern Iran: Despotism and Pseudo-Modernism 1926–1979*, New York, New York University Press, 1981

Keddie, N. R., *Iran: Religion, Politics and Society*, London, Frank Cass and Company Limited, 1980
—, *Modern Iran: Roots and Results of Revolution*, New Haven, Yale University Press, 2003

Keshmirshekan, H., 'Saqqa-khana School of Art', in *Encyclopaedia Iranica*, London and New York, Routledge & Kegan Paul, n.d.
—, 'Contemporary Iranian Art: Neo Traditionalism from the 1960s to the 1990s', doctoral thesis, School of Oriental and African Studies (SOAS), University of London, 2004
—, 'Neo-traditionalism and Modern Iranian Painting: The *Saqqa-khaneh* School in the 1960s,' *Iranian Studies*, vol. 38, no. IV, (December 2005): 607–630
—, 'Discourses on Postrevolutionary Iranian Art: Neotraditionalism during the 1990s', *Muqarnas*, vol. 23, 2006, pp. 131–57
—, 'Contemporary Iranian Art: The Emergence of New Artistic Discourses', *Journal of Iranian Studies*, Vol. 40, No. 3, June 2007, pp. 335–66
—, 'Parviz Tanavoli's Small-Scale Sculptures', introduction to the book *Jewelry by Parviz Tanavoli*, Tehran, Bon-gah Publication, 2008
—, (ed.), *Between Shadow and Light: Contemporary Iranian Art and Artists* (forthcoming)

Khansari, A. S., *Kamal-i hunar* (Perfection of Art: Life and Works of Mohammad Ghaffari Kamal-ol-Molk [1847–1940]), Tehran, Elmi Publishing Co., Soroush Press, 1989

Khatibi, A., and M. Sijelmassi, *The Splendour of Islamic Calligraphy*, London, Thames & Hudson, 1996

Khemir, S., 'Mobile Identity and the Focal Distance of Memory', in *Displacement & Difference: Contemporary Arab Visual Culture in the Diaspora*, ed. F. Lloyd, London, Eastern Art Publishing, 2001, pp. 43–51

Khosrokhavar, F., 'Post revolutionary Iran and the New Social Movements,' in *Twenty Years of Islamic Revolution: Political and Social Transition in Iran since 1979*, ed. E. Hooglund, Syracuse, N. Y., Syracuse University Press, 2002, pp. 3–18

Lenczowski, G., *Iran under the Pahlavis*, Stanford, Calif., Hoover Institution Press, 1978

Marashi, A., *Nationalizing Iran: Culture, Power and the State, 1870–1940*, Washington, University of Washington Press, 2008

Matsuda, M. K., *The Memory of the Modern*, New York, Oxford University Press, 1996

Mirsepasi, A., *Intellectual Discourse and the Politics of Modernization: Negotiating Modernity in Iran*, Cambridge University Press, 2000

Mojabi, J., *Pioneers of Contemporary Persian Painting: first generation*, trans. K. Emami, Tehran, Iranian Art publishing, 1997

Pakbaz, R., *Contemporary Iranian Painting and Sculpture*, trans. S. Melkonian, Tehran, Vizrat-i Farhang va Hunar (High Council of Culture and Art), 1974
—, *Encyclopaedia of Art*, Tehran, Farhang-i Mu'asir Publisher, 1999
—, 'Contemporary Art of Iran', *Quarterly Tavoos*, no. 1, Autumn 1999, pp 168–91
—, *Naqqashi-i Iran az dir-baz ta imruz*, Tehran, Nashr-i Naristan, 2000
—, *et al*, *Beh bagh-i hamsafaran:* (Pioneers of Iranian Modern Painting; Houshang Pezeshk-Nia, Sohrab Sepehri, Hossein Kazemi), eds: Ruyin Pakbaz & Yaghoub Emdadian, Tehran, Nazar Printing & Publishing Cultural & Research Institute, 2001
—, and Y. Emdadian (eds), *Charles Hossein Zenderoudi*, Tehran, Tehran Museum of Contemporary Arts, 2001
—, and Y. Emdadian (eds), *Pioneers of Iranian Modern Art: Massoud Arabshahi*, Tehran, Tehran Museum of Contemporary Arts, 2001

Ram, H., 'Multiple Iconographies: Political Posters in the Iranian Revolution', in *Picturing Iran: Art, Society and Revolution*, eds S. Balaghi and L. Gumpert, London, I. B. Tauris, 2003

Sattari, J., *Dar bi dawlati-i farhang: Nigahi be fa'aliyyat-hay-i farhangi va hunari dar baz-pasin salhay-i nizam-i pishin*, Tehran, Nashr-i Markaz, 2000

Shayegan, D., *Asiya dar barabar-i Gharb* (Asia Facing the West), Tehran, 1977
—, *Cultural Schizophrenia: Islamic Society Confronting the West*, trans. J. How, London, Saqi Books, 1992

Tadjvidi, A., *L'art Moderne En Iran*, Teheran, Iranian Ministry for Culture and the Arts, 1967

Tanavoli, P., 'Atelier Kaboud', in *Parviz Tanavoli, Sculptor, Writer and Collector*, ed. D. Golloway, Tehran, Iranian Art Publishing, 2000

Vernoit, S., *Occidentalism: Islamic Art in the 19th Century: The Nasser D. Khalili Collection of Islamic Art*, vol. 23, New York, Nour Foundation in association with Azimuth Editions and Oxford University, 1997

Winnicott, D., *Maturational Processes and the Facilitating Environment: Studies in the Theory of Emotional Development*, London, Hogarth Press. 1965

Yarshater, E., and R. Ettinghausen (eds), *Iran Faces the Seventies*, New York, Prager Publisher, 1971
—, 'Contemporary Persian Painting', in *Highlights of Persian Art*, eds R. Ettinghausen and E. Yarshater, New York, Westview Press, 1979

Every book is a story in the making. *Different Samples* has been a project as difficult as any that I have undertaken. Apart from the usual obstacles faced in the creation and production of a book of such scope, varied content and cultural importance, we have also been confronted with some less usual challenges. Principal among these has been the harvesting of works for over two hundred Iranian artists dotted around the world, while constantly passing the material through curatorial and design filters in an attempt to find the very best, most interesting people. And at the same time travelling across three continents in pursuit of interviews with many of these artists, in order to capture fresh insights and to be able to present the fullest possible picture of contemporary Iranian art.

The success of this book will be a tribute to my regular team of dedicated associates, with Roger Fawcett-Tang spearheading design as Creative Director, Christopher Dell fashioning the narrative nuts-and-bolts as Chief Editor, and Caroline Campkin building the frame as Production Coordinator, in association with CS Graphics. Our success will also be attributable to the many new faces that have been brought together in this groundbreaking and brilliant enterprise, and who have selflessly given their time, effort and enthusiasm. Foremost among these perspicacious minds has been Maryam Homayoun Eisler, whose curatorial and editorial contribution, meticulous research, artwork sourcing and dogged persistence have enriched this book.

Thanks are also due to our co-publishers Thames & Hudson, principally to Jamie Camplin and Jonathan Earl. Patience is a virtue well stocked in their offices, especially when it comes to dealing with my projects.

My fellow contributors to *Different Sames* deserve praise for their acceptance of demanding schedules in bringing this book to print. As a recognized authority with a solid understanding of the Iranian angle, but also with a Western academic perspective, Hamid Keshmirshekan was scouted early on to present the history of modern art in Iran. Mark Irving was commissioned to create a critical piece, where no real body of art criticism, or serious writing on the subject, has existed to date. His work speaks for itself. Anthony Downey's contribution is notable for its breadth of ideas.

Fereydoun Ave deserves mention for his early contribution to the framework of ideas behind this book, with long hours spent in Paris cafes discoursing on artists and their oeuvres, arguing each their merits. Many others are owed thanks: Farbod Dowlatshahi for his initial contribution, Narges and Alex Durini di Monza for their detached good sense and insights, Fereshteh Daftari for her incomparable curatorial expertise on the subject, Ziba de Weck Ardalan for her knowledge of the art scene, Gitty Rahbar for helping with the early ideas for the book and then helping with initial research, Edward Lucie-Smith for his overview of the Iranian contemporary movement, Leila Taghinia-Milani Heller for her market overview and dedicated follow-through on artists and their artworks, Kamran Diba for his historical insights, Daniela da Prato for her committed good sense on new trends on the

contemporary art scene in Tehran, John Martin for being a patient sounding board, Maryam Massoudi for her encyclopedic knowledge of Iranian art, Sunny Rahbar for her professional and curatorial support, Rose Issa for early counsel, Maryam Alaghband for her input, Vali Mahlouji for his interaction, Janet Rady for preparatory consultations, Shirley Elghanian for her thoughts and developing insights, Ali Bagherzadeh for his advice, Isabelle Van Eynd and Charlie Pocock for background briefings, Leila Khastoo for her curatorial input and new take on young Iranian artists, Leila Varasteh for her curatorial efforts and Jason Lee for his contribution.

Then there are all the featured artists, none of whom I had known before embarking on this enterprise, and every one of them deserving of our thanks for their artistic contribution and their time, whether for the profiles or in marathon sessions discussing art in general. These artists have become creative acquaintances, some even friends, but all have helped inform and enriched my journey. I would particularly like to thank Parviz Tanavoli, Y. Z. Kami, Sadegh Tirafkan, Alaleh Alamir, Shirin Neshat, Shoja Azari and Shirana Shahbazi.

Last but not least are the various Iranian and international galleries and organizations that have helped in the progress of this book by packaging their artists in a professional manner, making our heavy workload lighter. In Iran, particular thanks are due to Maryam and Omid Tehrani at the Assar Gallery, Rozita Sharafjahan for the Azad Art Gallery, Shahnaz Khonsari of the Mah Gallery, Ferial Salahshour of Day Art Gallery, Anahita Ettehadieh of The Silk Road Gallery and Nazila Noebashari of Aaran Gallery. In Dubai, Laura Trelford from ArtDubai, Claudia Cellini and Haig Avazian from The Third Line Gallery, Dariush and Shaqayaq Zand from Courtyard Gallery, Narges Hamzianpour from Basement Gallery and Mona Hauser from XVA Gallery. In New York our thanks go to Ken Maxwell at the Gagosian Gallery, Mary Morris and Lauren Pollock from LTMH Gallery, Eric Nylund from Gladstone Gallery, Cristian Alexa of Lombard-Fried Projects, Leslie Tonkonow of Leslie Tonkonow Projects, Caroline Dowling from Perry Rubenstein, Priska Juschka from Priska C. Juschka Fine Art, Jonathan Lavoie of I-20 Gallery and Leila Khastoo from Khastoo Gallery in Los Angeles. In London thanks are owed to Lucinda Ball from Xerxes Fine Art Gallery, Venetia Porter from the British Museum, Anthony Wilkinson from Wilkinson Gallery, Alia Al Senussi for the Albion Gallery and Hengameh Golestan. Andreas Lange of Schleicher & Lange Gallery in Paris; Mathias Stenglin of Klosterfelde Gallery in Berlin; Galerie Nordenhake in Stockholm; Galleria Suzy Shammah in Milan and Evoline Baumgartner from Galerie Bob van Orsouw in Zurich.

Then there are those whose name does not appear on this page, not for lack of gratitude, but rather for their own sensitivities. As an afterthought, this book is really the product of creative magna. Anything short of its success will be my responsibility.

Hossein Amirsadeghi
New York, February 2009

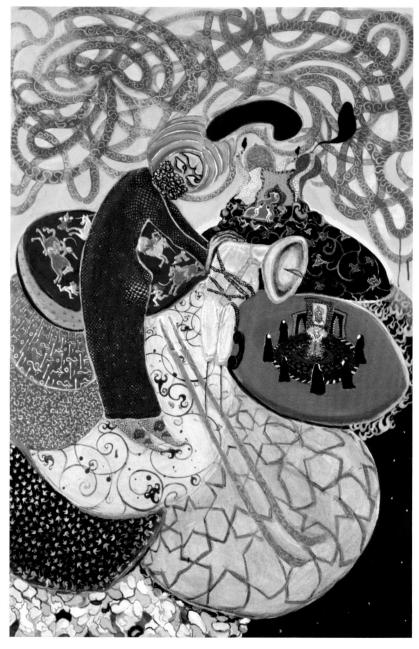

Negar Ahkami
Going Down, 2006
Acrylic, glitter and nail polish
on gessoed panel
122 x 81 cm
© Negar Ahkami
Courtesy of Negar Ahkami and
LTMH Gallery, New York
Photo: Hermann Feldhaus